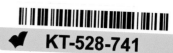
Contemporary Cultures of Display

EDITED BY EMMA BARKER

Yale University Press, New Haven & London
in association with The Open University

Acknowledgement

Grateful acknowledgement is made to the following source for permission to reproduce material in this book:

Pages 250–1: Willie Doherty: No Smoke Without Fire (1996) exhibition catalogue, London, Matt's Gallery.

First published 1999 by Yale University Press in association with The Open University

10 9 8 7 6 5 4 3 2

Library of Congress Cataloging-in-Publication Data

Contemporary Cultures of Display/ edited by Emma Barker.
 p. cm. -- (Art and its histories : 6)
 Includes bibliographical references and index.
 ISBN 0-300-07782-3 (h/b). -- ISBN 0-300-07783-1 (p/b)
 1. Art, Modern -- 20th century-- Exhibitions. 2. Art-- Exhibition techniques. 3. Public relations-- Art museums. I. Barker, Emma. II. Series.
N6490.C65673 1999
708 -- dc21 99-11436

Edited, designed and typeset by The Open University.

Printed in Italy

a216b6i1.1

1.1

Contents

Preface

This is the last of six books in the series *Art and its Histories*, which form the main texts of an Open University second-level course of the same name. The course has been designed both for students who are new to the discipline of art history and for those who have already undertaken some study in this area. Each book engages with a theme of interest to current art-historical study, and is self-sufficient and accessible to the general reader. This final book explores some of the ways in which contemporary understanding of art and its histories is constructed and informed by public display in museums and galleries. As part of the course *Art and its Histories*, it (along with the rest of the series) also includes important teaching elements. Thus the text contains discursive sections written to encourage reflective discussion and argument, and to contribute to the ongoing critical debate which surrounds the display of art.

The six books in the series are:

Academies, Museums and Canons of Art, edited by Gill Perry and Colin Cunningham

The Changing Status of the Artist, edited by Emma Barker, Nick Webb and Kim Woods

Gender and Art, edited by Gill Perry

The Challenge of the Avant-Garde, edited by Paul Wood

Views of Difference: Different Views of Art, edited by Catherine King

Contemporary Cultures of Display, edited by Emma Barker

Open University courses undergo many stages of drafting and review, and the book editor would like to thank the contributing authors for patiently reworking their material in response to criticism. Special thanks must go to all those who commented on the drafts, including the A216 course team, Nicola Durbridge, and Open University tutor assessors Anne Gaskell, Peter Jordan and Sue Vost. Thanks are also due to Professor Will Vaughan, external assessor for the course. The course editor was Nancy Marten. Picture research was carried out by Susan Bolsom-Morris and Tony Coulson with the assistance of Jane Lea, and the course secretary was Janet Fennell. Debbie Crouch was the graphic designer, and Gary Elliott was the course manager.

Introduction

EMMA BARKER

What are the conditions in which works of art are experienced today? In this book we will seek to answer this question by considering museums, galleries and other contexts of display.[1] In so doing, we will be concerned not simply with the arrangement of objects in space but also with the politics and economics of art institutions. The context of display is an important issue for art history because it colours our perception and informs our understanding of works of art. This is the fundamental point of this book: that museums and galleries are not neutral containers offering a transparent, unmediated experience of art. Rather, we need to consider them in terms of 'cultures of display', that is, with reference to the different ideas and values that can shape their formation and functioning. The central aim of this introduction, therefore, is to explore the problematic nature of display.

Although we are primarily concerned here with the conditions for looking at art that prevail today, it is impossible to understand them properly without considering the ways in which they have changed in recent decades. The book itself is structured so as to bring out a sense of these developments, moving outwards from an examination in Part 1 of the changes that have taken place within art's traditional sanctum – the museum – to consider in Part 2 the increasingly important phenomenon of the temporary exhibition, and finally in Part 3 by addressing the wider context in which art is produced and viewed today. Critical discussions of the current state of art often suggest that it is subsumed within a culture of 'spectacle'; we will examine this term later in this introduction. First, however, we will open up some key themes and issues by examining the concept of the 'museum without walls'.

The museum without walls

This phrase originated as a loose translation of the French writer André Malraux's *Le Musée imaginaire* (the imaginary museum), which was first published in 1947 (Plate 1). It has since gained wide currency as a useful shorthand for the diffusion of works of art beyond the museum by means of photographic reproduction. The museum without walls was, however, conceived by Malraux as referring primarily to a massive expansion of art beyond the classical canons of taste that had continued to prevail (just about) in the museums of the nineteenth century, to embrace works of every time and place that had previously been unknown or unappreciated.[2] By means of photography, he argued, 'a "museum without walls" is coming into being, and … it will carry infinitely farther that revelation of the world of art, limited perforce, which the "real" museums offer us within their walls …' (Malraux,

[1] In this book both the American term 'art museum' and the British usage of describing a public collection of fine art as a 'gallery' will be employed.

[2] On the classical canon, see Perry and Cunningham, *Academies, Museums and Canons of Art* (Book 1 of this series).

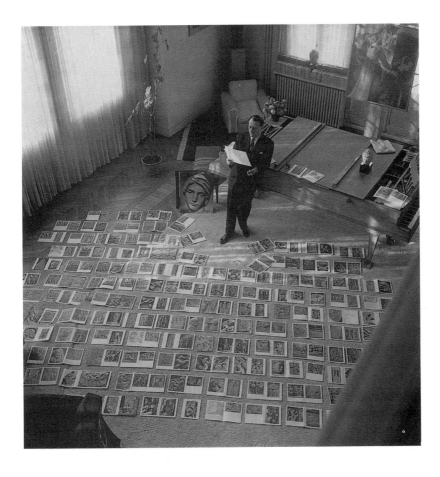

Plate 1 André Malraux with the illustrations for the *Museum without Walls*. Photo: *Paris Match* / Jarnoux.

The Voices of Silence, p.16). The creation of an expanded audience for art is the corollary of this: 'a new field of art experience, vaster than any so far known … is now, thanks to reproduction, being opened up. And this new domain … is for the first time the common heritage of all mankind' (*The Voices of Silence*, p.46).

For Malraux, the museum without walls is the latest stage in a process of 'metamorphosis' begun by the museum proper. It is the museum, he argues, that transforms an object (such as a fourteenth-century altarpiece) into a work of art by allowing it to be appreciated for its formal qualities alone without regard to the setting for which it was made or the function it once fulfilled. Photography extends this decontextualizing effect by stripping objects not only of their original significance but also of their material specificity: scale, texture, colour, etc. Malraux positively welcomes the overall homogenizing effect that this produces. According to him, it 'imparts a family likeness to objects that have actually but slight affinity', thereby making it possible to dignify them as works of art in a 'common style' (*The Voices of Silence*, p.21). By enlarging an ancient carved figurine so that it resembles a semi-abstract sculpture or by isolating a detail from a larger work in accordance with a modern preference for the fragment over the whole, moreover, photography can endow them with 'a quite startling, if spurious modernism' (*The Voices of Silence*, p.27). These visual tricks, especially the latter, remain standard in reproductions today.

Malraux's acknowledgment of the way that photographic manipulation assimilates objects from different cultures to a modernist aesthetic points to a fundamental problem at the heart of the museum without walls. Photography, he suggests, allows innumerable different styles to be distinguished and assessed in their own terms, thereby undermining the authority of any single aesthetic norm. But the diversity of this 'world of art' is based on a formalist approach – largely excluding consideration of both content and context – that is distinctively modernist.[3] The museum without walls can thus be viewed as a form of cultural imperialism, imposing a modern western conception of 'art' as well as a modernist aesthetic on objects from different cultures and periods. It is implicated in the conquests and thefts that have brought many such objects into western collections: Malraux himself, as his unsparing critic Georges Duthuit pointed out, had (in 1923) detached sculptures from the temple at Angkor in Cambodia (cited in Krauss, 'The ministry of fate', p.1005). As Case Study 6 shows, this kind of tension between the appreciation of objects from 'other' cultures and their appropriation (actual or aesthetic) is a major issue for contemporary museum display.[4]

No less significant and indeed problematic is Malraux's conception of the museum without walls as 'the common heritage of mankind'. Here, too, he saw photography as extending a process begun by the 'real' museum in making works of art accessible to people beyond a wealthy élite of art collectors. A commitment to promoting access was the starting point for Malraux's policy as France's first minister of cultural affairs between 1959 and 1969. It found its clearest expression in the nation-wide network of cultural centres (*maisons de culture*) that was established during these years to bring art to the people. In practice, however, this policy was at best controversial, at worst a complete flop. A fundamental problem, it can be argued, was Malraux's quasi-religious belief that people need only to be brought into contact with art in order to be able to understand and appreciate it. According to the French sociologist Pierre Bourdieu, for example, 'the love of art' is far from universal but depends on the possession of a class-specific 'cultural capital' (as exemplified by the kind of formalist approach employed by Malraux).[5] Malraux's ministerial career represents in extreme form the tension between high art and cultural democracy that, as many of the case studies here show, is now a crucial issue for museums.

The central paradox of Malraux's museum without walls is that it embraces photography but essentially restricts it to the role of a mechanism in the service of art. A very different analysis is offered in the cultural theorist Walter Benjamin's influential essay, 'The work of art in the age of mechanical

[3] For a discussion of the modernist emphasis on the formal qualities of works of art, see the Introduction to Wood, *The Challenge of the Avant-Garde* (Book 4 of this series).

[4] These tensions are exemplified by demands for the return of cultural treasures to their country of origin, such as Greece's claim to the Parthenon marbles in the British Museum. On this issue, see Case Study 2 in Perry and Cunningham, *Academies, Museums and Canons of Art* (Book 1 of this series). See also King, *Views of Difference* (Book 5 of this series).

[5] For a discussion of Bourdieu's ideas and an extract from his book *The Love of Art*, see Edwards, *Art and its Histories: A Reader*. For a Bourdieu-informed analysis of Malraux's cultural policy, see Looseley, *The Politics of Fun*, pp.33–48.

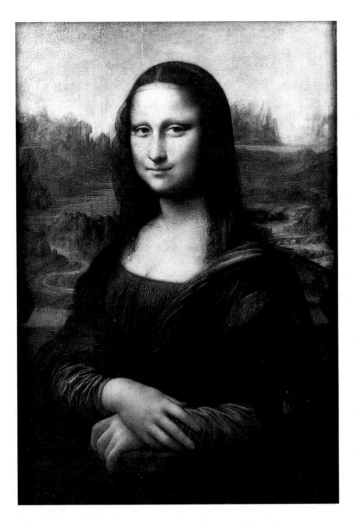

Plate 2 Leonardo da Vinci, *Mona Lisa, c.*1502, oil on panel,
77 x 53 cm, Musée du Louvre, Département des Peintures,
Paris. Photo: Copyright R.M.N.

reproduction' (1936). Welcoming photography's potential for emancipating the masses, Benjamin argued that it undermines the quasi-magical 'aura' of the unique work by creating a multiplicity of copies in place of a single original. Take, for example, the *Mona Lisa* (Plate 2): its very familiarity in reproduction means that the actual picture in the Louvre tends to strike viewers as smaller and less impressive than expected. Its 'presence' as a unique object can be said to have been depleted by the ubiquity of the image. Nevertheless, the crowds continue to gather around this most famous of paintings. Despite the significance of Benjamin's analysis, it is undeniable that the fascination of the unique original has been substantially enhanced by the mass production of images.[6] Photography (and, more broadly, the mass media) has undoubtedly thereby contributed to the vast increase in visitor levels at art museums and galleries that has taken place since the mid-twentieth century.

[6] This is a complex issue that we can only touch on here; the key point is that, if copies did not exist, it would be impossible to define any object as an original.

While Malraux's emphasis on photography's popularizing role has been proved correct in this respect, his conception of the museum without walls nevertheless fails to register the extent of its impact.[7] Today the status of an object as 'art' no longer depends on its unique existence as an original work from the hand of an individual artist. Certain forms of photography have now gained the status of an art form and are exhibited as such in museums. Many contemporary artists reject the traditional media of painting and sculpture and work instead with pre-fabricated materials and photographic media (see Plates 76 and 153). Admittedly, of course, the identification of such practices as art is a contentious issue for many people (inevitably so given that even early twentieth-century abstract art has yet to be uniformly accepted). To say that it depends ultimately on their presence in the museum might seem to confirm often expressed suspicions that modern art represents an art world 'conspiracy' perpetrated on the public. It can also, however, be seen in terms of the phenomenon that Malraux called metamorphosis: that is to say, the quasi-magical transformation of objects into art. From this perspective, the expanded definition of art now current can be understood as an extension of metamorphosis. The crucial point here is that the institutional power of the museum (considered more fully below) works against the levelling effect of photography and continues to uphold, however problematically, the distinction between what is and what is not art.

The museum without walls as it was formulated by Malraux certainly cannot be taken as an unproblematic concept. As we have seen, the rhetoric of diversity and openness is at least partly belied by his assumptions about the nature of art. Nevertheless, the term (especially in its translated form) has many resonances pertinent to the contemporary conditions for viewing art. It can, for example, be taken to refer to temporary exhibitions (discussed in Part 2) as opposed to museum collections. In a later edition of his book, Malraux described exhibitions as 'those brilliant and fleeting dependencies of the museum without walls' (*Museum without Walls*, p.160). The museum without walls might also be understood as the architectural counterpart to the works of art within museums, appropriately so since Malraux as minister was much concerned with the preservation of France's historic buildings (this issue is touched on in Case Study 2 and discussed in Case Study 8). Most apposite of all, perhaps, is to apply the term to open-air sculptures, otherwise known as public art; these certainly make art accessible beyond the real museum, as Malraux conceived the museum without walls as doing, but also raise difficult questions about the place of art in society (explored in Part 3).

[7] For postmodern cultural critique, the central weakness of Malraux's argument is the failure to grasp that the museum without walls would promote an endless recycling of the images and styles of the art of the past (identified as postmodernism); see, for example, Crimp, 'On the museum's ruins', pp.54–8 (this article was first published in 1980). Aspects of postmodernism are discussed in the first two case studies.

Display

The condition of being on display is fundamental to the construction of the category 'art' in the modern western world. Art's autonomy – its definition as a specialized set of objects and practices set apart from the more mundane concerns of society – is bound up with the existence of the museum, which, in displaying works of art, stops them being used for any purpose other than that of being looked at. By thus promoting specialized, distinctively aesthetic modes of looking, art museums function (according to Carol Duncan) as 'ritual sites' dedicated to the religion of art (Duncan, *Civilizing Rituals*, pp.7ff). It must be emphasized that this notion of a 'religion of art' should not be taken at face value. For Duncan, as for many cultural critics, the cult status of art is precisely what makes the museum problematic. However, display itself is just as much an issue here as art. We can put this in focus by noting that display is a verb as well as noun, active as well as passive: the point being that display is always *produced* by curators, designers, etc. As such, it is necessarily informed by definite aims and assumptions and evokes some larger meaning or deeper reality beyond the individual works in the display. In short, it is a form of representation as well as a mode of presentation.

Museums first and foremost impose meaning on objects by classifying them. This is true of any museum; a natural history museum, for example, will order the objects that it contains in accordance with categories derived from the biological sciences (for example, species and genus). Within an art museum, the classifications employed are derived from the discipline of art history; the works of art will therefore typically be arranged by period, school, style, movement or artist (or a combination of these). At the same time, the presence of a particular work of art in a museum (at least, in major instititutions such as the National Gallery in London or the Metropolitan Museum of Art in New York) already represents a form of classification: it has been distinguished from others that were not deemed worthy of inclusion on the basis of its authenticity, originality or some other quality (hence the phrase 'museum quality'). The final arbiters here, the people who make the judgements justifying the acquisition of a work for a collection or its inclusion in an exhibition, are museum curators and directors.[8] The nature of their role has been nicely summed up by the French artist Daniel Buren, who, commenting on a 1989 exhibition that identified contemporary artists from around the world as 'magicians', 'suggested that the real "magicians" of contemporary society were the museum curators' (Deliss, 'Conjuring tricks', p.53).

The artistry of the curator has been foregrounded over the course of the last century or so as a result of the increasing care devoted to the visual effect produced by the display of works of art within the gallery space. A sense that display itself has something of the status of a work of art is suggested by the double meaning of the term 'installation', referring, on the one hand, to

[8] It should, however, be pointed out that they sometimes make compromises: for example, if a donor offers a collection to the museum on condition that it is accepted in its entirety. Donors may insist that their collection be displayed together, thereby disrupting the orderly classifications of the museum (as has happened, for example, in the Metropolitan and the Musée d'Orsay in Paris).

the picture 'hang' or arrangement of objects and, on the other, to a type of art work that has developed since the 1960s, which may be site-specific and typically has to be dissassembled in order to be moved (see Plates 78 and 79). The curator Germano Celant, for example, notes that 'exhibition installation becomes the new pretender to originality ... [it] is in and of itself a *form of modern work*' (Celant, 'A visual machine', p.373).[9] The artfulness of modern display can produce an intensified aestheticization: careful spacing and lighting isolate works of art for the sake of more concentrated contemplation (as in the 'white cube' type of gallery space discussed in Case Study 1). Alternative stategies of display seek, by contrast, to recontexualize works of art in the world outside the museum. This can mean recreating the material setting in which they might once have been seen (as in the 'country house' style of display discussed in Case Study 8). In the case of exhibitions, it typically involves attempting to evoke their historical context with the help of information panels, documents, photographs, etc. (Plate 64). A recent example of such an exhibition was *Art and Power: Europe of the Dictators* (London, Hayward Gallery, 1995–6), which explored how art fared under the totalitarian regimes, both Fascist and Stalinist, of the period 1930–45.

Nevertheless, the fundamental aim of an art museum is to display works of art for the sake of their aesthetic interest. For contemporary museum critique, the particular significance of the aesthetic approach lies in the way that it seeks to bracket off or 'neutralize' the wider world beyond the museum. 'The alleged innate neutrality of museums and exhibitions', according to Ivan Karp, 'is the very quality that enables them to become instruments of power as well as instruments of education and experience' (Karp, 'Culture and representation', p.14).[10] This is also the point underlying Carol Duncan's account of the art museum as 'ritual site'; participation in its seemingly rarefied 'rituals' serves to confirm a particular sense of identity (in terms of class, race, gender, etc.) and thereby reinforces the ideological norms of society. Analysing the Museum of Modern Art in New York (see Case Study 1), for example, she argues that the dominance of male artists and the prominence of female nudes mean that progress through the spaces of the museum produces a 'ritual subject' (or identity) that is gendered masculine (Duncan, *Civilizing Rituals*, pp.114–15). This type of analysis is problematic (as Duncan acknowledges) in so far as it assumes that museum visitors passively absorb a uniform message rather than actively respond to display in different ways (for an example of a museum that has proved amenable to diverse 'readings', see Case Study 2). However, it does have the value of alerting us to the possible ideological significance of particular displays.

From some critical perspectives, however, all museum display is inherently problematic. For anyone who disputes the validity of the 'aesthetic' as a specialized domain (as, for example, does Bourdieu), display is necessarily

[9] Celant is one of a number of influential international curators; he was the curator of the 1997 Venice Biennale, for example. The essay quoted here was originally published in *documenta vii* in 1982 (for these international exhibitions of contemporary art, see Case Study 4).

[10] Although the point about 'neutrality' is most easily made with reference to art museums, it is not just aesthetics ('experience') that is at issue here but also (as the 'education' reference indicates) the claims made by all museums to be distinterested, objective sources of knowledge.

understood as a form of fetishism.[11] That is to say, by isolating objects for purposes of aesthetic contemplation, it encourages the viewer to project on to them meanings and values that have no real basis in the objects themselves. While the full logic of this argument is unacceptable to anyone who believes that it is possible to make distinctions between objects on purely visual grounds, the concept of fetishism is helpful in so far as it allows us to understand why some forms of display are more problematic than others. A case in point is the now standard practice of placing objects under spotlights in otherwise dimly-lit spaces so that they seem to glow of their own accord, endowing them with an air of mystery and preciousness. The problem here is that this kind of lighting is typically used for ancient and (as Case Study 6 shows) 'primitive' art – in other words, precisely those objects that are most alien to a modern western viewer – and can thus inhibit any engagement with the meanings and values they would have had in their original context. This does not mean that such lighting should not be used but rather, it can be argued, makes it important to ensure that the display as a whole fosters a degree of self-consciousness on the part of viewers about the cultural distance between themselves and the objects on show.[12]

The concept of fetishism also has relevance, however, to the display of western fine art and, in particular, to the Old Master and modern paintings that are the most highly prized objects in our society. Here, it is specifically Karl Marx's analysis of commodity fetishism that applies: the suggestion is that the special value attributed to such paintings serves to obscure or 'mystify' their real condition as commodities in a system of market exchange.[13] Of course, this may seem irrelevant to the present discussion given that the primary function of the museum is to take works of art out of commercial circulation and make them accessible to people who could not afford to buy them. Nevertheless, it can be argued that an awareness of the prices that a work of art *would* fetch *should* it come on the market profoundly informs the experience of display. Consider, for example, Vincent van Gogh's *Irises* (Plate 3), which (temporarily) became the most expensive painting in the world when it was auctioned for just under $54 million in 1987 (though, in the event, the Australian businessman who bought it proved unable to pay) and now hangs in the world's best endowed museum (no other could afford it). While the unique 'aura' (in Benjamin's term) of *Irises* ostensibly derives from the 'genius' of Van Gogh, the experience of the painting is now inescapably bound up with the fascination of sheer concentrated money. Clearly, this is an extreme case but not a wholly unrepresentative one. Moreover, in so far as the commodity status of art is here being not so much denied as celebrated, it takes on further significance as evidence of the contemporary culture of spectacle.

11 For a brief discussion of this term, see Case Study 11 in Perry, *Gender and Art* (Book 3 of this series).

12 The introduction of some element of cultural contrast is presented as the only solution to the problem of displaying other cultures in Karp, 'Culture and representation', pp.18–19. A similar element of self-consciousness about display is also often recommended as a strategy for museums in general; see, for example, Saumarez-Smith, 'Museums, artefacts and meanings', p.20.

13 The fundamental question here is whether (as Benjamin argued) 'such outmoded concepts as creativity and genius, eternal value and mystery' are *wholly* reducible to symptoms of commodity fetishism (Benjamin, 'The work of art', p.212). For a discussion of the relevance of the concept of the commodity to art, see Wood, 'Commodity'. As a related point, it can be noted that the type of lighting discussed in the previous paragraph originated in a retail context as a device for the display of commodities.

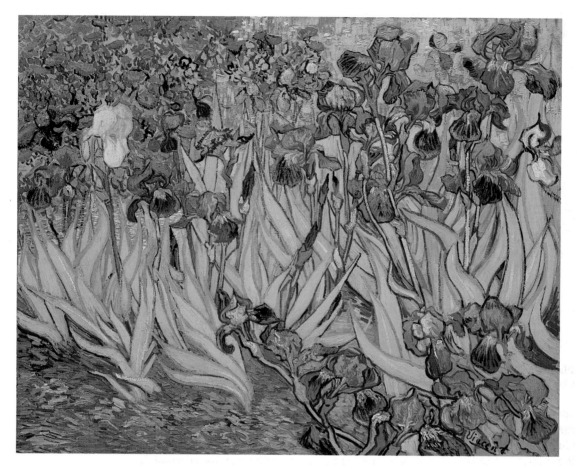

Plate 3 Vincent van Gogh, *Irises*, 1889, oil on canvas, 71 x 93 cm, The J. Paul Getty Museum, Los Angeles.

Spectacle

In its most literal sense, this word signifies a dazzling visual show. What we might call art-as-spectacle can be exemplified by the *Wrapped Reichstag* (Plate 4), a work by the husband-and-wife team of artists Christo and Jeanne-Claude, which consisted of covering the Reichstag building in Berlin with silvery fabric to spectacular effect. The work had a political dimension: what allowed the Christos' long-contemplated project to get official consent in 1994 was the end of the Cold War and the reunification of Germany (the Reichstag was subsequently to become the country's parliament building once again). Also significant is the sheer scale of the enterprise, which was completed in June 1995: it required a work-force of over 200 and reportedly cost some £8 million to carry out. From this follows a further point: huge amounts of time and money were expended to create not a permanent monument but a temporary construction.[14] But, of course, the *Wrapped Reichstag* survives still in a multitude of photographs; even during its fleeting existence, it was seen not only by over five million people in Berlin but also, through the medium of newspapers and television, by many more around the world.

[14] The *Wrapped Reichstag* was dismantled after only two weeks; the artists also produce more permanent works (drawings, models, etc.), the sale of which finances the wrapping works. Their refusal to accept subsidy for their work (among other factors) means that it should not necessarily be seen in the negative Debordian terms outlined below.

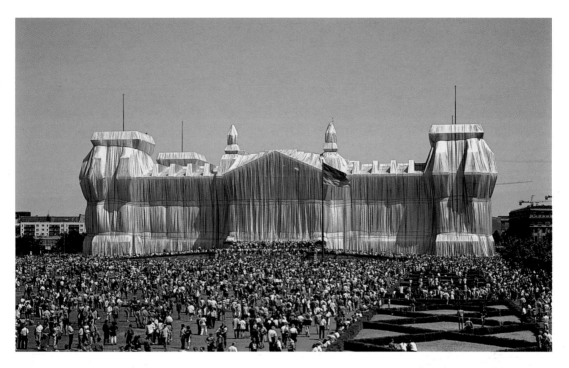

Plate 4 Christo and Jeanne-Claude, *Wrapped Reichstag*, 1971–95, Berlin. Photo: Wolfgang Volz. Copyright Christo 1995.

Spectacle is a key concept for analysing the condition of art in the era of mass media. Its currency in contemporary critical discourse can be traced back to Guy Debord's *The Society of the Spectacle* (1967), which elaborated the ideas of the French cultural revolutionary group known as the Situationists (in which he himself was a major figure).[15] Their central claim is that, under the prevailing conditions of capitalist production, life is largely mediated through images. The 'spectacle' is not simply a mass of images, however, but constitutes a frozen and distorted version of actual social relations. This argument draws on Marx's analysis of commodity fetishism, which already suggested that capitalism has the effect of obscuring fundamental social realities as it subordinates 'use value' to 'exchange value'.[16] The concept of the 'spectacle' develops directly out of a tradition of Marxist cultural criticism that laments the increasing commodification and bureaucratization of everyday life (and, more especially, leisure time) in the twentieth century. Its main concern is with the consumption of a highly technologized mass culture which, so it is argued, upholds the interests of capital by alienating the majority from their real needs. With Debord, this concern is accompanied by a particular emphasis on the image as the domain of illusion and ideology or, to put it another way, on visuality as a form of domination, one that dazzles and deceives, seducing or stunning the spectator into submission. This suspicion of vision makes 'spectacle' a valuable but also problematic term for considering the production and consumption of the visual arts.

[15] For a discussion of and extracts from *The Society of the Spectacle*, see Edwards, *Art and its Histories: A Reader*.

[16] In other words, when any relationship with actual human needs gives way to an essentially illusory monetary value; for a further use of these two concepts, see Case Study 4.

On this point, it is significant that Debord identifies two models of spectacle, though he says far more about 'diffused' spectacle – the capitalist version – than about the 'concentrated' form of totalitarian regimes (put schematically it is a case of television on the one hand and the Nazis' Nuremberg rallies on the other). In the context of art, spectacle can be said to have found its defining expression in the colossal monuments of totalitarianism, exemplified by the rival Nazi and Soviet pavilions at the 1937 Paris International Exhibition (Plate 67).[17] As the *Wrapped Reichstag* demonstrates, overwhelming scale can also be an element in contemporary art-as-spectacle, though, far from functioning as propaganda for a totalitarian regime, this work does not impose any particular meaning on its viewers and could be taken to symbolize an end to warring ideologies. In the consumer society of today, it can be argued, the spectacle finds its typical expression in the image that serves to promote consumption. This would allow art-as-spectacle to be defined by analogy with advertising in terms of its high production costs, typically glossy surfaces and attention-grabbing impact. It could be exemplified by reference to the much-hyped 'new British art' of the 1990s, notably the work of Damien Hirst (Plate 74).[18] It might even be thought significant that the major patron of this art, Charles Saatchi, made his fortune in advertising (on the Saatchi collection, see Case Study 4). All this begs the question: when used with reference to contemporary art, is 'spectacle' any more than a convenient derogatory term for policing the boundaries between high art and mass culture?

Any answer would need to consider the broader use of the term in support of the argument that art is being incorporated into a system of commercial entertainment, media hype and cultural tourism. In an article of 1992, deploring the widespread curatorial emphasis on high-profile exhibitions (spectacle in the sense of being ephemeral, attention-seeking 'shows'), the Belgian artist Jan Vercruysse declared:

> … our culture is sliding into a culture of spectacle. Media and spectacle-oriented performances and events with reference to art create a *negative energy*, turning art into an 'art event', a spectacle to be consumed for and by everyone. The attention for art roused by spectacle is bad since it is not founded on content but on the effect of its media existence. I contest the idea that all these media operations 'serve' art, resulting in an increase of real interest for art from more and more people.
>
> (Quoted in Walker, *Art in the Age of Mass Media*, p.70)

The 'culture of spectacle' is identified as a crucial issue by artists and critics concerned about the future of modern art on the grounds that, in turning art into merely another cultural commodity for leisure-time consumption, it necessarily compromises the potential for art as a form of critical practice. In

[17] Although the term is often applied to the nineteenth century (see Case Study 2) and earlier, it has been argued that spectacle in a strictly Debordian sense only emerged in the late 1920s with innovations in technology and the rise of Fascism; see Crary, 'Spectacle, attention, counter-memory'.

[18] Hirst's *Away from his Flock*, one of his 'trademark' animals in formaldehyde, was parodied in an advertisement in 1994; the artist and his dealer threatened to sue, but the case was settled out of court. This interaction of avant-garde art and mass culture is not new in itself; rather, as Tom Crow argues, the borrowing of mass cultural forms by avant-garde artists has from the first been followed by their re-appropriation by commerce; see Crow, *Modern Art in the Common Culture*, pp.33–6. However, the whole cycle does seem to have speeded up of late.

the 'spectacle', the challenge of the avant-garde is restaged (so the argument runs) as a form of theatre, a case in point being the Turner Prize (see Case Study 4), which, with its short-list of rival artists, positively invites controversy.[19] However, it is not only contemporary art that can be seen to be caught up in the 'spectacle'; indeed, the above-quoted claim that exhibitions are all too often media-friendly pseudo-events that do not really succeed in popularizing art applies just as well if not better to the blockbuster shows of Old Master and canonical modern painting discussed in Case Study 5. The fundamental problem of 'spectacle', it can be suggested, lies in the way that it subordinates art and its institutions to commercial and managerial priorities, producing a democratizing effect at the expense of serious engagement with or even close attention to works of art. In the worst case scenario, art becomes a mere pretext for more direct forms of consumption (in the museum restaurant and shop).

Any such shift away from direct involvement with – that is, actually looking at – works of art would certainly fit in with the general tendency of 'spectacle', as theorized by Debord, towards ever more mediated forms of experience. Here, it should be noted that his claims were subsequently developed into a much more extreme position by the French philosopher Jean Baudrillard. While Debord noted the increasing importance of cultural commodities or what he referred to as 'image-objects' to the world's economy (*The Society of the Spectacle*, para.15, p.16), Baudrillard argues that this proliferation of images means it is impossible to sustain belief in the existence of an underlying social reality. According to him, 'we are no longer in the society of the spectacle' but rather in the regime of the simulacrum – that is, of the image without a referent outside itself (Baudrillard, 'The precession of simulacra', p.273). Furthermore, Baudrillard argues, this sense of being lost in a world of appearances produces a compensatory striving to recapture the real in all its intensity that he calls 'hyperreality'. This concept is the most useful aspect of his work for us; it helps, for example, to explain the contemporary cult of heritage discussed in Case Study 8 (the hand-crafted past as more authentic than the prepackaged present). Equally, it could help to explain why the cult of the artist-genius seems, if anything, to have got stronger in recent years (the 'unreal' prices paid for Van Gogh's paintings are bound up with the supposed 'reality' of his suffering and suicide). However, accepting the full logic of Baudrillard's conception of a free-floating, essentially meaningless image world makes any further explanation or analysis impossible, whereas Debord's 'depth' model allows 'spectacle' to be tied down to fundamental politico-economic causes and offers the basis for a critique of its socio-economic effects (for these issues, see Case Study 7).

Ultimately, however, it must be emphasized that 'spectacle' is simply a useful concept rather than a verifiable reality. Like any theory that seeks to offer a total explanation of the world as we know it, it needs to be treated with a great deal of caution. The debate as to whether or not the 'society of the spectacle' is still with us is predicated on the debatable proposition that it

[19] On the definition of the avant-garde and of mass culture as its 'other', see the Introduction to Wood, *The Challenge of the Avant-Garde* (Book 4 of this series). The present discussion neglects the crucial differences between art and mass-produced cultural commodities such as film; some of these are addressed in Case Study 4.

did exist at some point. For present purposes, the crucial point is that any analysis of recent developments affecting art and its institutions solely in terms of a consumerist, manipulated culture of 'spectacle' would be unduly negative.[20] It means discounting the possibility that museums and galleries are not simply reinforcers of dominant ideology and may indeed have become more democratic over the last few decades. This suggestion can be supported by directing attention away from major museums closely associated with the rich and powerful (the 'usual suspects' of museum critique) to less well-established, especially non-metropolitan institutions (such as the Orchard Gallery in Derry, discussed in Case Study 9). Moreover, in so far as our world does resemble the one Baudrillard describes, it does not automatically follow that we have no option but to embrace the unceasing circulation of commodified images and abandon all idea of art as a specialized, privileged realm.[21] On the contrary, it could be said that the display of works of art in a museum is significant precisely because it can break the circuit, arrest the flow, by encouraging us to stop and contemplate a still or at least (to take account of video and other new art forms) slow image.

References

Baudrillard, Jean (1984) 'The precession of simulacra', in Brian Wallis (ed.) *Art after Modernism: Rethinking Representation*, New York, The New Museum of Contemporary Art/David R. Godine, Publisher, Inc., pp.253–81.

Benjamin, Walter (1973) 'The work of art in the age of mechanical reproduction' (first published 1936), in *Illuminations*, London, Fontana Press, pp.211–44.

Bourdieu, Pierre and Darbel, Alain (1991) *The Love of Art: European Art Museums and their Public*, Cambridge, Polity Press.

Celant, Germano (1996) 'A visual machine', in Reesa Greenberg, Bruce W. Ferguson and Sandy Nairne (eds) *Thinking About Exhibitions*, London, Routledge, pp.371–86.

Crary, Jonathan (1989) 'Spectacle, attention, counter-memory', *October*, no.50, Fall, pp.97–107.

Crimp, Douglas (1993) 'On the museum's ruins', in *On the Museum's Ruins*, Cambridge, Mass., MIT Press, pp.44–64.

Crow, Thomas (1996) *Modern Art in the Common Culture*, New Haven and London, Yale University Press.

[20] The repressive implications of spectacle (or, in his terminology, simulation and hyperreality) are most starkly spelled out in Baudrillard's discussion of the Pompidou Centre (see Case Study 1).

[21] The suggestion that the saturation of society by photographic and electronic images means that art and everyday life have now fused into a seamless continuum is associated with the argument that the present era is a distinctively postmodern one; see Case Study 2.

Debord, Guy (1994) *The Society of the Spectacle*, New York, Zone Books (first published 1967).

Deliss, Clémentine (1989) 'Conjuring tricks', *Artscribe International*, September–October, pp.48–53.

Duncan, Carol (1995) *Civilizing Rituals: Inside Public Art Museums*, London, Routledge.

Edwards, Steve (ed.) (1999) *Art and its Histories: A Reader*, New Haven and London, Yale University Press.

Karp, Ivan (1991) 'Culture and representation', in Ivan Karp and Steven D. Lavine (eds) *Exhibiting Cultures: The Poetics and Politics of Display*, Washington, DC, Smithsonian Institution Press, pp.11–24.

King, Catherine (ed.) (1999) *Views of Difference: Different Views of Art*, New Haven and London, Yale University Press.

Krauss, Rosalind (1989) 'The ministry of fate', in Denis Hollier (ed.) *A New History of French Literature*, Cambridge, Mass., Harvard University Press, pp.1000–6.

Looseley, David L. (1995) *The Politics of Fun: Cultural Policy and Debate in Contemporary France*, Oxford and Washington, DC, Berg Publishers.

Malraux, André (1954) *The Voices of Silence*, London, Secker and Warburg (Part 1: *Museum without Walls*).

Malraux, André (1967) *Museum without Walls*, revised and expanded edn, London, Secker and Warburg.

Perry, Gill (ed.) (1999) *Gender and Art*, New Haven and London, Yale University Press.

Perry, Gill and Cunningham, Colin (eds) (1999) *Academies, Museums and Canons of Art*, New Haven and London, Yale University Press.

Saumarez-Smith, Charles (1989) 'Museums, artefacts and meanings', in Peter Vergo (ed.) *The New Museology*, London, Reaktion Books, pp.8–21.

Walker, John A. (1994) *Art in the Age of Mass Media*, 2nd edn, London, Pluto Press.

Wood, Paul (1996) 'Commodity', in Robert S. Nelson and Richard Shiff (eds) *Critical Terms for Art History*, University of Chicago Press,

pp.257–80.

Wood, Paul (ed.) (1999) *The Challenge of the Avant-Garde*, New Haven and London, Yale University Press.

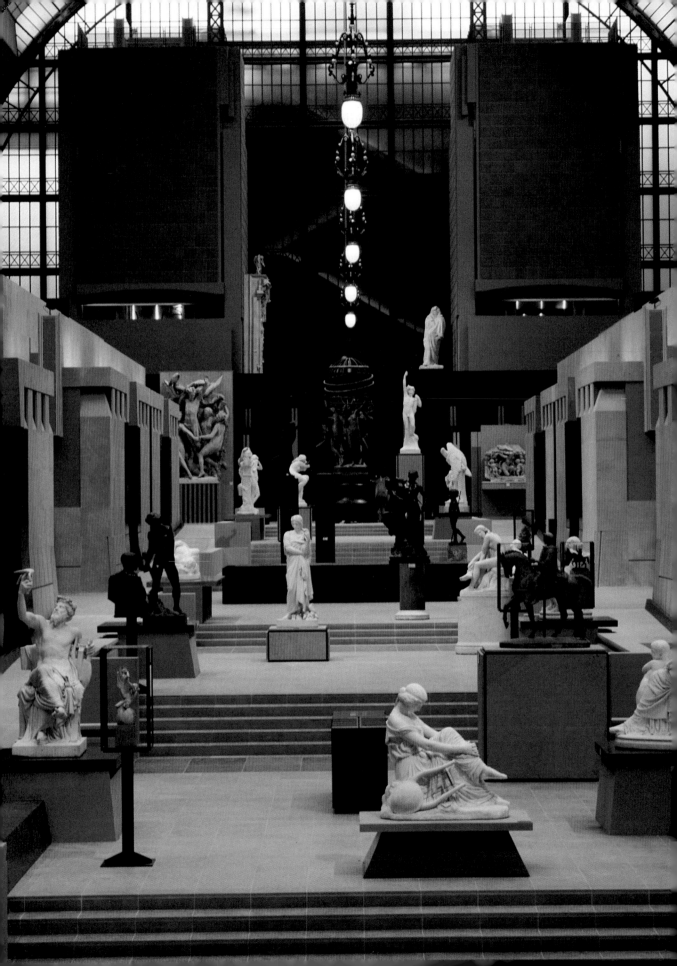

PART 1
THE CHANGING MUSEUM

Introduction

EMMA BARKER

In the last quarter of the twentieth century, art museums have changed and expanded to such an extent that it is tempting to say they have entered a new era in their history. Take, for example, the first great public art museum, the Louvre, founded in 1793 in the former palace of the French monarchy; since the early 1980s it has been transformed into the 'Grand Louvre', with the entire building now given over to the display of works of art (this project is touched on in Case Study 2). The glass pyramid that was designed as a new entrance to the museum provides a compelling new symbol of its identity (Plate 6), though in practice it has proved far too constricted to cope with the hordes of visitors. Long waits were also the order of the day after the opening in December 1997 of the vast and lavish Getty Center in Los Angeles (Plate 7), which houses the art museum founded by the oil billionaire J. Paul Getty (d.1976). New buildings and rising attendance levels can also be seen at many other art museums in the United States and Western Europe.

In the following three case studies we will examine and assess various aspects of contemporary museum culture. The first also offers a historical account of the origins of the so-called 'white cube' type of gallery space, which has remained enormously influential in art museums up to the present. However, as the other case studies reveal, museum design can take many different forms. The Musée d'Orsay in Paris, which is discussed in Case Study 2, represents a tendency to increasing complexity and conspicuousness in museum design which has emerged since the late 1970s. This development is bound up with a revival of interest in the imposing architecture of the great museums of the nineteenth century, which is exemplified by the recent restoration of the interior of the National Gallery in London (see Case Study 3). These studies also testify to the internationalism of contemporary museum design; the design of Orsay, for example, was the work of an Italian, Gae Aulenti, while the National Gallery chose the American firm of Venturi and Scott Brown to design its new extension.

At the same time, it should be noted that the organizational structure of museums differs from country to country. A basic distinction can be drawn between the United States (where they are predominantly private organizations which derive much of their funding more or less directly from corporate sources) and Europe (where most are state or municipal institutions

Plate 5 (Facing page) Interior of the Musée d'Orsay, Paris (detail of Plate 30).

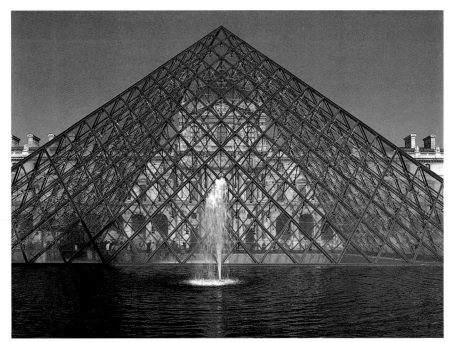

Plate 6 I.M. Pei, Pyramid, Musée du Louvre, Paris. Photo: Tim Benton.

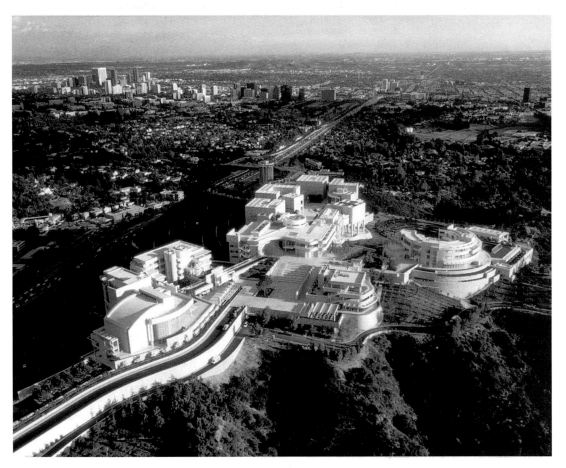

Plate 7 Richard Meier, Getty Center, Los Angeles (aerial view). Photo: John Stephens.

dependent on public subsidy). Most of the examples here follow the latter system, though the American model is exemplified by the Museum of Modern Art in New York (see Case Study 1). As the case studies show, each system places museums under distinct financial and political pressures. In particular, public museums are accountable to government for their share of taxpayers' money and need to be able to show that they are as accessible as possible (though, as we will see in Case Study 5, American museums are subject to similar pressures). This state of affairs can be traced back to the late 1960s when art museums first came under sustained attack for being élitist, exclusive institutions. Since then, they have developed educational programmes and other facilities for visitors in order to demonstrate their democratic credentials (for examples, see Case Study 3).

However, the extent to which art museums really have changed is open to debate. Most of those discussed here, for example, share a traditional, basically chronological arrangement of the works in the collection by national school, movement or style, and individual artist. This type of display has been criticized on the grounds that it reduces the complexity and variety of artistic production to a strictly unified narrative, expressing a single dominant point of view (western, élite, male, etc.). At issue here is not just the ordering but also the selection of works of art and the way that curators thereby assert and reinforce canons of aesthetic value. Some museums have attempted to present an alternative 'postmodern' understanding of the history of art. The Musée d'Orsay, for example, can be said to do so by including non-canonical works in the display (for a discussion of this claim, see Case Study 2), while the Museum of Modern Art in Frankfurt rejects chronological ordering and can thus be seen to emancipate the beholder from the tyranny of the predetermined narrative (see Case Study 1). However, this type of display can also be criticized on the grounds that it deprives visitors of any fixed points that would allow them to decide on their own route through the museum.

Whether or not the changes that art museums have undergone in recent decades are to be wholly or even largely welcomed is also an open question. The expansion of facilities (restaurants, shops, etc.) in order to attract and cater to a mass public has given rise to fears that the museum is being transformed into a leisure attraction or 'theme park' in which actually looking at works of art counts for very little and may even be avoided altogether (see the discussion of the art museum as spectacle in Case Study 2). While claims to the effect that museums are becoming indistinguishable from shopping malls may be exaggerated, they are certainly understandable after a visit to the Louvre pyramid where the one gives way to the other almost seamlessly. There is also the issue of how far rising attendance levels have involved a broadening of the social and cultural background of visitors; as we will see, there is evidence to suggest that there has not been a great deal of change in this respect. However, as noted in Case Study 3, it makes at least some difference if the museum has free admission. Ultimately, whatever criticisms can be made about art museums, we should at least acknowledge that they offer large numbers of people access to objects of visual, intellectual and historical interest that they are unlikely to see in any other context.

The modern art museum

CHRISTOPH GRUNENBERG

Introduction

In a groundbreaking and now classic series of articles first published in 1976, the art critic Brian O'Doherty emphasized the critical importance of modernist display or 'the white cube', as he termed it: 'An image comes to mind of a white, ideal space that, more than any single picture, may be the archetypal image of 20th-century art' (O'Doherty, 'Inside the white cube, part I', p.24). Anyone who has visited a modern art museum will be familiar with the type of gallery evoked by O'Doherty: a simple, undecorated space with white walls and a polished wood floor or soft grey carpet. Paintings are hung wide apart in a single row, sometimes with only one large work on each wall. Sculptures are positioned in the centre of the gallery with ample space surrounding them. The works of art are evenly lit, usually by spotlights hanging from the ceiling or by ambient neon light. In this specialized viewing context, mundane objects may be mistaken – momentarily at least – for works of art: 'the firehose in a modern museum looks not like a firehose but an esthetic conundrum' (O'Doherty, 'Inside the white cube, part I', p.25).

Although rarely acknowledged or even noticed, white has become the preferred background for the presentation of contemporary art in the twentieth century. Much of twentieth-century art has been produced with the clean spaces and white walls of modern museums and galleries in mind. The shaped canvases of the American artist Ellsworth Kelly, for example, are not conceivable without the white wall as background (Plate 8). Here the wall is an integral part of the work, defining as well as being defined by the painting's irregular shape, its scale and bright colour, enhanced by the lack of frame. In the modern museum the white wall sustains a curiously ambivalent existence between vigorous presence and complete invisibility. On the one hand, it emphasizes the essential formal qualities of abstract painting and sculpture. On the other, its inconspicuousness suggests that it is nothing more than a neutral context for the works of art.

This case study investigates how and why the modern art museum evolved, and seeks to uncover the reasons behind the global success and continuing authority of the white cube. It examines the effects of this mode of display on the perception and understanding of works of art and demonstrates that, far from being a neutral context, the white cube impinges on the viewing experience in many subtle ways. Moreover, as we will see, this type of display has been subjected to forceful critique on the grounds that it conceals the ideological character of the modern art museum. At the centre of this study will be the Museum of Modern Art in New York (founded in 1929), the earliest and most influential museum of this type, which is credited with establishing the white cube as an international standard. A number of other examples will also be considered in order to show some of the ways in which the model set by the original 'MOMA' has been modified in the latter part of the twentieth century.

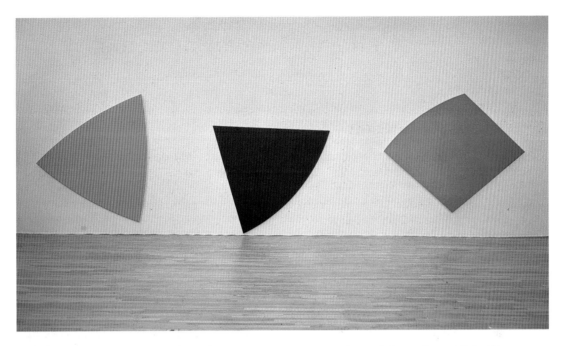

Plate 8 Installation view of Ellsworth Kelly, *Three Panels: Orange, Dark Gray, Green*, 1986, oil on canvas, panels 265 x 239 cm, 224 x 250 cm, 248 x 304 cm (295 x 1048 cm overall). Collection of the Douglas S. Cramer Foundation and the Museum of Modern Art, New York. Fractional gift of the Douglas S. Cramer Foundation. Photo: courtesy of Matthew Marks Gallery and the artist.

In order to analyse the experience of visiting a modern art museum, we need to take account of elements that can easily be overlooked: whether it is a public or private institution; the role of the board of trustees; the sources of its income (public funding versus private donations); the architecture (whether the museum occupies a purpose-built or a converted structure, for example); the design of the interior and the extent to which it follows the 'white cube' model; the layout of the galleries and the arrangement of the collection (by chronology, artist, medium, genre, etc.); the display of the works of art (the height at which pictures are hung, the lighting, etc.); the information supplied to visitors, whether on wall texts, labels, information sheets, guidebooks or through other means[1] – in short, the context of presentation.

Origins of the white cube

The primary sources for the study of museum display are installation photographs of galleries and exhibitions. For a long time the context of presentation did not receive any special attention, which explains the lack of visual and written evidence, especially for the early part of the twentieth century. We need to view this material critically, bearing in mind that it follows

[1] In many modern art museums, for example, the labelling is kept to a minimum with only the name of the artist, title, medium and date of the work being given. The rationale for limiting the information available to visitors is to aid concentration and avoid distraction; artists may choose to call their work 'Untitled' for the same reason.

certain rules and conventions. Installation photographs are generally black and white and show the spaces without any visitors. The art museum in general and the white cube in particular are presented in their ideal state – as a pure and absolute space seemingly conceived solely for the undisturbed presentation of art, unadulterated by the intrusion of human beings. The installation shot without figures reinforces, according to O'Doherty, a conception of the spectator in the white cube as a disembodied eye. This conception can also be discerned in the rules of conduct in museums: the ban on touching the works of art, talking loudly, eating, etc.

Compare Plates 9 and 10, which show a gallery in the Metropolitan Museum of Art in New York dating from around 1900 and the *Cubism and Abstract Art* exhibition held by the Museum of Modern Art in New York in 1936. Consider their architecture and decoration, the arrangement of the works of art, and how all these elements might affect the experience of the viewer. Can you suggest any reason for the replacement of the traditional model of museum display by a modernist one?

Discussion

In the Metropolitan Museum of Art a large number of paintings with heavy gold frames are hung against a dark painted wall. They are stacked in two or three rows so as to form an intricate pattern, with a larger painting at the centre of the main wall. The arrangement is by genre, most of the pictures being portraits, though the right-hand wall seems to be given over to a single large work which you may have identified as a history painting (it is Emmanuel Leutze's celebrated image of *Washington Crossing the Delaware* of 1850). Benches provide rest for tired visitors while railings serve to protect the paintings, together evoking a human presence in a way that the later photograph does not. In the Museum of Modern Art the paintings are hung at spacious intervals and in a single, though irregular, row. Instead of having wainscoting and cornices (as in the older gallery), the walls are completely undecorated. Nothing distracts attention from the works of art, implying a much more immediate, concentrated viewing experience than previously. A parallel can also be discerned between the light walls, right angles and overall austerity of the space and the abstract-geometric paintings (by Piet Mondrian) with their network of straight lines against pale grounds, suggesting that the display was conceived with this type of painting in mind.

◆◆

Radical innovations in museum display have generally evolved out of developments in art itself. Throughout the twentieth century, artists demanded and obtained environments that reflected the principles embodied in their work. The white walls and simple structures of modern architecture provided an appropriate context for the display of art that emphasized simplicity of means, clarity of expression and purity of ideals. The origins of the white cube can be traced back to the artist's studio and, above all, to the austere, simple laboratory spaces of the abstract artist in which creation is an act of rational and disengaged calculation.[2] The architect and abstract painter

[2] However, this does not necessarily mean that the sources of inspiration for abstract art are strictly rational and scientific. The work of Piet Mondrian (1872–1944), for example, was informed by nineteenth- and early twentieth-century spiritualist theories. His balanced compositions reflected basic oppositions such as the material and spiritual, individual and collective, male and female, etc.

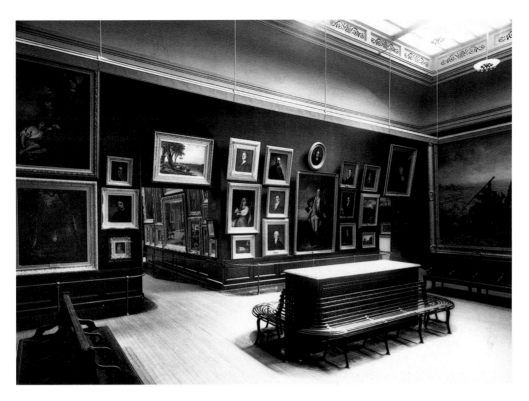

Plate 9 Picture gallery in the south wing, *c*.1900, Metropolitan Museum of Art, New York. All Rights Reserved, The Metropolitan Museum of Art.

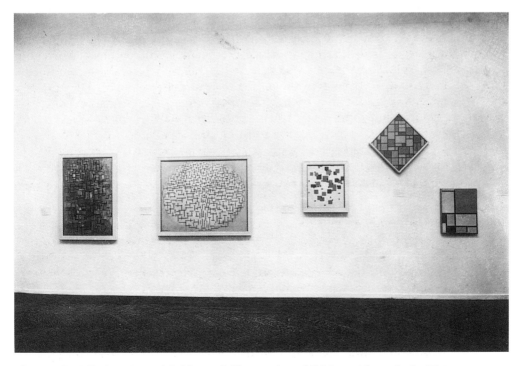

Plate 10 Installation view of *Cubism and Abstract Art* exhibition with works by Piet Mondrian, 1936, Museum of Modern Art, New York. Photo: courtesy of the Photographic Archives, Museum of Modern Art, New York, © 1999 Museum of Modern Art, New York. Works by Piet Mondrian © Mondrian/Holtzman Trust, c/o Beeldrecht, Amsterdam, Holland/DACS 1999.

Theo van Doesburg (1883–1931) declared: 'The painter himself must be white, which is to say without tragedy or sorrow … The studio of the modern painter must reflect the ambience of mountains which are nine-thousand feet high and topped with an eternal cap of snow. There the cold kills the microbes' (quoted in Wigley, *White Walls, Designer Dresses*, p.239).

Despite the important role played by MOMA in developing and disseminating the white cube, its genesis was complex and dependent on a variety of outside sources. Early manifestations of modernist display could be found in European museums and exhibitions after World War I, especially in Germany. Alfred H. Barr, Jr (1902–81), MOMA's first director, and Philip Johnson (b.1906), then head of its architecture department, encountered them on their extensive travels through Europe during the 1920s and early 1930s. MOMA adapted and refined these new display techniques, opting for what we now recognize as a modernist approach at the expense of other modes of presentation which are now mostly forgotten. The Folkwang Museum in Essen, Germany, for example, contained an extraordinary Expressionist[3] environment that reflected the artists' intentions and influences (Plate 11). Expressionist painting and sculpture (including site-specific works created especially for the museum) were combined with medieval furniture and 'primitive' art. As in modernist display, the galleries recalled the artist's studio but, in this case, did so by evoking the eclectic chaos and emotional turmoil of Expressionism. In addition to the by then common white walls, the galleries featured exposed brick and coloured walls. Although greatly impressed by the Folkwang Museum's display, Barr was extremely selective in his adaptation of elements from it.

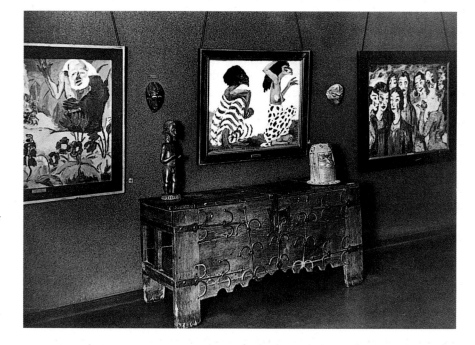

Plate 11 Gallery with paintings by Emil Nolde, African sculptures and medieval chest, 1929, Folkwang Museum, Essen, Germany.

[3] The German Expressionists were artists working around the turn of the twentieth century who sought to find ways of directly conveying feelings in their art and thereby to break with the dominant artistic and social conventions of the period. They turned for inspiration to 'primitive' art (African sculpture, for example), which they saw as more authentic, less sophisticated forms of expression.

Plate 12 Barnett Newman, *Vir Heroicus Sublimis*, 1950–1, oil on canvas, 242 x 514 cm, Museum of Modern Art, New York. Gift of Mr and Mrs Ben Heller. Photo: © 1999 Museum of Modern Art, New York. Reproduced by permission of the Barnett Newman Foundation. © ARS, New York and DACS, London 1999.

MOMA's adoption of the white cube model can be connected to Barr's conception of modern art as developing inevitably towards abstraction.[4] In the modern museum, abstract art and the white cube have entered into a symbiotic relationship. In their apparent exclusion of all reference to the wider world beyond the domain of pure form, they reinforce the decontextualization traditionally effected by the museum. The original function of a medieval altarpiece as an object of worship is obliterated in the museum as it is transformed into an object of aesthetic appreciation. This process is anticipated by abstract art (Plate 12), which has its natural home in the museum, as Philip Fisher has pointed out: 'For the museum, the abstractness that results from the effacement of specific religious, political, or personal symbolic features is ... the key feature. This process meant that, in its quest for authenticity, the museum culture in a factory world was inevitably tied in the long run to exactly the kind of abstract, imageless art that the twentieth century produced' (Fisher, *Making and Effacing Art*, pp.166–7).[5] The white cube owes its success to this strategy of effacement and simultaneous self-negation: highlighting the inherent (that is, formal) qualities of a work of art through the neutralization of its original context and content while, at the same time, remaining itself virtually invisible and thus obscuring the process of effacement.

[4] Barr's conception of the development of modern art was visualized in a diagram for the cover of the *Cubism and Abstract Art* catalogue. It is important to keep in mind that the chart was originally conceived as a didactic tool for the benefit of visitors to the exhibition. It is reproduced in Fernie, *Art History and its Methods*, p.180.

[5] The point being made here is that if (as Fisher argues) the museum houses objects defined in terms of their uniqueness and authenticity in opposition to mass-produced objects, then the abstract work of art can be seen as museum art *par excellence*. This is because (according to Fisher) its lack of reference to everyday life precludes it serving any useful purpose (usefulness being the most obvious characteristic of mass-produced objects). For further consideration of authenticity, see Case Study 3; for further consideration of 'use' with reference to contemporary art, see Case Study 4.

The Museum of Modern Art, New York

The Museum of Modern Art in New York was the first museum devoted exclusively to modern art, and its collection is generally considered to be the most comprehensive in the world. Since 1929 MOMA has played a crucial role in defining the modernist canon and in shaping the way that modern art is looked at and understood. During its first decade the museum's activities were dominated by exhibitions (such as the epoch-making *Cubism and Abstract Art* show illustrated above), while the intention was to hand over the works of art it acquired to the Metropolitan Museum of Art in New York and other institutions once they had attained the status of 'classics' (this idea was renounced in 1953). From early on, MOMA not only displayed painting, sculpture, drawings and prints but also incorporated architecture, design, photography and film into its programming.[6] At the time, the museum's commitment to providing a comprehensive survey of contemporary visual culture and its use of the most up-to-date methods of marketing and publicity to popularize modern art made it a unique institution.

Like many other museums in the United States, MOMA was founded by wealthy private benefactors and its trustees continue to be recruited from America's social élite. They determine the overall direction of the museum and, especially through the appointment of leading staff members, exert influence on its exhibitions policy. They have also decisively shaped the composition of the collection with donations of works of art. Accusations of undue influence date back to the early years of MOMA, when the museum was almost entirely financed by its trustees. The support of the Rockefellers (among other rich and powerful families) and their choice of modern art as the particular object of their philanthropy are significant. The introduction of modern art into the United States, it has been argued, happened from 'above' and was intricately linked to questions of class, taste, economics and politics. Modern art was elevated to the sphere of 'high culture', functioning as an indicator of social distinction. In the process, its original social and political agenda was obscured.[7] Not only was MOMA itself run with all the efficiency of a business competing in the capitalist economy, but the political activities of its trustees sometimes had a direct impact on the museum. The appointment of Nelson Rockefeller, president of MOMA from 1939 to 1941, as Co-ordinator of the Office of Inter-American Affairs in 1941, for example, led to an expansion of displays and acquisitions (through a special fund) of art from Latin America. (For criticisms of the way that MOMA became caught up in the promotion of US political and economic interests abroad, see note 10 below.)

MOMA's public identity is tied to its building on Manhattan's West 53rd Street, completed in 1939, which at the time (when it was surrounded by nineteenth-century houses) functioned as an effective manifestation of its modernist principles and internationalist outlook (Plate 13). The building

[6] However, the departments have operated separately throughout most of MOMA's history, perpetuating the traditional separation between high art and other forms of visual culture.

[7] This social and political agenda is addressed in Wood, *The Challenge of the Avant-Garde* (Book 4 of this series).

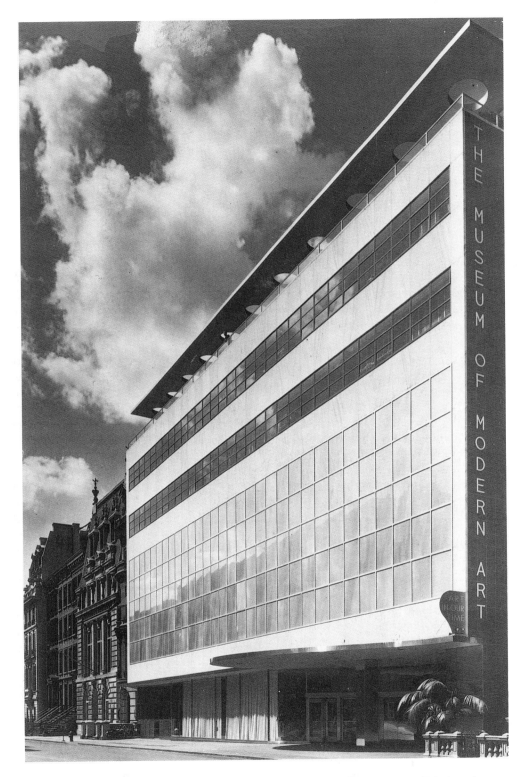

Plate 13 Philip L. Goodwin and Edward D. Stone, façade of the Museum of Modern Art, New York, 1939. Photo: © 1999 The Museum of Modern Art, New York.

represented a radical departure from the temple-like museum architecture that dominated the United States until after World War II: no ceremonial staircase but access at street level; no grandiose columns but a flat, clean façade set flush with the street front. Every means available was employed to attract visitors into the museum. Its name was prominently displayed on the side of the building, visible to pedestrians on nearby Fifth Avenue, home of New York's most exclusive shops. The glass-fronted ground floor with its gentle inward curve was designed to ease the transition from the street into the museum. Creating an effect similar to a department store, MOMA carefully exploited the lessons of contemporary commercial architecture. An affinity between the museum and the display of merchandise was noted by Walter Benjamin: 'The concentration of works of art in the museum approximates them to commodities which – where they offer themselves in masses to the passer-by – rouse the idea that he must also receive a share' (quoted in Grunenberg, 'The politics of presentation', p.201). While the design of MOMA may reveal something about art museums in general, it can more specifically be connected to its mission to 'sell' modern art to the American public.

At the same time, MOMA made every effort to remove art from any association with the sphere of business. The galleries were intended to provide a neutral environment for the contemplation of art – without any distraction from decoration, neighbouring works of art, or indeed any external influence at all (Plate 14). These calm, contained spaces (often said to have the 'intimacy' of a private home, a reminder that many works in the museum previously belonged to wealthy collectors) provide relief from the bustling metropolis outside and, more broadly, from the material world of production and consumption. In the design exhibitions organized by MOMA during the 1930s, utilitarian objects were displayed in a selective and aestheticized manner, the gleaming commodities being elevated to the status of works of art through a highly dramatic or isolated presentation (Plate 15). The effect of these displays was to make the objects seem even more desirable, effectively identifying the museum visitor as a consumer – rather than simply a disinterested viewer of art – and thereby confirming Benjamin's dictum. Above all, this isolation of the gallery space from the world outside the museum functioned (and continues to do so today) to reinforce the notion that art has nothing to do with money or politics but belongs to 'the universal and timeless realm of spirit' (Duncan and Wallach, 'The Museum of Modern Art as late capitalist ritual', p.46). MOMA's galleries are spaces for contemplation, producing an atmosphere of reverence reminiscent of a church free from the clutter of ordinary, everyday life. While this is true to some extent of any art museum, it can be argued that it is especially so in the case of modernist display: 'the more "aesthetic" the installations – the fewer the objects and the emptier the walls – the more sacralized the museum space' (Duncan, *Civilizing Rituals*, p.17).

At MOMA the visitors do not simply contemplate isolated works of art, but are also subjected to a compulsory course in the history of modern art. The plan of the opening exhibition for the new museum building, *Art in Our Time* (1939), illustrates the careful guidance of the public through space (Plate 16).

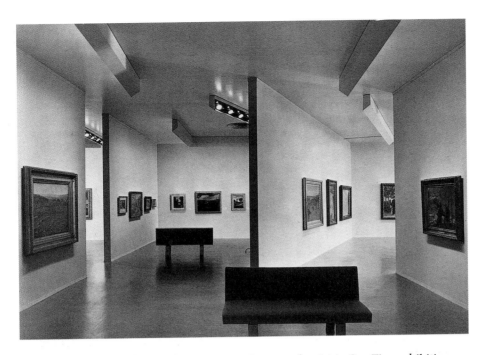

Plate 14 Installation view of upper-floor galleries at the *Art in Our Time* exhibition, 1939, Museum of Modern Art, New York. Photo: Robert M. Damora, courtesy of the Photographic Archives, Museum of Modern Art, New York.

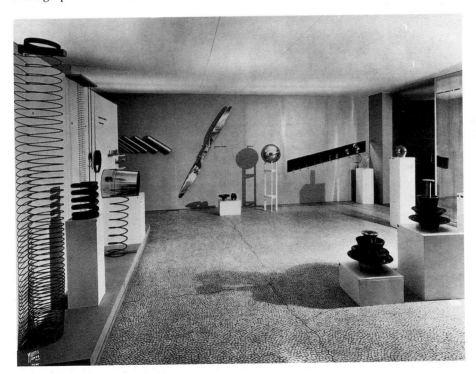

Plate 15 Installation view of *Machine Art* exhibition, 1934, Museum of Modern Art, New York. Photo: Wurts Brother, courtesy of the Museum of Modern Art, New York.

Plate 16
Philip L. Goodwin and Edward D. Stone, second floor plan at the time of the *Art in Our Time* exhibition, 1939, Museum of Modern Art, New York. Photo: Robert M. Damora, courtesy of the Photographic Archives, Museum of Modern Art, New York.

While the layout is surprisingly varied (subsequently the walls were predominantly organized in right angles), visitors progressed (and still do) through a series of galleries with little or no option of changing course, 'following the development of modern art in clear logical sequence' (Barr quoted in Read, 'Art in our time', p.339). In place of the display of works of art by national school typical of nineteenth-century museums, MOMA substituted an installation illustrating Barr's conception of modern art as a sequence of movements developing out of each other.[8] His classification of modern art in terms of movements or styles on the basis of the formal features of works of art, with special attention being accorded to the achievements of individual 'masters', conformed, however, to the traditional practices of art history. Certain movements, notably Cubism and Surrealism, which were singled out by Barr as being especially significant to the development of modern art, are still central to MOMA's displays of early twentieth-century art. This schema has since been extended to include subsequent movements such as Abstract Expressionism, which is presented as another high point in the unfolding of modern art (Plate 17).[9]

According to Barr, the aesthetic judgements made manifest at MOMA were based on 'the conscientious, continuous, resolute distinction of quality from mediocrity' (words later inscribed on a plaque at the entrance to the permanent collection). The museum's critics argue, however, that this emphasis on quality obscures the role that ideology plays in the selection and ordering of the works of art. According to Carol Duncan and Alan Wallach, MOMA only '*appears* to be a refuge from a materialist society, an ideal world apart' while, on a more fundamental level, it 'would reconcile

[8] See footnote 4 above. Significantly, the *Cubism and Abstract Art* exhibition was followed by one devoted to Surrealism, conceived both as a successor to and reaction against the movements represented in the earlier exhibition.

[9] The term 'Abstract Expressionism' is applied to painters working mainly in New York in the 1940s and 1950s. Although the 'drip' technique of Jackson Pollock's *One (Number 31, 1950)* (Plate 17) is very different from the large areas of colour in Barnett Newman's *Vir Heroicus Sublimis* (Plate 12), both are typical of Abstract Expressionism in their large, even monumental scale, which identifies these paintings as belonging most appropriately in the public space of the museum.

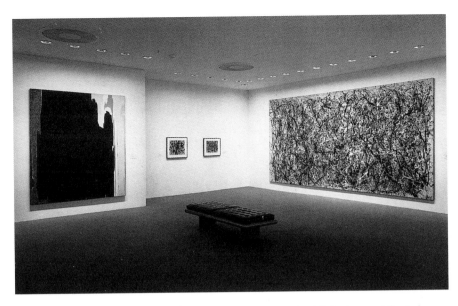

Plate 17 Installation view of the Permanent Collection of Painting and Sculpture, 1991, with Jackson Pollock's *One (Number 31, 1950)* on the right, Museum of Modern Art, New York. Photo: © 1998 Museum of Modern Art, New York. © ARS, New York and DACS, London 1999.

you to the world, as it is, outside' ('The Museum of Modern Art as late capitalist ritual', p.47; emphasis added). Their basic contention is that, in presenting works of art not as the products of a specific society or statements of political engagement but rather as the expressions of individual genius, MOMA supports the ideology of individualism that underlies the capitalist social order. Moreover, critical analyses of MOMA contend that it has become increasingly preoccupied with preserving and enlarging its collection of historic modern art and has thus failed to maintain its engagement with contemporary art. A relative decline in its influence is generally held to have taken place since the 1950s, the decade when the museum's austerely functional architecture became 'a ubiquitous symbol of corporate modernity' and which also witnessed the 'international triumph of American painting, a "triumph" which MOMA did much to engineer' (Wallach, 'The Museum of Modern Art', p.79). The critique developed by Duncan and Wallach (among others) has been extremely influential but, it can be argued, itself needs to be understood as part of the reaction to MOMA's institutional authority that emerged in the late 1960s and early 1970s. In the context of the cultural and political radicalism of the period, the museum came to be identified not just as the embodiment of an entrenched modernist orthodoxy but also as 'the cultural arm of "American Imperialism"' (Sandler, *American Art of the 1960s*, p.298).[10] More generally, it needs to be emphasized that this critique, no less than the museum itself, can be seen as political or even ideological in the assumptions on which it is based.

[10] Artists protesting against the Vietnam War drew attention to Rockefeller business links with armaments manufactures, for example. More broadly, this accusation referred to the museum's international exhibition programme, its determining role at major international exhibitions such as the Venice and São Paolo Biennales, and its long involvement with government agencies in helping to promote American culture and, by extension, its economic and political interests abroad.

Challenges to the white cube

From its earliest manifestations, modernist display has had its detractors and opponents. Among them are those artists who have sought to challenge the authority of the white cube. One objection is that it functions in support of purified and autonomous works of art and at the expense of less unified or formally contained statements. By contrast, the Pop artist Claes Oldenburg (b.1929) in his installation *The Street*, first presented at the Judson Gallery in New York in 1960, transformed a basement gallery into a celebration of the gritty urban environment.[11] Oldenburg filled the space with large amorphous cardboard shapes painted in black that sprawled over the walls, hung from the ceiling, and were scattered across the floor (Plate 18). It was everything the modern art museum was not: dirty, chaotic, fragmented, concerned with the excitement and depth of everyday life rather than with abstract notions of beauty or lofty ideals, as Oldenburg famously explained in 1961:

> I am for an art that does something other than sit on its ass in a museum. I am for an art that grows up not knowing it is art at all, an art given the chance of having a starting point of zero. I am for an art that involves itself with the everyday crap and still comes out on top. I am for an art that imitates the human, that is comic if necessary, or violent, or whatever is necessary. I am for an art that takes its form from the lines of life, that twists and extends impossibly and accumulates and spits and drips, and is sweet and stupid as life itself.

> (Quoted in Johnson, *Claes Oldenburg*, pp.16–17)

Plate 18 Claes Oldenburg, *The Street*, February–March 1960, Judson Gallery, Judson Memorial Church, New York. © Claes Oldenburg.

[11] Pop Art, which emerged in the late 1950s, engaged with popular and consumer culture by appropriating imagery from advertising, the media and everyday life.

Some museum officials reacted quickly to these developments and invited contemporary artists into the sacred spaces of the museum. In 1962, for example, Willem Sandberg, director of the Stedelijk Museum in Amsterdam, staged *Dylaby* (Dynamic Labyrinth). This exhibition not only redefined the relationship between artist and museum but, more importantly, also attempted to make the visitor an active participant rather than a distanced observer. The artists (Jean Tinguely, Niki de Saint Phalle, Daniel Spoerri, Martial Raysse, Robert Rauschenberg and Per Olof Ultvedt) were given complete freedom in the creation of their environments, which were largely constructed out of junk that was afterwards discarded.[12] Spoerri's gallery turned on its side by 90 degrees was symptomatic of the visitors' experience in the labyrinth (Plate 19); it suggested that the museum visit was to be a thought-provoking, inspiring, and enjoyable experience that would close the much lamented gap between art and everyday life. Instead of expressing grand ideas, the aim of art here was above all to create a sense of carefree playfulness, providing a variety of visual and tactile sensations leading to an almost anarchistic sense of enjoyment and temporary suspension of all traditional rules of museum behaviour as visitors were encouraged to touch and operate the works of art. *Dylaby* materialized ideas that were to define museums over the next two decades: the re-establishment of a significant relationship between art and society.

Plate 19 Daniel Spoerri, *Dylaby* (Dynamic Labyrinth), Room III, 1962, Stedelijk Museum, Amsterdam.
Photo: Swiss National Library, Daniel Spoerri Archives. © DACS 1999.

[12] All these artists were associated with Pop Art or its European counterpart, *Nouveau Réalisme* (New Realism).

With the emergence of the counter-culture in the late 1960s, challenges to the modern art museum took on an overtly political character and a more confrontational approach.[13] In a project for his 1971 one-person show at the Guggenheim Museum in New York, for example, the artist Hans Haacke (b.1936) used photography, text and statistics to document the concentration of real estate in New York: specifically, exploitative practices of corporate owners of slum properties occupied by deprived ethnic groups (Plate 20). In so doing, he aimed to expose what he called 'the socio-political value system of society' (Haacke, 'All the art that's fit to show', p.151). Insisting that politics had no place in a museum, the Guggenheim not only cancelled the exhibition but also dismissed the curator responsible. Haacke went on to produce a piece documenting the Guggenheim trustees' connections to several linked corporations. This kind of strategy on the part of artists has become known as 'institutional critique'. In this context, the term 'institution' refers not only to 'agencies of distribution' (museums, galleries, etc.) but also to 'aesthetic institutions', including the formal elements and organizing principles of works of art: 'It is a recognition that materials and procedures, surfaces and textures, locations and placement are not only sculptural and painterly matter to be dealt with … but that they are always inscribed within the conventions of language and thereby within institutional power and ideological investment' (Buchloh, 'Conceptual art', p.136). The crucial point is that, in avoiding traditional media such as painting and sculpture, an artist like Haacke defies the art museum's demand for major works. Most aspects of

Plate 20 Hans Haacke, detail of *Shapolsky et al. Manhattan Real Estate Holdings, a Real-Time Social System, as of May 1, 1971*, 1971. John Weber Gallery, New York, courtesy Hans Haacke. © DACS 1999.

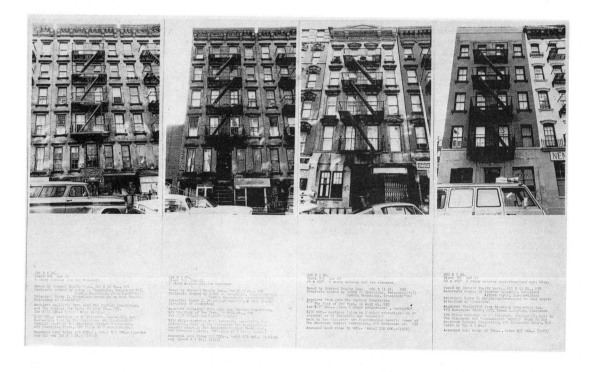

[13] This period witnessed the formation of protest groups such as the AWC (Art Workers' Coalition) in New York, who staged demonstrations and put forward a number of demands including greater representation of black and women artists. For examples of protests directed against MOMA, see Lynes, *Good Old Modern*, pp.437–41.

their traditional range of activities – collecting, preservation, display and mediation – have been challenged by artistic products that are ephemeral and transitory, of little or no commercial value, and defy the usual categorization according to medium.

However disruptive the artists' interventions and however radical their attempts during the period to escape the confines of institutions and the pressures of the art market, eventually most of them returned to the white cube (this includes Haacke, who continues to show in major institutions in Europe and the United States). Nevertheless, their investigation of the mechanisms of the art world formed part of a growing awareness of the exclusiveness of modern art museums and of the extent to which they are controlled by a social and cultural élite whose tastes they reflect. Numerous attempts to transform them into more open and democratic institutions followed. Probably nowhere was this programmatic shift in the conception and function of the modern art museum more pronounced than at the Pompidou Centre in Paris, which opened in 1977 (Plate 21). Housed in a massive building of futuristic design with exposed structural support system and brightly coloured service pipes, it is much more than a traditional museum – as its full name indicates: Georges Pompidou National Centre for Art and Culture. In addition to the national collection of modern art and exhibition galleries, it contains a public library, a centre for industrial design, cinemas and a music centre. The integration of a range of cultural resources within one transparent and dynamic container was intended to bring about a democratization of culture, breaking down conventional boundaries between high and low.

Plate 21 Renzo Piano and Richard Rogers, Pompidou Centre, Paris, 1977. Photo: Documentation du Musée National d'Art Moderne.

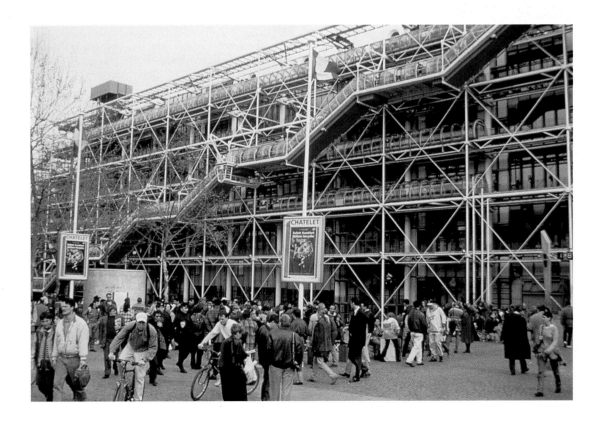

In many respects, the Pompidou Centre was judged a triumph, exceeding the most optimistic expectations, but it has also been criticized: 'Walking through the complex, which has been designed to make every visitor, even the most museum-shy, feel at home, it almost appears as if the proverbial fear of culture had flipped over into its opposite, namely indiscriminate enjoyment of a mixture of painting, sculpture, interior decoration, cafeteria, and place where the kids are persuaded to paint' (Spies, 'Canonization of the cynic', p.130). According to another critic, the philosopher Jean Baudrillard, the presence of the museum contradicts the building's exterior: 'A body entirely composed of flux and surface connections chooses for its content the traditional culture of depth' ('The Beaubourg-effect', p.6). More broadly, Baudrillard argued that the Pompidou Centre merely undermines the culture that it is supposed to democratize by attracting more people than the building can cope with (in fact, the building had to close for several years in the late 1990s for major refurbishment).[14] Even without accepting Baudrillard's proposition that it represents a containment of the violent energies that had found a more positive outlet in the political activism of 1968, it can be acknowledged that the popular success of the Pompidou Centre points to the implicit dangers of the marketing of art and culture as spectacle.

Beyond the modern art museum

Today museums of modern art can be found in many cities in the United States and Western Europe.[15] The German city of Frankfurt, for example, opened its Museum of Modern Art in 1991. Unlike its namesake in New York, this museum does not attempt to recount a comprehensive history of modern art from its origins to the present. Despite the name, it belongs to a group of museums of contemporary art founded since the late 1960s. This development results in part from the realization that a multiplicity of diverse movements and an endless flood of works of art make a complete survey all but impossible. Collections often start with art of the immediate post-World War II era, significantly with 'national schools' such as Abstract Expressionism in the United States: prominent, for example, in the Museum of Contemporary Art in Los Angeles, founded in 1979. Alternatively, they may begin with Minimalism and Pop Art of the 1960s as, for example, in Frankfurt. In both of these museums, the starting point and core of the collection was determined by the acquisition of a major private collection.

The first American institution to replace the word 'modern' in its name with 'contemporary' was the Institute of Contemporary Art in Boston, a non-collecting institution modelled on the German *Kunstverein* or *Kunsthalle*,[16] which was established in 1936 as a branch of the Museum of Modern Art in New York. As the ICA's director, James S. Plaut, declared in 1948: '"modern

[14] Surveys of visitors to the Pompidou Centre show that those who visit the permanent collection and art exhibitions (as opposed to other parts, especially those that have free admission) have much the same cultural and social background as those who visit other art museums: see Heinich, 'The Pompidou Centre and its public'.

[15] For a discussion of some of the reasons why a city may establish a museum of modern art, see Case Study 7.

[16] These organizations are devoted to the promotion and display of contemporary art. The first examples date from the early nineteenth century.

art" describes a style which is taken for granted; it has had time to run its course and, in the pattern of all historic styles, has become both dated and academic' (Nelson W. Aldrich and James S. Plaut, '"Modern art" and the American public, a statement by the Institute of Contemporary Art, formerly the Institute of Modern Art', 17 February 1948, quoted in *Dissent*, p.52). The term 'contemporary' has so far remained free from the historical, ideological and aesthetic implications associated with 'modernist' and 'modernism'. It suggests permanent contemporaneity, avoiding the inflexibility and emphasis on the preservation of the past typical of traditional collecting institutions. One director has suggested: 'As soon as single pieces of venture [avant-garde] art are recognised and become classics, they should no longer be exhibited and could be given to other state or municipal museums. It cannot be the objective of a Museum of Contemporary Art to earn itself a reputation by accumulating a collection of classics' (Klotz, 'Centre for Art and Media Technology, Karlsruhe', p.81). Clearly, this set-up resembles the conception of New York's MOMA in its early 'experimental' phase. However, as the history of MOMA demonstrates, such a policy proves difficult to maintain once the works of art have become valuable assets.

Recent museums break with the model set by MOMA not only in the scope of their collections but also in their architecture, exemplified by the 'postmodern museum'.[17] One of the most celebrated and successful examples is the Museum of Modern Art in Frankfurt, mentioned above, designed by the Austrian architect Hans Hollein (Plate 22). Instead of a museum whose main distinction is its invisibility – a neutral container intended to promote

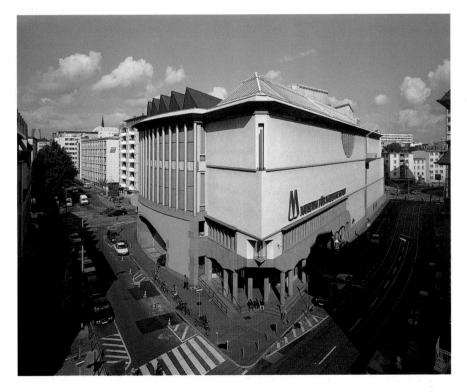

Plate 22
Hans Hollein, south-west façade, Museum of Modern Art, Frankfurt am Main, 1991. Photo: Rudolf Nagel, Frankfurt am Main. Reproduced by courtesy of Museum für Moderne Kunst, Frankfurt am Main.

[17] For further discussion of the concept of the postmodern museum, see the following case study.

Plate 23
Hans Hollein,
isometric plan of
exhibition spaces,
ground floor,
mezzanine level,
Museum of Modern
Art, Frankfurt am
Main. Reproduced
by courtesy of
Museum für
Moderne Kunst,
Frankfurt am Main.

the undisturbed contemplation of works of art – Hollein has created a building in which almost every room is different in size, plan, and height. The wide variety of original spatial solutions derived from its unusual wedge-shaped site (Plates 23, 24). Hollein acknowledges that 'neutral space doesn't exist: there are only characteristic spaces of a different magnitude (and access to them), with which the work of art enters into a dialogue – in reciprocal intensification' ('To exhibit, to place, to deposit', p.41).

Even in this most ingenious and spectacular of museum buildings, however, we still find simple spaces following the premise of the white cube. Large areas of white wall provide a solid background for the works of art within a complex architectural structure that defies permanence and finality. A variety of windows and openings allow frequent views from the upper galleries into adjacent spaces or on to the surrounding buildings and streets. As Rosalind Krauss has pointed out, one of the most striking features of the postmodern museum is the vista:

> the sudden opening in the wall of a given gallery to allow a glimpse of a far-away object, and thereby to interject within the collection of *these* objects a reference to the order of another. The pierced partition, the open balcony, the interior window – circulation in these museums is as much visual as physical, and that visual movement is a constant decentering through the continual pull of something else, another exhibit, another relationship, another formal order, inserted within this one gesture which is simultaneously one of interest and of distraction: the serendipitous discovery of the museum as flea-market.

(Krauss, 'Postmodernism's museum without walls', p.347)

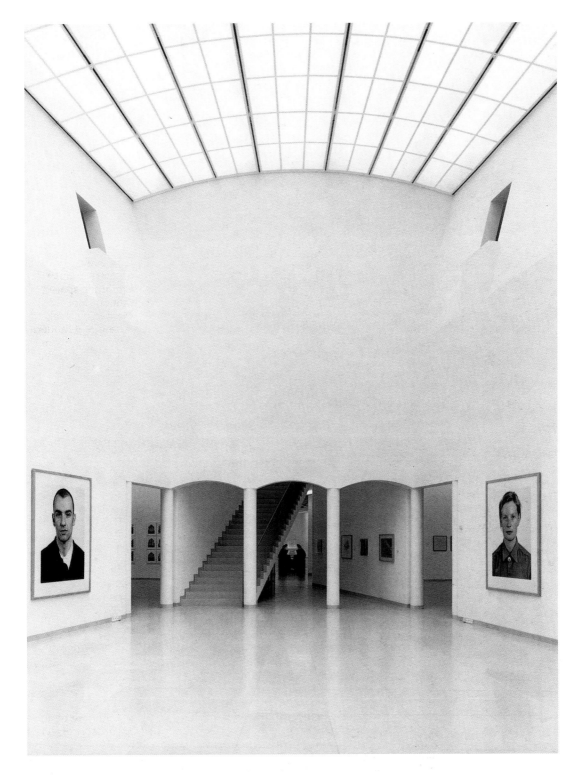

Plate 24 Central hall with works by Thomas Ruff, Museum of Modern Art, Frankfurt am Main, 1991. Photo: Rudolf Nagel, Frankfurt am Main. Reproduced by courtesy of Museum für Moderne Kunst, Frankfurt am Main. Works by Thomas Ruff © DACS 1999.

No prescribed route exists in the Frankfurt museum. The collection has literally to be 'explored', so that the visitor risks going through the same space twice or even getting lost. Chronological or stylistic sequence is impossible to maintain and is therefore rendered insignificant. Instead, a concentrated experience of both art and architecture has become the critical element of the museum visit, thereby reinforcing a sense of the specialness of art and its separation from the wider world. Priority is given to the confrontation with powerful works of art, installations or groups of works by a single artist, often occupying an entire gallery. 'Each individual room could thus be seen as an event, heightening the impact of its intrinsic contrapuntal dynamic', the museum's director has claimed (Ammann, 'From the perspective of my mind's eye', p.49). The Frankfurt museum thereby breaks with the emphasis on the progressive development of art over time characteristic of museums like MOMA.[18]

An alternative to postmodern museum architecture is provided by the conversion of existing, usually industrial buildings. This practice has developed since the 1960s when many artists moved beyond the traditional media of painting and sculpture to include mixed-media works, large-scale installations and performances. They discovered disused warehouses and factories which provided the space, flexibility and informality required for experimental works.[19] (By contrast, the relatively modest scale of MOMA's galleries can be seen as a contributing factor to its seeming ambivalence towards some forms of experimental art.) Today industrial spaces have become one of the most favoured settings (especially by artists) for the display of contemporary art. In Los Angeles, for example, while the new Museum of Contemporary Art was being built, an abandoned police garage was converted by architect and exhibition designer Frank Gehry (b.1929) into the 'Temporary Contemporary' (Plate 25). This proved so successful that it has become a permanent part of the museum (subsequently renamed the Geffen Contemporary after a major donor). At the Hallen für Neue Kunst (Halls for New Art) in Schaffhausen, Switzerland, a collection centred on Minimalist and Conceptual art is displayed in the large, well-lit spaces of a former textile factory (Plate 26). These spaces resonate with the ideals of anonymity, seriality[20] and industrial production that are embodied in Minimalist objects and installations, focusing attention on their subtle material qualities. As in the early manifestations of the white cube, they isolate and 'protect' the art from the distractions from the outside world, confirming their status as pure art objects.

[18] Rosalind Krauss has argued that the atemporal, postmodern museum 'would forego history in the name of a kind of intensity of experience, an aesthetic charge that is … radically spatial'. Its origins, she argues, lie in the distinctive perceptual experience offered by Minimalist art (Krauss, 'The cultural logic of the late capitalist museum', p.46).

[19] The development can be traced to artists and galleries who first discovered the lofts of SoHo in New York in the late 1960s, moving into the huge commercial spaces originally built in the late nineteenth and early twentieth centuries for light manufacturing industries and as warehouses. See Case Study 4.

[20] That is to say, works of art using a series of identical objects (as in mass production) arranged in a strict order as opposed to the unique art object. Minimalist artists typically employed sheet metal, perspex, bricks and other industrial materials to make regular, geometric constructions on a large scale.

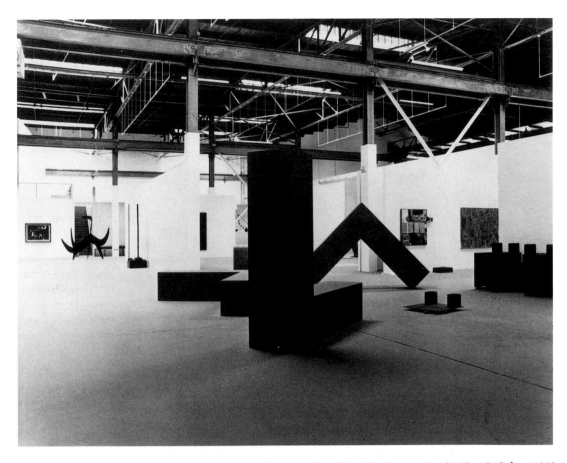

Plate 25 *The First Show* at the Temporary Contemporary, Los Angeles, renovation by Frank Gehry, 1983, Museum of Contemporary Art, Los Angeles. Photo: Squidds & Nunns.

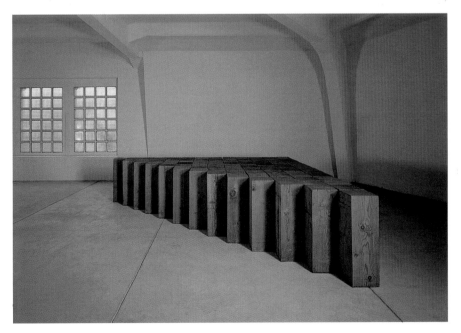

Plate 26 Gallery with Carl Andre, *Sum 13*, 1978, Hallen für Neue Kunst, Schaffhausen, Switzerland. Photo: Rausmüller Collection, Hallen für Neue Kunst, Schaffhausen. Works by Carl Andre © Carl Andre/VAGA, New York and DACS, London 1999.

Conclusion

This case study has sought to demonstrate that modern art museums are anything but neutral spaces. On the one hand, the white cube is a historically constructed type of environment that is associated with the canonization of specific types of art. On the other hand, such museums are controlled by trustees, directors and curators who bring their own socially determined tastes and priorities to bear on the acquisition and display of works of art. As we have seen, modern art museums have been widely criticized for their aesthetic conservatism, social exclusiveness and ideological biases, both from within the contemporary art world (for example, by artists) as well as by art historians. Nevertheless, the white cube as a mode of presentation has demonstrated a surprising longevity, as it continues to be constantly reinvented and transformed to fit the latest developments in contemporary art and the latest museum concepts.

The history of the modern art museum in the twentieth century can be described as a struggle between revolution and preservation, participation and protection, experimentation and isolation. Today, like most art museums, modern art museums are attracting unprecedentedly high numbers of visitors; many new institutions are being founded while existing ones go on expanding. (At the time of writing, MOMA was embarking on its third major building project since the 1960s.[21]) At the same time, much twentieth-century art continues to be widely regarded as difficult, and small institutions devoted to contemporary art struggle for audiences and funding. Although not alone in seeking to bridge the gap between high art and popular appeal, seriousness of purpose and commercialization, education and entertainment, the dilemma of modern art museums is undoubtedly an especially acute one.

References

Ammann, Jean-Christophe (1991) 'From the perspective of my mind's eye: on the occasion of the opening of the Museum of Modern Art, Frankfurt', in Jean-Christophe Ammann and Christmut Präger (eds) *Museum für Moderne Kunst und Sammlung Ströher*, Frankfurt am Main, Museum für Moderne Kunst, pp.47–59.

Baudrillard, Jean (1982) 'The Beaubourg-effect: implosion and deterrence', *October*, no.20, Spring, pp.3–13.

Buchloh, Benjamin H.D. (1990) 'Conceptual art 1962–1969: from the aesthetic of administration to the critique of institutions', *October*, no.55, Winter, pp.105–43.

Dissent: The Issue of Modern Art in Boston (1985) exhibition catalogue, Boston, Institute of Contemporary Art and Northeastern University Press.

Duncan, Carol (1995) *Civilizing Rituals: Inside Public Art Museums*, London and New York, Routledge.

Duncan, Carol and Wallach, Alan (1978) 'The Museum of Modern Art as late capitalist ritual: an iconographic analysis', *Marxist Perspectives*, vol.1, no.4, Winter, pp.28–51.

[21] In order to help give shape to its plans, MOMA organized a series of lectures and debates about the museum and its future; see Elderfield, *Imagining the Future*. Another work about MOMA that was published as this book was going to press is Staniszewski, *The Power of Display*.

Elderfield, John (ed.) (1998) *Imagining the Future of the Museum of Modern Art*, Studies in Modern Art 7, New York, Museum of Modern Art.

Fernie, Eric (1995) *Art History and its Methods: A Critical Anthology*, London, Phaidon.

Fisher, Philip (1991) *Making and Effacing Art: Modern American Art in a Culture of Museums*, New York, Oxford University Press.

Grunenberg, Christoph (1994) 'The politics of presentation: the Museum of Modern Art, New York', in Marcia Pointon (ed.) *Art Apart: Art Institutions and Ideology across England and North America*, Manchester University Press, pp.192–211.

Haacke, Hans (1983) 'All the art that's fit to show', in A.A. Bronson and Peggy Gale (eds) *Museums by Artists*, Toronto, Art Metropole, pp.151–2.

Heinich, Nathalie (1988) 'The Pompidou Centre and its public: the limits of an utopian site', in Robert Lumley (ed.) *The Museum Time-Machine*, London and New York, Comedia/Routledge, pp.199–212.

Hollein, Hans (1991) 'To exhibit, to place, to deposit: thoughts on the Museum of Modern Art, Frankfurt', in Andreas C. Papadakis (ed.) *New Museology*, London, Academy Editions, p.41.

Johnson, Ellen H. (1971) *Claes Oldenburg*, Harmondsworth, Penguin.

Klotz, Heinrich (1991) 'Centre for Art and Media Technology, Karlsruhe', in Andreas C. Papadakis (ed.) *New Museology*, London, Academy Editions, pp.73–81.

Krauss, Rosalind (1990) 'The cultural logic of the late capitalist museum', *October*, no.54, Fall, pp.3–17.

Krauss, Rosalind (1996) 'Postmodernism's museum without walls', in Reesa Greenberg, Bruce W. Ferguson and Sandy Nairne (eds) *Thinking About Exhibitions*, London and New York, Routledge, pp.341–8.

Lynes, Russell (1973) *Good Old Modern: An Intimate Portrait of the Museum of Modern Art*, New York, Atheneum.

O'Doherty, Brian (1976) 'Inside the white cube: notes on the gallery space, part I,' *Artforum*, vol.XIV, no.7, March, pp.24–30. The three articles were also published as *Inside the White Cube*, Santa Monica, Lapis Press, 1986.

Read, Helen Appleton (1939) 'Art in our time', *American Magazine of Art*, vol.32, no.6, June.

Sandler, Irving (1988) *American Art of the 1960s*, New York, Harper & Row.

Spies, Werner (1982) 'Canonization of the cynic: Centre Beaubourg in business – the Marcel Duchamp exhibition', in *Focus on Art*, New York, Rizzoli.

Staniszewski, Mary Anne (1998) *The Power of Display: A History of Exhibition Installations at the Museum of Modern Art*, Cambridge, Mass. and London, MIT Press.

Wallach, Alan (1998) 'The Museum of Modern Art: the past's future', in *Exhibiting Contradictions: Essays on the Art Museum in the United States*, Amherst, University of Massachusetts Press, pp.73–87.

Wigley, Mark (1995) *White Walls, Designer Dresses: The Fashioning of Modern Architecture*, Cambridge, Mass. and London, MIT Press.

Wood, Paul (ed.) (1999) *The Challenge of the Avant-Garde*, New Haven and London, Yale University Press.

The museum in a postmodern era: the Musée d'Orsay

EMMA BARKER

Introduction

In the previous case study we encountered the concept of the 'postmodern museum'. In the present case study we will pursue this notion through a detailed consideration of a single institution: the Musée d'Orsay in Paris (which opened in December 1986). Unlike the examples previously discussed, it is not a purpose-built museum of modern art but a museum devoted to nineteenth-century art housed in a disused railway station of the same period. Like the Frankfurt Museum of Modern Art, however, it offers a spectacular architectural experience that may compete with the art for the visitors' attention and even disorientate them. Indeed, the Musée d'Orsay has been cited as typically postmodern in its 'creation of an interior sense of inescapable complexity, an interior maze' (Harvey, *The Condition of Postmodernity*, p.83). Orsay can also be said to present a postmodern account of the history of art by challenging the standard modernist canon of nineteenth-century art. It gives space not only to the celebrated works of the French avant-garde but also to many neglected and even disdained aspects of nineteenth-century European art.[1]

What makes the Musée d'Orsay an especially useful subject for discussion is the intense controversy that initially surrounded it. Responses to the new museum ranged from 'stupendous achievement' to 'dangerous', 'shocking' and 'ominous' ('The Musée d'Orsay: a symposium', pp.92, 95–6). Moreover, the commentators who criticized it did so for apparently contradictory reasons. While some complained that 'historical context has become primary at Orsay' (Michael Brenson, *New York Times*, 6 March 1988) or bemoaned 'an excess of sociologism', the art historian Linda Nochlin regretted that the museum failed to bear out earlier expectations that it would involve 'a certain attention to the idea, even the mission, of a *social* history of art' ('The Musée d'Orsay: a symposium', pp.96, 86). The hostile stance evident in much of the published reactions to Orsay needs to be set against its manifest success with the general public. By the time of its tenth anniversary, it had received nearly 30 million visitors (not counting attendance at temporary exhibitions, which also attract large numbers of visitors).

In this case study we will analyse the genesis of the Musée d'Orsay, taking account both of broad cultural shifts on the international level and of political factors specific to France. The basic contention is that, while major art museums throughout the world share many of the same features, it is important not to neglect the national context. We will also examine the design of Orsay as an example of museum architecture which demonstrates some of the problems that can be involved in converting an existing building for the

[1] For a discussion of nineteenth-century avant-garde art, see Parts 1 and 2 of Wood, *The Challenge of the Avant-Garde* (Book 4 of this series).

display of works of art. In considering the installation of the works of art in the museum, our aim will be to assess just how far Orsay does depart from the modernist canon and adopt a new 'revisionist' outlook. This will lead on to a more general consideration of display in the museum, and finally to an assessment of the phenomenon of the museum as spectacle.[2]

Revisionist currents

When the Gare d'Orsay was inaugurated as part of the festivities marking the Universal Exhibition of 1900 (a successor to the Great Exhibition held in London in 1851), the military painter Édouard Detaille (1848–1912) commented: 'the station is superb, and has the look of a palace of art' (quoted in Mainardi, 'Postmodern history at the Musee d'Orsay', p.33). In deference to the station's prominent site on the Seine, almost opposite the Louvre, its architect Victor Laloux (1850–1937) concealed the iron and glass train shed behind an elaborate stone façade which echoed the classical architecture of the past (Plate 27). The interior of the building, a hotel as well as a station, was also lavishly decorated. For much of the twentieth century, the so-called Beaux-Arts style of architecture represented by the Gare d'Orsay has been little admired (the name derives from the Ecole des Beaux-Arts or School of Fine Arts in Paris where Laloux was a professor). Judged by reference to the ideals of architectural modernism, with its emphasis on purity of form and strict functionality, the architecture of Orsay could be seen not merely as hideously over-decorated but also, since it conceals the building's mundane purpose, as positively dishonest.

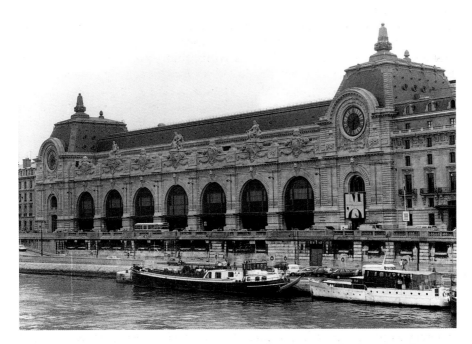

Plate 27 The Musée d'Orsay viewed from across the Seine. Photo: Copyright R.M.N.

2 For a discussion of this term, see Introduction, pp.16–20.

In the 1960s it was proposed that the now redundant station should be demolished and a modern hotel built in its place. In the wake of World War II, drastic urban reconstruction had become the prevailing trend in both Western Europe and North America. Such schemes reflected, however distantly, the modernist vision of making the city anew, exemplified by Le Corbusier's 1924 proposal for sweeping away much of central Paris and replacing it with a landscape of skyscrapers. What saved Orsay from the fate of so many other buildings was the outcry over the destruction of Les Halles (ironically, as a strictly functional iron and glass structure, the market of Les Halles represented just the kind of nineteenth-century architecture that modernists admire). Permission for the hotel scheme was rescinded in 1971 and Orsay designated a historical monument in 1973. This decade witnessed the consolidation of a new conservationist mentality and a renewed appreciation of hitherto despised aspects of nineteenth-century architecture. This shift in taste did not carry everyone with it, however; an architect on the committee which selected the architectural practice ACT to restore Orsay and convert it into a museum would have preferred to pull down a building which revealed 'all the most horrible defects of the decadent architecture of its period' (*Le Débat*, p.25).

The scheme for a museum of nineteenth-century art to be housed at Orsay originated in the early 1970s when a new use was being sought for the station. It could not have been conceived without the recent revival of interest in the so-called academic and official art of the period, conventionally exemplified by the work of William Adolphe Bouguereau (1825–1905), with its idealized figure types inspired by classical statues and smooth, quasi-photographic surfaces (Plate 28).[3] In the late 1960s 'revisionist' scholars began to champion once famous and successful artists such as Bouguereau who were condemned in the prevailing modernist account of nineteenth-century art for their artistic conservatism and ideological conformism – judged by comparison with the standard of innovation and independence set by the avant-garde. The rehabilitation of academic art, manifested in a series of exhibitions in Europe and the United States, was vehemently opposed by art critics and historians faithful to the modernist canon. In 1973, for example, the presence of paintings by the likes of Bouguereau in the galleries of the Metropolitan Museum of Art in New York was deplored by John Rewald, a leading authority on Impressionism, who declared that these 'kitschy', 'titillating' and 'insipid' works should be left in the storerooms 'as evidence of the bad taste of a bygone era' (Rewald, 'Should Hoving be de-accessioned?', p.2).[4]

[3] The term 'academic' relates to the doctrines and teaching of academies of art; 'official' implies that the artists trained by and belonging to such insitutions enjoyed state patronage. On the early history of the French Académie royale, see Case Study 3 in Perry and Cunningham, *Academies, Museums and Canons of Art* (Book 1 of this series). The use of Bouguereau as an example may be convenient but it can also be misleading and tendentious: while he did train at the Ecole des Beaux-Arts (the nineteenth-century descendent of the original Académie), much of his work was bought by American millionaires rather than the French state. We might just as well exemplify nineteenth-century academic art by reference to Fernand Cormon's *Cain* (Plate 41), which depicts a scene from biblical rather than classical myth and in a more 'realistic' manner; Cormon (unlike Bouguereau) was a professor at the Ecole. Both paintings were exhibited, in 1879 and 1880 respectively, at the Paris Salon, from which they were bought for the national collection of contemporary art at the Musée du Luxembourg (which closed in 1937 after academic art fell from favour).

[4] Thomas Hoving was then director of the Metropolitan Museum; see Case Study 5.

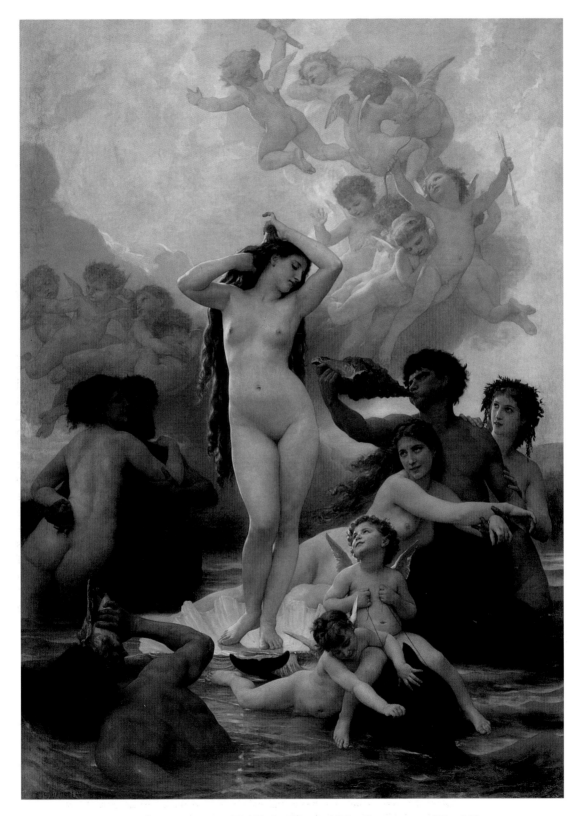

Plate 28 William Adolphe Bouguereau, *The Birth of Venus*, 1879, oil on canvas, 300 x 218 cm, Musée d'Orsay, Paris. Photo: Copyright R.M.N. / P. Selert.

The rehabilitation of academic art continued to arouse hostility well into the 1980s, as we will see below, and indeed still does today.[5] Nevertheless, attempts by devout modernists to dismiss the whole phenomenon as some kind of aberration clearly underestimate its importance. In general terms, it can be said that the last few decades have witnessed a reappraisal of nineteenth-century art and architecture which represents a significant departure from the modernist orthodoxy of the post-war era. These trends can also be seen as part of a more fundamental shift towards postmodernism in late twentieth-century culture. The connotations of this term are too wide-ranging to be addressed properly here, but we can identify some aspects of postmodern culture that are especially relevant to this case study. These are, first, a new interest in and borrowing from the past, especially in architecture, where references to a variety of historical styles are employed with a distinctive playfulness.[6] Second, postmodernism is said to involve a breaking down of the boundaries between art and everyday life, the collapse of the distinction between high and mass culture (exemplified by the mutual influence of art and advertising). The idea that the present era is a peculiarly 'postmodern' one was at its height around the time that the Musée d'Orsay opened.

Cultural politics

The Musée d'Orsay also fits into a long French tradition of promoting the arts for the sake of the personal glory of the ruler and the prestige of the nation as a whole. As such, it can be seen as the successor to the Pompidou Centre, which owed its existence largely to the president after whom it was named. Orsay itself was to be succeeded by the *grands projets* of President Mitterrand, a series of cultural initiatives involving major construction work which included the 'Grand Louvre' project (the centrepiece of which was the glass pyramid designed by I.M. Pei for the forecourt of the Louvre as a new entrance for the museum – see Plate 6). The scheme for Orsay became official policy in 1978 during the presidency of Giscard d'Estaing, who adopted it as his own *grand projet*. From the first, it was envisioned that the 'Museum of the Nineteenth Century' (as it was initially known) would include not only painting and sculpture but also the decorative arts, architecture, photography, etc. In the French context, these plans were highly innovative and can be linked to a new, expanded conception of cultural heritage concerned with

[5] For an example of a hostile reaction to an exhibition of a British academic artist, see Case Study 5 in Perry and Cunningham, *Academies, Museums and Canons of Art* (Book 1 of this series).

[6] Although postmodern architecture takes many different forms, a famous early example is the AT & T (now Sony) building in New York (built 1979–84) designed by Philip Johnson, a skyscraper which instead of being a standard modernist glass and steel box is topped by a broken classical pediment of a type conventionally used not in huge buildings but in domestic furniture. Both the borrowing from architectural tradition and the deliberate jokiness with which it is done can be seen as typical of postmodernism. At the time, the AT & T building aroused intense controversy.

rural traditions and 'industrial archaeology' as well as the fine arts, which developed during the 1970s.[7] Giscard designated 1980 as *l'année du patrimoine* (national heritage year) in France.[8]

When Mitterrand's socialist government took power in 1981, he decided after some deliberation to continue the Orsay project but give it a stronger historical orientation. Madeleine Rebérioux, a historian of socialism, was appointed vice-president of the project to bring this about. The museum's starting-point, for which various historical dates had previously been proposed, was set at 1848, the year of revolutions in Europe. Political rather than aesthetic logic also determined the choice of cut-off point: 1914, the outbreak of the World War I (though in fact post-1900 painting and sculpture are barely represented in the museum). Rebérioux also wanted Orsay to show the impact of industrialization on the culture and society of the period. She suggested that the displays might include objects of no great aesthetic merit but 'characteristic of mass culture in the late 19th century', that is, objects that could have been seen in the homes of the poor as well as the arts patronized by the élite. Her fundamental aim was 'to enlarge the museum's potential public and in doing so to create a new one. We know for a fact that working class people in France rarely visit museums, and polls have shown that even with Beaubourg's [the Pompidou Centre's] tremendous popular success, its audience includes but a tiny three percent of the working class' (Lipton and Corn, 'Report from Paris', p.48).

In the event, however, neither technological change nor class conflict has much of a presence in the Musée d'Orsay – hence the disappointment expressed by Nochlin (see p.50 above). Rebérioux's proposals for integrating art and history were rejected by the curatorial team led by Michel Laclotte (who went on to become director of the Louvre). Françoise Cachin, director of Orsay at the time it opened, insisted that there was no point in trying to reconstruct the period as a whole: 'The power of the works speaks for itself and history, in an art museum, is art history' (*Le Débat*, p.65). Not only do painting and sculpture take pride of place, as in any conventional art museum, but even the furniture is displayed 'less for what it can tell us about nineteenth-century life than for the aesthetic genius it expresses' (*Le Débat*, p.64) (see Plate 29). Cachin explicitly rejected the practice, standard in British and especially in American museums, of combining the fine and decorative arts in a 'period room'. By maintaining all the different art forms in their own separate spaces, Orsay gives out the message that art occupies a special zone of its own quite apart from the ordinary world of everyday life. In this respect, it could hardly be less postmodern.

All that survives of Rebérioux's proposals are a few low-key displays outlining some of the key events and developments of the period, which are easily overlooked by visitors. The effect, she argued, is to marginalize history as 'context without any real purchase on the works' (*Le Débat*, p.51). Her objection is not simply that Orsay obscures the ways in which artistic activity was

[7] The range of art forms represented at Orsay is hardly innovative in itself, as MOMA in New York has included a similar range of media since it was founded. Moreover, Giscard himself put the emphasis on 'high culture' and was hostile to the populism of the Pompidou Centre.

[8] For a discussion of official policy towards heritage under Giscard, see Hoyau, 'Heritage and "the conserver society"' (first published in 1980). This kind of critique of heritage can also be found in Britain; see Case Study 8.

Plate 29 A furniture gallery in the Musée d'Orsay. Photo: Tim Benton.

informed by and dependent on contemporary politics and society, but also that, in doing so, it deprives visitors of information that could help them make sense of what they see. As the quotation in the paragraph above shows, Cachin believes that works of art 'speak for themselves'. Any suggestion that explanatory material might be placed alongside them was thus opposed on the grounds that 'the visual must always take precedence over the document or the usually dreary didactic panel' (*Le Débat*, p.64). However, these assumptions have been called into question by the French sociologist Pierre Bourdieu (cited by Rebérioux), who argues that works of art do not 'speak' in a universal language that is accessible to everyone. On the contrary, it is only the affluent and well-educated museum visitor who comes equipped with the knowledge and skills needed to understand and take pleasure in them.[9] In this view, a conventional art museum like Orsay serves essentially to affirm the cultural superiority of a middle-class élite.

The design of Orsay

When the museum opened, Detaille's comment about the Gare d'Orsay (quoted above, p.51) was used as evidence of the building's appropriateness to its new function. In practice, however, the task of converting the station for the display of works of art without compromising the integrity of a historical monument presented immense problems. Laclotte and his colleagues seem to have been determined that Orsay should not only be a museum but also look like one, inside as well as out. What they wanted were

[9] This position is developed in Bourdieu and Darbel, *The Love of Art* (see the extract in Edwards, *Art and its Histories: A Reader*).

calm, contained galleries that would be conducive to the contemplation of works of art and would also be reminiscent of the monumental grandeur of the great museums of the nineteenth century. Their preferences represented a rejection of the characteristic museum design of the 1970s in which the building itself is conceived as a kind of box divided by movable partitions for the sake of flexibility. The Pompidou Centre originally exemplified this type of museum, but its immense open spaces were converted into conventionally solid and permanent galleries during the 1980s. Significantly, the architect responsible for its redesign, Gae Aulenti, was also employed at Orsay to modify ACT's interior design.

As completed by Aulenti (with the support of the curators), the design of the museum represents a decisive break with the original ornate architecture by Laloux. The principal modification introduced into the great glass and metal vault of the train shed is a pair of stone structures running down its length which provide two series of smaller, enclosed galleries. They can be seen in Plate 30, which shows the view experienced by visitors immediately after they have entered at the west end of the station and walked down a flight of steps into the main space of the museum. You then progress along the central alley-way (usually described as the 'nave'), mounting as the floor level rises gradually by steps and ramps. From the east end, you can look back down towards the entrance (Plate 31). In this photograph, which is taken from one of the stone towers at the far end, you can also see the raised terraces which give access to further galleries on either side of the main space. When the museum opened, much of the commentary was highly critical, with one writer, for example, declaring the overall effect 'quite inappropriate … either as a response to the original building or for its new purpose' (Buchanan, 'From toot-toot to Tutankhamun', p.48).

What impression do these photographs of Orsay make on you – are you impressed, surprised, puzzled or what? Can you discern any justification for the negative comment quoted above?

Discussion

What I think emerges clearly, even from photographs or perhaps especially from them, is just how spectacular the museum is. Whether or not you apprehend the spatial logic of the building (and it is certainly not easy to do so), the plunging perspective and, in the second photograph, the bird's eye view are wonderfully impressive. You may wonder whether these effects are achieved at the expense of the original architecture; certainly, you can see very little of the station's arches from the lower levels of the nave. You may also have noted the contrast, which could be termed incongruity, between the lightness and airiness of the vault and the weighty, earthbound stone structures inserted beneath it. Whether or not this struck you, you may have been puzzled by the heavy pattern cut into these structures towards the top which almost has the look of battlements. Given what we know of the curators' concerns, this ornamentation and also the use of stone are presumably intended to endow the space with the grandeur and dignity traditionally associated with museums. These photographs, however, tend to suggest that the effect is not particularly museum-like but stands more as a strong architectural statement in its own right, which could distract attention from the works of art.

◆◆

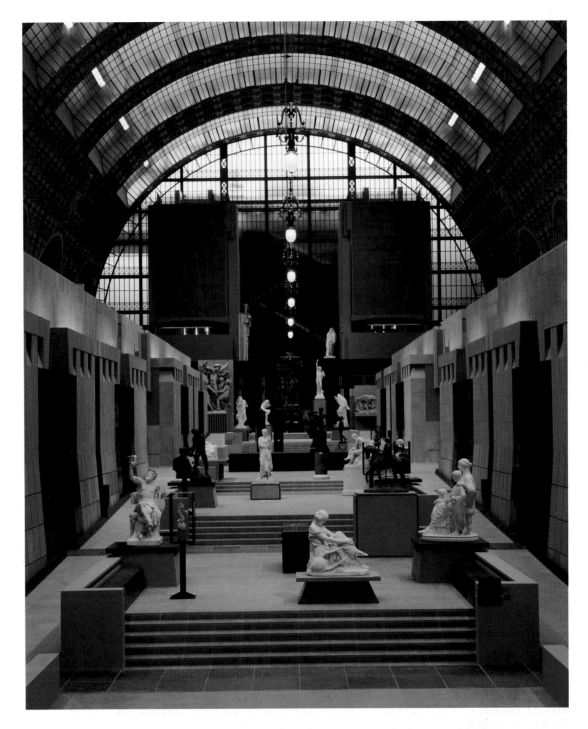

Plate 30 Interior of Musée d'Orsay looking east from the entrance, at the lower end of the ascending ramp of the main area of the museum. Photo: Copyright R.M.N. / Michèle Bellot.

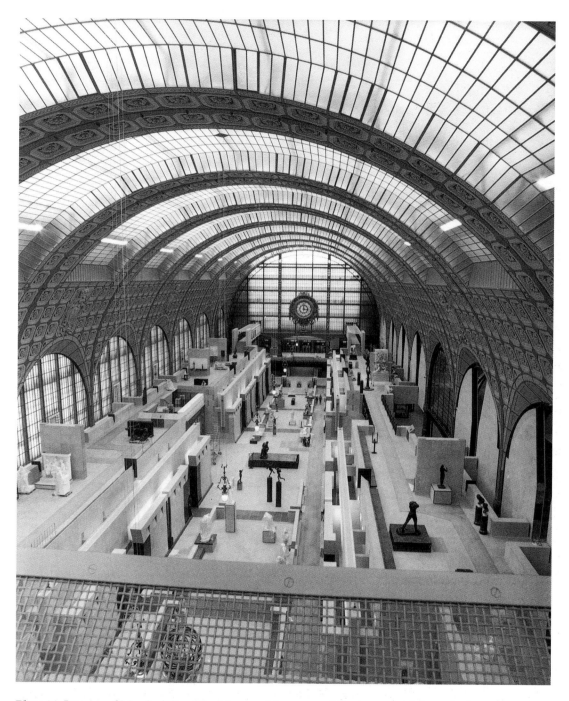

Plate 31 Interior of Musée d'Orsay looking west from one of the towers at the east end.
Photo: Copyright R.M.N.

In the commentary that appeared after Orsay opened, the conversion was widely described as being ancient Assyrian or Egyptian in style, despite the museum's insistence that no such historical reference had been intended. These apparently archaizing features and the insistent decorative motifs used throughout the museum meant that the design was widely taken to exemplify the historicism and playfulness of postmodern architecture. Orsay can be contrasted to the subsequent redesign (opened 1994) of the nineteenth-century galleries at the Metropolitan Museum in New York, which had previously taken the form of a typically 1970s-style open space with partitions. There, as at Orsay, the goal was permanence and dignity as in a nineteenth-century museum, but the solution adopted was to create a straight pastiche (without any postmodern playfulness) of the Beaux-Arts style, which had been extremely influential in the United States (Plate 32).[10] Like Orsay, however, these new galleries have been widely criticized; one architectural writer has described them as being in 'a reproduction style better suited to Disneyland' (Newhouse, *Towards a New Museum*, p.146). Gary Tinterow, the curator responsible for the project, explained that the museum wanted to create a historically appropriate setting for the paintings, even though 'in the future the style of our new galleries will inevitably speak more of our period, the 1990s, than of the period we emulated, the 1890s' (Tinterow, 'New galleries for old, pp.26–7). More generally, we can conclude that all museum design is bound up with changing architectural fashions and also that the style of specific examples will depend on place as well as time.

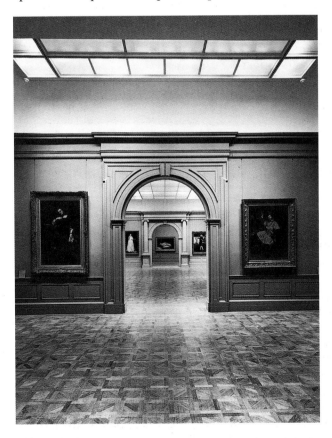

Plate 32 Gallery of nineteenth-century European paintings with view towards Courbet's *Woman with a Parrot* at the far end, 1993, Metropolitan Museum of Art, New York.

[10] The Metropolitan's new galleries were specifically intended to evoke the work of the firm of McKim, Mead and White, the museum's architects from 1904. The approach adopted here can also be connected to the American museum tradition of 'period rooms'.

The installation of Orsay

What kinds of reaction to Orsay do we find in the following extracts? Do they suggest that it should be regarded as a 'revisionist' museum? Does it seem to you that the old canonical modernist view of nineteenth-century art has now been decisively challenged?

The Musée d'Orsay is now the grandest international statement of what might be called a postmodernist view of 19th century art. In this view, the modernist belief in a century aesthetically polarized into the blacks and whites of left-wing / right-wing, hero / villain, genius / dauber has dissolved into infinite shades of grey. Instead of a battlefield, we have a huge family of artists whose connections with one another are far more subtle and binding.

(Rosenblum, *Paintings in the Musée d'Orsay*, p.13)

[The Musée d'Orsay] stands … as the temple of a dangerous historical revisionism. This attempt to reproduce, however partially, the 19th-century context in which Monet, Courbet, … [etc.] were marginalized is a project of incredible violence … Orsay's lack of consideration for what should be a clear-cut hierarchy strikes me as both frightening and threatening.

(Alain Kirili in 'The Musée d'Orsay: a symposium', p.95)

It wasn't a new theoretical vision of the nineteenth-century that engendered the museum but, once again, a fortunate chance which permitted us to display in one space works that were scattered in different places … In short, for us, there can be no comparison between Cézanne and Bouguereau, and there was no question of introducing any equivocation in this hierarchy of value … If the public derived the impression that they are in the presence of a revisionist museum, we would feel we had failed.

(Françoise Cachin in *Le Débat*, pp.58, 66–7)

The failure [of revisionism] lies in the refusal of those in control at Orsay to carry out the ultimate dream of the admirers of 'official' art and hang these pictures mixed in with the works of the so-called modern tradition … The decision to segregate was certainly a wise one; the juxtaposition of 'official' and avant-garde artists has been tried, and it is always a disaster, degrading for the avant-garde and crushing for the academic.

(Rosen and Zerner, 'The judgement of Paris', p.21)

Discussion

The first two extracts represent utterly opposed positions, one enthusiastically welcoming and the other fiercely deploring the perceived revision of the modernist canon represented by Orsay (in fact, the quotations given at the start of this case study to illustrate the immense variety of responses to the museum are by the same two authors). However, Orsay's director denies that it is a revisionist museum at all, maintaining that it is only by chance that it includes both academic and avant-garde works. Contrary to Kirili's claim that Orsay is oblivious to the superior aesthetic value of the latter, Cachin maintains that just such a hierarchy of value underlies the museum. What she means by this is spelled out in the final extract, the authors of which take into account not just the expanded range of art housed at Orsay but also how it has been installed. The revisionist aspect of the museum, Rosen and Zerner point out, is restricted by a decision not to hang avant-garde and academic works side by side but to keep them separate from each other – something they applaud.

Overall, it seems that Rosenblum is somewhat over-optimistic in his claim that the old modernist division of nineteenth-century art into two distinct camps, one of which is infinitely superior in aesthetic quality to the other, has 'dissolved' into a more nuanced, 'postmodernist' view of the period.

◆◆◆

A further conclusion to be drawn from these texts is that a museum is itself a kind of text which can be 'read' in different ways by different people. While perhaps less true of some museums than others, this is clearly the case at Orsay where the installation of the works of art can function in ways quite other than those intended by the curators. Thus, while they might deny that they proposed any major revision of the modernist canon, the prominent placing of *The Romans of the Decadence*, a vast canvas by Thomas Couture (1815–79), in the main space of the museum made it inevitable that this once admired but in recent times relatively little-known painting would attract much new attention (Plate 33). The same is true of the sculpture in the same space. A visitor might well conclude that academic art holds pride of place in the museum, whereas the famous works of the Impressionists and other avant-gardists have been relegated to the relative obscurity of the top-floor galleries to the north of the train shed (Plate 34). In fact, these galleries had been selected as a place of honour because they are the only ones in the museum to be top-lit (that is, benefiting from natural light from windows set in the roof). Laclotte explained that 'the fact of having placed Cézanne, Gauguin or Monet in a good light and with much more space clearly indicates our hierarchy' (*Le Débat*, p.14). It may be doubted, however, that this distinction would be apparent to most visitors.

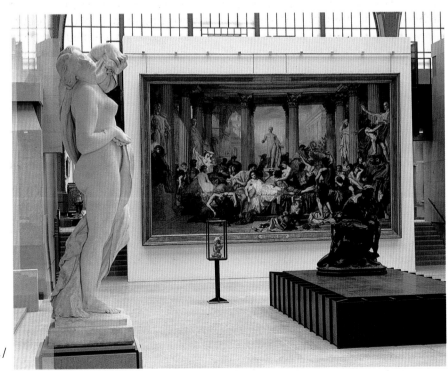

Plate 33 Thomas Couture, *The Romans of the Decadence*, 1847, oil on canvas, 466 x 775 cm, *in situ* in the Musée d'Orsay. Photo: Copyright R.M.N./ Michèle Bellot.

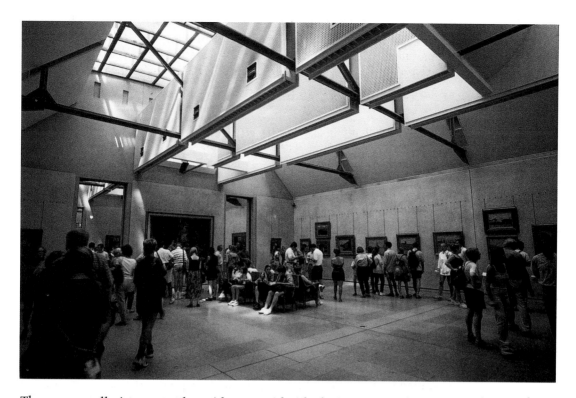

The upper galleries cannot be said to provide ideal viewing conditions; it has been commented that daylight diffused against the pale walls has the effect of making even the light and airy Impressionist canvases there look oddly dark and dull. Nevertheless, they are relatively simple in design and, as such, do not distract attention away from the works of art as the more architecturally complex lower-level galleries in the main space of the museum have been said to do (Plates 35 and 39). According to one commentator at the time the museum opened: 'At no point can a group of pictures be seen in a simple, clear-cut space, without an intruding column, or a change in level, or a break in a screening wall, or some other interruption' (House, 'Orsay observed', pp.67–8). Although even canonical works in the museum are affected by these problems, it can be argued that certain aspects of the installation have the effect of suggesting that academic art does not need to be taken seriously. The ornate ballroom of the station hotel, for example, is devoted to the 'official' art of the post-1870 era, with works such as Bouguereau's *Birth of Venus* (Plate 28) being shown on easels for lack of wall space (Plate 36). The paintings compete for attention not only with the original decor but also with sculpture placed there in defiance of the museum's usual rule about keeping the different art forms separate.[11] The overall implication seems to be that, unlike canonical works of art, they are not good enough to be looked at for their own sake and require a historical context in order to be appreciated.

Plate 34 The Impressionist galleries, Musée d'Orsay. Photo: Paul M.R. Maeyaert, Mont de l'Enclus (Orrior), Belgium.

[11] According to Sherman, 'Art history and art politics', p.59, this installation also falsifies history by suggesting that this type of painting, employing a mythological subject as an excuse for eroticism, represented the official taste of the Third Republic (which replaced the Second Empire in 1870) when in fact the state's acquisitions increasingly shifted towards landscape and genre from the 1880s.

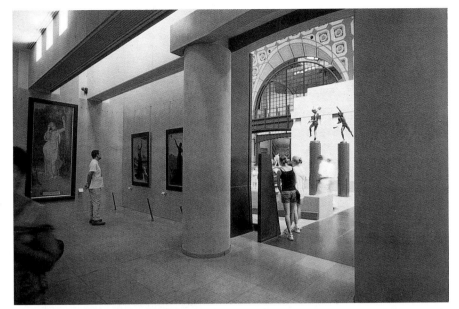

Plate 35 View illustrating problems of display in lower galleries on the right-hand side of the central space in the Musée d'Orsay. Photo: Paul M.R. Maeyaert, Mont de l'Enclus (Orrior), Belgium.

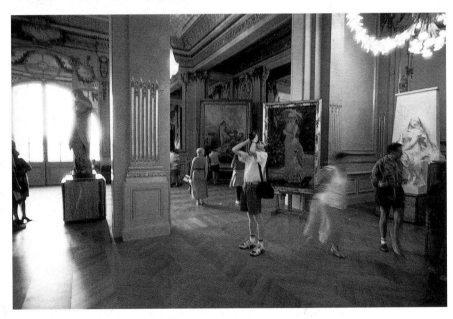

Plate 36 Former hotel ballroom in the Musée d'Orsay, with paintings by Bouguereau and others on easels. Photo: Paul M.R. Maeyaert, Mont de l'Enclus (Orrior), Belgium.

Display in the museum

Near the beginning of this case study we noted that some commentators have attacked Orsay for being too historical, too concerned with the social context of art. On the face of it, these remarks are very odd: as we have seen, plans to cover different aspects of nineteenth-century society and culture did not come off. In fact, when they are read in context it becomes clear that what is primarily being criticized is the way that the museum impedes reverent contemplation of the renowned masterpieces of the period, first because of the low standard of display (impressive but distracting design, poor lighting systems) and second because of the presence of paintings by less well-known

artists and of other art forms. The literary historian Stephen Greenblatt, for example, claims that 'the museum remakes a remarkable group of highly individuated geniuses into engaged participants in a vital, immensely productive period in French cultural history … But what has been sacrificed on the altar of cultural resonance is visual wonder centred on the aesthetic masterpiece' ('Resonance and wonder', p.54). In fact, however, as further analysis of the museum will reveal, the basic principles of display applied to the canonical works at Orsay are actually the same as in many other art museums.

Take, for example, the display of the works of Gustave Courbet (1819–77), the leading avant-garde painter of the mid-nineteenth century, whose works are all grouped together on the lower level (Plate 37). This means that they cannot easily be compared with those of other exponents of the contemporary Realist movement in painting of which he is considered to be the key figure. Moreover, the fact that the space devoted to Courbet opens off the so-called nave of the museum, about half-way along on the left, endows it with something of the character of a side chapel or transept in a church. Without taking the analogy too seriously, it can be argued that this serves to promote an attitude of reverence towards one of the 'saints' of the established canon of nineteenth-century art. Elsewhere at Orsay, major artists such as Paul Cézanne (1839–1906) are similarly allotted their own gallery, thereby isolating their work from that of their contemporaries. This type of display, often termed chapel-like, is typically employed in modern art museums as well as in the Metropolitan's nineteenth-century galleries, many of which are dedicated to a single artist. Its overall effect is to reinforce a highly traditional conception of art history made up of individual geniuses whose unique creativity owes nothing to the world in which they lived.

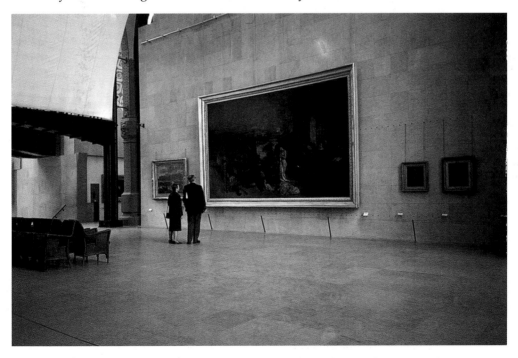

Plate 37 The Courbet 'transept' in the Musée d'Orsay. Photo: Tim Benton.

The display is also conventionally chronological, which serves to uphold a notion of artistic development through time. (In this respect it conforms to the model of earlier art museums, not that of the non-linear postmodern museum.) Thus, Courbet is followed by Édouard Manet (1832–83), the next major figure in the modernist canon, whose early work hangs near by on the same side of the nave. The complexities of Orsay's layout mean, however, that the connection is not as clear as it is in the Metropolitan where, at the time of the reopening of the nineteenth-century galleries, it was possible to look from Manet's dressed, standing *Woman with a Parrot* towards Courbet's naked, reclining one (Plate 32).[12] At the same time, Orsay's policy of displaying academic and avant-garde art separately (also followed in the Metropolitan) means that Manet's famous *Olympia* (Plate 38) hangs on the opposite side of the nave from *The Birth of Venus* (Plate 39) by Alexandre Cabanel (1823–89). It has long been something of an art-historical cliché to contrast Manet's depiction of a naked prostitute, which scandalized its original viewers, with Cabanel's conventionally titillating mythological nude, which was bought by the Emperor Napoleon III himself. The historical justification for doing so is that both works were shown at the great art exhibition of the period, the Paris Salon, in 1865 and 1863 respectively. Undoubtedly, a thorough-going 'revisionist' display would hang them together even though the Manet/ Cabanel contrast exemplifies the over-simplistic modernist polarization

Plate 38
Édouard Manet,
Olympia, 1863,
oil on canvas,
130 x 190 cm,
Musée d'Orsay,
Paris.
Photo: Copyright
R.M.N./Gérard
Blot.

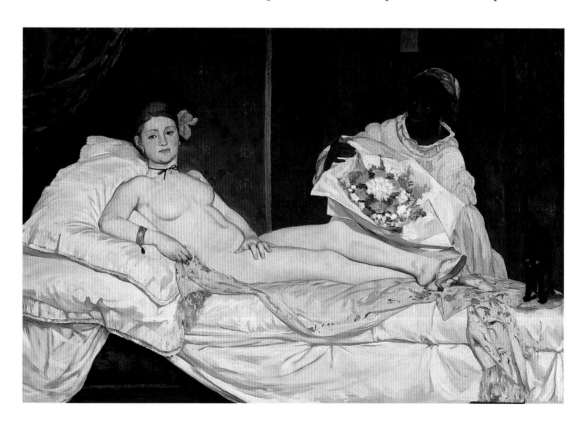

[12] The label noted that 'this picture, for which Victorine Meurent posed in 1866, was probably Manet's answer to Courbet's *Woman with a Parrot*, exhibited in the Salon of 1866' (quoted in Bal, 'The talking museum', p.105). The display ignored another possible connection, between Courbet's painting and Cabanel's *Birth of Venus* (Plate 39), of which the Metropolitan owns another version.

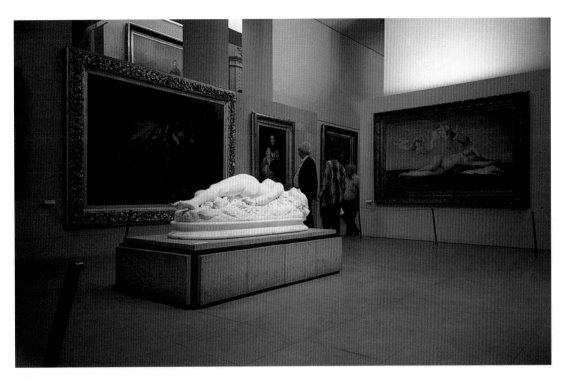

Plate 39 Alexandre Cabanel, *The Birth of Venus*, 1863, oil on canvas, 130 x 225 cm, *in situ* (far right) in the Musée d'Orsay, Paris. Photo: Tim Benton.

between 'good' avant-garde and 'bad' academic art. In refusing to do so, Orsay affirms that the display functions to uphold the established aesthetic hierarchy rather than to foster understanding of the complexities of the history of art.

More fundamentally, the mode of display adopted at Orsay and elsewhere means that *Olympia* or any other canonical painting of a female nude is presented primarily as an example of the work of an individual, almost invariably male, artist. From a feminist perspective, we may regret the failure of the museum to take account of broader issues of gender and power, in relation to authorship and representation, which have informed art-historical discussion of nineteenth-century French painting in recent years.[13] At the same time, it is possible to note that paintings of the nude can reveal something fundamental about the nature of display in art museums. In this respect, Courbet's *Origin of the World* (Plate 40), which entered the museum's collection in 1995, is an especially pertinent example. On the one hand, its acquisition can be hailed as bringing to light a key work by a great artist which had long been thought lost. On the other, the pornographic character of the image might be considered highly offensive to women and, as such, its public display in the museum could be deplored. The fact remains that *The Origin of the World* could hardly be shown in any other more or less public setting, such as an office or a hospital, where it would be seen by people who had no choice in the matter. The museum, as a space dedicated to display to which visitors come specifically to look at works of art, neutralizes the subject-matter

13 On this subject see the Introduction to Perry, *Gender and Art* (Book 3 of this series).

Plate 40 Gustave
Courbet, *The
Origin of the
World*, 1866,
oil on canvas,
46 x 55 cm,
Musée d'Orsay,
Paris. Photo:
Copyright
R.M.N./
H. Lewandowski.

of Courbet's painting and foregrounds its aesthetic dimension.[14] More
generally, we may conclude that the museum continues to function to uphold
the specialness of art as a category completely separate from everyday life.

The museum as spectacle

As was noted above, Orsay has proved a great popular attraction. What draws
the public in large numbers is, above all, the presence of the Impressionist
and Post-Impressionist paintings. One of the major reasons for establishing
the museum in the first place was the inadequacy of the existing Jeu de Paume
Museum (which formerly housed them) to cope with the ever-increasing
crowds. The unique appeal of the modernist canon of French nineteenth-
century art was confirmed when the attendance levels rose by more than 25
per cent in 1993 on the occasion of Orsay's showing of French paintings from
the Barnes Foundation.[15] Although temporary exhibitions attract a largely
Parisian audience, the majority of visitors to the museum are foreign tourists:
over 70 per cent of its public are there for the first time. Many of these are
likely to follow the set route around the museum, starting with the pre-1870
works on the lower level, though no doubt quite a few also make straight for
the top floor. Some of the least frequented spaces are the middle-level galleries
containing post-1870 works that fall outside the modernist canon (including
non-French art), though whether this is because the mostly first-time visitors
are exhausted before they get this far or because paintings such as *Cain* (Plate
41) by Fernand Cormon (1845–1924) remain devoid of interest or pleasure
for present-day viewers should perhaps be left open.

[14] Of course, this statement assumes that visitors to the museum are not simply willing to
view images they see as art, but also have the knowledge and skills needed to perceive the
stylistic aspects of the work. The neutralization process does not function for all viewers: this
much is apparent from the many attacks made on paintings of the nude. For a discussion of
the cultural status of the nude in art, see Nead, *The Female Nude*.

[15] On this and other comparable exhibitions, see Case Study 5.

Plate 41 Fernand Cormon, *Cain*, 1880, oil on canvas, 380 x 700 cm, Musée d'Orsay, Paris. Photo: Copyright R.M.N.

Above all, of course, Orsay is undoubtedly a spectacular place to visit. At the time of its opening, different commentators offered contrasting evaluations of this aspect of the museum. Some saw it as rivalling the works of art for the visitors' attention. Two writers reported that the most popular display appeared to be the model of the Paris Opera (completed 1875) and its *quartier* (district) installed under a transparent floor. They described it as 'very like the whole museum, a spectacle which demands viewing of and for itself' (House, 'Orsay observed', p.73) and as 'something of a high culture Disneyland', marking the transition from art to 'mindless forms of mass entertainment' (Mainardi, 'Postmodern history at the Musée d'Orsay', p.36). However, Orsay was also hailed as 'a dazzling, highly articulated fusion of past and present, station and museum, observer and art work … a kind of postmodernist *Gesamtkunstwerk* [total work of art], providing a transmedia architectural spectacle (in the best sense of the word) of a kind not seen in Paris (apart from the International Expositions [Universal Exhibitions]) since the opening of Garnier's Opera in 1875' (Marvin Trachtenberg in 'The Musee d'Orsay: a symposium', p.105).[16] The terms 'postmodern' and 'spectacle', allusions to Disney theme parks and the Universal Exhibitions, were all combined in Rosenblum's similarly rapturous account of the museum in the same forum.

On the basis of these accounts, both positive and negative, we can suggest that the traditional model of the art museum as an exclusive, quasi-sacred space has been displaced at Orsay (at least in the central space created out of the former train shed) by a new populist model of the museum as spectacle. As such, it can be associated with other, commercial environments which make use of spectacular architectural imagery, such as the Disney theme parks,

[16] *Gesamtkunstwerk* is a term coined by the composer Richard Wagner (1813–83), who aspired to turn opera into the ultimate artistic experience, combining music, painting and poetry.

which are often taken to be exemplary of postmodernism. The combination of up-to-date technology and nostalgic make-believe that is characteristic of such sites of visual consumption can also be traced back to the Universal Exhibitions. These associations make it possible to applaud Orsay as a form of postmodern spectacle which succeeds (even if only inadvertently) in evoking something of the larger culture of the nineteenth century. From a more critical perspective, it speaks rather of a continuing deployment of spectacle as a form of social control; the building of the Paris Opera formed part of the massive city redevelopment project of Napoleon III that 'raised many of the same questions raised today by urban renewal, slum clearance and gentrification' (Mainardi, 'Postmodern history at the Musée d'Orsay', p.36). Not just Orsay, it can be argued, but central Paris itself functions today primarily as a glossy, nostalgic tourist attraction from which the poor of the region are effectively excluded.[17]

Arguably, Orsay is above all significant for its expansion of the canon of nineteenth-century art, on the one hand, and its immense appeal to a mass public, on the other. In neither case, however, does it appear that the museum has brought about any marked revision of existing hierarchies. As we have seen, implicit within the display is a continuing allegiance to the modernist canon of aesthetic value, while most of the visitors are tourists and thus, by definition, at least modestly affluent.[18] Moreover, everything suggests that Orsay's great attraction for them is based on the presence of the acknowledged masterpieces of Impressionism. It follows that the notion that the canon of nineteenth-century art has been decisively revised as part of a broad cultural shift towards postmodernism needs to be treated with some caution. A case in point is Robert Rosenblum's claim that the ubiquity of photography has helped to bring about a new appreciation of academic painters who would formerly have been dismissed as 'worthless artists who chose brushless, glossy, mechanical truth over personal facture and significant form' (Rosenblum, *Paintings in the Musée d'Orsay*, p.17).[19] Academic paintings have certainly been popularized through photographic reproduction (you can even buy a fridge magnet of Bouguereau's *Venus*, complete with trendy clothes to dress her in), but this does not necessarily mean that their status as art has been enhanced. The fact that people do not apparently go to the museum in order to see paintings of this kind suggests that they remain non-canonical. Rather than being singled out as works of art worthy of reverent contemplation, they form part of the overall spectacle of Orsay.

[17] For a fuller discussion of these issues, see Case Study 7.

[18] However, it is at the very least debatable whether the broadly middle-class public that Orsay and other art museums attract today can be defined as an élite (as Bourdieu would have it) in any meaningful sense of the term. A major difference between the 1960s (when Bourdieu did his research) and today is the much greater provision of visitor services aimed at promoting access; for those at Orsay, see Schneider, *Creating the Musée d'Orsay*, pp.84–7 (this informative book appeared after the present study was completed).

[19] This can be related to more general claims about the saturation of contemporary society by photographic imagery as one of the prime features of postmodern society; see Introduction. The sharp contours and smooth surfaces of many academic paintings undoubtedly lend themselves to reproduction: with the Bouguereau fridge magnet mentioned below, for example, Venus is cut out of her setting and reproduced alone.

References

Bal, Mieke (1996) 'The talking museum', *Double Exposures: The Subject of Cultural Analysis*, London and New York, Routledge, pp.87–134.

Buchanan, Peter (1986) 'From toot-toot to Tutankhamun', *Architectural Review*, vol.180, no.1078, December, pp.48–53.

Bourdieu, Pierre and Darbel, Alain (1991) *The Love of Art: European Art Museums and their Public*, Cambridge, Polity Press (original French edition 1969).

Le Débat (1987) March–May, no.44 (special issue devoted to Orsay).

Edwards, Steve (ed.) (1999) *Art and its Histories: A Reader*, New Haven and London, Yale University Press.

Greenblatt, Stephen (1991) 'Resonance and wonder', in Ivan Karp and Steven D. Lavine (eds) *Exhibiting Cultures: The Poetics and Politics of Display*, Washington, DC, Smithsonian Institution Press, pp.43–56.

Harvey, David (1989) *The Condition of Postmodernity: An Enquiry into the Origins of Cultural Change*, Oxford, Blackwell.

House, John (1987) 'Orsay observed', *Burlington Magazine*, vol.129, no.1007, February, pp.67–73.

Hoyau, Philippe (1988) 'Heritage and "the conserver society": the French case', in Robert Lumley (ed.) *The Museum Time-Machine*, London and New York, Comedia/Routledge, pp.27–35.

Lipton, Eunice and Corn, Wanda (1983) 'Report from Paris. Musée d'Orsay: art history vs. history, *Art in America*, Summer, pp.47–51 (interview with Madeleine Rebérioux).

Mainardi, Patricia (1987) 'Postmodern history at the Musée d'Orsay', *October*, no.41, Summer, pp.30–52.

'The Musee d'Orsay: a symposium' (1988) *Art in America*, January, pp.85–106.

Nead, Lynda (1992) *The Female Nude: Art, Obscenity and Sexuality*, London and New York, Routledge.

Newhouse, Victoria (1998) *Towards a New Museum*, New York, Monacelli Press.

Perry, Gill (ed.) (1999) *Gender and Art*, New Haven and London, Yale University Press.

Perry, Gill and Cunningham, Colin (eds) (1999) *Academies, Museums and Canons of Art*, New Haven and London, Yale University Press.

Rewald, John (1973) 'Should Hoving be de-accessioned?', *Art in America*, January, pp.24–30.

Rosen, Charles and Zerner, Henri (1987) 'The judgement of Paris', *New York Review of Books*, 26 February, pp.21–5.

Rosenblum, Robert (1989) *Paintings in the Musée d'Orsay*, New York, Stewart, Tabori and Chang.

Schneider, Andrea Kupfer (1998) *Creating the Musée d'Orsay: The Politics of Culture in France*, University Park, Pennsylvania State University Press.

Sherman, Daniel J. (1990) 'Art history and art politics: the museum according to Orsay', *Oxford Art Journal*, vol.13, no.2, pp.55–67.

Tinterow, Gary (1993) 'New galleries for old', *The New Nineteenth-Century European Paintings and Sculpture Galleries*, New York, Metropolitan Museum of Art, pp.7–28.

Wood, Paul (ed.) (1999) *The Challenge of the Avant-Garde*, New Haven and London, Yale University Press.

The Sainsbury Wing and beyond: the National Gallery today

EMMA BARKER AND ANABEL THOMAS

Introduction

> Since its foundation in 1824 the National Gallery has existed to bring the best possible pictures to the widest possible public.
>
> (*National Gallery Report*, 1993–94, p.5)

In the previous two case studies we have been concerned primarily with the foundation of new museums. In this case study, by contrast, our aim is to explore the various ways in which the National Gallery currently seeks to fulfil its historical commitments or, to put it another way, how an art museum established in the early nineteenth century has adapted to the very different world of today. On the one hand, we will examine some of the more recent additions to the collection and assess the extent to which it can now be said to present a revised view of the canon of Old Master painting. On the other, we will consider the steps that have been taken in order to facilitate public access to the collection and, more broadly, to promote enjoyment and understanding of works of art. An issue of general relevance to this case study is the question of authenticity; underlying the aim of making great art accessible to everyone is the assumption that the gallery functions to allow people to see 'the real thing'.[1] At the same time, as we will see, recent modifications testify to a recognition that the visitor's experience will inevitably be coloured by the method of display and the architectural setting. To start with, therefore, we will consider its most recent extension, the Sainsbury Wing, which opened in 1991.

The Sainsbury Wing

> The completion of this last major addition to the National Gallery is the final chapter in a long story of debate, indecision, official prevarication and uncertainty.
>
> (Amery, *A Celebration of Art and Architecture*, p.18)

Although the National Gallery has always had to contend with official reluctance to spend public money on the arts, previous building work had been financed by the government. However, the proposed extension on the 'Hampton site' immediately to the west of the gallery, acquired for the purpose in 1959, finally became a reality only as a result of an endowment from

[1] In this context 'the real thing' may be taken to mean an authentically historical work of art (as opposed to a modern fake), a genuine work by a renowned artist (as opposed to one by an associate or other contemporary of the artist), or a work preserved in a condition that represents some kind of truth about the essential identity of the object (this can mean either returning it to what is believed to be its original appearance or respecting the changes that the work of art has undergone over time). This case study will touch on the second of these aspects and consider the third more fully.

members of the Sainsbury family (of the supermarket chain of the same name). When the project was announced, Tim Sainsbury explained that he and his brothers had been so impressed by the gallery's success in attracting increasing numbers of visitors that they wished to provide for its enhancement (though, obviously, they would also have calculated on receiving a lot of positive publicity as a result) and thus to ensure its continuance as 'one of the world's great museums' (National Gallery press release, 2 April 1985). A similar note was struck in much of the press coverage, with one journalist, for example, declaring that there was 'an opportunity to build a world-class gallery ... on one of the most prestigious sites not only in Britain but in the world' (Charles Knevitt, *The Times*, 3 April 1985). The National Gallery could thus be seen to be competing with the great new museum buildings of Germany, France and the United States – if rather belatedly and on a fairly modest scale.

Far from being an unmixed blessing, the very prominence of the site, facing on to Trafalgar Square in the centre of London's West End, helps to account for the difficulties that the National Gallery encountered in seeking to expand on to the Hampton site. During the early 1980s, a government-sponsored competition was held to find a design for an extension that would not just house its collection of early Renaissance paintings but also include commercial office space. At this stage, the Trustees could envisage no way of funding the extension other than collaboration with a property developer.[2] The winning design, by the firm of Ahrends, Burton and Koralek, was refused planning permission after the Prince of Wales made a speech attacking modern British architecture in 1984, in which he described it as 'a monstrous carbuncle on the face of a much loved and elegant friend' (quoted in Amery, *A Celebration of Art and Architecture*, p.49). When the new Sainsbury-funded project was announced, the Chairman of the Trustees explained that the plan was to invite up to six firms to submit ideas for a design that should 'relate sympathetically to the old building, have an architectural distinction worthy of the site and be complementary to Trafalgar Square' (quoted in Amery, *A Celebration of Art and Architecture*, p.50). As a result of the National Gallery selection process, the American architects Robert Venturi and Denise Scott Brown received the commission for the Sainsbury Wing.

Compare the Ahrends, Burton and Koralek model (Plate 42) with the Sainsbury Wing as it was built (Plate 43). What do you think Prince Charles had in mind when he described the former as a monstrous carbuncle? In what ways does the latter fit in better with the existing architecture?

Discussion

The most striking element of the Ahrends, Burton and Koralek design is the tower, with its angular design and use of metal, which seems somewhat reminiscent of a television aerial or some other aspect of modern technology. This creates a strong vertical element which could seem out of proportion and out of keeping with the adjoining classical building. You would be right

[2] The Trustees have public responsibility for the National Gallery. They are, in effect, a committee composed of famous, distinguished and wealthy individuals who can contribute various kinds of expertise, about art or management, for example. Most museums in Britain and the United States have a comparable committee, whether or not they are actually termed trustees, though their official status and precise function vary considerably.

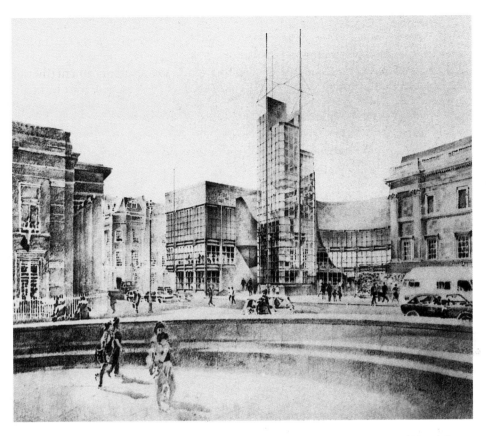

Plate 42 Project for the National Gallery extension by Ahrends, Burton and Koralek. Perspective by Richard Davis. Reproduced by courtesy of Ahrends, Burton and Koralek.

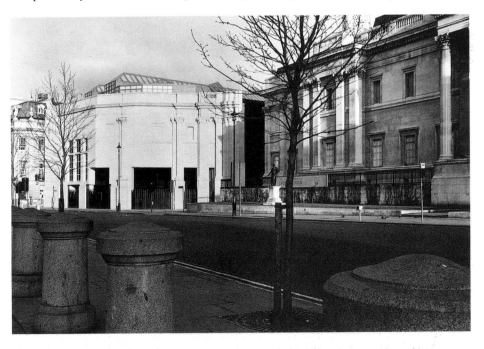

Plate 43 National Gallery, Sainsbury Wing, exterior view from Trafalgar Square. Reproduced by courtesy of the Trustees, The National Gallery, London.

to assume that it was this tower that incurred most royal wrath (the Prince of Wales also called the building 'a kind of vast muncipal fire station, complete with the sort of tower that contains the siren'). The Sainsbury Wing, by contrast, makes no bold or outrageous statement. It takes its cue from the existing architecture, maintaining the same roof-level and using the same materials (Portland stone). Above all, it continues the classical order on the original façade though, as you can see, the Corinthian columns and blank windows inset between them do not continue all along the front of the new wing but gradually disappear as it moves further from the join between the two buildings.

◆◆

The Prince of Wales's intervention made it almost inevitable that a classical design would be chosen for the Sainsbury Wing. The whole episode gave rise to great resentment on the part of the British architectural profession, many of whose leading members (including Richard Rogers, one of the entrants in the original competition) are convinced modernists. However, Venturi and Scott Brown do not simply represent an anti-modern approach but rather offer a distinctly postmodern take on the classical language of architecture. When their design was made public, one commentator declared that Venturi had 'seen fit to regard Classicism not as a long-standing tradition with its own internal coherence and intricate subtleties, its own evolving canons of rhythm, balance and counterpoint ... but rather as an open basket of goodies to be plundered at will in the service of me-ist self-expression' (Farelly, 'Contumacy and contravention in architecture', p.32).[3] When the building itself was unveiled, much of the commentary was similarly critical. Many architectural writers deplored the elaborate contrivances and wilful inconsistencies, such as the fading away of the classical order and the gaping holes in the façade which make clear that the columns are purely decorative and have no structural logic.[4] On the whole, however, especially inside, these 'ironic' postmodern details are not obtrusive and the overall effect is inoffensive, if not especially distinguished.

Underlying the design are the practical requirements of the gallery, set out for the architects in a lengthy brief. Whatever the alleged defects of the grand staircase that widens as it ascends to the main-floor galleries (for example) when judged by reference to architectural precedent, its sheer scale has a definite functional logic. Defending the building, Venturi observed that the National Gallery resembles a sports stadium in the crowds that it now attracts. The main priority, however, was to display the paintings to their best advantage. In this respect, the Sainsbury Wing has been widely regarded as a success, though the size of the staircase means that the galleries are

[3] The terms used in the title of this article are a play on the title of Robert Venturi's influential book, *Complexity and Contradiction in Architecture* (1966), a key text of postmodernism.

[4] While the decorative use of classical orders has been going on for centuries, Venturi has been accused of making a virtue (or vice) of the fact. Gavin Stamp, for example, complained that Venturi 'feels obliged to stress what we know already – that a facade is just a facade' (*The Times*, 4 May 1991). In other words, he goes beyond the traditional use of the orders for decorative effect by making it imposssible to ignore the structural redundancy of his columns.

somewhat smaller than they otherwise could have been. The arrangement of the sixteen galleries in three parallel sequences, with a vista down the centre (Plate 44), reveals the influence of the single most admired example of early gallery design in Britain, Dulwich Picture Gallery (Plate 45), as does the top-lighting.[5] Both the layout and lighting are also reminiscent of a church. More specifically, the pale grey colour of the walls contrasting with the dark grey stone used for the door and floor surrounds evokes a fifteenth-century Florentine church – appropriately so since many of the (mostly Italian) paintings hanging in the Sainsbury Wing are altarpieces. Thus, the galleries allow for the undistracted contemplation expected in art museums whilst also conveying something of their original viewing conditions (Plate 46).

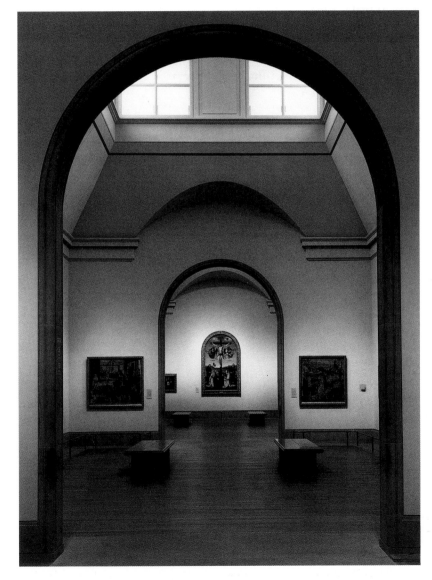

Plate 44 National Gallery, Sainsbury Wing, interior view, vista through central galleries with view of ceiling. Reproduced by courtesy of the Trustees, The National Gallery, London.

[5] Dulwich Picture Gallery (built 1811–13), designed by Sir John Soane (1753–1837), has attracted new attention in the late twentieth century with the revival of interest in nineteenth-century museum design.

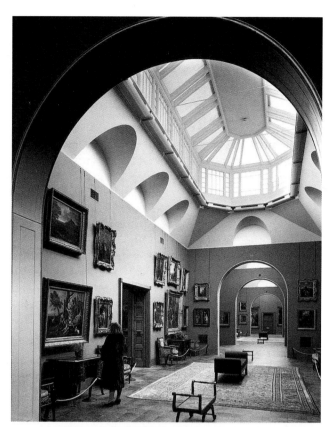

Plate 45 Dulwich
Picture Gallery,
interior view, vista
through central
galleries with view of
ceiling. Photo: Martin
Charles. Reproduced
by permission of the
Trustees of the
Dulwich Picture
Gallery, London.

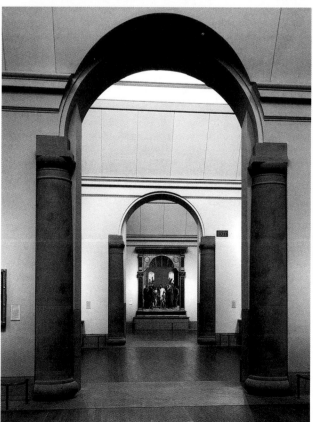

Plate 46 Cima da
Conegliano, *The
Incredulity of Saint
Thomas* (*in situ*
viewed through
arches), *c.*1502–4,
oil on panel,
294 x 199 cm,
National Gallery,
London. Reproduced
by courtesy of the
Trustees, The
National Gallery,
London.

Expanding the collection

The aquisition of Dürer's luminous *St Jerome* ... adds a new and illuminating inflection to the story of European art that the National Gallery now tells.

(*National Gallery Report*, 1996–97, p.5)

Among the paintings now displayed in the Sainsbury Wing is a small panel depicting *St Jerome* (Plate 47) by Albrecht Dürer (1471–1528), bought in 1996 to supplement the National Gallery's relatively limited holdings of German art. Although it contains a more even representation of the canon of western painting than most other great European art museums, the collection has historically been dominated by Italian art, especially painting of the early and High Renaissance, with the French and Netherlandish schools also being strongly represented.[6] Over the years, increasing attempts have been made to 'plug the gaps' (within the historical and geographical confines of the existing collection), but it was only around 1990 that the National Gallery began systematically to purchase works by German artists. Among other recently acquired German paintings are a double portrait by Lucas Cranach (1472–1553) (Plate 48), which was singled out by its director, Neil MacGregor, in a 1996 interview (cited below) as the most notable acquisition that he had made, and a landscape by Caspar David Friedrich (1774–1840) (Plate 49), which in 1987 was the first example of German Romantic painting to enter the collection. The latter purchase represented something of a gamble since, at the time, it was thought to be only a slightly later copy by another artist. An exhibition focusing on the painting was staged by the gallery in 1990 in order to prove that its purchase was indeed authentic.

Plate 47 Albrecht Dürer, *St Jerome*, *c*.1496, oil on panel, 23 x 17 cm, National Gallery, London. Reproduced by courtesy of the Trustees, The National Gallery, London.

[6] See Case Study 7 in Perry and Cunningham, *Academies, Museums and Canons of Art* (Book 1 of this series). In the Louvre, Rijksmuseum and Prado, for example, the collection is strongest in – or even dominated by – the national school. In the National Gallery, by contrast, British painting occupies a rather modest space, reflecting its relatively low status in the canon of western painting.

Plate 48 Lucas Cranach the Elder, *Portraits of Johann the Steadfast and Johann Friedrich the Magnanimous*, 1509, oil on panel, left 41 x 31cm, right 42 x 31 cm, National Gallery, London. Reproduced by courtesy of the Trustees, The National Gallery, London.

Plate 49 Caspar David Friedrich, *Winter Landscape*, probably 1811, oil on canvas, 33 x 45 cm, National Gallery, London. Reproduced by courtesy of the Trustees, The National Gallery, London.

In the case of the *St Jerome*, the National Gallery could claim to have at last acquired a work by the greatest of all German artists.[7] The purchase was all the more momentous since Dürer's paintings are not represented in any other British public collection and no others by him are ever likely to come on to the market. However, the gallery's judgement was questioned by the controversial art critic Brian Sewell, who argued that it was 'inconceivable that a composition so inept' should be the work of Dürer and that the *St Jerome* must be 'by another and inferior hand' (*Evening Standard*, 15 August 1996). According to him, it was simply too late to make amends for British neglect of German art with major acquisitions. The continued failure to appreciate and collect German paintings until very recently can be explained by reference to the formalist aesthetic and pro-French bias prevailing in Britain during the first half of the twentieth century.[8] In 1913, for example, the influential art critic Roger Fry (especially significant for his promotion of what he dubbed 'Post-Impressionism') described Dürer as heir to the craft tradition of German art, with its 'perverted technical virtuosity', and characterized his work as deficient 'from the point of view of pure design' (Fry, *Vision and Design*, pp.137, 139). Above all, neglect of German art can be attributed to the impact of two world wars and the legacy of anti-Nazi feeling.

A similar mixture of aesthetic and political factors can be adduced to account for the National Gallery's failure until 1984 to acquire a single work by the most important figure in French neo-classical painting, Jacques-Louis David (1748–1825) (Plate 50). David's supposedly cold and statue-like style did not appeal to

Plate 50 Jacques-Louis David, *Jacobus Blauw*, 1795, oil on canvas, 92 x 73 cm, National Gallery, London. Reproduced by courtesy of the Trustees, The National Gallery, London.

[7] For a discussion of Dürer as the paradigmatic German Renaissance artist, see the Introduction to Part 2 in Barker *et al.*, *The Changing Status of the Artist* (Book 2 of this series).

[8] That is to say, the standard by which all works of art were judged was that provided by late nineteenth- and early twentieth-century French painting, above all the work of Cézanne, which seemed to minimize the significance of subject-matter and moved towards a non-naturalistic, proto-abstract style. For an extract from Roger Fry's *Vision and Design*, see Fernie, *Art History and its Methods*, pp.157–67.

nineteenth-century British collectors, whose distaste owed much to the artist's association with the French Revolution and subsequently with Napoleon. Nor did matters greatly improve after 1900: the otherwise pro-French Fry thought David's figures looked like waxworks. As a result, there were no examples of his work available in British private collections for the National Gallery to purchase, so that special permission had to be given by the French authorities for the painting in question to be imported into Britain. Although it is not so unusual for the gallery to buy pictures from abroad (as it did in the case both of the Friedrich and the Cranach), it is easier to raise funds to purchase works that are already in Britain and thus to preserve them 'for the nation'. The Dürer had previously hung in an English country house, as did *St Michael Triumphant over the Devil* (Plate 51) by the relatively obscure Bartolomé Bermejo (active *c.*1460–98), purchased in 1995. Fifteenth-century Spanish painting is poorly represented outside Spain and, as such, this acquisition represents a significant departure from the standard canon of European art.

In the last few decades, prices on the art market have risen so much that even a work by a little-known artist like Bermejo can cost several million pounds (though the actual prices paid have seldom been specified in the National Gallery's annual reports). At the same time, the funding that it receives from the government to make acquisitions has remained frozen or even been reduced. Many recent purchases, including that of the Bermejo, would not have been possible had not J. Paul Getty, Jr made an endowment of £50 million in 1985. As with the Sainsbury Wing, this example shows how much the National Gallery now relies on financial support from the private sector. In the past, of course, the collection was often enriched by gifts and bequests from individual benefactors, a tradition continued today by Sir Denis Mahon, who has promised a number of important paintings to the gallery, including *Elijah fed by Ravens* (Plate 52) by Guercino (1591–1666). Seventeenth-century Bolognese painting, in which Guercino is a major figure, fell from favour in the mid-nineteenth century, at least partly as a result of its condemnation by the influential art critic John Ruskin, with the result that no examples were acquired by the gallery for over a hundred years.[9] The revival of interest was marked in 1997 with an exhibition of the Mahon Collection entitled *Discovering the Italian Baroque*. However, such paintings (described as 'weird, florid, ornamental, gaudy and silly' in an otherwise appreciative review by Adrian Searle in *The Guardian*, 4 March 1997) seem unlikely – at least at present – to regain their former popularity with the general public.

Throughout the late twentieth century the National Gallery has sought not only to 'plug the gaps' but also to build up its representation of the major figures of the European canon of painting.[10] Many acquisitions thus reinforce the existing strengths of the collection, as, for example, with the purchase of *Samson and Delilah* (Plate 53) by Peter Paul Rubens (1577–1640) in 1980. Speaking in 1996, Neil MacGregor claimed that in some ways it was easier to

[9] Until 1957, when it bought Guido Reni's *Adoration of the Shepherds* at the urging of Mahon, then one of the trustees; for the changing canonical status of seventeenth-century Italian painting and Mahon's role in its rediscovery, see the essay by Michael Kitson in *Discovering the Italian Baroque*.

[10] For its acquisitions of works by Poussin, see Case Study 1, p.40, in Perry and Cunningham, *Academies, Museums and Canons of Art* (Book 1 of this series).

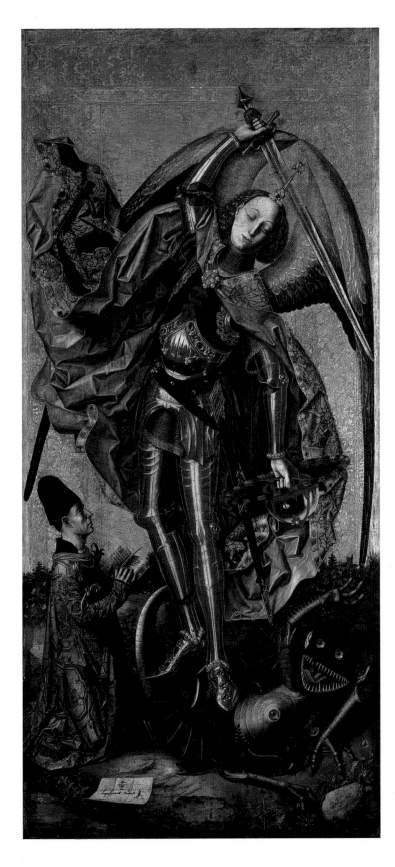

Plate 51 Bartolomé Bermejo, *St Michael Triumphant over the Devil with the Donor, Don Antonio Juan, c.*1486, oil and gold on wood, 180 x 82 cm, National Gallery, London. Reproduced by courtesy of the Trustees, The National Gallery, London.

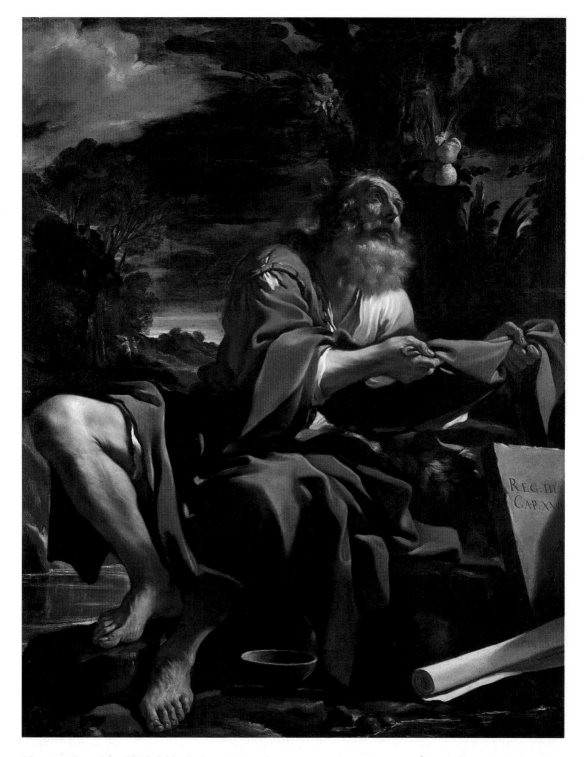

Plate 52 Guercino, *Elijah fed by Ravens*, 1620, oil on canvas, 195 x 157 cm, Mahon Collection, on long-term loan to the National Gallery, London. Reproduced by courtesy of the Trustees, The National Gallery, London.

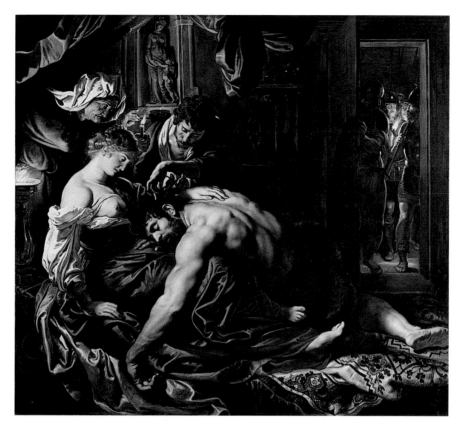

Plate 53 Peter Paul Rubens, *Samson and Delilah*, c.1609, oil on panel, 185 x 205 cm, National Gallery, London. Reproduced by courtesy of the Trustees, The National Gallery, London.

buy 'masterpieces' because they clearly belonged in a collection like the National Gallery 'where the overall standard is uniquely high'. By contrast, it was only possible to justify buying a modest picture by a lesser artist when it was 'absolutely supreme of its kind' (MacGregor, 'Personality of the year', p.25). As examples of the latter, he named *A Wall in Naples* (Plate 54) by Thomas Jones (1742–1803) and *The Friedrichsgracht, Berlin* (Plate 55) by Eduard Gaertner

Plate 54 Thomas Jones, *A Wall in Naples*, c.1782, oil on paper laid down on canvas, 11 x 16 cm, National Gallery, London. Reproduced by courtesy of the Trustees, The National Gallery, London.

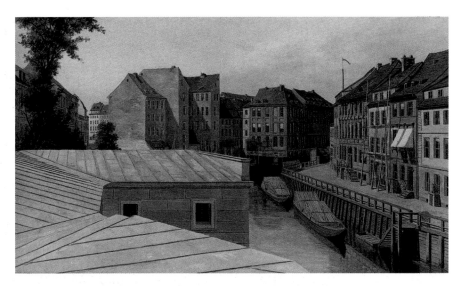

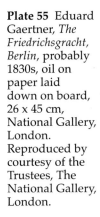

Plate 55 Eduard Gaertner, *The Friedrichsgracht, Berlin*, probably 1830s, oil on paper laid down on board, 26 x 45 cm, National Gallery, London. Reproduced by courtesy of the Trustees, The National Gallery, London.

(1801–77). Their acquisition, in 1993 and 1987 respectively, doubtless represents a certain modification of the existing canon but can hardly be said to reflect a major shift of taste. They can be aligned, on the one hand, with a long-standing European tradition of topographical painting and, on the other, with an equally familiar modernist preference for formal clarity and pictorial restraint. A further point to be noted here (for reasons that will become clear below) is that these pictures, one by a British and the other by a German artist, hang in the same room in the East Wing of the National Gallery.

Displaying the collection

> Over the last eight years, the London National Gallery has been sumptuously redecorated in a style more splendid than at any other time in its history.
>
> (*Palaces of Art*, p.64)

The programme of redecoration being carried out at the National Gallery since the mid-1980s has revealed the splendours of the main building which had been hidden from view for several decades. Partitions and false ceilings have been swept away, original gilding restored, walls rehung with damask, and drab carpets given way to gleaming wooden floors. The barrel-vaulted Duveen Room, for example, which had been divided up into low-ceilinged spaces for the display of small Dutch pictures, now provides an opulent setting for seventeenth-century Flemish painting (Plate 56). It has also acquired state-of-the-art lighting systems and air-conditioning. All this has been made possible by an anonymous benefactor, while similar alterations elsewhere in the building have also relied on private funding. Several galleries now bear the names of sponsors; for example, one housing seventeenth-century Parisian painting is called the Yves Saint Laurent Room (Plate 57). This space forms part of the northern extension, which was only built in the early 1970s but completely redesigned in the late 1990s; poorly proportioned, dark rooms with no distinguishing features have been replaced by spacious, well-lit galleries with a traditional architectural character (notice the marble trim and coved ceiling).

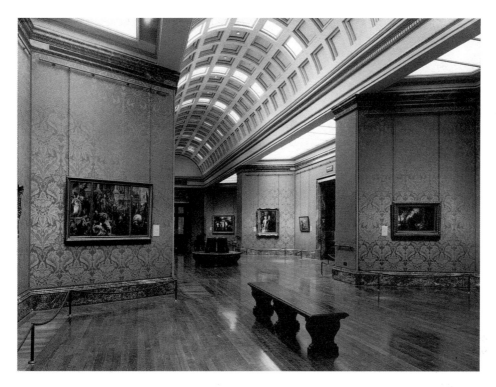

Plate 56 Duveen Room, National Gallery, London. Reproduced by courtesy of the Trustees, The National Gallery, London.

Plate 57 Yves Saint Laurent Room, National Gallery, London. Reproduced by courtesy of the Trustees, The National Gallery, London.

Broadly speaking, the redecoration of the National Gallery represents a return to tradition in the display of public art collections.[11] As the recent redesign of the North Wing suggests, this does not simply involve restoration of historic interiors to the way they used to be. Rather, it is predicated on a new concern for and appreciation of the ways in which the setting affects the experience of visitors. After World War II, imposing museum architecture tended to be covered up in the belief that it was not only a distraction but also had an off-putting élitist character. Thus, the typical wall-covering in galleries at the time was rough hessian rather than rich damask. Today, by contrast, the National Gallery seeks to rediscover its own past splendours in order to display canonical masterpieces in an appropriately grand manner and to enhance the visitors' enjoyment of them. This does not mean that democratizing art has become less of a priority (as we shall see), but rather that the gallery has developed a heightened self-consciousness about itself as an institution with a history, not just a collection of pictures. In this respect, this new historicizing approach to display can be aligned with the recent proliferation of writing about the history, theory and practice of museums (of which this book forms part).

One of the aspects of display to which such writing has drawn attention is the way that the arrangement of works of art (or indeed any object) in a museum necessarily involves imposing a certain order and meaning upon them. 'All museums are exercises in classification', Ludmilla Jordanova argues ('Objects of knowledge', p.23). In the case of the National Gallery, there has recently been a revision of the principles underlying the presentation of the collection. Since 1991 the traditional display of pictures by national school has been replaced by a new division into four broad historical periods. The Sainsbury Wing, for example, contains paintings from 1260 to 1510, with Italian, Netherlandish and German pictures hanging in close proximity (though usually still in separate spaces). When it opened, it could be seen to give greater prominence to the early northern schools, which had previously languished in the dreary North Wing, far from the main entrance. One critic even declared that, by challenging the old dominance of the Italian school, 'the new hang at the Sainsbury Wing radically rewrites the history of art' (Richard Dorment, *Daily Telegraph*, 25 June 1991). While the Italian paintings still dominate numerically and also dictate the architectural character of the Sainsbury Wing, the period-based display enables new connections to be made between schools. Thus, for example, *St Jerome* can be compared to contemporary painting from Italy which Dürer had just visited and the Flemish influence on Bermejo's *St Michael* can be effectively demonstrated.

As a result of these shifts, the National Gallery now offers a chronological route through the collection, starting with the Sainsbury Wing and ending in the East Wing. From a critical perspective, this could be seen as an authoritarian approach, forcing visitors to view every painting as a canonical example of the art of a particular period. In practice, however, they do not have to follow this curatorial classification of the collection but can move around the gallery as they please. Many are likely to make straight for their

[11] See Case Study 8 for other galleries that have adopted a similar approach to display. It should, however, be noted that unlike the National Gallery of Scotland (for example), the London gallery almost without exception displays paintings in a single row so as to avoid problems of visibility.

personal favourites (such as the perennially popular Impressionist paintings in the East Wing). According to MacGregor, people need a clear intellectual framework in order to make their own decisions; the gallery's job is 'to enable the public to move around the past with confidence. The confidence they need is that there are fixed points, individuals objects which have been identified, dated, established; and various routes through those fixed points which they can follow' (MacGregor, 'Scholarship and the public', p.193). For this reason, the policy is that paintings should stay in the same place as much as possible so that visitors know where to find them (the gallery thus assumes a preponderance of regular visitors, a point we shall return to below). Indeed, the Sainsbury Wing was built with certain spaces designed for specific works of art, assuming a fixed canon of value and leaving relatively little room for manoeuvre; for example, *The Baptism of Christ* by Piero della Francesca (*c.*1415/ 20–92) forms the centrepiece of a chapel-like gallery dedicated to this artist, commonly revered as one of the greatest masters of the fifteenth century (Plate 58). By contrast, paintings thought to be of lesser quality hang on the lower floor, many of them crammed together on screens. The public is thus offered a two-tiered view of the art of the past, separating off canonical art from more obscure works.[12]

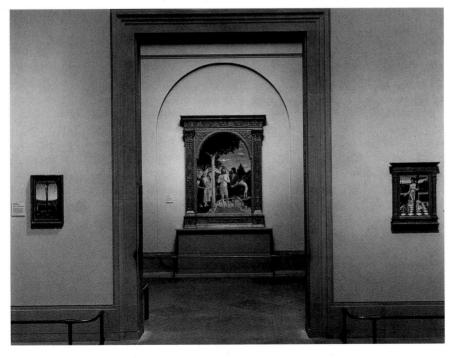

Plate 58 Piero della Francesca, *The Baptism of Christ* (*in situ*), National Gallery, London. Reproduced by courtesy of the Trustees, The National Gallery, London.

[12] However, this does at least mean that these works are not simply relegated to the storeroom. Moreover, the division is not absolutely hard and fast – there is some movement between floors. After *The Young Michelangelo* exhibition discussed below, for example, two small paintings by Domenico Ghirlandaio (to whom Michelangelo is believed to have been apprenticed) and his brother David which took a prominent role in the exhibition were not returned to their previous obscurity but hung in the Sainsbury Wing.

Compare Piero della Francesca's *Baptism of Christ* (Plate 59) with the *Symbolic Representation of the Crucifixion* (Plate 60) by Giovanni Mansueti (active 1484–died 1526/7), which hangs in the basement. What reasons can you discern for their respective positions? Consider the architecture of the Sainsbury Wing as well as the genre, subject-matter, composition, style and date of the paintings. (The purpose of this activity is to suggest that the display is not just determined by aesthetic quality but also reflects a conventionally canonical view of early Renaissance art.)

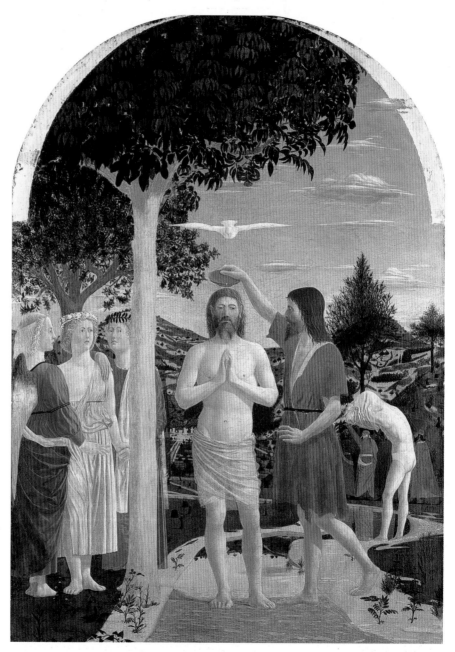

Plate 59 Piero della Francesca, *The Baptism of Christ*, 1450s, egg tempera on panel, 167 x 116 cm, National Gallery, London. Reproduced by courtesy of the Trustees, The National Gallery, London.

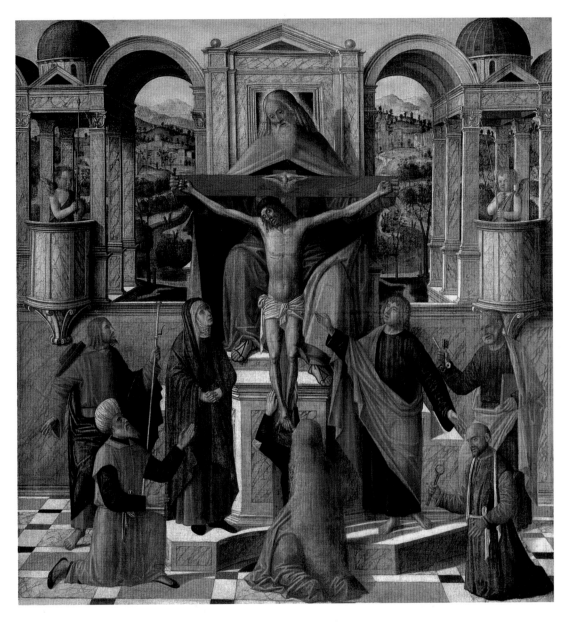

Plate 60 Giovanni Mansueti, *Symbolic Representation of the Crucifixion*, probably 1492, oil on canvas, 130 x 124 cm, National Gallery, London. Reproduced by courtesy of the Trustees, The National Gallery, London.

Discussion

Both paintings are altarpieces, with the figure of Christ forming a vertical at the centre of the composition. However, while Plate 59 is a relatively naturalistic scene, with three angels observing Christ being baptised almost as if they were casual onlookers, the latter is a symbolic representation with the crucified Christ on a much smaller scale than the figure of God the Father and various saints standing around in stiff, exaggerated attitudes of veneration. The *Baptism* is set in a tranquil-looking, distinctly Italian landscape whereas Mansueti's painting has an ornate architectural setting. Overall, the

former has a simple composition with few figures, balanced geometric structure and cool, pale tonality, all of which would be set off by the pale walls, darker surrounds and tranquil atmosphere of the Sainsbury Wing (which, as we saw, vaguely evokes a church, though not necessarily the cluttered reality of Renaissance church interiors). The *Crucifixion*, by contrast, has an elaborate composition, with a large cast of figures, and is brightly coloured in heavy reds and blues. You might see this picture as more 'old-fashioned', with its more obviously devotional character, even though it actually dates from some 40 years later. Thus, we can suggest both that the Sainsbury Wing was conceived with artists such as Piero in mind and that his work is essentially admired, on the one hand, for its 'forward-looking' naturalism and, on the other, for its formal qualities (which conform to a twentieth-century modernist aesthetic).

◆◆

Making the collection accessible

> great things ... have happened in the last ten years. [One of them] has been, I think, the expansion of the access to the collection through education, through touring pictures, through the micro-gallery, whatever.
>
> (Neil MacGregor, 'Personality of the year', p.23)

The opening of the Sainsbury Wing not only expanded the space for paintings but also provided new facilities for visitors, including a larger shop, a restaurant and a lecture theatre as well as the Micro Gallery. Sponsored by American Express, this provides a computer guide to the collection, allowing visitors to find out about individual pictures or to explore the history of European painting as it is represented in the gallery. It offers alternative modes of classification to those embodied in the actual display; visitors can, for example, adopt a thematic approach and seek out examples of particular types of painting or subject-matter. Other forms of electronic access to the collection are also being promoted, with its catalogue made available on CD-Rom and the possibility of 'virtual visits' on the Internet being explored. However, the fundamental aim of all these developments in technology is not to provide a substitute for seeing 'the real thing', but rather to encourage people to visit the gallery and to give them a clearer idea of what they want to look at and why. In this respect, perhaps the most significant innovation is the CD-Rom sound guide introduced in 1995, which allows visitors to listen to a commentary on almost any painting on the main floor as they stand in front of it, and is intended to encourage attentive looking as opposed to aimless wandering through the galleries. Opening hours have also been extended.

At the same time, like other major London-based arts institutions, the National Gallery also needs to justify its share of public subsidy by showing that it does not solely benefit residents of the capital and those in a position to visit it on a regular basis. Since the early 1990s it has developed a programme of touring either a pair of pictures or a single work around the country. In 1998, for example, the recently acquired painting of the racehorse *Whistlejacket* (Plate 61) by George Stubbs (1724–1806) was exhibited at the National Racing Museum at Newmarket and three other towns near racecourses. Its purchase was assisted by the Heritage Lottery Fund, which has 'made it clear that

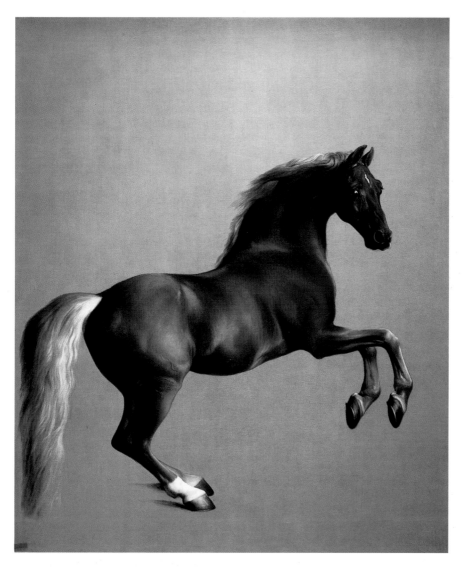

Plate 61
George Stubbs,
Whistlejacket, 1762,
oil on canvas,
292 x 246 cm,
National Gallery,
London.
Reproduced by
courtesy of the
Trustees, The
National Gallery,
London.

pictures bought with lottery money belong in a very special sense to the public' (*National Gallery Report*, 1996–97, p.5). The touring exhibition represents a way of making this public ownership more of a reality and, especially in this case, of reaching an audience beyond the usual gallery-going public. The high finish of Stubbs's painting, with its quasi-photographic effect, and its straightforward and obviously appealing subject-matter make it accessible to people who do not have much familiarity with art. Like Impressionist painting, *Whistlejacket* combines canonical status with popular appeal and thus helps the National Gallery to justify spending public money on art. It stated that 'the enthusiasm with which he [*sic*] has been everywhere received demonstrates beyond doubt that high art can indeed be enjoyed by a huge public' (*National Gallery Report*, 1997–98, p.6).

However, the National Gallery consciously avoids a *populist* approach, and argues that there is no necessary conflict between acccessibility and serious engagement with the paintings. On the contrary, 'scholarship is a way of making the collection accessible' (MacGregor, 'Scholarship and the public',

p.192).[13] In this respect, it remains faithful to the nineteenth-century ethos that looking at works of art should be instructive as well as enjoyable. In addition to the talks, study days and courses organized by the Education Department, the goal of informing the public is fostered through its exhibition programme. Before 1991 the gallery had only a single room set aside for exhibitions, and even now the limited size of the purpose-built exhibition space in the somewhat gloomy basement of the Sainsbury Wing means that it cannot present massive blockbuster shows (though it ventured on to this territory with *Degas: Beyond Impressionism*, staged in 1995). Instead, it has continued with its existing practice of holding exhibitions around paintings from the collection, notably with a series entitled *Making and Meaning*, sponsored by the oil company Esso.[14] On occasion, they have been devoted to more than one work by the same artist, as with *The Young Michelangelo* held in 1994–5, but as a rule they focus on a single painting such as *The Ambassadors* (Plate 62) by Hans Holbein (1497/8–1543), which was the subject of the final exhibition in this series in 1997–8.

In the first of these exhibitions, the gallery sought (among other things) to demonstrate that the two paintings in the collection believed to be by Michelangelo were indeed his work. Before it opened, an article claiming that *The Entombment* (Plate 63) had been painted by another artist entirely was published by Michael Daley, a independent polemicist concerned with authenticity in attribution and conservation. Although his arguments were rejected by most serious commentators, the controversy aroused public interest and no doubt helped account for attendance levels of well over 100,000. Thus, while the exhibition was highly academic in intent, it engaged popular fascination with the archetypal figure of the artist-genius.[15] Daley went on to allege that Holbein's *Ambassadors* had been harmed as a result of cleaning and restoration between 1993 and 1996. He argued that the artist would have wanted the brilliant colours revealed by the process to be toned down and also criticized the reconstruction of damaged areas of paint. Anticipating such accusations, the gallery had collaborated in the making of a television documentary about the restoration in which MacGregor stated: 'Our duty is to present to the public as much as we can of what the artist intended us to see. The first priority is to preserve pictures for the future, the second is to make the experience of looking at them as enjoyable as possible for the present'

[13] For an example of a critique of the National Gallery for failing to make its collection accessible, see Millard, 'On a higher plane', 94. Millard asserts that the 'hallowed atmosphere' of the Sainsbury Wing stifles the viewer, and deplores the failure to acknowledge the Eurocentrism of the collection, arguing that the information in the Micro Gallery is too much tied to traditional art-historical categories.

[14] Esso's sponsorship made it possible for the gallery not to charge for admission to the *Making and Meaning* series. Usually, however, there is an entry fee for exhibitions in the Sainsbury Wing. For a discussion of the issues arising from commercial sponsorship of exhibitions, see Case Study 5.

[15] On Michelangelo as the archetypal great artist, see the historical introduction to Barker *et al.*, *The Changing Status of the Artist*. One further point to be made is that (like Dürer's *St Jerome* and indeed also Rubens's *Samson and Delilah*, about which similar doubts have been raised) it is an early work and does not reveal the familiar characteristics of the artist's mature style – hence the claims made by Sewell and Daley that they are simply not good enough to be by so great an artist. While both seek to challenge the institutional power of the National Gallery, they do so in the name of values (the great artist, the masterpiece) that the gallery itself shares.

(*Restoring the Ambassadors*).[16] In the exhibition the newly restored *Ambassadors* was displayed together with other paintings by Holbein and his contemporaries as well as prints, books and other objects in order to illuminate its original artistic, political, intellectual and religious context (Plate 64).

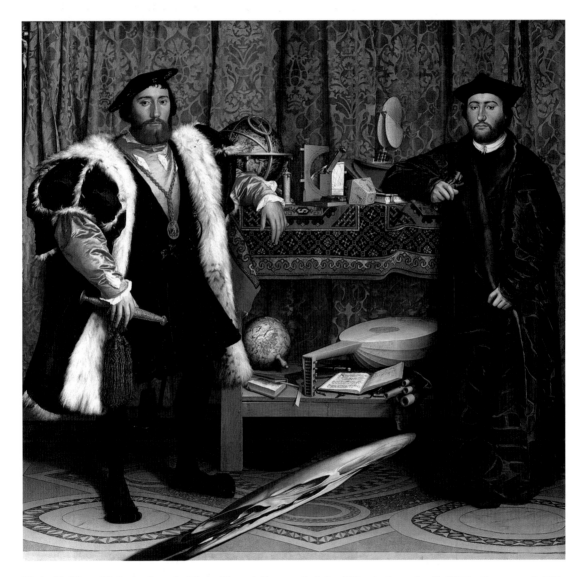

Plate 62 Hans Holbein, *Jean de Dinteville and Georges de Selve* ('*The Ambassadors*'), 1533, oil on panel, 207 x 210 cm, National Gallery, London. Reproduced by courtesy of the Trustees, The National Gallery, London.

[16] Critics of the gallery's restoration practices (and also of the restoration of Michelangelo's Sistine Chapel ceiling) argue that the result is to leave paintings looking too bright and flat, resembling the colour photographs with which a modern mass audience is more familiar. More fundamentally, however, both sides in the debate are united by their assumption that they have insight into the artist's intentions and that their approach is thus more authentic. For a discussion of the problems involved in the conservation of painting, see Phillips, *Exhibiting Authenticity*, pp.133–62. On the question of authenticity in the restoration of historic buildings, see Case Study 8.

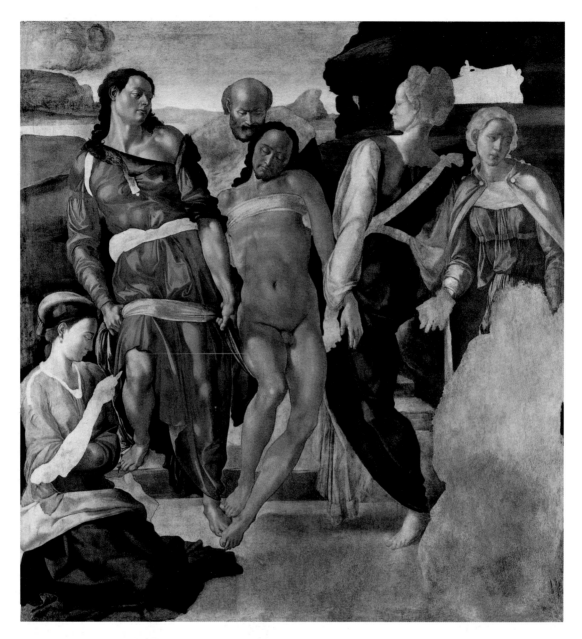

Plate 63 Michelangelo, *The Entombment*, *c*.1500–1, oil on panel, 162 x 150 cm, National Gallery, London. Reproduced by courtesy of the Trustees, The National Gallery, London.

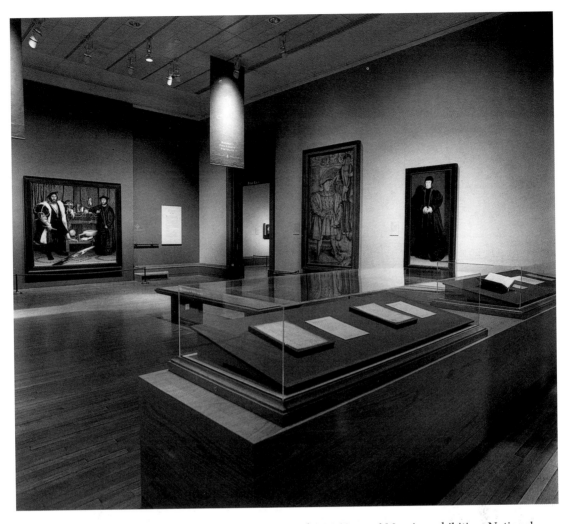

Plate 64 Hans Holbein, *The Ambassadors* on display in the *Making and Meaning* exhibition, National Gallery, London. Reproduced by courtesy of the Trustees, The National Gallery, London.

More generally, the significance of the *Making and Meaning* exhibitions is that they promote different ways of looking at famous pictures. Simply by being moved from the lavish surroundings of the main galleries to the plain exhibition space and by being displayed alongside a much wider range of visual material than usual, they can be seen as something other than the unique creation of an individual artist. Admittedly, this shift of emphasis is not taken very far: the artist remains the primary point of reference in interpretation. The material specificity that constitutes the authenticity of the paintings is also foregrounded in these exhibitions. The one devoted to Rubens's landscapes in 1996–7, for example, included a display showing how the panels on which he painted were made. From a critical perspective, this approach might be thought to promote the cult of the original and to reinforce the fetishism of the object. That is to say, while technical analysis seems to be strictly scientific and value-free, it actually contributes to the mystique of the 'real thing'. More positively, the gallery can be said to make art accessible by

addressing the fascination of many people with the making not just of paintings but of hand-crafted objects of all kinds.[17] At times, moreover, as in displaying large-scale colour photographs of paintings not available for loan alongside its own most treasured works, the National Gallery has shown itself willing to offend purists (for whom any such juxtaposition of high art and mass medium is anathema) for the sake of presenting the subject fully to the public. Thus, while it upholds the supreme value of the works in the collection, the gallery's role as their guardian is balanced against its commitment to making them accessible.

Conclusion

> Museums are like the family sepulchres of art. They testify to the neutralization of culture.
>
> (Theodor Adorno, 'Valéry Proust Museum', quoted in Sherman, 'Quatremère/Benjamin/Marx', p.123)

> Museums in their pervasiveness and inevitability monopolize certain fields of vision, and thus constitute a strategy of power linked to hegemonic capitalism.
>
> (Adorno, paraphrased in Sherman, 'Quatremère/Benjamin/Marx', p.123)

The above quotations summarize the two dominant strands in the contemporary critique of museums by art historians and cultural commentators. To conclude this case study, we shall consider their relevance to the National Gallery. To start with, can it be said that it serves as a kind of tomb for paintings which are in some sense 'dead'? The basis for this claim is that they have lost their original historical context and are therefore deprived of any meaningful, functional existence. As we have seen, a consciousness of the importance of the physical surroundings in which works of art would once have been seen underlies the design of the Sainsbury Wing. At the same time, the gallery seeks to show that it is not simply a mausoleum for dead art, but a context in its own right in which the paintings can assume new meanings and uses: for example, with its associate artist scheme which seeks to encourage contemporary artists to engage with the art of the past. Furthermore, as we have seen, the fabric of the building itself has undergone significant changes in recent years, though, it must be admitted, the account of art history that the gallery presents has remained pretty much the same (only minor modifications to the canon, greater concern with periodization in the display). However, individual pictures may be seen in a somewhat different light as a result of being moved around within the building (for example, from the main floor galleries to the exhibition space). Nor do they necessarily remain within the institution, but may be sent on loan to others elsewhere in Britain or indeed to other parts of the world. Although the most obvious modifications to a painting result from reattribution to a different artist or from cleaning and restoration, it can also (we might suggest) be reanimated by the personal response of individual visitors.

[17] The gallery draws heavily on the expertise of its scientific and conservation departments in another recent venture to increase access, the television series *Making Masterpieces* (shown on BBC2 in 1997).

Any such conception of unmediated communion with works of art based on visual perception is invalidated, however, if we accept the second of the two propositions outlined above. Underlying the notion that objects in a museum are lifeless is the further implication that the aesthetic experience does not constitute a legitimate use of them because it is restricted to a privileged few. Given that (so the argument goes) anyone without the cultural and social background needed to appreciate works of art is effectively excluded, the museum has a fundamentally ideological character.[18] In other words, the National Gallery stands accused of promoting an élitist culture as a universal value, thereby obscuring the relationship between art and market values. There is undoubtedly something in this; while the gallery may prefer to play down the monetary value of the works in the collection, the snob appeal of art in general and Old Master paintings in particular clearly helps to account for the support that it receives from corporate and individual sponsors (Sainsbury, Getty, etc.). But does this mean that the gallery's concern with acquiring and preserving paintings that it considers to be authentic masterpieces 'for the nation' should be viewed as just so much hypocrisy? As we have seen, it does not take for granted that the paintings in the collection will 'speak for themselves', but employs a wide variety of methods to make them accessible. Admittedly, its resolutely scholarly approach is bound to seem inadequate to advocates of a more populist position. But at least the fact that the gallery only contains representational works means that visitors can respond to the subject-matter and admire the illusionistic effects, avoiding the problems that can be involved in trying to make modern art accessible to a broad public.[19]

A defining feature of the National Gallery remains to be mentioned. Admission is free of charge, as it was when it was founded in 1824. Free access to museums has historically been the rule in Britain, though it is the exception elsewhere. One of the few great art collections outside Britain without an entry fee is the National Gallery of Art in Washington, DC, which, as its name suggests, is modelled on its London counterpart.[20] The tradition of free access derives from the idea that public collections are the property of the whole nation; its supporters emphasize that you cannot make people pay to see what they already own. Critics argue that, far from being a

[18] This position is especially associated with Pierre Bourdieu; see the previous case study, p.56. Bourdieu's research shows that it is precisely working-class people, who are the least frequent visitors to art museums and least equipped with the necessary 'cultural capital', who are most likely to associate them with tombs. This point has been confirmed by more recent research relating to museum visiting in Britain; see Merriman, 'Museum visiting as a cultural phenomenon', p.155.

[19] On these issues, see Case Study 7. The collection does in fact include some modern, anti-illusionistic works (a Cubist painting by Picasso of c.1914, for example). However, all post-1900 works have been placed on loan to the Tate Gallery (and vice versa) so as to avoid a confusing overlap between the two institutions.

[20] On the origins of the National Gallery of Art, founded in 1936, see Duncan, *Civilizing Rituals*, pp.95–101. Similarly located in the nation's capital (in the calm green setting of the Washington Mall), it too is essentially a collection of paintings but includes twentieth-century art as well. It also built a major extension in the late twentieth century, the East Building (designed by I.M. Pei and completed in 1978). Built in a modern idiom with much use of glass, it conformed to the then prevailing belief that traditional museum architecture was intimidating and was intended to provide a more accessible entrance. In this respect, it is a forerunner to Pei's Louvre pyramid.

democratic right, free admission to museums represents a subsidy to the middle classes who form the majority of visitors. In practice, the principle of free access has been undermined by the decline in government subsidy to museums and galleries since the 1980s, which has led many to introduce charges.[21] All the evidence indicates that this step leads to a reduction in the total number of visitors and also discourages regular visits by locals (as opposed to one-off visits by tourists). At present, the National Gallery estimates that it receives approaching five million visitors a year; this raises questions about just how many visitors the gallery can take without serious problems of overcrowding. In upholding the principle of free access, it remains part of the public life of the capital. In this respect, it can be argued that it is not incongruous or ironic (as critics of the gallery's undemocratic character would claim) that 'aesthetic refreshment' (in MacGregor's phrase) should be made available in a building overlooking Trafalgar Square, London's principal space for political demonstrations, but quite appropriate.

References

Amery, Colin (1991) *A Celebration of Art and Architecture: The National Gallery Sainsbury Wing*, London, National Gallery Publications.

Barker, Emma, Webb, Nick and Woods, Kim (1999) *The Changing Status of the Artist*, New Haven and London, Yale University Press.

Discovering the Italian Baroque (1997) exhibition catalogue, London, National Gallery Publications.

Duncan, Carol (1995) *Civilizing Rituals: Inside Public Art Museums*, London and New York, Routledge.

Farelly, E.M. (1987) 'Contumacy and contravention in architecture: the Venturi effect', *Architectural Review*, vol.181, June, pp.32–7.

Fernie, Eric (ed.) (1995) *Art History and its Methods: A Critical Anthology*, London, Phaidon.

Fry, Roger (1981) *Vision and Design*, Oxford University Press (first published 1920).

Jordanova, Ludmilla (1989) 'Objects of knowledge: a historical perspective on museums', in Peter Vergo (ed.) *The New Museology*, London, Reaktion Books, pp.22–40.

MacGregor, Neil (1991) 'Scholarship and the public', *Journal of the Royal Society of Arts*, vol.139, pp.191–4.

MacGregor, Neil (1996) 'Personality of the year' (interview conducted by Paul Josefowitz), *Apollo*, December, pp.23–32.

Merriman, Nick (1989) 'Museum visiting as a cultural phenomenon', in Peter Vergo (ed.) *The New Museology*, London, Reaktion Books, pp.149–71.

Millard, John (1991) 'On a higher plane', *Museums Journal*, October, pp.32–4.

[21] In July 1998 the Labour government promised to provide funds to allow museums to drop the practice of charging.

The National Gallery Report, annual publication, London, National Gallery Publications.

Palaces of Art: Art Galleries in Britain 1790–1990 (1991) exhibition catalogue (ed. Giles Waterfield), London, Dulwich Picture Gallery.

Perry, Gill and Cunningham, Colin (eds) (1999) *Academies, Museums and Canons of Art*, New Haven and London, Yale University Press.

Phillips, David (1997) *Exhibiting Authenticity*, Manchester University Press.

Restoring the Ambassadors (1996) a film for BBC2, directed by Patricia Wheatley.

Sherman, Daniel J. (1994) 'Quatremère/Benjamin/Marx: art museums, aura and commodity fetishism', in Daniel J. Sherman and Irit Rogoff (eds) *Museum/Culture: Histories, Discourses, Spectacles*, London and New York, Routledge, pp.123–43.

Venturi, Robert (1966) *Complexity and Contradiction in Architecture*, New York, Museum of Modern Art.

PART 2
EXHIBITION-ISM

Introduction

EMMA BARKER

Nowadays, when people visit an art museum or gallery within more or less easy access of their home, it is highly likely that they are doing so in order to see its current show. Almost every major art instititution takes for granted that it ought to have an ambitious and varied programme of exhibitions. The need for dedicated exhibition galleries has been one of the principal motivations for the building of museum extensions in recent decades. For much of the twentieth century, however, museums concentrated on their permanent collections rather than on staging exhibitions. They played a comparatively minor role in the previous great age of exhibitions, from the mid-nineteenth to the early twentieth centuries; exhibitions were then typically held in purpose-built structures or commercial premises. Having become a defining feature of contemporary museum culture, they now arguably dominate the public perception of art.

If (as we have seen) museum display involves the construction of art-historical narratives and offers an implicit evaluation of works of art, this holds even more true of the exhibition. As a strictly temporary phenomenon, it can reveal the new and unfamiliar, offering striking new interpretations and reassessments for consideration. With contemporary art, as Case Study 4 shows, exhibitions not only serve to bring recent work by living artists to critical attention but also help to shape the actual forms of current artistic practice. Exhibitions do not necessarily break new ground, however. The 'blockbuster' shows discussed in Case Study 5, for example, function primarily to present canonical masterpieces of western painting for the delectation of visitors. Both aspects of exhibition practice are addressed in Case Study 6, which discusses canon-confirming shows of African 'tribal art' as well as much more innovative exhibitions of different kinds of art from Africa.

The following case studies also consider different types of exhibition venue. They range from the informal, artist-run spaces discussed in Case Study 4 to ethnographic museums which, as Case Study 6 shows, have their own distinctive traditions of display very different to those of art museums. However, there is also a certain amount of overlap between the three case studies in this respect; all of them, for example, consider exhibitions shown at the Royal Academy in London. *Les Magiciens de la Terre* (Magicians of the Earth), an exhibition of contemporary art from around the world staged by the Pompidou Centre in 1989, is considered in both Case Studies 4 and 6 (Plates 65 and 66). This particular show was staged only in Paris, whereas most of the exhibitions discussed here toured to several venues. Together, these case

Plate 65 (Facing page) Grande Halle, La Villette, *Les Magiciens de la Terre* exhibition (detail of Plate 66).

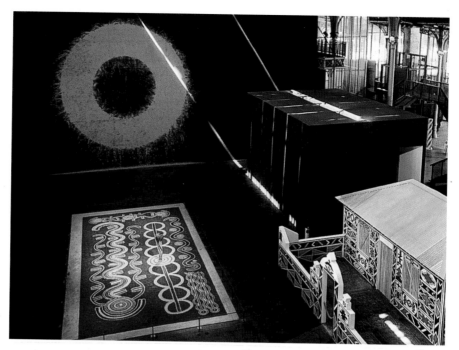

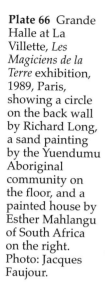

Plate 66 Grande Halle at La Villette, *Les Magiciens de la Terre* exhibition, 1989, Paris, showing a circle on the back wall by Richard Long, a sand painting by the Yuendumu Aboriginal community on the floor, and a painted house by Esther Mahlangu of South Africa on the right. Photo: Jacques Faujour.

studies provide an outline of an international exhibition circuit spanning North America and Western Europe but excluding most of the rest of the world.

Exhibitions can be seen as a popular form of display serving to democratize the art museum. This function is exemplified by the phenomenon of the large, well-attended blockbuster show, examples of which are discussed in all the case studies. To what extent such exhibitions fulfil the claims made for them and really do succeed in making high art accessible to a mass public is examined in Case Study 5. Case Study 4, by contrast, considers the tensions between the exhibition as a popular and didactic medium and its more specialist function as a means of filtering and evaluating artistic activity. It demonstrates that, even though it is usually only in commercial gallery shows that the works of art on display are actually for sale, exhibitions are inextricably bound up with the art market. Nor is this true only of contemporary art, as can be seen from references to dealers and collectors in Case Study 6. A further commercial aspect of exhibitions is the money raised by blockbusters from the sale of tickets and merchandising.

Relative to other museum displays, exhibitions are also more likely to occasion controversy. A museum is likely, for example, to be criticized for accepting sponsorship for an exhibition from a firm engaged in some dubious form of business (this issue is discussed in Case Study 5). Major exhibitions can also provide a focus for protests about the under-representation of work by women and black artists in mainstream museum culture (as Case Studies 4 and 6 both show). In the present climate of cultural debate, virtually any exhibition has the potential to displease or antagonize some observers, whether for a cautious and conservative take on its subject or for its innovative, even iconoclastic contents and approach. If the latter, it could be the case that the instititution putting on the exhibition is deliberately opting for sensationalism for the sake of publicity and increased attendance levels. Nevertheless, it can be argued, an element of debate is a defining feature of a lively and thoughtful 'culture of exhibitions'.

Exhibitions of contemporary art

SANDY NAIRNE

Introduction

This case study examines exhibitions of contemporary art. It looks at how the presentation and appreciation of contemporary art has changed in recent years, and charts the growth of a 'culture of exhibitions' centred on the display of new art. Art and exhibitions have evolved together, so that contemporary art cannot be fully understood independently of its presentation. Moreover, these developments have had a significant impact on the modern art museum. Regular changes in the main displays at the Tate Gallery in London or the Stedelijk Museum in Amsterdam, for example, mean that the collection itself has become a kind of exhibition, presenting a range of contemporary art: painting, sculpture, video or installation.

In this case study we examine the making of exhibitions and the different types of venue with particular reference to the contemporary art scene in London. We also consider exhibitions as part of an international system through which works of art are valued and exchanged. This is a complex matter because of the diversity of contemporary art and the diversity of the key players: artists, collectors, critics, curators, dealers and the public. The system is inextricably bound up with a market in which the price cannot be fixed by the usual forces of supply and demand, and in which there is considerable overlap between the interests of private individuals and those of public institutions. From these issues, we move to a discussion of major international exhibitions and of commercial and independent galleries in New York.

The growth in exhibitions

Before World War II the exhibition of contemporary artists' work in Britain and France was dominated by exhibiting societies. Whereas in Paris there was no longer a single state-sponsored Salon but many annual exhibitions staged by artists' societies, in London the members of the Royal Academy continued (as they still do today) to organize their summer exhibition.[1] By the end of of the nineteenth century an increasingly important role was already being played by private exhibitions in dealers' galleries such as the Grosvenor Gallery in London and Durand-Ruel in Paris, both of which were keen to promote new art. By contrast to Paris, independent initiatives of international significance in London, usually led by artists or critics, such as the two Post-Impressionist exhibitions (organized by Roger Fry) of 1910 and 1912 and the International Surrealist exhibition of 1936 were controversial and influential rarities.[2]

[1] For the early history of the Royal Academy, see Case Study 4 in Perry and Cunningham, *Academies, Museums and Canons of Art* (Book 1 of this series).

[2] For an account of one early artist-organized show in Paris, see Case Study 8 in Wood, *The Challenge of the Avant-Garde* (Book 4 of this series). On Roger Fry, see p.81 above.

A direct connection between the turn of the century and the present day is provided by large international exhibitions (such as the Venice Biennale, founded in 1895 and held every two years), which have grown indirectly from the Universal Exhibitions or World's Fairs (as they were called in the United States), inaugurated by the Great Exhibition of 1851 held in London.[3] In them, the ideology of modernity, manifested through displays of design and manufacture, went hand in hand with imperialist ambitions and racist assumptions; the Paris Universal Exhibition of 1889, for example, was notable not only for the building of the Eiffel Tower but also for its displays of African and other 'primitive' dwellings complete with living residents.[4] The imperial and national rivalries underlying all these exhibitions came to a peak at the one held in Paris in 1937, at which the German and Russian pavilions faced each in a stark confrontation of opposing ideologies (Plate 67).[5]

Such competitive origins have left traces in the art biennials of today, in which artists are frequently selected as representatives of their country and prizes are sometimes offered. By contrast, *documenta*, the single largest periodic exhibition of contemporary art, was created to be the antithesis of the propagandist exhibitions of the years before 1939. It was initiated in 1955 in the badly bomb-damaged German city of Kassel, against the backdrop of the trauma of the Second World War and the Nazis' attacks on modern art which they considered to be 'degenerate'[6] (Plates 68 and 69). Here was the renewal

Plate 67 View of the 1937 Paris International Exhibition, with the German and Soviet pavilions facing each other. Photo: Baranger / © Arch. Phot. Paris / CNMHS.

[3] For a discussion of the Great Exhibition, see Case Study 8 in Perry and Cunningham, *Academies, Museums and Canons of Art* (Book 1 of this series).

[4] On the 1889 exhibition as an expression of the ideology of modernity, see Case Study 7 in Wood, *The Challenge of the Avant-Garde* (Book 4 of this series).

[5] It was also for this exhibition that Picasso painted *Guernica* as a mural for the Spanish pavilion; see the Conclusion to Wood, *The Challenge of the Avant-Garde* (Book 4 of this series).

[6] On the 'Degenerate Art' exhibition held by the Nazis in Munich in 1937, see the Conclusion to Wood, *The Challenge of the Avant-Garde* (Book 4 of this series).

of a humanist ideal, playing down the more disruptive aspects of modernism and offering a vision of a universal, timeless contemporary art. It provided a model for the exhibition as a utopian and redemptive experience.

The key institution staging contemporary art exhibitions in post-war Britain was for many years the Arts Council of Great Britain, founded in 1945 with the aim of promoting the 'fine arts' and improving access to them. As well as building up a collection of contemporary art on which to draw for touring exhibitions,[7] the Arts Council also offered financial support to a burgeoning number of independent art galleries (such as the Museum of Modern Art in Oxford, founded in 1965, and the Ikon Gallery in Birmingham, founded in 1963). The national institutions such as the Tate Gallery (and the national museums of Wales and Scotland) and the larger regional institutions also started to collect and exhibit a wider range of contemporary art in the post-war period.[8] London acquired a

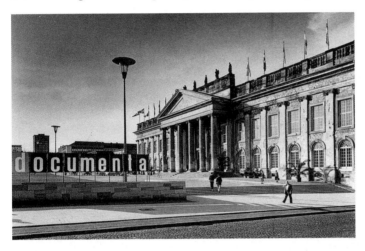

Plate 68 The Museum Fridericianum, Kassel, during the first *documenta*, 1955. The building, ruined during the Second World War, had been provisionally reconstructed. Photo: Günther Becker, courtesy of the *documenta* archive, Kassel.

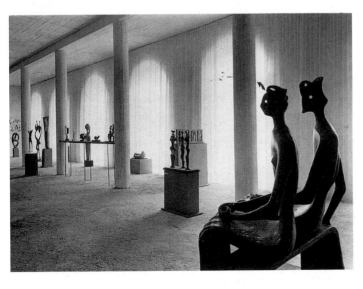

Plate 69 The Anglo-Saxon hall of fame at *documenta I*, with Henry Moore's *King and Queen* in the foreground, 1955. Photo: Günther Becker, courtesy of the *documenta* archive, Kassel.

[7] The Arts Council (now the Arts Council of England) continues today to be responsible for a regular programme of national touring exhibitions through the South Bank Centre.

[8] Founded in 1897 as the national gallery of British art, the Tate has collected modern foreign art since 1916. Like other national museums and art galleries, it is funded directly by central government rather than indirectly via the Arts Council. For recent developments at the Tate, see Case Study 7.

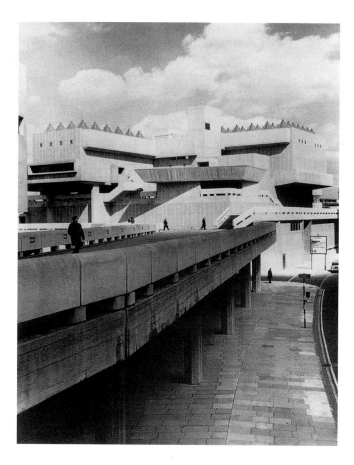

Plate 70
Hayward Gallery,
London. Photo:
Marcus Leith,
courtesy of The
Hayward Gallery,
SBC.

major new exhibition venue in 1968 with the opening of the Hayward Gallery
(managed by the Arts Council until 1987), leaving the Tate to develop its
own programme of exhibitions (Plate 70).

The mid-1960s marked a distinct shift in activity with several important
developments. The growth in affluence encouraged a steady increase in the
contemporary art market, which became closely associated with popular
music and fashion: dealers such as Robert Fraser in London (famously
pictured by the British artist Richard Hamilton at a point at which he and
Mick Jagger had just been arrested on drugs charges: Plate 71) or Leo Castelli
in New York were featured in the growing number of Sunday newspaper
colour supplements and weekly and monthly magazines. Artists were quick
to create 'alternative spaces', enjoying the flexibility and the informal, creative
resonances of the warehouse or workshop (this was also true in Turin, Toronto,
New York, Berlin and Vancouver). In London the new spirit of the avant-
garde was exemplified in independent initiatives such as the SIGNALS Gallery
founded by David Medalla and Paul Keeler in 1966, the short-lived Arts Lab
(a chaotic, experimental multi-media venue housed between 1967 and 1968
in London's Drury Lane: Plate 72) or even the constantly changing fortunes
of the Institute of Contemporary Arts (founded in 1947 to foster
experimentation in the arts, the ICA moved in 1967 into imposing new premises
on the Mall).

The emergence of new exhibition types and a wider range of venues over the
last century has been bound up with a shift away from clear-cut artistic
conventions or classifications (oil painting, watercolour, carved and modelled

sculpture) to far more complex and diverse forms of artistic practice. Once contemporary art had left the conventional frame and plinth behind, it was inevitable that it should depend more directly on the whole context in which it is seen. From the later 1960s public art museums and galleries themselves started to change, becoming more animated spaces, offering a wider range of exhibitions and developing educational programmes, which would eventually influence the form of the exhibitions themselves. These developments have allowed for greater interaction between art and audience, encouraging visitors to develop their own responses rather than simply being passive spectators. For some observers, however, they involve the danger of emphasizing spectacle over contemplation, activity over engagement.

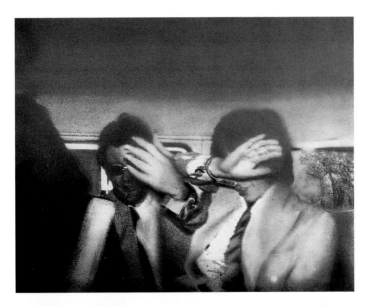

Plate 71 Richard Hamilton, *Swingeing London 67*, 1968–9, colour print on paper, 50 x 71 cm, Tate Gallery, London. © Richard Hamilton. 1999 All Rights Reserved, DACS.

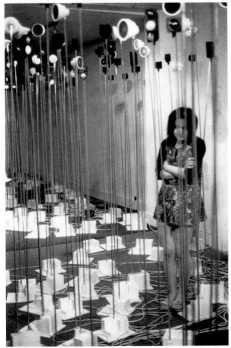

Plate 72 Installation by Takis, October 1967, Arts Lab, London. Photo: courtesy of Biddy Peppin. © ADAGP, Paris and DACS, London 1999.

The culture of exhibitions

By the 1980s Britain could be said to have produced a 'culture' of contemporary exhibitions, something that Paris had had from the turn of the century and New York achieved in the 1950s. The range of exhibitions is fed by the much increased numbers of students at the many art colleges in the London area and by the growth of non-specialist audiences for whom looking at contemporary art is one of a range of available leisure activities. In any week now in London, *Time Out* magazine will list at least 90 venues showing contemporary art, ranging from major institutions with their own collections like the Tate Gallery and the National Portrait Gallery, to the larger venues dedicated to temporary loan exhibitions like the Hayward and the Barbican, to the medium-scale public galleries like the Whitechapel, the Serpentine, the ICA, the South London Gallery and Camden Arts Centre, to the many commercial galleries featuring exhibitions of new work and the temporary and less formal spaces often organized by artists themselves.[9]

The exhibitions staged at these venues vary in format. Most obviously, there is the standard one-person show, which might be a display of an artist's recent work in one of the smaller galleries or, in the case of an established figure, a major retrospective at the Tate or the Hayward Gallery. Group exhibitions may have a unifying theme or, at the other extreme, be selected by open submission (as with the annual Whitechapel Open). There are constant performances, events, discussions, a number of serious journals debating the full range of contemporary art (such as *Art Monthly*, founded in 1976, and *Frieze*, founded in 1991), regular coverage in the broadsheet newspapers, a diverse array of art prizes (from the Tate-administered Turner Prize set up in 1984, which is offered for the best contribution by a British artist under 50, to the Jerwood Painting Prize, which was established by a private charitable foundation in 1993), and a regular London Contemporary Art Fair. Although the contemporary art scene is centred on London, there are also important exhibitions and events in cities such as Glasgow, Manchester, Birmingham, Newcastle and Brighton.

This activity needs to be understood in terms of the relationship between exhibitions and their various purposes, audiences and locations. The commercial gallery dealer selects artists with sales in mind and chooses a building with clients in mind, the question of where they will travel being critical. Artists running their own space will show work by other artists who are sympathetic to their own philosophy and choose a space on the basis of lowest cost and proximity to where they work, with studio and exhibiting space often overlapping. In London the smartest commercial galleries have traditionally been located in the West End and Mayfair, an area associated with the sale of luxury goods. Galleries can now be found in the East End and Hackney, which have become the areas where artists live and work since they are most likely to provide low-rental space for their use. A converted paint factory in St John's Wood (a smart residential area) houses the Saatchi Gallery (opened in 1985), which shows changing groups of works from Charles Saatchi's very extensive collection of contemporary art. This highly influential gallery creates the impression of being not so much a private enterprise as a public institution.

[9] The Whitechapel Art Gallery and the South London Gallery originated in attempts by late nineteenth-century philanthropists to bring art to the working classes: on these developments, see Case Study 8 in Perry and Cunningham, *Academies, Museums and Canons of Art* (Book 1 of this series). A descriptive list of exhibition venues in London and beyond can be found in Buck, *Moving Targets*.

The emergence of a 'culture of exhibitions' corresponds to the post-war commercial and popular success of British artists. From an older generation including David Hockney and Anthony Caro, to a middle generation of artists such as Richard Deacon and Antony Gormley, to a younger generation whose best-known representatives are Damien Hirst and Rachel Whiteread, their works are exhibited and purchased around the world.[10] This is often with the official support of the British Council, which plays an influential role through the exhibitions that it organizes abroad.[11] Foreign promotion often starts through the initiative of private galleries, hoping to sell the work on to collectors or museums, or through the influence of collectors themselves. While any artist's success will owe a great deal to the efforts of dealers and curators working on their behalf, the publicity around the current generation of yBas (young British artists) makes much of the fact that they helped launch their own careers through their skills of self-promotion.[12]

The same generation received its most high-profile London showing to date with *Sensation* at the Royal Academy of Arts in the autumn of 1997, the contents of which were selected entirely from the collection of Charles Saatchi (Plates 73 and 74). The artists' apparent obsession with death and sex (and above all the inclusion of Marcus Harvey's painting based on a notorious

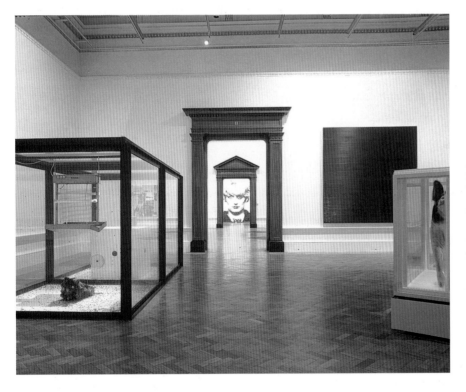

Plate 73
Installation view of *Sensation* exhibition, looking towards Marcus Harvey's *Myra* and with Damien Hirst's *A Thousand Years* on the left, 1997, Royal Academy of Arts, London. Photo: courtesy of The Saatchi Gallery, London/ © Stephen White.

[10] Both Deacon and Gormley belong to the generation dubbed 'New British Sculpture' when it came to prominence in the early 1980s. Deacon won the Turner Prize in 1987 and Gormley in 1994. Whiteread and Hirst also won the Turner Prize in 1993 and 1995 respectively.

[11] The British Council (founded in 1934) is the official body responsible for promoting cultural exchange between the United Kingdom and other countries.

[12] In particular, the exhibition *Freeze*, organized by Damien Hirst and others in a disused Port of London Authority building in 1988, 'occupies a mythical place in the written and verbal history of recent British art' (*Sensation*, p.13).

Plate 74 Damien Hirst, *Isolated Elements Swimming in the Same Direction for the Purpose of Understanding*, 1991, MDF, melamine, wood, steel, glass, perspex cases, fish, 5% formaldehyde solution, 183 x 274 x 31 cm, The Saatchi Gallery, London. Photo: Anthony Oliver, London.

photograph of the child murderer Myra Hindley) aroused a storm of controversy, resulting in the resignation of four Royal Academicians. Was this a genuine example of the avant-garde subverting conventional values, or did it simply demonstrate that exhibiting the yBas in this 'establishment' venue was a stage-managed piece of theatre to gain media attention? What is certain is that *Sensation* received large numbers of visitors (285,737 in all) and provided a much needed boost to the Royal Academy's finances.[13]

While the yBas seem a distinctly British phenomenon, the way that some of them have been singled out for special attention can be understood in terms of the priorities of the international art system. The commercial network is reinforced through the most influential art magazines (such as the New York-based *Artforum*), which contain reviews of exhibitions around the world, filtering artistic activity to concentrate on artists whose work is perceived to fit an 'international' agenda. The exchange of ideas has been speeded up by the development of cheap air-fares since the 1960s, which facilitates travel by the artists, curators, dealers and critics who take part in this 'international' system (on the limits of this internationalism, see below).

[13] On the financial implications of successful exhibitions for the institutions that stage them, see the following case study.

On the basis of the above account, what specific features and underlying factors can you suggest to explain the expanded showing of contemporary art in London?

Discussion

A solid institutional infrastructure for the arts is provided by the art colleges, public galleries and organizations such as the Arts Council and the British Council. At the same time, there seems to be plenty of flexibility as, for example, in the emergence of informal, artist-run spaces and the way that Charles Saatchi's private collection has been able to take on a quasi-public role. The emergence of a 'culture of exhibitions' is connected more widely to the growth of a service economy geared to the provision of leisure facilities and, we may assume, to a higher demand from buyers (though Saatchi is obviously an unrepresentative case). The artists' works and achievements have also generated these developments, although some commentators believe that they may simply be catering to a commercially inspired demand for novelty and a media-oriented taste for notoriety and sensationalism.

◆◆

Looking at the contemporary situation in historical perspective, the most crucial long-term development is the loss of a single system of judgement, such as the Royal Academy broadly provided for much of the nineteenth century. Today, by contrast, the position of artists, their status and reputation have to be charted through a more diverse set of institutions. Therefore, the increasing number of exhibition venues, both private and public, despite differing aims and approaches, are the common ground through which collectors, critics and curators are connected. Exhibitions are central to the economic and social system within which all art is produced, distributed and debated.

Exhibitions and value

We will now examine in more detail the role of exhibitions in establishing the value of contemporary art. Works of art can be considered to have two kinds of value: use value and exchange value, a distinction formulated by Karl Marx with reference to the nature of the commodity in the capitalist system. Art differs from literature or film in having no immediate mass market (where the price is fixed for identical and mass-produced versions of the same object or experience); it depends very largely on the production of individual, unique works. While some works of art circulate widely in the form of reproductions, these cost far less and serve a primarily decorative function. Arguably, one of the most important functions of contemporary art is that it may promote critical or even moral discussion among its viewers. This *use*, while dependent on the nature of the art itself, is linked both to commentary, to professional critical assessments, and to the setting in which it is seen, to the institutional context of gallery and museum exhibitions in which works of art are not simply displayed but also accompanied by programmes of talks and seminars.

Turning to the question of exchange value, the price of a work might appear to offer some indicator of how it is valued artistically as well as commercially, functioning as a means by which works of art could be compared or measured, like the pricing of goods or stocks and shares. For in most economic systems the price of a commodity is influenced by the supply (how much is being made?), by the demand (how much do people want it?) as well as by the quality of its construction and materials (is it made by hand or by a machine, of gold or paper?). Art, however, is a product in which there is always a very limited supply because it is made not just by an individual but by a particular artist. Compared to the association of the work of art with a specific name, the actual qualities of the object itself may not count for very much (as people sceptical about the claims made for contemporary art often complain). Demand thus becomes the crucial factor in the art market, with huge prices being paid for the work of a few sought-after artists while the great majority find it difficult to make a living at all.

In the usual run of things, the works that fetch the highest prices on the art market are also the ones that are most exhibited. A German critic and publisher, Willi Bongard, published a newsletter for collectors of contemporary art, *Art Aktuell* (1970–85), which exemplified these two ideas of value by issuing a list of the top 100 artists organized around a 'price/ point' ratio. For many years the American artist Jasper Johns (Plate 75) came top of the list, later displaced by the German artist Joseph Beuys and then by

Plate 75 Jasper Johns, *Flag*, 1954–5, encaustic, oil and collage on fabric mounted on plywood, 107 x 154 cm, Museum of Modern Art, New York. Gift of Philip Johnson in honour of Alfred H. Barr, Jr. Photo: © 1998 Museum of Modern Art, New York. © Jasper Johns, DACS, London and Vaga, New York, 1999.

Andy Warhol (Plate 76). The points were awarded by surveying the most important galleries and museums around the world and ascribing to each artist a certain number of points: more for an exhibition at the Museum of Modern Art, New York, for example, and less for a German *Kunsthalle*. The points were a way of calculating reputation or standing in the art world, using exhibitions as the dominant guide to the use value of an artist and the price of work as an indicator of the exchange value. Bongard's commentary alongside the price / point ratio then indicated whether a particular artist was over- or under-priced and represented bad or good value for the potential buyer.

Bongard's newsletter demonstrated the degree to which the contemporary art world, despite its fragmentation, could act as a single system of influence, with curators and dealers both making a contribution. But such a 'system' is not without its resistors; for example, feminist groups such as the Guerrilla Girls protest about the neglect of women artists (Plate 77). In 1992 a demonstration was staged outside the Guggenheim Museum's 'downtown' branch in New York's SoHo (lower Manhattan) when it opened with an exhibition featuring six artists, five men and only one woman (the veteran French-American sculptor Louise Bourgeois). Artists' groups engaging with a range of political and social issues (including gender and race) and/or working with deprived urban communities (such as Group Material, set up

Plate 76 Andy Warhol, *Marilyn Monroe* (diptych), 1962, silkscreen ink on synthetic polymer paint on canvas, 200 x 140 cm each panel, Tate Gallery, London. © The Andy Warhol Foundation for the Visual Arts, Inc. / ARS, New York and DACS, London 1999.

THE ADVANTAGES OF BEING A WOMAN ARTIST:

- •Working without the pressures of success.
- •Not having to be in shows with men.
- •Having an escape from the art world in your 4 free-lance jobs.
- •Knowing your career might pick up after you are eighty.
- •Being reassured that whatever kind of art you make it will be labeled feminine.
- •Not being stuck in a tenured teaching position.
- •Seeing your ideas live on in the work of others.
- •Having the opportunity to choose between career and motherhood.
- •Not having to choke on those big cigars or paint in Italian suits.
- •Having more time to work after your mate dumps you for someone younger.
- •Being included in revised versions of art history.
- •Not having to undergo the embarrassment of being called a genius.
- •Getting your picture in art magazines wearing a gorilla suit.

A PUBLIC SERVICE MESSAGE FROM **GUERRILLA GIRLS** CONSCIENCE OF THE ARTWORLD
532 LaGUARDIA PLACE, #237• NY,NY 10012

Plate 77
Guerrilla Girls,
*The Advantages of
Being a Woman
Artist*, postcard
insert with
*Confessions of the
Guerrilla Girls*,
HarperPerennial,
1995. © 1995
Guerrilla Girls.

in New York's Lower East Side in 1980, and Loraine Leeson's and Peter Dunn's Docklands Community Poster Project[14]) have consistently rejected the international exhibition system, shunning the continuous interchange between money and art, and with it the place of curators as gatekeepers and controllers. These artists assert through their work a different kind of use value for art.

A similar resistance has been expressed by artists who seek to adapt spaces in ways which fit their needs, and to control where possible the uses of their art, whether by taking greater control over the museum or by forming galleries of their own. The development of this radical tradition in the 1960s was followed, however, by the resurgence of more traditional forms of painting and sculpture evident in the Royal Academy's 1981 exhibition *A New Spirit in Painting*, encouraging the re-emergence of a powerful and authorial curatorship in the 1980s.[15] While traditional forms (valued for the authentic touch of the specific artist) can readily be promoted by dealers and auctioneers, the booming art market of the 1980s also meant that types of work originally made outside the mainstream (installation and video, for example) were gradually accommodated within the commercial sector (see

[14] Also set up in 1980, this project aimed to express local people's concerns about the redevelopment of the Docklands in London. See Case Study 7.

[15] This exhibition, in which only male artists were represented, sought to demonstrate the continued vitality of painting as an art form. It was curated by Norman Rosenthal, exhibitions secretary of the Academy, Christos Joachimides, a Berlin-based curator, and Nicholas Serota, director of the Whitechapel who became director of the Tate in 1988. The return to more traditional ideas of curating in the 1980s was also reflected in various museum building projects (such as the Art Institute of Chicago) where the radical, open and participative ideas evident in earlier buildings such as the Pompidou Centre were discarded in favour of hierarchy, order and classicism.

below). The flexibility of the system, its proven capacity to absorb and commodify the marginal, makes the very idea of 'alternative' practices and spaces somewhat problematic today.

The role for exhibitions (and their curatorship) at the centre of the economics of the art world is also in tension with their educational role as a vehicle for communication with the public. A case in point is the always controversial annual exhibition that the Tate Gallery devotes to the four artists short-listed for the Turner Prize, which was set up 'to encourage excellence in contemporary British art and its presentation and to foster a greater public interest in it' (quoted in Button, *The Turner Prize*, p.30). Although a small professional jury decide on the winner, many people come to the Tate (over 80,000 visitors in 1997) to make their own evaluation. The media 'hype' which surrounds the Turner Prize as an event (brought about largely because of the attachment of network television coverage through Channel 4's sponsorship) amplifies both aspects of the prize: the increasing public interest in contemporary art (although some attack this is as superficial) and the enhanced status and commercial value given to a few artists (although for some its very controversy and public prominence devalue it as a serious exhibition). The fact that the 1997 short-list consisted of four women artists indicates that the mainstream part of the art system has responded to the criticisms and challenges that have been directed against it over the last few decades (Plates 78 and 79).[16]

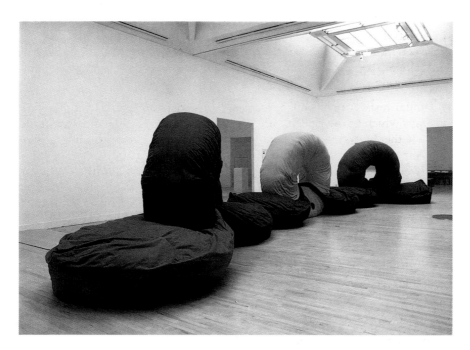

Plate 78 Angela Bulloch, *Superstructure with Satellites*, 1997, at the exhibition of short-listed artists for the Turner Prize, Tate Gallery, London. Photo: courtesy of the Tate Gallery, London.

[16] However, some critics saw this as a political decision, taken in order to ensure a female winner after an all male short-list in the previous year. The most recent (1998) short-list consisted of three women and one man. The latter, Chris Ofili, won.

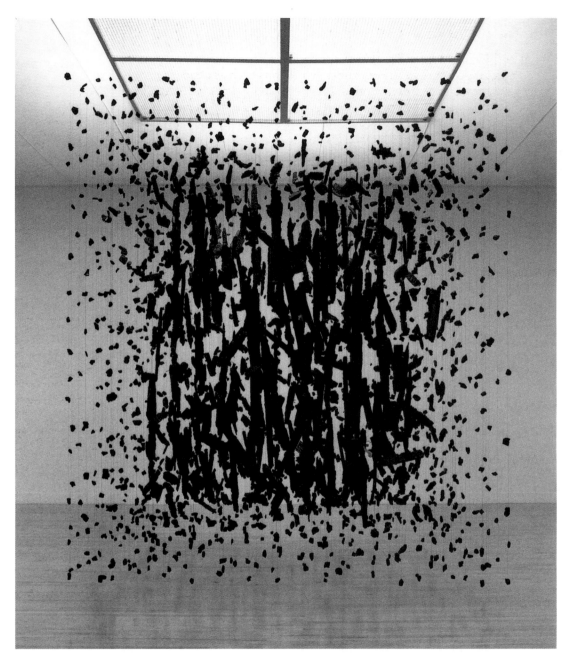

Plate 79 Cornelia Parker, *Mass (Colder Darker Matter)*, 1997, charcoal retrieved from a US church struck by lightning, 366 x 320 x 320 cm, at the exhibition of short-listed artists for the Turner Prize, Tate Gallery, London. Photo: Marcus Leith/Mark Heathcote. Courtesy of the artist and the Frith Street Gallery, London.

International exhibitions and biennials

Several of the large international biennials such as those in Venice, Sydney or São Paulo, together with international exhibitions such as *documenta*, can have a very considerable impact on an artist's reputation and influence. As noted above, biennials sometimes involve a competition, although the art world provides its own constantly competitive system in the market without having much need for official prize-giving. While its internationalism is largely confined to Europe, North America, and some Pacific rim countries such as Japan and Australia, the boundaries are not entirely fixed, and exhibitions are one of the most visible determinants for cultural change.

For many years, for example, the Venice Biennale seemed like a fixed and selective map of the world, with the national pavilions in which each country exhibits its own artists set in the rather formal layout of the public gardens. Indeed it took Australia more than a decade to gain agreement and a site for its own pavilion. In 1993, however, the number of countries represented in the Venice Biennale was expanded, albeit in the form of add-on East and South African, Irish and Turkish delegations (that is, without their own pavilions). The choice of 'cultural nomadism' as the Biennale theme reinforced the decision of a small number of countries to select artists for their pavilions whose hybrid citizen status put into question definitions based on a nationalistic agenda. Even before the Biennale theme was proposed, Austria's curator acknowledged its complex cultural identity by selecting three artists, only one of whom was Austrian.

International exhibitions usually function to suppress the power relations between countries and cultures. However, a crucial strand of recent curatorial debate has highlighted the issue of cultural identity and national stereotyping. The assumptions of most western museums and galleries that the artists of Europe and North America are those of the greatest interest have been challenged over several years. Those artists who have crossed borders themselves, critics and magazines broadening debate, and the struggles for recognition and self-determination by the indigenous artists of the American and Australian continents have all been influential. A few high-profile international exhibitions have also questioned cultural assumptions, drawing attention to art which might differ in materials or forms of construction. *Les Magiciens de la Terre* (Paris, 1989), for example, controversially endeavoured to realign the prevailing internationalism by mixing 50 artists from the 'centre' with 50 from 'peripheral' positions (Plate 66). As Gavin Jantjes put it soon after:

> *Les Magiciens de la Terre* laid open the Western/Eurocentric consciousness like a surgeon dissecting his own body without an anaesthetic. It revealed that the Eurocentric gaze has distinct and daunting problems when fixed upon the 'cultural other', its achievements and methodologies. To imply that equality in the cultural arena is signified by everyone exhibiting together is both illusionistic and historically unsound.
>
> (Quoted in Ferguson *et al.*, 'Mapping international exhibitions', p.37)[17]

The influential role played by powerful curators who select the themes and artists for international exhibitions tends to work against any decisive break with established practice. They bring their own agenda to the task and may

[17] For further discussion of this exhibition, see Case Study 6.

be unconcerned with what others see as the pressing issues in contemporary art; the director of the 1995 Venice Biennale, Jean Clair (director of the Picasso Museum in Paris), was widely criticized for focusing on figurative art, for example. The *documenta* series has reflected the obsessions of successive directors but still addresses current artistic issues. The most prestigious of the international exhibitions, it is now visited by around a million people during its 100 days, an audience which comes from across Europe and beyond. Critical reactions (and images) are taken back across the world to join debates about contemporary art in colleges, galleries and museums elsewhere.

Catherine David, selected as the director for *documenta x* in 1997 (and the first woman to direct one of the series), sought to modify the way the exhibition was created and understood. Instead of using the large and magnificent park at the lower end of Kassel, the exhibition was moved up to the railway station, the symbolic site of transition and immigration (Plate 80). The conventional museum spaces were still used, but the works on display within them had a strong bias towards installation, film and video as opposed to painting or sculpture. An Internet site, a set of public discussions, and the catalogue also made up a significant part of the whole exhibition. A relatively high proportion of non-western artists were included, but the real priority seemed to be to reject the notion of art as spectacle and give space to a programme of self-consciously critical art. In so doing, it looked back to the *documentas* of 1968 and 1972 (prior to what were perceived as more market-influenced exhibitions in 1982 and 1986). An exhibition series which had originally been formed with a vision of social reconstruction was reversed to emphasize social fragmentation and contemporary social crisis. The modernist belief that art might supply a unifying philosophical purpose no longer applied.

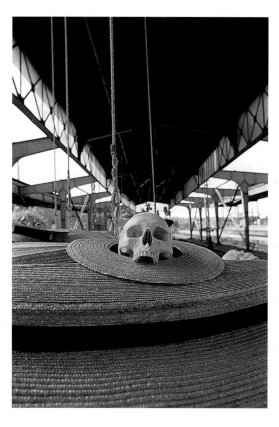

Plate 80 Sculpture and performance by TUNGA at Kassel Railway Station, *documenta x*, 1997. Photo: Richard Kasiewicz, courtesy of the *documenta* archive, Kassel.

Determined that *documenta x* should not be (as she termed it) a bazaar, a market place, David refused to give the press an advance list of the artists to be selected for the 1997 exhibition. It has become a matter of immense importance to dealers that 'their' artists should be included in *documenta*, with the result that enormous, if indirect, pressures are brought to bear on the directors. To counter this and to avoid simply selecting from existing works already seen elsewhere, David invited artists to make new works for the exhibition, many of them for specific sites in the town. This strategy was clearly informed by the practices of the late 1960s and early 1970s, when artists themselves sought to resist the formality of the museum and the demands of dealers by creating site-specific works and other types of art that went beyond what was conventionally exhibitable. At the same time, it followed a more recent trend on the part of curators towards positioning works beyond the walls of the gallery or museum.

In this respect, it is revealing that *documenta x* coincided with the third of the ten-yearly Sculpture Projects in the German city of Münster (first staged in 1977). It is one of a number of international exhibitions and commissioning organizations such as Artangel (UK based, founded 1985) which specifically address the question of location. In *Chambres d'amis* (Ghent, 1986), for example, artists created works in the homes of local people and then invited visitors to view them (Plate 81). Others involve artists being invited to make or hang their works in offices or public buildings. Does a new form of art emerge (different from the tradition of modern public sculptures permanently sited) and does a passing audience actually get interested in the works? Or is it only the more specialist and dedicated visitor who is prepared to spend time searching the city and following maps and directions into unlikely corners? The Münster Sculpture Projects started with the intention of providing the city with some large-scale public art works for its parks and open spaces. What has evolved is a more open-ended set of commissions in which some artists have moved from the physical (exemplified in 1977 by Claes Oldenburg's giant snooker balls) to the conceptual (exemplified by Janet Cardiff's work for 1997, an audio tour of the town led by the artist).

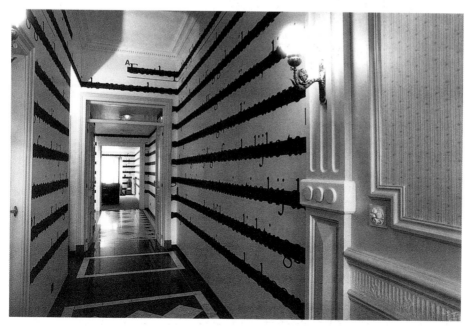

Plate 81
Installation by Joseph Kosuth, *Chambres d'amis*, 1986, Ghent. Photo: Dirk Pauwels/ Stedelijk Museum voor Actuele Kunst, Ghent. © ARS, New York and DACS, London 1999.

If (as was noted above) a tension between different kinds of viewer is inherent in contemporary art exhibitions, this holds especially true of international exhibitions. Extensive media pressures, and more complicated sites, mean that they present the danger of artists being parachuted into a city without being able to form any relationship with an audience beyond the art world visitors from elsewhere who are already informed of their concerns. (What, for example, did locals make of *documenta x*, which, for some commentators at least, was characterized by a high-minded intellectualism and disregard for visual pleasure?) A different approach was offered in Antwerp in 1993, when curator Iwona Blazwick sought to involve various local organizations in the formation of the exhibition *In Taking a Normal Situation...* Some of what was exhibited was developed out of discussions between local groups and the visiting artists. While most works were presented within a conventional museum context, the gallery had become the surrounding frame for a new and wider process of interaction. The international and the local were combined.

Commercial and independent galleries

While the selections of the major international exhibitions, the public museums and art galleries are hugely influential in themselves, the international system depends on the relation between these choices and those of the commercial dealers. Specialist commercial galleries are found in most of the capital cities of western countries, but New York has remained the most powerful centre of the contemporary market. The art market boom of the 1980s had its greatest impact here, though dealers elsewhere also benefited. This section looks more closely at how smaller exhibition venues, both those run by dealers and those run by artists, form a part of the system, with particular reference to the rise and fall of the downtown area of SoHo as the centre of New York's contemporary art scene.

Commercial art galleries, although they stock some works in the manner of a shop, are mostly given over to the promotion of exhibitions which replicate those found in the public sector. Over the past 50 years dealers have moved away from plush, domestic-type spaces with carpets, wallpapers and comfortable chairs (associated with the sale of luxury goods) to adopt and adapt a cooler aesthetic, first from the museum and then from the warehouses favoured by artists for their own non-commercial (independent) exhibition spaces. This has allowed artists the chance to exhibit larger paintings and sculptures, and more recently installations, video and new media works, within commercial as well as more public contexts – and with some success. While installations may not sell so readily to collectors, the associated drawings, studies and images can generally be framed and made available in some form. For the artist, this situation creates a tension between a desire to limit the power of the market system and the need to sell works to finance the making of new projects.

The new wave of dealers prominent in the 1980s was represented for many by the figure of Mary Boone, who opened a gallery in SoHo in 1977. Her list of artists typified the 'return to painting' of the late 1970s and 1980s; it included such American 'stars' as David Salle, Eric Fischl and (until he moved to the

Pace Gallery in 1984) Julian Schnabel. She also exhibited German artists represented by the Cologne dealer Michael Werner (then her partner), such as Georg Baselitz and Marcus Lupertz, both of whom (with Schnabel) were featured in *A New Spirit in Painting* at the Royal Academy. What characterized her operation was a more determined and high-profile manner, a cool and sharp style of presentation using architect-designed conversions (Plate 82), appearances in magazines and close links with well-known collectors. As Boone said at the time, she would have liked to be considered as a 'curator' herself, as if sharing the responsibilities of a museum for preserving and documenting outstanding paintings and sculptures (Nairne, *State of the Art*, p.67).

Mary Boone's slick operation was very different from the first commercial galleries to open in SoHo, originally a light manufacturing and distribution area into which artists started to move, often living and working in co-operatively owned buildings. When the Paula Cooper Gallery opened in SoHo in 1968, one of the first to do so, the location helped to define its 'alternative', artist-oriented character. Cooper states: 'I wanted to get away from the old pattern of uptown galleries … I didn't want to be bothered with all the social trimmings, things that often counted more than the art itself' (quoted in Greenberg *et al.*, *Thinking about Exhibitions*, p.354). The advantage of SoHo, for both artists and the galleries that followed them, was the availability of large spaces at low rents. Over the following years, SoHo mapped the new

Plate 82 Mary Boone Gallery, West Broadway, New York, 1993, building renovation and design by Richard Gluckman, with Bill Jensen's *Terre Verte*, *Dim* and *Untitled* on display. Photo: Dorothy Zeidman.

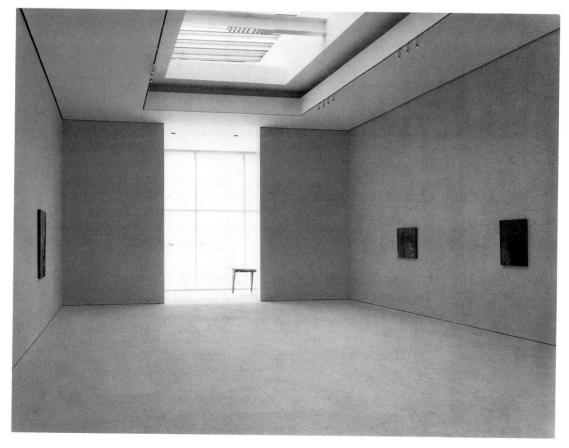

and expanding intersection in the contemporary art world between commerce (high prices and high profile), public interest (Saturday crowds and organized tours to galleries and studios) and fashion (designer stores and café-bars).

With commercial development and rising rentals in the 1980s, SoHo lost some of its influence to the East Village (a poorer neighbourhood), which briefly became an alternative spectacle, a kind of art fair in the city featuring both commercial and independent spaces (the latter including Group Material). By 1986 it was almost overcome by the self-conscious media attention which followed this new area. Writing in the *New Yorker* magazine, Calvin Tomkins described how originally:

> a sense of neighbourhood solidarity and the frustration of not being able to have their work shown in SoHo galleries combined to produce the new art scene. Artists began turning their storefront studios into part-time galleries, several of which became full-time spaces. Since the time lag between innovation and discovery in today's art world now stands at approximately thirty-seven seconds, the public quickly appeared in droves.
>
> (Quoted in Greenberg *et al.*, *Thinking about Exhibitions*, p.402)

In the wake of the new clubbing scene, with such 'stars' as Jean-Michel Basquiat (also represented for a time by Mary Boone) and Keith Haring (who, like Basquiat, first emerged as a graffiti artist), a productive overlap emerged between new spaces as galleries and new clubs and bars. Art, music and performance shifted between each, leaving the museum increasingly isolated and less relevant. But with the burn-out of the East Village scene, the untimely death of several artists (including Basquiat and Haring), and the voracious commercialization of SoHo itself (now engulfed with tourists and shoppers), many commercial galleries headed either back uptown, like Mary Boone, or, like Paula Cooper, over to Chelsea on the West Side of Manhattan to extend the garage aesthetic a stage further. By the mid-1990s, while contemporary art maintained a strong presence in SoHo (enhanced by the Guggenheim's downtown branch housed in a former garment factory), Chelsea had become the prime area in which to open a gallery.[18]

How have notions of appropriate gallery space and location changed in recent decades? What precedents, parallels and possibilities do developments in New York suggest for the contemporary art scene in London?

Discussion

The fundamental move has been away from conventional museum-style galleries to the informality of the warehouse or industrial space, the use of which was first pioneered by artists before being taken up by commercial galleries and then also by public museums. These developments are bound up with a parallel shift away from smart shopping zones to less developed areas where spaces are available at low rents. Here, the shift from uptown

[18] The SoHo Guggenheim forms part of a more general trend for museums housed in disused industrial/commercial buildings; see Case Study 1. More broadly, the development and 'gentrification' of SoHo and the East Village, with working-class residents losing their homes, raise questions about the implications of using art for urban regeneration; see Case Study 7.

Manhattan to SoHo can be said to find an echo in the expansion of the London art scene from the West End to the East End. In both cities we can discern an overlap between the public and private sectors; both the Mary Boone Gallery of the 1980s and the Saatchi Gallery (as a converted factory typical of the new-style gallery space) can be said to represent the fusion of individual enterprise and curatorial aspirations. We may also wonder whether the now thriving London art scene might not produce (allowing for its more scattered geography) some of the problems that arose with the success of SoHo, with rising rents forcing out artists and dealers from the areas which they had colonized.

◆◆◆

The point at issue here is that commercial and independent spaces serve different functions from the public gallery. The huge number of exhibitions that they present, together with reviews in the specialist art magazines, provide an essential backdrop to the purchases made by key collectors and museum collections. The independent and commercial galleries, however different their purposes, share an ability to concentrate on specific strands of art and to express distinct identities and identifications (whether by gender, race, class, location or political interest). The complexities of this culture cannot easily be expressed through mass appeal museums (now with audience figures in the millions each year). While developments both in and out of the museum have created new opportunities for interaction between art and a broad public, the smaller institutions continue to play a crucial role in the contemporary art scene.

Conclusion

Future exhibitions of contemporary art will continue to reflect the demands of artists, curators and, increasingly, visitors. Following the circular pattern of institutional changes, artists will seek new alternatives, and the commercial and museum sectors will almost certainly follow in adopting some of the aesthetic and manner of such new 'spaces'. In the future some of these spaces will be virtual rather than real, making further use of the Internet and also digital television as well as the low-tech solutions of using magazines and specially created publications as locations for an exhibition. However, the demand for an event, for spectacle – evident in the Turner Prize or the *Sensation* exhibition – gives greater force to exhibitions presented in real space and time. In the same way as the mass production of art postcards has driven larger numbers of people to travel to view the original, so the virtual exhibition may simply reinforce interest in the real.

Despite the changing nature of international exhibitions and the growth of new kinds of exhibition project outside the museum, the dynamic of contemporary art will continue to depend on the independent spaces. Although the large exhibitions and the museums have the greatest effect in forming new critical audiences for the future (where most people will find a use value in contemporary art), it is through the independent spaces that the loop between the museums, the international exhibitions and the commercial galleries can be influenced and market values altered. And if there is an

increasing variety of venues, it will strengthen the position of the exhibition as the central focus for selection and evaluation in the delicate ecology of the art world.

Who chooses and with what assumptions and values in mind? The role of the curator, the dealer and the artist *as selector* is central to our examination of exhibitions of contemporary art. We have seen how the number and range of exhibitions has grown, the growing tension between spectacle and contemplation and between public and private sectors, and how within a 'culture of exhibitions' the inter-relation between different parts of the contemporary art world provides a 'system' within which different kinds of value are expressed. Equally, we have seen how the types of spaces and buildings have been influenced by artists' own initiatives, by their resistance to the commercial and museum sectors. A central phenomenon has been the relationship between *new* art and *new* institutions: each has helped to change the other.

References

Buck, Louisa (1997) *Moving Targets: A User's Guide to British Art Now*, London, Tate Gallery Publishing.

Button, Virginia (1997) *The Turner Prize*, London, Tate Gallery Publishing.

Ferguson, Bruce W., Greenberg, Reesa and Nairne, Sandy (1997) 'Mapping international exhibitions', *Art and Design*, vol.12, no.1–2, January–February (special issue: 'Curating: the contemporary art museum and beyond', ed. Anna Harding), pp.30–7.

Greenberg, Reesa, Ferguson, Bruce W. and Nairne, Sandy (eds) (1996) *Thinking about Exhibitions*, London and New York, Routledge.

Nairne, Sandy (1987) *State of the Art: Ideas and Images in the 1980s*, London, Chatto and Windus in collaboration with Channel 4 Television Co. Ltd.

Perry, Gill and Cunningham, Colin (eds) (1999) *Academies, Museums and Canons of Art*, New Haven and London, Yale University Press.

Sensation: Young British Artists from the Saatchi Collection (1997) exhibition catalogue (contributors Brooks Adams, Lisa Jardine, Martin Maloney, Norman Rosenthal and Richard Shone), London, Royal Academy of Arts with Thames and Hudson.

Wood, Paul (ed.) (1999) *The Challenge of the Avant-Garde*, New Haven and London, Yale University Press.

Exhibiting the canon: the blockbuster show

EMMA BARKER

Introduction

What, exactly, is a blockbuster show? One commentator has defined it as 'a large-scale loan exhibition which people who normally don't go to museums will stand in line for hours to see' (Elsen, 'Assessing the pros and cons', p.24). Another rejects this straightforward view of blockbusters as a popular phenomenon and emphasizes the calculation and even manipulation required to stage one. From this perspective, it is 'an exhibition that aims for maximum coverage and maximum publicity to attract maximum attendance' (West, 'The devaluation of "cultural capital"', p.75). Although large-scale, highly publicized art exhibitions drawing several hundred thousand visitors took place as early as the mid-nineteenth century,[1] the blockbuster show as we know it is a relatively recent phenomenon. This label covers different types of exhibition, but we will mostly be concerned in this case study with blockbuster shows of western art (primarily painting). These are usually shown in two or three venues on both sides of the Atlantic. The host institution has almost always received commercial sponsorship to help cover the costs of staging the exhibition. There will also nowadays be advance booking facilities so as to make it possible to see the show without queuing. However, not every exhibition with these characteristics attracts enough visitors (a minimum of 250,000, I would suggest) to count as a blockbuster.

From the positive perspective represented by the first of the above quotations, the blockbuster exhibition is a scholarly endeavour which serves to educate and entertain the public, bringing prestige and profit to the host institution in the process. However, as the second quotation suggests, much commentary adopts a more negative position. In this case study it will be our aim to explore and assess the blockbuster phenomenon, taking account of the various objections that have been raised. One of these is the claim that such exhibitions have a very narrow range of subjects and, contrary to the justifications put forward for staging them, seldom shed any new light on the history of art. Another criticism we will need to consider is that the seeming democratization of art brought about by the blockbuster is an illusion; the huge crowds attending the exhibition and the hype surrounding it mean that visitors are unable to have any meaningful or even enjoyable contact with the works of art. Above all, we must address concern about the commercialization that the blockbuster represents; this includes the commodification of art through the sale of souvenirs and the possibility that the demands of the business sponsor may take precedence over the host institution's own goals. First, however, we need to examine how and why the blockbuster exhibition has become such a significant phenomenon.

[1] On an early example, the Manchester Art Treasures exhibition of 1857, see Case Study 8 in Perry and Cunningham, *Academies, Museums and Canons of Art* (Book 1 of this series).

Background and rationale

The history of the blockbuster exhibition in Britain can be traced back to *The Treasures of Tutankhamun*, which was mounted by the British Museum in 1972 (Plate 83). More modest in scale than many (there were a total of 50 exhibits), it was visited by 1,694,117 people over nine months. The blockbusters of today cannot rival this figure, though this can be partly explained by the fact that few of them are open for more than three months at any one venue. In any case, *The Treasures of Tutankhamun* was obviously not the kind of art exhibition defined above, but rather falls into the category of blockbuster that the art critic Robert Hughes has called 'Gold of the Gorgonzolas'. Usually displays of the artefacts of an ancient civilization or of the highlights of an important foreign collection, these exhibitions offer a fascinating spectacle of wealth, power, mystery and exoticism.[2] As such, their visitors include people who would not be interested in art solely for its formal qualities or historical significance. They may also function as a form of cultural diplomacy, serving as vehicles for national self-promotion; the initiative for the Tutankhamun exhibition, for example, came from Egypt.

A version of the Tutankhamun exhibition was subsequently seen in several American cities, ending up at the Metropolitan Museum of Art in New York. Thomas Hoving, the Metropolitan's director from 1967 to 1977, is widely credited with having conceived the blockbuster format. At a time when American art museums were under attack for being élitist, he introduced a new element of populism by mounting a series of spectacular exhibitions. In the process, the civic responsibility of the museum – its mission to reach and educate as large a public as possible – was reinvented in terms of boosting attendance figures through such temporary attractions. Other museums, in America and elsewhere, soon followed suit. Since the 1970s the death of the blockbuster has often been predicted. Factors cited include rising insurance costs and the anxieties of conservators about potential damage to works of art as a result of their being loaned to other museums for exhibition purposes.

Plate 83 Crowds queuing for *The Treasures of Tutankhamun* exhibition, 1972, British Museum, London.

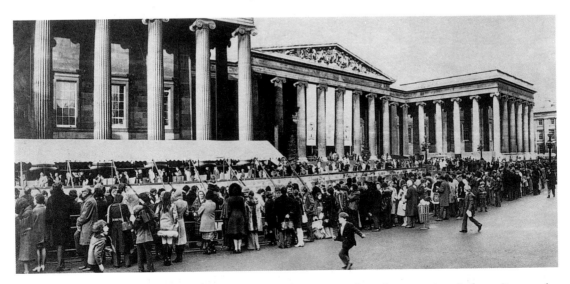

2 In this respect these exhibitions raise questions about the perception of other cultures and their artefacts; on these issues, see King, *Views of Difference* (Book 5 of this series).

Nevertheless, the blockbuster continues to flourish, with the difference that the 'treasures of …' type of show now tends to be overshadowed by exhibitions devoted to famous artists. Among the highest attendances at a single venue in recent years were for *Henri Matisse* (Museum of Modern Art, New York, 1992–3) and *Claude Monet, 1840–1926* (Art Institute of Chicago, 1995), both of which attracted nearly a million visitors.

The perpetuation of the blockbuster format suggests that such exhibitions have become indispensable to the institutions that stage them. By making charges of élitism less credible, they not only enhance the museum's public image but also thereby safeguard its financial viability. As Anne Higonnet has put it, 'blockbusters help to maintain an extremely fragile equation in which attendance equals popularity equals "cultural democracy" equals ideological justification equals funding' ('Whither the Barnes?', p.64). This statement refers specifically to the United States, where the majority of museums now rely for funding on a variety of sources, including government agencies and corporations. Significantly, the blockbuster developed precisely during the period in which American museums ceased to be substantially supported by relatively small numbers of wealthy private donors.[3] As well as ingratiating a museum with its funders, blockbusters also represent an important source of income in their own right through the sale of tickets and souvenirs. While it is usually only major institutions in big cities that can attract the necessary crowds, the blockbuster format has also provided a solution to the financial problems of the Barnes Foundation, a small private museum just outside Philadelphia. Highlights of its remarkable collection of late nineteenth- and early twentieth-century French painting, including works by Seurat (Plate 84), Cézanne, Matisse and Picasso, were shown in Paris, Tokyo and elsewhere from 1993 onwards, attracting substantial audiences.

By comparison to the United States, Britain has much less of a tradition of blockbuster exhibitions. The main reason is that, as in Europe as a whole, the running costs of public museums and galleries have been covered by the government, so they have not had the same incentive to make money out of exhibitions. The exception that proves the rule is the Royal Academy, which receives no public subsidy and so does need to mount regular blockbusters; the most highly attended exhibition of paintings in Britain to date was *Monet in the '90s* at the Academy, which attracted 658,289 visitors in 1990.[4] However, changing circumstances have pushed other institutions in the same direction. As the real value of their grants steadily declined from the mid-1980s, British museums and galleries had to start raising much more of their income themselves. At the same time, they were given greater control over their own affairs and assured that they could keep any money they earned instead of having to hand it over to the government. In general terms, these developments can be seen as a partial privatization of public institutions in line with the political agenda of the Conservative government at the time. The crucial point, whether we approve or disapprove of the commercialization of museums, is that they were given no choice but to follow this course.

[3] For an example of the earlier type of museum funding, see the discussion of the Museum of Modern Art, New York in Case Study 1.

[4] The record for the 1990 Monet show will almost certainly have been broken by the time you read this by *Monet in the 20th Century*, held in early 1999. Both exhibitions were also shown at the Museum of Fine Arts, Boston. The Academy began holding loan exhibitions (in addition to the annual summer exhibition of work submitted by living artists) in 1870.

Plate 84 Georges Seurat, *Models (Les Poseuses)*, 1886–8, oil on canvas, 200 x 250 cm, Barnes Collection, Philadelphia. Photo: © 1995 The Barnes Foundation. Reproduced with the permission of The Barnes Foundation TM, All Rights Reserved.

Mechanics of a blockbuster

Any major exhibition, whether or not it attains blockbuster status, takes several years to plan and typically involves several museums in collaboration. Whether or not a particular institution succeeds in becoming one of the venues for the show depends on what it can offer in exchange. Blockbusters of Impressionist and Post-Impressionist painting, for example, will be seen in at least one city in the United States and probably also in Paris because these are the places that have major collections of this kind of art. The highly centralized and (at least until recently) well-funded French museum system has helped to ensure that major exhibitions come to Paris. In other words, a situation very different to the one in which American museums operate produces much the same effects, so far as staging blockbusters is concerned. By contrast, very few of these exhibitions come to London. With no collection of its own to use as a bargaining tool, the Royal Academy was lucky to be offered a showing of *Monet in the '90s* by its American organizers. And if the National Gallery had not owned one of the largest versions of Cézanne's treatment of the *Bathers* theme (Plate 85), the 1996 exhibition of this artist's work might well not have been shown at the Tate Gallery as well as the Philadelphia Museum of Art and the Grand Palais (the main exhibition space in Paris).

Plate 85 Paul Cézanne, *Bathers* (*Les Grandes Baigneuses*), *c.*1900–6, oil on canvas, 127 x 196 cm, National Gallery, London. Reproduced by courtesy of the Trustees, The National Gallery, London.

The costs involved in mounting such exhibitions are so high that museums, notably in Britain and America, have become increasingly reliant on commercial sponsorship. Sponsors often foot the bill for the publicity campaign which ensures that a potential blockbuster attracts sufficient visitors. In return, they will receive various perks such as special private views at which to entertain their friends and clients. Above all, sponsorship offers good publicity, allowing companies to appear responsible and public-spirited. Significantly, it is especially attractive to those whose business activities give them a particularly dubious reputation. One of the biggest and also most controversial sources of arts sponsorship in the United States, for example, is the tobacco company Philip Morris, which has supported many blockbusters including *Origins of Impressionism* at the Metropolitan in 1994 and the Museum of Modern Art's *Picasso and Portraiture* in 1996.[5] Major sponsors also include oil companies such as Esso (also known as Exxon) and Mobil, both of which have funded exhibitions in Britain.[6] From the perspective

[5] Both these exhibitions were subsequently seen at the Grand Palais in Paris. Philip Morris also sponsored the *'Primitivism' in Twentieth Century Art* exhibition at MOMA (on which, see the following case study).

[6] For an example of exhibition sponsorship by Esso, see Case Study 3. The sponsorship of Mobil has been attacked by the artist Hans Haacke, whose work *Metromobilitan* drew a connection between its involvement in South Africa under apartheid and its sponsorship of *The Treasures of Ancient Nigeria* exhibition at the Metropolitan Museum of Art in 1985; see the following case study (on the exhibition) and Wallis, 'The art of big business'.

of museums, the principal negative aspect of this form of funding is probably the time and energy involved in wooing potential sponsors and in establishing a continuing relationship with particular firms (in other words, persuading them to fund further exhibitions). At any one time, the number of companies prepared to sponsor major exhibitions is quite small, and in the 1990s museums have found it increasingly difficult to obtain sponsorship money.

Because their main concern is publicity for themselves rather than art *per se*, such companies are primarily interested in sponsoring a potential blockbuster. It can prove difficult, if not impossible, to find a sponsor for exhibitions devoted to less mainstream art that are unlikely to achieve very high attendance levels. The Royal Academy's 1996 exhibition of the work of Frederic Leighton (1830–96), for example, almost did not take place for this reason.[7] This raises fears that commercial sponsorship can become a form of censorship, restricting museums to staging only the most popular kinds of exhibition, though, as Victoria Alexander argues, 'museums clearly have some discretion in balancing … mass-appeal shows with smaller, more academic shows' which do not have external funding (*Museums and Money*, p.74). Sponsorship can also be criticized on the grounds that it effectively reduces works of art to the level of advertising. The sponsor's prefaces in exhibition catalogues can certainly give this impression, though the likelihood is that hardly anyone reads them. One, for example, declares that Picasso 'gained his reputation by breaking down barriers and setting new standards for others to follow. Internationally, he was a leader and a visionary … we pursue the same principles of leadership, vision and originality of thought for the benefit of our clients' (*Picasso: Sculptor/Painter*, p.9). Others avoid this kind of rhetoric and merely stress the sponsor's commitment to making art accessible to the public.

The commercial character of the blockbuster is not, however, confined to the relationship with the sponsor. Marketing plays a crucial role in ensuring the success of the exhibition. The host institution will, of course, take out advertisements, but no less important in encouraging people to visit the show are assurances in the media that it is a not-to-be-missed, once-in-a-lifetime experience. The Tate, for example, mounted a massive campaign to publicize the 1996 Cézanne exhibition; newspaper articles with headlines such as 'Hot ticket for culture vultures' and 'Cézanne hits town' appeared well in advance of the opening. Such publicity emphasizes not only the art-historical significance of the exhibition but also the sheer scale of the whole enterprise; the number of exhibits, the attendance figures (actual or anticipated), the costs involved and the resulting profits all figure prominently in blockbuster 'hype'. While the exhibition itself constitutes a product to be 'sold', it will also be accompanied by a wide range of merchandising on sale in the museum shop: T-shirts, fridge magnets, scarves, etc. Critics often complain that museum merchandising degrades and distracts attention from the works of art. While snobbery doubtless plays a part in these objections, this does not necessarily let museum merchandising off the hook (particularly when the quality of the picture reproduction is so bad that the result is a travesty of the original).

[7] For a discussion of the Leighton exhibition, see Case Study 5 in Perry and Cunningham, *Academies, Museums and Canons of Art* (Book 1 of this series). It went ahead in the end thanks to donations from collectors of and dealers in Victorian art.

However, the single most important commodity associated with a blockbuster exhibition is usually the one with the greatest intellectual respectability: the catalogue. Since the 1970s these have been transformed from slender guides to the works on display to vast and glossy tomes, which are often too heavy to carry around the exhibition and function instead as a souvenir. Some do not even have individual catalogue entries but only a checklist of exhibits at the end of the main text, allowing them to be sold as free-standing books after the show has ended. Exhibitions offer valuable marketing opportunities for publishing companies, who often combine with museums to produce catalogues. The benefit to the consumer is that because of the large numbers of sales they can be expected to have, catalogues are often much more affordable than other well-illustrated art books. The scholarship they contain tends to be rather old-fashioned by the standards of current academic art history; the catalogue of a 1991 exhibition of the work of John Constable (1776–1837), for example, contains a mass of facts about the paintings (date, provenance, etc.) but makes no attempt to locate them in a broader historical context, only referring to what it dismissively terms 'literary and sociological readings' in order to reject them (quoted in Rosenthal, 'Constable at the Tate', p.81).[8] Some commentators contend that art museums are reluctant to mount 'revisionist' or 'critical' exhibitions because they fear antagonizing their business sponsors and other donors.

Blockbusters and their subjects

Look at the cartoon reproduced in Plate 86, paying particular attention to the caption. What seems to be going on in this scene? What point does it make? On the evidence so far presented, do you think it a reasonable assessment?

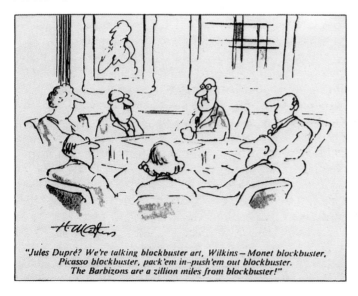

"Jules Dupré? We're talking blockbuster art, Wilkins — Monet blockbuster, Picasso blockbuster, pack 'em in–push 'em out blockbuster. The Barbizons are a zillion miles from blockbuster!"

Plate 86
Cartoon from *Art in America*, June 1986. Copyright Henry Martin.

[8] By contrast, the catalogue for a previous exhibition at the Tate devoted to another British landscape painter, the eighteenth-century artist Richard Wilson, held in 1982–3, offered a more radical approach that considered the political implications of his work. The ferocious reaction that it inspired from (mostly right-wing) commentators may have discouraged any subsequent attempts at similar approaches; on this episode, see McWilliam and Potts, 'The landscape of reaction'.

Discussion

The figures can be identified as curators discussing possible subjects for an exhibition that they hope will be a blockbuster. The man with glasses and his fist on the table (probably the museum director) is rebuking a colleague who has been foolish enough to suggest an artist whose name means little or nothing to anyone who isn't a specialist in the field (the Barbizon school was a group of mid-nineteenth-century French painters conventionally regarded as being of interest primarily as forerunners of Impressionism). The director is clear that only a name as famous as Monet or Picasso will serve to attract crowds of visitors. The cartoon draws attention to the narrow range of subjects that can qualify an exhibition for blockbuster status. The examples mentioned so far have shown that exhibitions devoted to these two artists have indeed been among the most successful exhibitions of recent years and that others have come from broadly the same area of art history – that is, canonical modernist painting of the late nineteenth and early twentieth centuries.

◆◆◆

Admittedly, of course, the examples were selected in order to demonstrate this point. It would be misleading to suggest that the *only* exhibitions of western art that can achieve blockbuster status are those devoted to canonical modernist painting. *The Genius of Venice*, for example, an exhibition of sixteenth-century Venetian art held at the Royal Academy in 1983, attracted 452,885 visitors. Not only did this show fall outside the most obvious blockbuster territory, but it also offered a thematic approach as opposed to the standard monographic (single artist) format. Nevertheless, *The Genius of Venice* would clearly not have been the great popular and critical success that it was had it not been for the presence of paintings by key figures in the canon of Italian Renaissance art. The great revelation of the show was widely considered to be a late work by Titian (*c*.1488–1576), *The Flaying of Marsyas* (Plate 87), which had been borrowed from a Czech collection; it was reported to have made a great impact on contemporary artists as well as art lovers.[9] Asking whether international exhibitions of Old Master paintings produced anything of lasting significance to compensate for the attendant risks to great works of art and the neglect of permanent collections, one art historian suggested: 'If any recent exhibition is remembered in years to come, I am inclined to believe that it will be *The Genius of Venice* for this one picture' (Haskell, 'Titian and the perils of international exhibition', p.10).[10]

Despite the success of the occasional theme exhibition, the majority of shows that achieve blockbuster status are devoted to the work of a single canonical artist. The central aim of such an exhibition is to bring together a significant proportion of the total *oeuvre* and thereby to provide an opportunity to appreciate and assess the artist's achievement. The exhibition of the work of

[9] This can perhaps be connected to the early 1980s revival of painting, which laid great stress on the kind of loose, 'expressive' brushwork for which Titian is renowned; the Royal Academy had staged *A New Spirit in Painting* in 1981 (see Case Study 4). For Titian's 'late style', see p.23 of Barker *et al.*, *The Changing Status of the Artist* (Book 2 of this series).

[10] One aspect of this neglect is that, while exhibition catalogues become more and more lavish, many major museums still lack an adequate catalogue of their permanent collection.

Johannes Vermeer (1632–75), which was held at the National Gallery of Art, Washington, DC and the Mauritshuis in The Hague in 1995–6, for example, included around two-thirds of a surviving output of only just over 30 paintings. A comparable number of Vermeers had not been seen together since 1696 when 21 of them were sold at auction; in this case, therefore, the usual hype about a once-in-a-lifetime experience was not unjustified. Vermeer provided an ideal subject for a blockbuster exhibition, one that could enable

Plate 87 Titian, *The Flaying of Marsyas*, *c*.1576, oil on canvas, 212 x 207 cm, The Archbishop's Castle, Kromeriz, Czech Republic. Photo: František Zahradniček, Prague, by permission of The Archbishop's Castle, Kromeriz.

the host institutions to gain both kudos and money. The project could be justified as a contribution to art-historical scholarship on the grounds that here was a major canonical figure who had not been 'done' before, while, at the same time, the apparent mystery surrounding the artist and the special fascination of his paintings ensured high attendances (430,000 visitors at The Hague alone).[11] However, monographic exhibitions devoted to one of the greatest names in the canon of Old Master painting are relatively infrequent.

As the cartoon above suggested, the standard blockbuster subjects are the major canonical figures of the 'classic' period of modernism: roughly from Impressionism to Surrealism. As the cartoon also hinted, this means that some artists are 'done' with such regularity that it becomes difficult to justify exhibitions of their work as a contribution to scholarship. Any institution that puts on one devoted to Monet runs the risk of being accused of being motivated largely by financial considerations. After the 1995 Chicago Monet show closed, for example, one journalist drily observed: 'In terms of the museum's bottom line the exhibition was a triumph' (Kaufman, 'It takes Monet to make money', p.15). It offered no revelations; rather, it could be said that 'the greatest and most famous works are reassuringly present' (Bretell, 'Chicago: Claude Monet 1840–1926', p.771). The catalogue was somewhat perfunctory; it contained only a short introduction which did not address recent scholarship on the artist. By contrast, *Monet in the '90s* claimed to break new ground by bringing together as many as possible of his 'series' paintings depicting such motifs as straw stacks and poplar trees (Plate 88). 'The show recreates as fully as possible Monet's own exhibitions of the 1890s', its organizers declared (Tucker, *Monet in the '90s*, p.xi); the catalogue also offered an elaborate exegesis of the political connotations of his motifs.[12] However, these arguments were not referred to in the actual exhibition (this could have been done with explanatory wall panels) (Plate 89). Thus, the organizers could maintain a certain scholarly credibility whilst making no demands on the visitors' attention that could distract from the visual pleasures offered by Monet's landscapes.

The other great blockbuster subject, as the cartoon further suggests, is Pablo Picasso (1881–1973), who is, of course, not merely a canonical modernist figure but one commonly identified as *the* artist of the twentieth century. A huge Picasso retrospective, for example, was staged by the Museum of Modern Art in New York in 1980 at the time of its fiftieth anniversary; comprising nearly 1,000 works, it took up the entire building and attracted over a million visitors. More recent exhibitions of the artist's work have tended to justify themselves by offering a more specialized perspective; MOMA's *Picasso and Portraiture*, referred to above, is a case in point. One art historian described the exhibition as 'the first serious attempt to explore this important subject in depth' (Cowling, 'Paris: Picasso and the portrait', p.60) but then, like many other commentators, went on to express reservations about the approach that had been adopted. The main complaint was that it reduced complex works of art to the level of banal autobiographical documents by encouraging visitors

11 For a discussion of the work of Vermeer and its appeal to modern viewers, see Case Study 8 in Barker *et al.*, *The Changing Status of the Artist* (Book 2 of this series).

12 In fact, Paul Hayes Tucker's 'political' interpretation of Monet's paintings of this period has been challenged by representatives of both the 'old' and 'new' art history. For an account that nuances Tucker's interpretation, see House, 'Time's cycles'.

Plate 88 Claude Monet, *Poplars (Banks of the Epte)*, 1891, oil on canvas, 100 x 65 cm, Philadelphia Museum of Art, Philadelphia. Given by Chester Dale.

Plate 89 Installation view of the *Monet in the '90s* exhibition, 1990, Royal Academy of Arts, London. Photo: courtesy of the Royal Academy, London.

to view images that are frequently not portraits in any meaningful sense of the word as depictions of Picasso's various wives and mistresses (Plate 90). As such, the exhibition could be said to represent a distinctly blockbusterish approach to art history, one that has more than a little in common with the sensationalism of the biopic (a film about the artist did in fact appear about the same time). While this may be unfair as an assessment of *Picasso and Portraiture*, it is clear that its subject owes his high place in the blockbuster stakes to a significant extent to popular fascination with the mythology of the artist as womanizing genius.

More generally, any monographic blockbuster can be said to reinforce the mystique of genius by offering up the work of a single canonical artist as an object of veneration. By contrast, a thematic exhibition can allow visitors to judge for themselves whether the most famous names are indeed better artists than their contemporaries. *Origins of Impressionism*, for example, included not only works by the most famous (male) artists of the movement, but also a painting by Berthe Morisot (1841–85) and one by Eva Gonzalès (1849–83), paltry representation perhaps but significant in view of the fact that monographic exhibitions of women artists seldom if ever attain blockbuster status. However, too many works by less celebrated names can compromise an exhibition's blockbuster potential; thus, while *Origins of Impressionism* sought to show that, in the 1860s, the artists we now know as the Impressionists had close ties with the dominant artistic currents of the period, the latter were only represented in any force in the first room. Ultimately, no would-be blockbuster can afford to mount a thorough critique (in line with

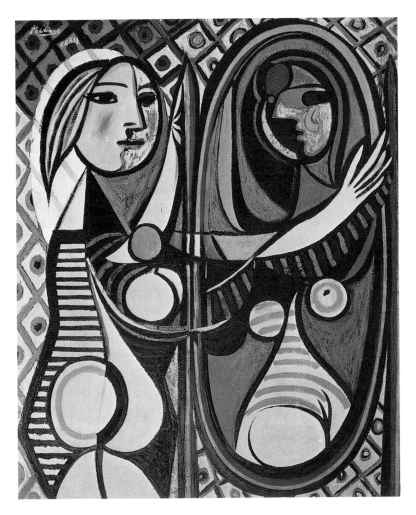

Plate 90
Pablo Picasso,
*Girl Before a
Mirror*, 1932,
oil on canvas,
162 x 130 cm,
Museum of
Modern Art,
New York. Gift of
Mrs Simon
Guggenheim.
Photo: © 1998
The Museum of
Modern Art, New
York.

current scholarship) of the old, familiar narrative of a heroic avant-garde pursuing its own artistic goals without regard for conventional expectations. If this mythology did not endow the canonical modernist figures with a special aura of bold innovation and uncomprising integrity, they would surely not have attained their current supremacy in the blockbuster stakes. To this extent, the blockbuster phenomenon may even be said to be inimical to the development of art-historical scholarship.

Blockbusters and their visitors

The difficulty here is in establishing exactly who goes to blockbusters. Doubtless, as the opening quotation suggests, their visitors include people who have seldom if ever set foot in an art museum before. They will also certainly include people who regularly attend exhibitions, and indeed affluent art lovers who are prepared to travel large distances and pay a great deal of money in order to attend an important one. This is taken for granted by critics who make such comments as: 'Anyone interested in Monet or in modern painting must go to Chicago to see the present exhibition' (Bretell, 'Chicago: Claude Monet 1840–1926', p.771). Even those visitors who live in the city in which a blockbuster is taking place will need to be able to afford the ticket

price, which is likely to be higher than the host institution's usual entrance fee (if there is one). Concessionary prices may still be too high for an unemployed person or student. However, the ticket prices would probably seem quite reasonable to people whose leisure activities also include going to the West End theatre, rock concerts, soccer finals, etc. In general, it is unlikely that the visitors to a blockbuster represent a significantly wider section of the population than is usual with art museums.

People's reasons for going to see the blockbuster will range from an existing interest in a particular artist to a wish not to miss what they have heard is a once-in-a-lifetime experience. They may not want to see the show so much as to be able to say that they have seen it in order to hold their own in conversation. In this respect, it can be argued that 'the blockbuster provides "cultural capital" for a socially aspirant middle class' (West, 'The devaluation of "cultural capital"', p.77).[13] Whether the visitors get out of it what they hoped or expected will depend on a variety of factors. While they may have the satisfaction of seeing famous works of art with which they are already familiar in reproduction, they can also face the disappointment of discovering that several of those that they anticipated seeing are not present – because they were judged too fragile to travel, for example, or for some other reason.[14] More likely, however, it will be the scale of the exhibition that proves frustrating since visitors may succumb to exhaustion long before they have reached the end. The advantage for the museum of having so many works in the show is that it allows many more people to see the exhibition at any one time than would be the case if it were smaller.

Undoubtedly the main downside of the blockbuster so far as most visitors are concerned is the difficulty of seeing the pictures on account of the crowds. This problem can be reduced though not eliminated by the host institution ensuring that the exhibits are well spaced (the failure to do so made things worse at The Hague showing of the Vermeer exhibition) and by controlling the numbers of visitors at any one time, though it may be reluctant to restrict its profits by doing so. In the case of the Chicago Monet show, 'fully half of the respondents [in the comments book] protest at the jostling "zoo-like" crowds' (Kaufman, 'It takes Monet to make money', p.15). These problems encapsulate the paradox inherent in the mass viewing of works of art. Many paintings that now draw crowds, including those of Vermeer, were never meant to be viewed by more than a few people at a time. This also holds true for the Impressionists, who, at least from around 1870, primarily produced small-scale, informal pictures for sale to private collectors and exhibited them in relatively small spaces. These conditions fostered the very qualities that make their work so popular today: the characteristic subject-matter of sunny landscapes and people at leisure, the light, sketchy brushwork and fresh, bright colours. However, their current status as crowd-pleasers only dates from the mid-twentieth century, the period at which cheap colour photography first enabled large numbers of people to hang reproductions in their own homes.

[13] The concept of 'cultural capital' is taken from the work of Pierre Bourdieu; see Case Study 2.

[14] For example, Seurat's *Models* (Plate 84) from the Barnes Foundation (which was then prohibited from making loans) was one of several major works by the artist not present in the exhibition of his work at the Grand Palais in 1991.

While the Impressionists combine avant-garde prestige with popular appeal, other aspects of canonical modernist art are less accessible to uninitiated viewers and, as such, less obvious blockbuster material.[15] A case in point is Cézanne, an associate of the Impressionists who nevertheless remained a figure apart, staying most of the time in his native Provence, and has never attained such widespread popularity. The catalogue of the 1996 exhibition of his work (which was promoted as the first full-scale retrospective of the artist's career for 60 years) characterized Cézanne as as 'an infinitely mysterious artist', 'a painter's painter, an artist for those who especially love painting'. However, its authors did not feel that this meant they needed to make a special effort to interpret his work for a wider audience, but declared that: 'Words cannot communicate the visual and spiritual emotion that he so miraculously transmitted to canvas and paper, which visitors to the exhibition will undoubtedly sense for themselves' (*Cézanne*, pp.13–16). In practice, however, most of the institutions that stage blockbusters accept they have an obligation to do all they can to help their visitors to understand and appreciate the works of art. For its showing of the Cézanne exhibition, for example, the Tate Gallery commissioned a small book (which sold more copies than the expensive catalogue) as a guide to understanding his work: its author, Paul Smith, began by acknowledging the difficulties that Cézanne's work could present to the viewer. Unfortunately, however, visitors would probably not have read anything in advance, and there was no comparable explanatory material in the exhibition itself to help viewers make sense of what they were looking at (Plate 91).

Plate 91 Installation view of *Cézanne* exhibition showing *The Large Bathers* (1906) from the Philadelphia Museum of Art, 1996, Tate Gallery, London. Photo: David Giles, PA News Photo Library, London.

[15] Abstract art, for example, does not usually figure significantly in the blockbuster stakes.

Now let us look at some of the publicity generated by the Tate's showing of the exhibition which a visitor could have read beforehand. What view(s) of Cézanne do you find in the extracts below, and what purpose do you think they serve? Do they agree with each other?

There is a sense in which Cézanne is, like Poussin, a *peintre philosophe* [philosopher painter]. But it is one of the revelations of this show that he's not in any sense [a] dry academic artist ... It demonstrates what an extraordinarily rich and varied artist he was ... The subject matter is much more accessible for a late twentieth century audience. When people look at the late portraits, or some of the still-lives [Plate 92] or images of Mont Sainte-Victoire [Plate 93], they will realise the passion remains undimmed ... Cézanne has a continuing relevance. He is one of the great masters.

(Nicholas Serota, director of the Tate Gallery, *Independent*, 6 February 1996)

Plate 92 Paul Cézanne, *Still Life with Apples*, 1893–4, oil on canvas, 66 x 82 cm, The J. Paul Getty Museum, Los Angeles.

Looking at Cézanne is a deeply pleasurable thing … There is something in the way he puts down paint, or a pencil mark, that is of a complexity and a probing quality that satisfies deeply, like eating a very good meal. He is satisfying and reassuring, and in that sense a very accessible artist … He means a lot to people. There's great beauty, great profoundness; there's a very big human spirit in his work.

(Joseph Rishel, curator of the exhibition, *Daily Telegraph*, 3 February 1996)

Universally acclaimed as the father of Modernism, he is held up as the root of every movement in the history of modern art. He is the ultimate painter's painter. Cézanne, as Picasso said, is 'the father of us all'. Certainly, the Tate's exhibition is a triumph. But is it a success for Cézanne? Does the artist we know at the end of this Odyssey live up to his reputation? … Certainly, Cézanne invented a new way of seeing the world but his show is not about landscapes and still-lifes. It is about passion, sex and death.

(Iain Gale, *Independent*, 9 February 1996)

Just as the sheer beauty of Cézanne's painting is underemphasised so is its emotion. All the talk of 'formal significance', 'plastic values', etc., has given the impression of a cool modernist analyst. But this was not his artistic quest or the character of the man … There is a wild, primitive side to his art …

(John McEwen, *Sunday Telegraph*, 11 February 1996)

Plate 93 Paul Cézanne, *Mont Sainte-Victoire with Large Pine*, *c*.1886–8, oil on canvas, 66 x 90 cm, Courtauld Institute Galleries, London.

Cézanne is a daunting, deceptive and contrary artist ... The blockbusting treatment of his work ... leaves him as hard to define as his beloved Mont Sainte-Victoire in a summer heat-haze ... [He] can neither be turned into a colourful 'Year in Provence' annotator of domestic and rustic life, nor, quite, does he fit the bill as the exemplar of Modern Art, the groundbreaking radical, the prototypical avant-gardist. Scholarship tells us many things about him, but it does not really explain him nor the reasons why we return to this difficult, taciturn, dangerous artist.

(Adrian Searle, *Guardian*, 7 February 1996)

Discussion

It seems to me that those responsible for the show were worried that it might not appeal very much to the public and wanted to reassure potential visitors that they would enjoy it. Their comments appear to have decisively shaped the way the exhibition was discussed in the press. They emphasize that Cézanne was not only an important figure in the history of art but an accessible artist as well. It is pointed out that (as with the Impressionists) his paintings don't have complex, literary subjects and depict recognizable, agreeable things like the Provençal landscape. The journalists don't necessarily accept this rather cosy view – the last one specifically rejects it – but all of them agree that the exhibition is not about art in a narrowly formalist sense. Above all, the publicity claims, Cézanne was not just an innovative artist but also a man of passion. In other words, the focus is on the human interest of the paintings just as it was in *Picasso and Portraiture*, even though Cézanne led a far less sensational life.

◆◆◆

In the event 408,608 people saw the Cézanne exhibition in London (limitation on numbers kept the attendance figures from going much higher). If asked, most would probably have said that the exhibition lived up to their expectations. The problem is that they would be unlikely to confess to being disappointed for fear of appearing uninformed and unsophisticated. In all probability, most people did enjoy the exhibition, but it would be impossible to say how much of their pleasure derived from looking at Cézanne's work and how much of it from a sense of achievement at getting into it and the excitement of the whole event. In general, the problem with the blockbuster phenomenon is that, in presenting high art as popular entertainment, it glosses over the complexity of many works of art and the difficulties that they can present to uninitiated viewers. As such, the blockbuster show can be seen as an aspect of the commercialized culture of spectacle, one that turns people into blind worshippers at the shrine of art. For, as Smith points out with reference to Cézanne, without some concept or category to apply to the work of art, 'looking remains nebulous, and is not seeing, properly speaking, at all' (*Interpreting Cézanne*, p.6). In other words, enjoyment cannot be entirely separate from understanding. In so far as most blockbusters do not adequately acknowledge this, their contribution to the democratization of art is necessarily a limited one.

The aftermath

As we have seen, the objections that can be made about blockbusters do have at least some validity. However, to categorize the entire phenomenon as fundamentally malign would be excessive. Ultimately, its implications are really only crucial for the institutions that stage them. Holding one can produce many benefits: to take only one example, it can lead to a significant increase in the number of people joining the 'friends' association (unrestricted admission to exhibitions being a standard perk of museum membership). However, the problem is that many of these memberships may be allowed to lapse after a year. More generally, many of the people who saw the blockbuster may not make a return visit until the next big, highly publicized exhibition. In other words, the institution finds itself under pressure to stage another blockbuster soon, which may not be easy. The worst case scenario is when one thinks it has a blockbuster on its hands, only to find itself with half-empty galleries and debts instead of profits. The Tate's 1991 Constable show, for example, was expected to repeat the success of its 1976 exhibition devoted to the same artist, which attracted 313,659 visitors, a figure that was still a record for the Tate fifteen years later. In the event, however, only 169,412 people went to Constable II. It seems likely that the English artist has lost out by comparison to the ever popular Impressionists because, although his landscapes offer not dissimilar visual pleasures, he lacks the same avant-garde glamour.

But the negative implications of the blockbuster phenomenon may not be confined to the host institutions. The fear is that it tends to operate at the expense of less well-funded institutions outside metropolitan centres which are not in a position to stage such exhibitions, not least because sponsorship is unlikely to be available. Julian Treuherz, curator of the National Museums and Galleries on Merseyside, for example, finds it 'worrying that there are people going to exhibitions like Cézanne who have not been to their local gallery in years' (quoted in Kelly, 'Status queue', p.23). For the major institutions themselves, the principal concern is, as we noted above, that they will find they can afford to stage only blockbuster-type shows. (At best, the money raised by a blockbuster can be used to subsidize less profitable exhibitions. Conversely, the failure of the 1991 Constable show reportedly forced the Tate to cancel some of its planned exhibitions.) According to the director of the National Gallery: 'The real worry about exhibitions is not whether the sponsor will go on supporting a blockbuster. It's really whether the economic pressures on museums will be so great they will only be able to consider putting on exhibitions which will generate a good deal of peripheral profit' (MacGregor, 'Personality of the year', p.26).

References

Alexander, Victoria D. (1996) *Museums and Money: The Impact of Funding on Exhibitions, Scholarship and Management*, Bloomington and Indianapolis, Indiana University Press.

Barker, Emma, Webb, Nick and Woods, Kim (eds) (1999) *The Changing Status of the Artist*, New Haven and London, Yale University Press.

Bretell, Richard (1995) 'Chicago: Claude Monet 1840–1926' (exhibition review), *Burlington Magazine*, vol.137, November, pp.771–4.

Cézanne (1996) exhibition catalogue (contributors Françoise Cachin and Joseph J. Rishel *et al.*), London, Tate Gallery Publishing.

Cowling, Elizabeth (1997) 'Paris: Picasso and the portrait' (exhibition review), *Burlington Magazine*, vol.139, January, p.60.

Elsen, Albert (1986) 'Assessing the pros and cons', *Art in America*, June, pp.24–7 (special section devoted to museum blockbusters).

Haskell, Francis (1990) 'Titian and the perils of international exhibition', *New York Review of Books*, 16 August, pp.8–12.

Higonnet, Anne (1994) 'Whither the Barnes?', *Art in America*, March, pp.62–9.

House, John (1992) 'Time's cycles', *Art in America*, October, pp.127–35.

Kaufman, Jason Edward (1996) 'It takes Monet to make money', *Art Newspaper*, no.55, January.

Kelly, Judith (1996) 'Status queue', *Museums Journal*, May, pp.21–3.

King, Catherine (ed.) (1999) *Views of Difference: Different Views of Art*, New Haven and London, Yale University Press.

MacGregor, Neil (1996) 'Personality of the year' (interview conducted by Paul Josefowitz), *Apollo*, December, pp.23–32.

McWilliam, Neil and Potts, Alex (1986) 'The landscape of reaction', in A.L. Rees and Frances Borzello (eds) *The New Art History*, London, Camden Press, pp.106–19.

Perry, Gill and Cunningham, Colin (eds) (1999) *Academies, Museums and Canons of Art*, New Haven and London, Yale University Press.

Picasso: Sculptor/Painter (1994) exhibition catalogue (contributors John Golding and Elizabeth Cowling), London, Tate Gallery Publishing.

Rosenthal, Michael (1991) 'Constable at the Tate', *Apollo*, August, pp.77–84.

Smith, Paul (1996) *Interpreting Cézanne*, London, Tate Gallery Publishing.

Tucker, Paul Hayes (1990) *Monet in the '90s: The Series Paintings*, exhibition catalogue, London, Royal Academy of Arts.

Wallis, Brian (1986) 'The art of big business', *Art in America*, June, pp.28–33 (special section devoted to museum blockbusters).

West, Shearer (1995) 'The devaluation of "cultural capital": post-modern democracy and the art blockbuster', in Susan M. Pearce (ed.) *Art in Museums* (New Research in Museum Studies 5), London and Atlantic Highlands, NJ, Athlone Press, pp.74–93.

Africa on display:
exhibiting art by Africans

ELSBETH COURT[1]

Introduction

This case study discusses exhibitions of African art held outside of Africa, primarily in Europe and the United States. Indeed, 'African art' can be seen as a largely 'out-of-Africa' phenomenon. While both 'art' and exhibitions were mostly unknown in Africa until relatively recently, African-made objects have been appropriated by non-Africans for purposes of display for well over a century. This case study explores the significance of exhibitions in shaping our understanding of African art and provides a survey of some of the key shows of African art held since the mid-1980s. It also offers a more detailed discussion of the *africa95* season, a large-scale programme of cultural events which was held in Britain in the autumn of 1995. The emphasis here is on the Royal Academy show *Africa: The Art of a Continent*, the centrepiece of the season, and one other major exhibition, *Seven Stories about Modern Art in Africa* at the Whitechapel Art Gallery.

The case study begins, however, with a discussion of the Kenyan-born artist Magdalene Odundo, who contributed to *africa95* by curating an exhibition of African metalwork at the Crafts Council in London. Her work and career serve to introduce the key issues that will concern us in this case study: first, the *canon*, that is, the received classifications that have delimited the category of 'African art', together with the challenges to it made by artists and Africanist scholars; second, the *curator*, used here broadly to refer to the different strategies used for displaying 'art' from Africa as well as the role, whether conventional or innovative, played by the individuals responsible for specific exhibitions; and third, the *critic*, encompassing both the published response to an exhibition and its reception by audiences.

Approaching African art with Magdalene Odundo

In the winter of 1997–8 an exhibition of work by Magdalene Odundo was held at the Michael Hue-Williams Gallery, which specializes in sculpture. It is one of many galleries dealing in modern and contemporary art along London's Cork Street. Close by are the Royal Academy, the major auction houses and many other commercial galleries. In the exhibition, eleven large and contrasting 'untitled' terracotta vessels were presented as art: ten installed inside on a shared podium or single plinth while the largest was displayed on its own facing the street (Plate 94). The stark white space set off the intense red-orange colour of the work, drawing attention to its burnished, smooth surfaces (achieved by four kiln firings) and precise details like the slightly flared rim

[1] I wish to thank Emma Barker for her assistance in preparing this case study.

Plate 94 Magdalene Odundo, *Untitled* gourd-like vessel, hand built, unglazed
terracotta, 70 x 33 cm, as exhibited 1997–8 at the Michael Hue-Williams Gallery,
London. Photo: courtesy of Michael Hue-Williams Fine Art Ltd, London.

and odd knobs or 'blemishes' (the artist's term) above the base. Odundo's new work was acclaimed by ceramicists and Africanists, but despite the high-profile venue the exhibition was ignored by mainstream art critics.

While Odundo's work can be appreciated simply for its compelling aesthetic qualities and as a superb technical accomplishment, it takes on a richer significance for viewers familiar with the artistic traditions of East Africa. Like most African pottery over the centuries, her vessels are hand built from coils and unglazed. They evoke the ancient pottery of the Middle Nile valley (Nubia) such as Kerma ware (thin-walled, 'tulip' beakers in red and black). At the same time, her vessels are reminiscent of the human form; some of the shapes resemble a head and/or torso, the small knobs suggesting a navel or nipple. This too can be related to African traditions; Odundo herself has cited the 'totally mesmerizing' body art of Mangbetu women, whose heads are given a distinctive shape through binding their hair into a tall crown opening on to a disc (quoted in Berns, *Ceramic Gestures*, p.17).[2] While the notion of women as receptacles is widespread in African cultures (based on the metaphor of the female body as a container for human life), the artist does not so much reinforce the association as disrupt it by impeding containment with a skewed neck or blocked spout.

Odundo affirms her art's connection to Africa and her belief 'that historical and contemporary work can be viewed as a continuum' (*African Metalwork*, p.26). She also stresses the importance of her non-African training (she has an MA from the Royal College of Art) and opportunities to her development: 'You can work from the African tradition and also view it from a distance. That was my culture shock: I had thought I had left something behind but I had actually gained something new' (quoted in Berns, *Ceramic Gestures*, p.19).[3] If, as Emmanuel Cooper declares, Odundo has achieved technical 'perfection' while subverting tradition 'with wit and style' (Cooper, 'Tradition in studio pottery', p.207), this is largely owing to the premises of British studio pottery: craft competency, on the one hand, and 'fine arts' creative expression, on the other. The work in the winter exhibition seemed to indicate a shift towards a more sculptural, even conceptual approach, making clear that Odundo's response to African and other ceramic traditions is a highly personal and innovative one.

For present purposes, the special interest of Odundo's work is that it resists and thereby draws attention to two pernicious and interrelated notions that haunt the discourse on 'African art'. First, there is the demand for 'authentic' art, identified with timeless 'tribal' traditions as opposed to modern individual creation. The key criterion here is freedom from external influence; as we will see, this can entail an exclusive focus on art of the past.[4] For living artists,

[2] The Mangbetu are a north-east Congo ethnic group living adjacent to Sudan and Uganda.

[3] Marla Berns curated a travelling exhibition of Odundo's work in the USA; the book cited is its catalogue.

[4] As Christopher Steiner has put it, the definition of 'canonical African art has always been based on a standard of cultural or ethnic purity – that is, an object that is untainted by outside influence' (Steiner, 'Can the canon burst?', p.214).

'authenticity' means lack of exposure to a western-style, academic art education, now widely available in Africa. André Magnin, an influential curator, claims that this kind of training produces artists capable only of an arid technical mastery and generates a 'fuzzy aesthetic' caused by the accompanying hybridization of different representational systems (Magnin, *Contemporary Art of Africa*, p.10). The extensive international promotion of 'autodidact' or 'naïve' art as *the* authentic contemporary African art has been widely criticized as a denial of the real conditions of artistic practice in Africa: according to the Tanzanian-born artist and writer Everlyn Nicodemus, 'all this twaddle about "hybrid" objects and "transitional" art is nothing but a refusal to acknowledge the paradigm shift which is at the heart of modern African art' (*Seven Stories*, p.35).

The second, associated notion assumes a dichotomy between 'art' and 'craft', one that has long been central to western artistic practice but was unknown in Africa until fairly recently. Although this distinction is often said to be in decline, there is evidence to suggest that it retains considerable force.[5] The crucial distinction here is between meaning and making: 'art' is defined in terms of its content, the ideas that it conveys; 'craft' in terms of process, the skills that produce it. More specifically, it involves a higher status for fine art (painting, sculpture, etc.) than for decorative art (pottery, textiles, etc.). It is thus unsurprising that, as we will see, western interest in 'African art' has tended to focus on objects that best fit in with notions of 'fine art' (especially figural sculpture) and has neglected a huge array of other objects. In this respect, the exhibition *African Textiles and Decorative Arts* (New York, Museum of Modern Art, 1972, curator: Roy Sieber) represented a significant breakthrough. More fundamentally, however, the art/craft divide has served to deny Africans the status of artist, recognizing their manual dexterity but implying that they lack the capacity for creative, intellectual endeavour. Both the 'authenticity' prejudice and the 'craft' label can be said to perpetuate the colonialist stereotype of Africans as the 'primitive' cultural 'other': childlike, irrational, instinctive.[6]

Yet Odundo has achieved a not inconsiderable success in her career. Far from suffering from the 'authenticity' prejudice, she was included in a major touring exhibition of contemporary African art, *Africa Explores* (discussed below), as an 'international' artist. Her work has been acquired by a number of museums including the Brooklyn Museum of Art in New York, where one of her vessels is displayed in the African art section amidst ethnic East African objects (Plate 95). This association with the past rather than with contemporary art practice may be somewhat problematic. Still more anomalous is the acquisition of some of her ceramics by the Department of Medieval and Later Antiquities in the British Museum. While this could be taken as evidence that Odundo's work is unclassifiable, collapsing the art/craft distinction, the fact is that labels (and gender) do matter. Discussing a workshop at the Yorkshire Sculpture

[5] The separation between art and craft is maintained in British public collections. The Tate St Ives, for example (see Case Study 7), displays ceramics by Bernard Leach on the grounds that they are central to any definition of St Ives art, but these are loans since the Tate Gallery itself collects according to a narrower definition of 'art'.

[6] On these issues, see also the Introduction to King, *Views of Difference* (Book 5 of this series).

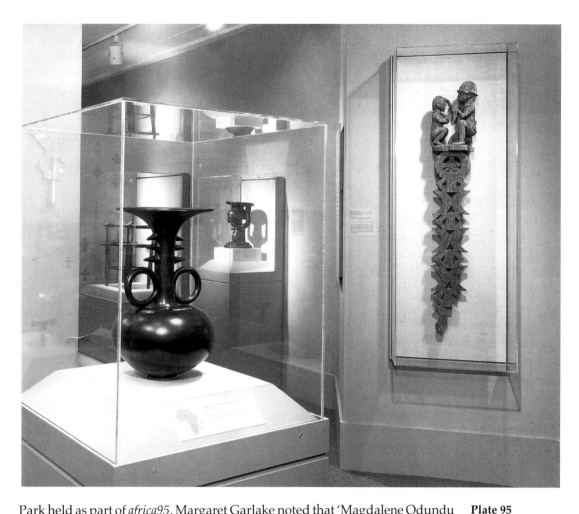

Park held as part of *africa95*, Margaret Garlake noted that 'Magdalene Odundu [*sic*], potter and artist of international stature, has been excluded from the Loder-inspired workshops on the grounds that she is a "craftswoman"' (Garlake, 'Africa now?', p.11).[7]

Consider the above discussion in terms of the three 'Cs' listed in the introduction (canon, curator and critic). To what extent does Odundo's career reflect shifts in attitudes to African art?

Discussion

Since she is a living artist trained in Britain working in ceramics, Odundo's work is the reverse of canonical African art. To the extent that she has been successful in her career, it would seem that the old stereotypes have lost at least some of their hold. Some individuals playing a curatorial role are named (Magnin, Sieber, Berns). Issues of curatorship in the broader sense are raised by the display of pots as works of art in a typical western 'white cube'

Plate 95
Permanent museum installation of East African art featuring (on the left) Magdalene Odundo's *Vessel*, 1990, ceramic, height 41 cm, diameter 25 cm, Brooklyn Museum of Art, New York. Frank L. Babbott Fund and purchased with funds given by Dr and Mrs Sidney Clyman, 1991.26.

[7] The arts patron Robert Loder (Triangle Trust, London) has played an important role in raising the profile of African art. In the early 1980s Loder (with the sculptor Anthony Caro) developed the Triangle International Workshops in New York state; these are short-term residential retreats that bring established artists to work together. From the late 1980s on Loder's initiative, this model has been adopted in several African countries and other parts of the world.

modernist setting; however, there is nothing to indicate whether this is a novel or a usual strategy for presenting 'African art'. Critics figure here primarily as an absence: the lack of published response to Odundo's exhibition seems to suggest that old attitudes discriminating against African artists and/ or excluding ceramics from the category of art die hard in the wider art world as opposed to more specialized circles. However, as you will see if you check the reference, the supportive comment by Margaret Garlake quoted just above was published in a mainstream art magazine so perhaps we should modify this assessment a bit.

◆◆

Exhibitions of African art before *africa95*

In the decade prior to 1995, a series of path-breaking exhibitions helped to move forward the agenda for African art. Before examining these developments, however, we need to consider the dominant paradigm for the interpretation and display of African art during the twentieth century. The persistent emphasis on 'authentic' objects originating in a 'tribal' context, along with the accompanying disregard for individual authorship and dates of production, reflects the colonialist attitudes of the second half of the nineteenth century when African material first entered Europe in large amounts. Aesthetic appreciation of African objects has concentrated on the wooden masks and figural sculptures of West and Central ('sub-Saharan') Africa, whose canonical status is closely bound up with 'Primitivist' appropriation of their formal qualities by modern artists such as Picasso.[8] The canon's geographical omissions are apparent from the bold line demarcating the 'Country of Negro Art' in a 1920s book featuring African works in the Barnes Collection (Plate 96). Contrary to this conception of African art, moreover, the continent has been connected with the rest of the world through centuries of trade by many routes.

The dominant paradigm operates through a dialectic between modernism, which approaches African art through formalist aesthetics, and anthropology, which offers an ethnographic approach. This means that an African object may be understood and displayed either as a work of art or as an ethnographic artefact. On the one hand, the modernist conception of the autonomous, universal art object requires works of African art to be well spaced and carefully lit so that the viewer can concentrate on their formal qualities. On the other, the ethnographic method considers a wide range of artefacts (including items of personal adornment, domestic use, etc.) and seeks to place them in their cultural context. In ethnographic museums an object is displayed along with others of similar function or arranged according to ethnic or regional origin. 'Contextualization' is provided by means of explanatory labels and visual aids (such as photographs). Historically, such displays have been

[8] The defining moment in this history of appropriation as it is conventionally recounted is Picasso's 'discovery' of African masks in the Ethnographic Museum at the Trocadéro in Paris in 1907, while he was working on *Les Demoiselles d'Avignon*; see King, *Views of Difference* (Book 5 of this series), Case Study 1, Plates 7 and 8. As noted above, the interest of artists in such objects was not based on their formal qualities alone but informed by the notion of 'primitive' art as more 'direct' and 'elemental', expressing fundamental human emotions.

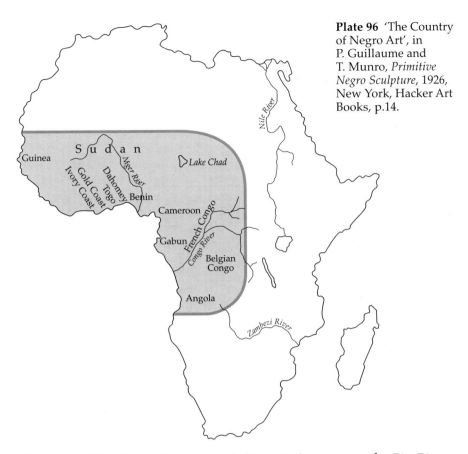

Plate 96 'The Country of Negro Art', in P. Guillaume and T. Munro, *Primitive Negro Sculpture*, 1926, New York, Hacker Art Books, p.14.

characterized by dense placement of objects in large cases; the Pitt Rivers Museum in Oxford preserves this late nineteenth-century style of presentation (Plate 97).[9] Nowadays, it is standard museum practice for African objects to be displayed as art in uncluttered, spot-lit cases with brief explanatory labels and grouped by origin, as in the Rockefeller Wing of the Metropolitan Museum of Art (its first major display of art from Africa, the Pacific Islands ('Oceania') and the Americas), which opened in 1982.

Exhibiting objects

The earliest displays of African-made objects from the point of view of art took place not in public museums but in private spaces, primarily commercial galleries; collectors and dealers have thus played a major role in defining the category of 'African art'. From just before the First World War, African masks and sculptures were exhibited in several western cities, especially Paris and New York; in the 1920s *art nègre* was all the rage. The first major art museum presentation was the exhibition of *African Negro Art* at the Museum of Modern Art in New York in 1935. Fifty years later, in 1984, MOMA staged *'Primitivism'*

[9] The Pitt Rivers Museum follows a typological model of display with objects arranged according to purpose; offering comparisons across different social groups, it was originally intended to illustrate the evolution of humanity. The basic theoretical premise (known as 'Social Darwinism' and now discredited) was that the so-called primitive 'races' provided evidence of a stage of development that Europe had experienced in prehistoric times. For attitudes to African art in the period around 1900, see Coombes, *Reinventing Africa*.

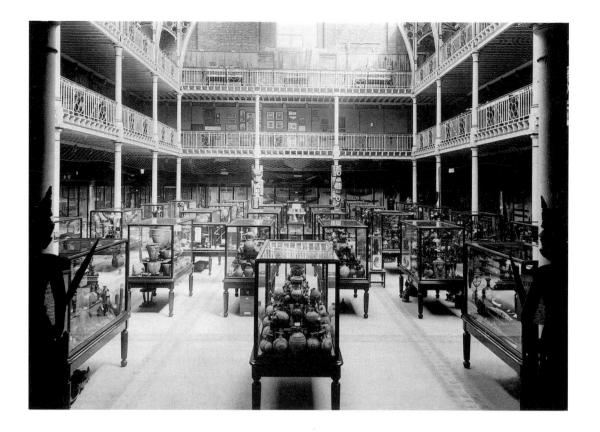

Plate 97 Interior of the Pitt-Rivers Museum, University of Oxford, c.1895. © Pitt Rivers Museum B67.95.3.

in 20th Century Art: Affinity of the Tribal and the Modern, curated by William Rubin. The aim of this blockbuster show was to indicate formal 'affinities' between the 200 'tribal' objects (Oceanic and American as well as African) and 150 works of modern western art. The presentation was strictly modernist with no contextualization of the 'tribal' works, which were discussed in the catalogue exclusively in terms of their interest to and influence on western artists. It was as if they had no history prior to entering a European collection; in this respect, the exhibition shared the priorities of dealers and collectors for whom the origins of a 'primitive' or 'tribal' object count for little (being reduced to the mere label, 'Fang', 'Kota', etc.) while its western provenance (e.g. ownership by Picasso) can hugely inflate its market value.[10]

The particular significance of the *'Primitivism'* show was that its unambiguous support for the modernist canon provoked the formulation of opposing positions. While many critics responded enthusiastically to what they saw as the sheer beauty of the works on display, scholars were highly critical of MOMA's modernist approach. Most obviously, it could be faulted from an ethnographic perspective for its obliteration of cultural differences. Ivan Karp argued that it turned the makers of the non-western objects on display into 'modern artists who lack only the individual identity and history of modern art' (Karp, 'How museums define other cultures', p.152). Others noted the

[10] The market in such art thus differs from the market in western art in which, though provenance may be significant, it is the signature of/attribution to a specific artist that is crucial. The way that the role of the artist is supplanted by that of the collector in this market is discussed by Sally Price, *Primitive Art in Civilized Places*, pp.100–7. The term 'tribal' art is used as a less pejorative term than 'primitive' but is still problematic since the 'tribe' as a discrete entity was promoted, if not invented, by colonialists.

exhibition's failure to acknowledge the colonialist context in which these objects were brought to Europe. James Clifford argued for a less narrowly art-historical account of 'modernism's recognition of African "art"', one that 'would raise ambiguous and disturbing questions about aesthetic appropriation of non-Western others, issues of race, gender and power' (Clifford, 'Histories of the tribal and the modern', p.197). What angered the artist and critic Rasheed Araeen, by contrast, was the assumption of a singular modernism that excluded non-western artists: 'I'm no longer your bloody objects in the British Museum. I'm right here in front of you, in the flesh and blood of a modern artist' (Araeen, 'From primitivism to ethnic arts', p.172).[11]

Subsequent exhibitions have explored the problems underlying the display of African objects. A notable example was *Art/Artifact: African Art in Anthropology Collections* (New York, Center for African Art, 1988, curator: Susan Vogel), which was concerned with the way that perceptions of African art have been shaped by western cultural assumptions and sought to show how much the identification of an object as art depends on its physical setting.[12] It did so by presenting visitors with five distinct strategies of display: a simple white space with objects displayed purely for their formal qualities; a room containing an unsubtitled video showing the installation of memorial posts, suggesting the impossibility of recovering the original experience; a nineteenth-century 'curiosity room' with an array of man-made and natural objects; a 'Natural History Museum Diorama' offering a traditional ethnographic approach; the 'Art Museum' presenting isolated 'masterpieces' of African art. In a review that argued against a context-bound approach on the grounds that it denies 'the objects of the Other any potential on their own' (Faris, 'ART/artifact', p.779), James Faris noted that the question implicit in the title was left unresolved. According to Vogel, however, this was intentional: 'The migration of the exhibition [on tour] between art museums and science museums exactly reflects the issues it raises' (Vogel, 'Always true to the object', p.204).

An innovative exhibition characterized by less curatorial licence, more rigorous scholarship and a similar sharp attention to design was *Images of Africa: Emil Torday and the Art of the Congo 1900–1909* (London, Museum of Mankind, 1990–1, curator: John Mack), which was awarded first prize for a museum exhibition by the National Art Collections Fund.[13] Its particular contribution was to reconstruct and represent the formation of an early twentieth-century collection of African art in the course of ethnographic fieldwork conducted by the anthropologist Emil Torday for the British Museum. Acknowledging that London had stood somewhat aloof from the fashion for *art nègre*, it suggested that Torday nevertheless provided a significant model of admiration for the artistic achievements of a Central African people (the Kuba) combined with a precise and sympathetic

[11] Araeen's anger fuelled the founding of the journal *Third Text: Third World Perspectives on Contemporary Art and Culture* in 1987. He subsequently curated the exhibition *The Other Story* at the Hayward Gallery in 1989. See also the Introduction to King, *Views of Difference* (Book 5 of this series), and Araeen's case study in the same volume.

[12] The privately funded Center (now Museum) for African Art was founded in 1984 by Susan Vogel, formerly curator of African art at the Metropolitan.

[13] The Museum of Mankind was the ethnographic branch of the British Museum until its closure in early 1998. The department is being rehoused at the main Bloomsbury site. For further analysis of the issues raised by the Torday exhibition, see Mack, 'Kuba art and the origins of ethnography'.

documentation of their culture. The exhibition was divided into three sections, each of which included both serial objects (carved mugs, knives, etc.) and major pieces such as the rare *ndop* sculptures representing Kuba kings. Transition between the sections was made explicit through the decoration, art work and contextualization. The entry to the room devoted to royal art, for example, was indicated by a change in wall colour from white to forest green, a royal family mask and a photograph of King Kot aPe with his courtiers (Plate 98).

Exhibiting artists

A major departure of recent years has been the increased exposure of previously neglected modern and contemporary African art.[14] Among the surge of exhibitions of the 1990s was *Contemporary African Artists: Changing Traditions* (New York, Studio Museum of Harlem, 1990–1, curator: Grace Stanislaus); curated by an African-American, it featured work by nine academically trained artists, five of whom went on to be represented in the 1990 Venice Biennale. An important role in bringing African artists to international attention was also played by a slightly earlier exhibition with a global scope: *Les Magiciens de la Terre* (Magicians of the Earth) (Paris, Centre Georges Pompidou, 1989, curator: Jean-Hubert Martin). Martin explained: 'The basic idea during the elaboration

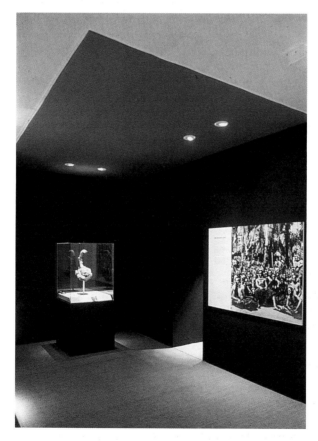

Plate 98 Installation view of *Images of Africa* exhibition, 1990–1, Museum of Mankind, London. Photo: courtesy of the British Museum.

[14] There was, however, a precedent in an important series of exhibitions which took place in the 1960s at the time of the first wave of political independence; for example, *Contemporary African Art* held at the Camden Arts Centre in London in 1969 included works (mostly paintings) by 90 artists.

of our exhibition was to question the relationship of our culture to other cultures of the world' (Buchloh, interview, p.22). He and his co-curators (including André Magnin for Africa) selected 100 artists evenly divided between the 'centre' and the 'margins'; representatives of the latter included sixteen Africans, most 'autodidact' or 'folk' artists. The centre/margin division was not followed in the exhibition itself, where the display strategies varied in accordance with the different types of art-making; for example, a house was built as a support for the figures of voodoo deities by Cyprien Tokoudagba from the Republic of Benin.

The juxtaposition of art works from very different cultures in *Magiciens* did not, according to Ivan Karp, represent much of an improvement on MOMA's *'Primitivism'* show: 'the master narrative of the whole exhibition asserted a fundamental underlying similarity in spirit and intent among the producers of such disparate works of art' (Karp, 'How museums define other cultures', p.152). While *Magiciens* was intended to be egalitarian in its acknowledgement of the individual creativity of every artist regardless of origin (they were all listed alphabetically in the catalogue), the lack of a context for understanding the 'margins' was widely seen as a problem. The choice of 'magic' as the theme, identifying art as part of a universal search for 'spirituality' (apparently conceived as less 'Eurocentric' than a narrowly formalist approach), was criticized in similar terms. According to anthropologist and curator Clémentine Deliss, it ignored the specific conditions of art practice in contemporary Africa (for example), making it impossible for the exhibition to address 'the politics of the present' (Deliss, 'Conjuring tricks', p.50). The fundamental objection raised was that the curators remained wedded to a conception of the 'purity' (or authenticity) of 'other' cultures. In viewing them only as victims of 'Western contamination', Araeen argued, *Magiciens* failed to recognize 'their aspirations and struggles to enter into the modern world' (Araeen, 'Our Bauhaus others' mudhouse', pp.19, 14).[15]

A subsequent exhibition conceived partly as a response to *Magiciens* was *Africa Explores: 20th-Century African Art* (New York, Center for African Art, 1991: curators: Susan Vogel with Ima Ebong). The aim was to redress its omissions by addressing the artistic, historical and cultural context of African art.[16] Vogel explained: 'while my back had been turned studying traditional African art, contemporary African art had become a large and fascinating domain, one that condensed both ancient and new traditions and tasted of both Africa and the West' (*Africa Explores*, p.8). She devised an ambitious scheme for classifying the full range of African art, so as to indicate the major aspects of twentieth-century artistic production; her five categories were 'Traditional', 'New Functional', 'Urban', 'International' and 'Extinct'. However, the use of these

[15] The irony here is that, as another critic noted, the curators had rejected the idea of an 'original purity' and 'emphasized societies in transition, in many cases choosing Western and non-Western artists who represent an exchange of influences between their respective cultures' (Heartney, 'The whole earth show', p.92). Araeen himself was included as an artist of the 'centre'. In the work of the 'marginal' artists, however, cross-cultural exchange largely took the form of imitation or celebration of western consumer culture, as, for example, in sign paintings and the coffin in the shape of a Mercedes by Kame Kwei of Ghana; one was also included in *Africa Explores*.

[16] After opening in two venues in New York (the other being the New Museum of Contemporary Art in SoHo), *Africa Explores* toured in a reduced version to ten venues in the USA and Europe, including the Tate Gallery Liverpool (on which see Case Study 7).

categories was criticized as arbitrary and misleading. John Picton, for example, argued that they were based on a reductive opposition between traditional and modern art practice which obscured the interchange in Africa between 'older and newer traditions' (Picton, 'Desperately seeking Africa', p.106).

The category most represented in *Africa Explores*, accounting for one-third of the exhibits, was 'Urban': a term which applied primarily to the commercial art of sign painting. Chéri Samba, a sign painter from Zaire (now Republic of Congo) who had also been included in *Magiciens*, was represented by no fewer than eight works. Overall, the exhibition was weighted towards brash and lively works by 'autodidact' artists who (as noted above) offer a new version of 'authentic' African art. By contrast, academically trained artists were only represented in the 'International' section; the bias here was, moreover, towards diaspora artists such as Odundo. Broadly speaking, the vogue for contemporary African art which developed in the aftermath of *Magiciens* was characterized by precisely this preference for the naïve and the popular over the modern and the international. The most direct legacy of the 1989 show is the CAAC: Collection d'Art Africain Contemporain (its director is André Magnin), works from which were loaned to *Africa Explores*.[17] Strongly criticized by African artists and critics for the bias in its selection, *Africa Explores* highlighted the issue of curatorial control. A review by Olu Oguibe concluded: 'Africans must narrate themselves and must not be mere stagehands in a ventriloquist's show' (Oguibe, review, p.22).

Consider the above discussion in terms of the three 'Cs' listed in the introduction. What have been the major innovations? Where do problematic issues still exist?

Discussion

A major shift away from the old modernist canon of 'tribal' sculpture has clearly taken place; this is most apparent in the new interest in work by contemporary African artists. But the fact that notions of 'authenticity' continue to be applied in this area indicates that the old paradigm still retains some force. Nevertheless, curators have played a major role in bringing African art to international attention and, in some cases at least, have sought to put it in some kind of context (the *Torday* show, *Africa Explores*), thereby starting to move away from the old ethnographic / aesthetic opposition. There has also been a significant trend towards a new attentiveness to the actual settings in which works of art are displayed (*Art/Artifact*, *Torday*). Even where the central theme or organizing principle of an exhibition has been problematic ('*Primitivism*', *Magiciens*, *Africa Explores*), this has nevertheless had the positive effect of stimulating critical debate and inspiring subsequent 'corrective' exhibitions. However, as Oguibe points out in the quotation immediately above, curatorial control has remained in the hands of white westerners (the only exception cited here being the Studio Museum of Harlem show). Third World writers and artists have had little say in the ways in which they were represented in these exhibitions and have only been able to react – usually critically – to them.

◆◆

[17] Despite its institutional identity, the CAAC is the private collection of Jean Pigozzi. A selection from it was exhibited as *Africa Hoy* in Las Palmas, Grand Canary, in 1991; the exhibition was shown as *Out of Africa* at the Saatchi Gallery in London in 1992.

A blockbuster and its antidote: *africa95*

africa95 was the name both of a 'season celebrating the arts of Africa' and of the temporary, non-profit organization which co-ordinated it in partnership with 40-odd arts institutions in the UK. The programme of events included the visual arts, music, drama, dance, cinema, literature, conferences and broadcasts. It was initiated in 1992 by Robert Loder and Clémentine Deliss, who became its artistic director. They developed the 'artist-led' approach of the season, laying the emphasis on 'the artist's voice and the process of art-making today'.[18] The aim was to promote exchange and collaboration between artists across Africa and the UK. The visual arts programme thus included not only exhibitions of modern and contemporary African art (some 50 in all), but also artists' workshops such as the one at the Yorkshire Sculpture Park, which involved 21 sculptors from nine African countries, the UK and USA.

The genesis of *africa95* was inextricably linked to the Royal Academy's plans for a major exhibition of African art. Its exhibitions secretary, Norman Rosenthal, was inspired by *Treasures of Ancient Nigeria*, a travelling exhibition shown at the Academy in 1982.[19] 'The idea was born that we should attempt to make a bold, synoptic survey of the visual culture of Africa stretching back in time to the very beginnings of artistic endeavour and geographically over the entire continent,' the president of the Academy explained (*Africa: The Art of a Continent*, p.8). However, the twentieth century was omitted despite the protests of scholars. The failure to persuade the Academy to shift its position gave rise to the entire *africa95* project, which sought to ensure that a conception of an 'authentic' Africa of the past did not prevail. By contrast, the 'continent' approach adopted by the Academy seemed timely: 'The moment just arrived to do a show on the whole of Africa,' explained Tom Phillips, the painter, academician and African-art enthusiast who took over the task of curating it (*Independent*, 17 October 1995). A key element here was the ending of apartheid in South Africa, which both affirmed geographical unity and provided crucial sources of sponsorship for *africa95*.

Africa: The Art of a Continent

Africa: The Art of a Continent was hyped in typical blockbuster fashion as 'the show of a lifetime' (*Independent*, 17 October 1995). The project was a highly ambitious one, being the Academy's largest exhibition ever, with over 800 objects, and its most expensive, at a cost of £1.5 million. At the same time, Phillips stated, it remained an RA-style art exhibition rather than an ethnographic showcase: 'It's not so much a sophisticated show of naïve objects as a naïve show of sophisticated objects' (*Independent*, 17 October 1995). The bias of Phillips's taste was partially offset by the expertise of the many

[18] These quotations are drawn from the official brochures for the season, copies of which are held in the *africa95* archive at the School of Oriental and African Studies, London. The conception of *africa95* was informed by a series of seminars on issues in contemporary African art at SOAS in 1991–2 convened by John Picton and Clémentine Deliss.

[19] This exhibition included naturalistic sculptures which (like the Kuba sculptures collected by Torday) can be more easily assimilated than other African objects to the traditional canons of European art. After British troops sacked Benin City in 1897 and looted thousands of objects (many of which were acquired by the British Museum), there was disbelief that Africans could have been capable of the technical sophistication evident in the 'Benin bronzes'. Claims have recently been put forward for the return of the objects to Nigeria (of which royal Benin is now part).

scholars, including anthropologists and archaeologists, who advised on the selection of the objects and contributed to the enormous catalogue, which offered overviews of regional cultural history and a detailed account of each object. Only a tiny proportion of these scholars were African; as if to forestall criticism, the catalogue also included general essays by black academics Kwame Anthony Appiah and Henry Louis Gates, Jr. Before the exhibition even opened, controversy had been aroused by plans to exhibit Djenne terracotta sculptures looted from Mali, plans only dropped by the Academy after the British Museum threatened to withdraw its loans if the terracottas were exhibited.[20] The last-minute withdrawals of loans by the Egyptian Ministry of Culture also caused problems.

Plate 99
Installation view of East Africa wood gallery, *Africa* exhibition, 1995, Royal Academy, London. The Nubian slit drum described on the next page is on the far right. Photo: Stephen White, courtesy of the Royal Academy.

Like the catalogue, the exhibition was arranged in regions (seven in all) on the basis of broad cultural groupings, avoiding rigid political classifications by 'nation'. This meant that visitors to the exhibition took a journey clockwise round the continent, starting in ancient Egypt and Nubia. It continued with East Africa where the visitor first encountered objects of a kind displayed in most of the exhibition's thirteen galleries: small or medium-sized, wooden and monoxylous (carved out of a single piece). Although the exhibition as a whole focused on representations of the human figure, this section revealed the great diversity of the monoxylous tradition, including sculptures, chairs and house poles (Plate 99). Next, on to Southern Africa, which offered works varying widely in date and media, including the Linton panel, the largest

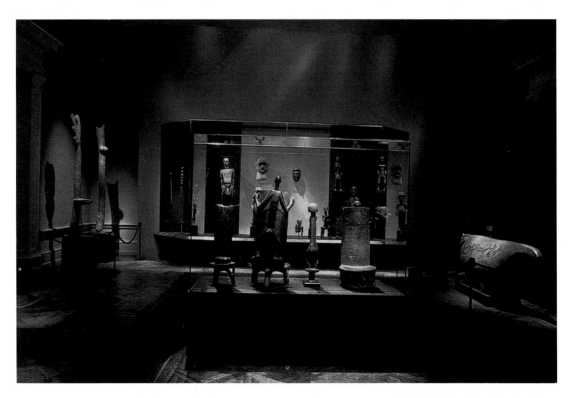

[20] Widespread smuggling of excavated objects and other works of art from Third World countries takes place in defiance of UNESCO conventions. In 1994, for example, the Academy was widely criticized for holding an exhibition of antiquities from the private Ortiz collection, most of the items in which had no provenance and had clearly been smuggled out of their country of origin.

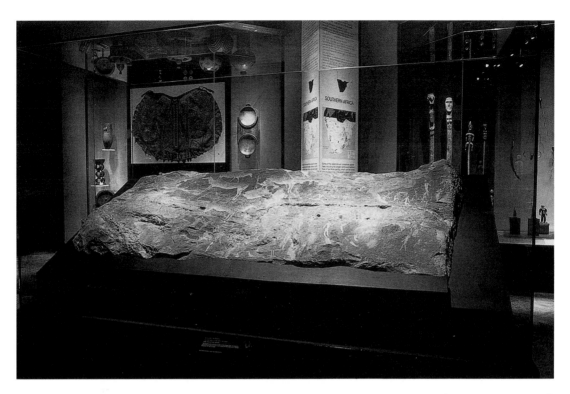

Plate 100 Installation view of Southern Africa gallery with Linton panel, *Africa* exhibition, 1995, Royal Academy, London. This photograph suggests the density of its display and includes an explanatory panel providing contextual information in the centre rear. Photo: Stephen White, courtesy of the Royal Academy.

known fragment of ancient rock painting (Plate 100). Only then, halfway through, did a spacious gallery for Central Africa allow for the contemplation of the canonical forms of 'African art': power figures ('fetishes') and masks (Plate 101). West Africa and the Guinea Coast featured treasures of ancient and more recent kingdoms: Ife, Benin, etc. Continuing across the zone of the Sahel, the journey ended in Muslim North Africa (and back in Egypt) where a tall *minbar* pulpit cast its shadow across the ceiling.

Each gallery contained such large, sometimes idiosyncratic counterpoints to the majority of exhibits (such as a large Nubian slit drum in the shape of an ox and decorated with Islamic motifs – looted during the British conquest of Umdurman in 1898 – in the East Africa section). Visual comparisons were promoted by sets of serial objects (gold weights, chairs, incised ostrich eggs) or, more subtly, by positioning objects in a single line of vision. As in other recent Africa exhibitions, most of the rooms were darkened with objects spot-lit; one critic complained that the effect seemed to echo late nineteenth-century notions of 'the dark continent' (James Hall, *Guardian*, 10 October 1995). Responses ranging from 'superbly lit' (Garlake, 'Africa now?', p.191) to 'appallingly insensitive' (Doran Ross in *African Arts*, p.6). All these commentators, however, criticized the lack of contextualization: the labels were too discreet, both very brief and often placed at a distance.[21] Taken together

[21] A similar style of display, though in a typically modernist white setting and with a slightly greater attention to context, characterized a subsequent showing (in a reduced version) at the Guggenheim Museum in New York. The exhibition also toured to Berlin.

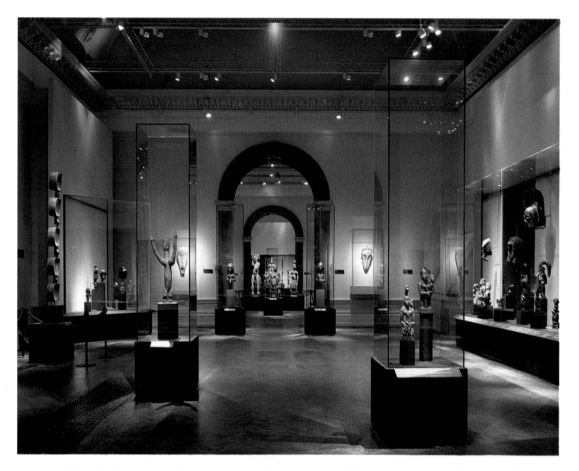

Plate 101 Installation view of Central Africa galleries, *Africa* exhibition, 1995, Royal Academy, London. Kongo figures are in the foreground cases, with Kota figures and masks on the far right and Fang figures in the centre background. On either side of the doorway are white Fang masks said to recall the work of Modigliani; the multi-seated stool displayed vertically so that it evoked Brancusi's *Endless Column* (see review extracts below) is on the far left. Photo: Richard Bryant, Arcaid, London.

with the catalogue, Roy Sieber argued, the exhibition was less problematic and indeeed 'admirable insofar as it aspires to a balance rarely found' (*African Arts*, p.68). While few visitors would have read the catalogue, the Academy did offer alternative forms of guidance. The Education Department developed its largest-ever progamme of lectures, tours and other events with the aim of reaching a new audience. Study sessions for schools allowed children to handle objects similar to those in the display cases (Plate 102).

Consider the following extracts from reviews and commentaries on *Africa: The Art of a Continent*. What attitudes towards African art do they represent, and what assessments do they offer of the success and/or validity of the exhibition?

> Almost wherever one looks, there is something strangely familiar. A mask that is surely by Modigliani, a wooden totem pole which must have been carved by Brancusi, a fetish out of a Picasso painting.
>
> (John Russell Taylor, *The Times*, 4 October 1995)

Plate 102 School children handling an ostrich egg at a teaching session for the *Africa* exhibition, 1995, Royal Academy, London. Photo: Hugh Pinney, London.

We are taking the domestic objects of African town and village life and putting them on walls that have hung Titian and Rembrandt … The Royal Academy asks us to judge these works as art, rather than as artefacts … Take such objects out of their domestic context and hold them up as art and they cannot stand the strain. They look exotic, exciting, colourful but primitive. But we are not supposed to say that.

(Simon Jenkins, *The Times*, 10 October 1995)

… far from being an event rooted in the old kinds of colonialist or modernist or other kinds of appropriationist ignorance, it is one that delights in their exposure … this is both a revelation of the enormous unknown breadth of African art and a demonstration of the fact that it will no longer quite do to consign such art to the *wunderkammer* [cabinet of curiosities] marked 'Primitive' and 'Tribal'.

(Andrew Graham-Dixon, *Independent*, 17 October 1995)

… the decision to display a five-seated Ngome royal stool not horizontally but vertically, such that it is made to resemble Brancusi's *Endless Column* … encapsulates the core question the show fails to address: that by decontextualizing utilitarian artefacts, detaching them from their original intentions, then repositioning them in a museum environment where they are appropriated for their aesthetic qualities alone, the complex historical relationship that brought these beautiful African objects into various Western collections is erased.

(Kobena Mercer, 'Art of Africa', pp.28–9)

What, after all, does it matter that this pair of concepts – *Africa, Art* – was not used by those who made these objects? They are still African; they are still works of art. Maybe what unites them as African is our decision to see them together, as the products of a single continent … to take these African artworks seriously does not require us to take them as their makers took them.

(Kwame Anthony Appiah, 'The arts of Africa', pp.48–50)

Discussion

The first review indicates the continued currency of the old Primitivist approach, unable to validate African works of art without reference to their appropriation by canonical modern artists. Taylor ignores their original context, using a term ('totem pole') that relates to another continent as well as a

somewhat pejorative one ('fetish'). The second extract, by contrast, manifests a pre-modernist aesthetics in denying that such 'primitive' objects could possibly be art. Jenkins's claim that African art is merely 'domestic' is so misleading that one wonders if he could really have looked at the exhibits. He suggests that the Academy is being 'politically correct' in admitting these works into its hallowed halls. This text reveals that, at least for this establishment London venue, the exhibition did represent a significant expansion of the canon beyond western art. The third text offers an enthusiastic response, in line with the Academy's own emphasis on the exhibition's temporal and geographic scope ('enormous unknown breadth'). Graham-Dixon rejects the idea that aesthetic appreciation of African art necessarily involves a kind of appropriation and claims that the exhibition does too. The next text argues that, on the contrary, the display actually encourages viewers (such as Taylor) to see African objects in modernist terms and is complicit in their appropriation by the West. For Mercer, African art consists of utilitarian objects which should not be decontextualized by travel or display; thus, while he insists on their beauty, his position denies them the capacity to take on purposes other than those for which they were made – like Jenkins, in fact. In the final extract, Appiah argues that the fact that a western concept (whether 'art' or 'Africa') has been imposed on the objects does not finally matter; a project like this exhibition is a valid one because we can self-consciously and thoughtfully choose to view them as 'African art'.

◆◆◆

Seven Stories about Modern Art in Africa

The linchpin of *africa95*'s modern art exhibitions was experimental in process, diverse in approach and variable in execution. Conceived by Clémentine Deliss for the Whitechapel Art Gallery, *Seven Stories about Modern Art in Africa* continued the history of African art told at the Academy into the present.[22] Neither a general survey nor a showcase for individual artists, it proposed to 'provide a series of personal interpretations … of specific movements or connections which have significantly qualified twentieth-century modern art in Africa' (*Seven Stories*, p.13). Rather than expressing a single curatorial voice, it consisted of seven sections curated by five African artists and art professionals.[23] Each section covered developments in one country, with works of art selected in order to highlight such issues as evolving traditions, methods of art education, national politics (including government art policy), local conditions and transnational cross-currents. The fundamental aim was to challenge the clichéd view of 'African art' (exemplified by the emphasis on 'autodidacts') and to offer instead views informed by the concerns of artists themselves. Ambitious and complex, the project involved an extended process of discussions and negotiations.

[22] The exhibition toured to the Malmö Kunsthall, Sweden, where the more spacious venue allowed for better viewing. The SoHo branch of the Guggenheim in New York summarily cancelled its planned showing of the exhibition.

[23] All had international curatorial experience. David Koloane was co-curator, with David Elliott, of *Art from South Africa* (Oxford, Museum of Modern Art, 1990–1). Salah Hassan, Chika Okeke and Wanjiku Nyachae were all involved in the first Johannesburg Biennial in 1995. El Hadji Sy has curated in Germany.

The seven stories, elaborated in the catalogue, were as follows. For Nigeria, Chika Okeke, a lecturer in art, outlined a complex narrative ('The Quest') charting the relationships between the nation's three major schools of art since the 1950s (Plate 103).[24] By contrast, El Hadji Sy, one of Senegal's most high-profile artists, encapsulated the shift from the academic 'School of Dakar' (1960s) to the experimental, performance-based 'Laboratoire Agit-Art'. Conditions in Ethiopia and Sudan since the mid-1970s have forced many artists to emigrate. The theme chosen by Salah Hassan (from Sudan but now a professor of art history in the United States) was 'connections', not only across the world but also between past and present. While these four stories all involved interactions between the first modern 'masters' and subsequent generations of artists in each country, this model had less relevance to South Africa, where most modern black artists were marginal or expatriate until the 1990s. Its story, 'Art Moments', curated by the internationally renowned artist David Koloane, examined two contrasting modern genres: realistic works, often with explicitly political content, and (by contrast) Abstract-Expressionist-style painting. In a final pair of stories, Kenyan curator Wanjiku Nyachae juxtaposed works by Kenya's 'self-taught' (actually, workshop trained) and Uganda's 'art school' artists.

Consisting mostly of paintings displayed in the white spaces of a modern art gallery, *Seven Stories* could hardly have provided a stronger visual contrast to the Academy's show. The entrance to the exhibition was marked by the Nigerian artist Erhabor Emokpae's *Struggle between Life and Death* (Plate 104). A striking, semi-abstract work depicting a bisected circle and two hand prints, it offers multiple symbolic readings: black and white, life and death, head and hand, spirit and matter, tradition and modernity – dualities applicable

Plate 103 Two curators, Chika Okeke (Lecturer in Art, University of Nigeria) and David Koloane (South Africa, curator and painter), in front of Uche Okeke's drawings (1950s/60s) at the preview of the *Seven Stories* exhibition, 1995, Whitechapel Art Gallery, London. Photo: Stephen Williams.

[24] On modern art in Nigeria, see also Case Study 8 in King, *Views of Difference* (Book 5 of this series).

Plate 104 Erhabor Emokpae, *Struggle between Life and Death*, 1962, oil on board, 61 x 122 cm, collection of Afolabi Kofo-Abayomi, Lagos. Photo: courtesy of the Whitechapel Art Gallery, London.

to modern African art. In the main (downstairs) gallery, the densely packed Nigeria display contrasted with the more orderly and selective Sudan and Ethiopia sections (Plate 105). Senegal was problematic because of the difficulties of relocating performance-based art to a conventional gallery and, as critics complained, the selection of only three artists, with Sy's own work accounting for over half of the display (Plate 107). Upstairs, South Africa attracted the most acclaim; starting with Dumile Mhlaba's *African Guernica* (as its title suggests, evoking Picasso's painting in both content and composition – see Plate 106), it centred on a sombre display of works relating to the murder of black leader Steve Biko. The final two sections were widely thought to be weaker than the rest.

Seven Stories received much less media coverage than the Royal Academy show, typically being considered along with other modern and contemporary art exhibitions in the *africa95* programme. Many critics seem to have had problems with the distinctively modern practices represented in the exhibition, which were seen as derivative of western art and as lacking in visual appeal. One commentator characterized this creditable attempt 'to give us the history of artistic debate within Africa since 1940' as harder for Europeans to look at than *Big City: Artists from Africa*, the 'more westerner-friendly' show at the Serpentine Gallery (Lillington, 'Out of Africa', p.50) (Plate 108).[25] The intellectual and visual demands of *Seven Stories*, with its multiple narratives and 60 artists crammed together in a relatively small space, contributed to the disappointing reception. One of the more sympathetic critics characterized it as a 'visually intractable but fascinating show' (Garlake,

[25] *Big City: Artists from Africa* was another show based on the resources of Pigozzi's collection featuring 'autodidact' art. Both it and a similar exhibition, *Vital: Three Contemporary Artists from Africa* (Tate Gallery Liverpool), featured work by Cyprien Tokoudagba.

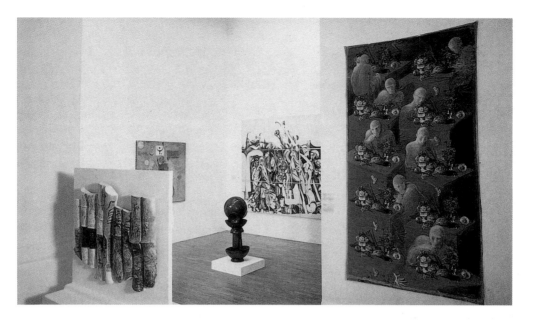

Plate 105 Installation view of Sudan and Ethiopia stories at the *Seven Stories* exhibition, 1995, providing comparisons between different generations of 'academic' artists, left to right: (i) Zerihun Yetmegeta, *Scale of Civilization*, 1988, mixed media with bamboo (ii) Abdel Basit El Khatim, *Untitled*, 1990, acrylic on wood (iii) Amir Nour, *Doll*, 1992, bronze sculpture (iv) Ibrahim El Salahi, *The Inevitable*, 1984–5, ink on paper (v) Hassan Musa, *Cena Musa*, 1994, textile ink on printed fabric, Whitechapel Art Gallery, London.

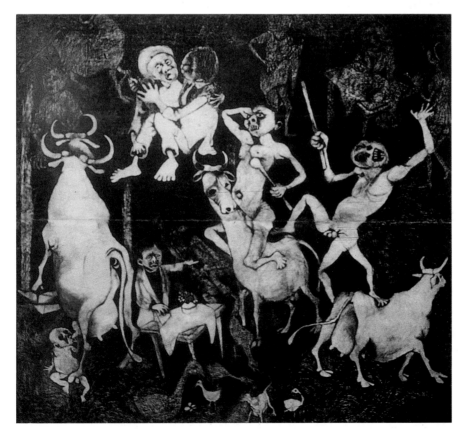

Plate 106 Dumile Mhlaba, *African Guernica*, early 1970s, charcoal on paper, 270 x 330 cm, De Beers Centenary Art Gallery, University of Fort Hare. Photo: courtesy of Whitechapel Art Gallery, London.

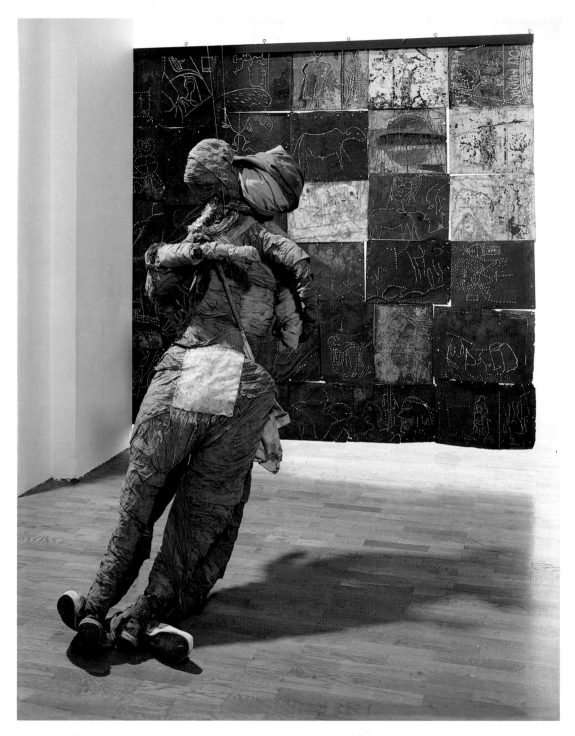

Plate 107 Objects of Performance display replicating a section of the outdoor studio space of Laboratoire Agit-Art, Dakar, Senegal, at the *Seven Stories* exhibition, 1995, Whitechapel Art Gallery, London. In the foreground are Issa Samb's textile mannequins with, behind, a partition assembled from recycled metal rectangles with pierced graffiti. Photo: Steve White.

'Africa now?', p.11). By comparison to most mainstream critics, African diaspora reviewers offered more thoughtful if not necessarily more positive accounts. Everlyn Nicodemus, a contributor to the catalogue but rather critical of the exhibition itself, acknowledged that *Seven Stories* nevertheless 'succeeded in marking a decisive moment in the western reception of modern African art' (Nicodemus, 'Art and art from Africa', p.33).

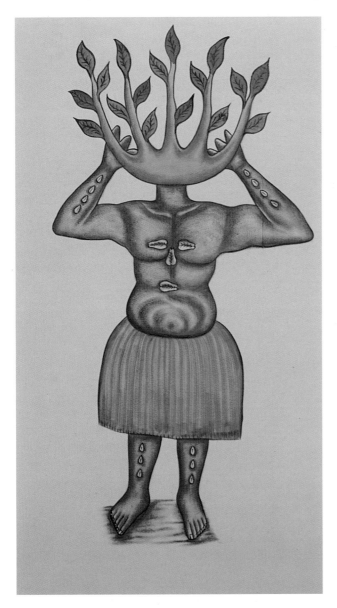

Plate 108 Cyprien Tokoudagba, *Aziza: God of the Forest*, 1995, detail of mural on the wall of the Serpentine Gallery, London, for the *Big City: Artists from Africa* exhibition. Exhibition co-curated by Julia Peyton-Jones, director of the Serpentine Gallery, with André Magnin, independent curator and curator of the CAAC, The Pigozzi Collection-Geneva. Photo: Hugo Glendinning.

Conclusion: *africa95* in perspective

The significance and success of *africa95* can be assessed on several different levels; first, the sheer scale of the season which, if not comparable to earlier festivals in Africa itself (such as *Festac*, staged in Lagos, Nigeria, in 1977), was unprecedented in the UK. Then there is the question of attendance levels, which seem to have been generally very high. Among the art exhibitions, the Royal Academy unsurprisingly did best, attracting over a quarter of a million visitors, while the Whitechapel attracted only 23,000. Above all, whereas the Academy usually has a strong predominance of middle-aged, middle-class visitors, *Africa: The Art of a Continent* succeeded in attracting an ethnically diverse audience, including many children and students, indicating that the expansion of the canon can help to bring in a new public to art institutions. The lesser impact of *Seven Stories* was compensated for by other exhibitions that challenged the old orthodoxies about African art. The most widely acclaimed was the Nigerian-born artist Sokari Douglas Camp's *Play and Display: Masquerades of Southern Nigeria* at the Museum of Mankind, which combined Kalabari masks and video footage of a Kalabari masquerade with her own large and dynamic sculptures (Plate 109). At once visually striking and conceptually serious, they create bridges between local traditions and modern art, art and ethnography, as well as raising issues about the gendering of artistic practice.[26]

Three major issues kept recurring in the critical commentary on *africa95*. First, there was the accusation that it involved a 'totalizing' of Africa, representing the continent as a single, unchanging entity. One assessment, for example, argued that the organizers' mistake was to 'treat a complex land mass such as Africa as a monolithic structure – in other words like a country' and that the season as a whole largely failed 'to situate Africa in the present' (Enwezor, 'Occupied territories', pp.38–9). Although most obviously relevant to the 'centrepiece' of the season, such objections also applied to *africa95* as a whole in that, having been conceived in response to the Academy's initiative, it could not help reproducing the opposition between past and present, tradition and modernity, etc. A second objection addressed the question of 'curating the other', arguing that the asymmetry of political and economic power meant that Africans still did not control their own representation. Olabisi Silva, a Nigerian-born critic, lamented that Africa '… remains at the mercy of European benefactors … *africa95* should have been a cultural celebration; on some levels it is, but somehow a bitter aftertaste of cultural paternalism lingers on' (Silva, '*africa95*', p.20). The third objection related to the venue; it was complained that, though held in London (problematic in itself for many), *africa95* concentrated on art 'from' Africa while African diaspora and black British artists went unrepresented. If the former did play a part, as we have seen, the continent-based approach of *africa95* did in fact mean that the latter were officially outside its remit.

[26] The British-educated Douglas Camp is herself Kalabari. According to custom, it is only men who make and perform the masquerade; women are not permitted to make masks. The exhibition stressed the continuation of masquerade in the present, the reinvention of tradition, counteracting notions of an Africa of the past, and showed that for the Kalabari the main interest lies not in the mask as an isolated object but in the performance of the masquerade.

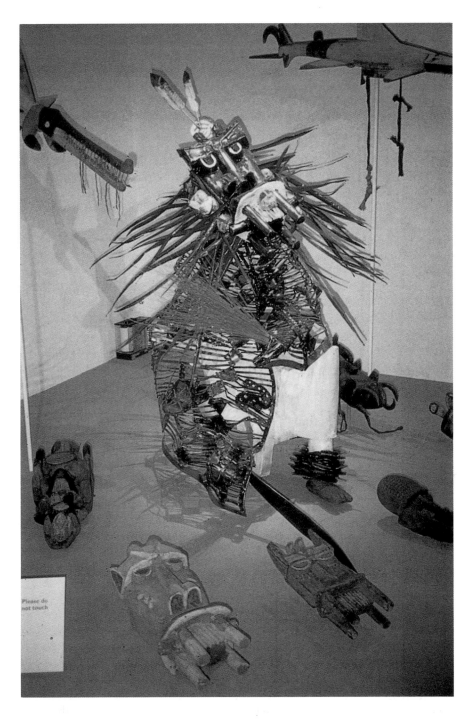

Plate 109
Sokari Douglas
Camp, *Otobo*
(hippo) sculpture
in mixed media
with ceremonial
water spirit
masks hanging
on either side,
1995, wood, steel
and palm stem
brooms,
height 183 cm, as
exhibited at the
Museum of
Mankind,
London.
Photo: Doran H.
Ross, 1995.

Ultimately, the criticism and complaint generated by *africa95* can be seen as both inevitable and productive. As Margaret Garlake observed:

> Transformation is painful, exhilarating, intellectually intractable and often visually alienating, but without its confrontations there can be no cultural creativity. To have ensured the continuity of cultural collision is not the least of the achievements of Africa'95 [*sic*].

(Garlake, 'Africa now?', p.12)

Undoubtedly, the season did not entirely succeed in its goals of challenging old clichés about 'African art', of displacing western curatorial control so as to foreground African artists, and of promoting artistic exchanges between Africa and the UK. Nevertheless, with hindsight, it is clear that it made a significant contribution to the ongoing process that is realizing these aspirations. Since *africa95* there has been a marked increase in the involvement of African artists in exhibitions, workshops and festivals around the world. Much ground remains to be covered, as we saw from the limited response to Magdalene Odundo's 1997–8 show. Yet there is also evidence that artists from Africa are moving into the cultural mainstream; both she and the Nigerian-born artist Yinka Shonibare, who had been represented in *Sensation* at the Royal Academy which coincided with Odundo's exhibition in nearby Cork Street, were invited to a reception at Windsor Castle for prominent figures in the arts in Britain in April 1998. While both were established before *africa95*, their involvement in the season increased their celebrity.[27] They, like many of the other African artists and Africanist scholars who also participated, are actively engaged in restructuring the canon, discrediting the ideas and values on which it has been based, and formulating new ways of understanding and appreciating art from Africa.

References

Africa: The Art of a Continent (1995) exhibition catalogue, ed. Tom Phillips, Munich and New York, Prestel Verlag.

Africa Explores: 20th-Century African Art (1991) exhibition catalogue, ed. Susan Vogel, New York, Center for African Art.

African Arts (1996) vol.29, no.3, summer (special issue on *africa95*).

African Metalwork (1995) exhibition catalogue, London, Crafts Council.

Appiah, Kwame Anthony (1997) 'The arts of Africa', *New York Review of Books*, 24 April, pp.46–51 (revised version of essay in *Africa: The Art of a Continent*).

Araeen, Rasheed (1989) 'Our Bauhaus others' mudhouse', *Third Text*, 6, Spring, pp.3–14.

Araeen, Rasheed (1991) 'From primitivism to ethnic arts', in Susan Hiller (ed.) *The Myth of Primitivism*, London and New York, Routledge, pp.158–82 (article reprinted from *Third Text*).

Berns, Marla (1995) *Ceramic Gestures: New Vessels by Magdalene Odundo*, exhibition catalogue, University of California, Santa Barbara, University Art Museum.

Buchloh, Benjamin (1989) interview with Jean-Hubert Martin, *Third Text*, 6, pp.19–27.

Clifford, James (1988) 'Histories of the tribal and the modern', in *The Predicament of Culture: Twentieth-Century Ethnography, Literature, and Art*,

[27] For a discussion of Shonibare's work using textiles, see Case Study 1 in King, *Views of Difference* (Book 5 of this series). Shonibare's *How does a Girl Like You, Get to Be a Girl like You*, exhibited in *Sensation* (on which see Case Study 4), was originally commissioned for an *africa95* exhibition, *The Art of African Textiles: Technology, Tradition and Lurex* (London, Barbican Art Gallery; curator: John Picton).

Cambridge, Mass., Harvard University Press, pp.189–214.

Coombes, Annie E. (1994) *Reinventing Africa: Museums, Material Culture and Popular Imagination in Late Victorian and Edwardian England*, New Haven and London, Yale University Press.

Cooper, Emmanuel (1997) 'Tradition in studio pottery', in Ian Freestone and David Gaimster (eds) *Pottery in the Making: World Ceramic Traditions*, London, British Museum, pp.206–11.

Deliss, Clémentine (1989) 'Conjuring tricks', *Artscribe International*, September–October, pp.48–53.

Enwezor, Okwui (1996) 'Occupied territories: power, access, and African art', *Frieze*, January–February, pp.37–41.

Faris, James (1988) '"ART/artifact": On the museum and anthropology', *Current Anthropology*, vol.29, no.5, 1988, pp.775–9.

Garlake, Margaret (1995) 'Africa now?', *Art Monthly*, November, pp.10–12.

Heartney, Eleanor (1989) 'The whole earth show', *Art in America*, July, pp.91–7.

Karp, Ivan (1997) 'How museums define other cultures', in Susan Feagin and Patrick Maynard (eds), *Aesthetics*, Oxford University Press, pp.148–53 (first published 1991).

King, Catherine (ed.) (1999) *Views of Difference: Different Views of Art*, New Haven and London, Yale University Press.

Lillington, David (1995) 'Out of Africa', *New Statesman*, 29 September, p.50.

Mack, John (1998) 'Kuba art and the birth of ethnography', in Enid Schildkrout and Curtis Keim (eds) *The Scramble for Art in Central Africa*, Cambridge University Press, pp.63–78.

Magnin, André with Soulillou, Jacques (1996) *Contemporary Art of Africa*, London, Thames and Hudson.

Mercer, Kobena (1995) 'Art of Africa', *Artists Newsletter*, December, pp.28–30.

Nicodemus, Everlyn (1995–6) 'Art and art from Africa: the two sides of the gap', *Third Text*, 33, Winter, pp.31–40.

Oguibe, Olu (1993) review of *Africa Explores*, *African Arts*, January, pp.16–22.

Picton, John (1992) 'Desperately seeking Africa, New York, 1991', *Oxford Art Journal*, vol.15, no.2, pp.104–12.

Price, Sally (1989) *Primitive Art in Civilized Places*, University of Chicago Press.

Seven Stories about Modern Art in Africa (1995) exhibition catalogue, London, Whitechapel Art Gallery.

Silva, Olabisi (1998) '*africa95*: cultural colonialism or cultural celebration?', in Katy Deepwell (ed.) *Art Criticism and Africa*, London, Saffron Press, pp.15–20.

Steiner, Christopher (1996) 'Can the canon burst?', *Art Bulletin*, vol.78, no.2, June, pp.213–17.

Vogel, Susan (1991) 'Always true to the object, in our fashion', in Ivan Karp and Steven D. Lavine (eds) *Exhibiting Cultures: The Poetics and Politics of Museum Display*, Washington, DC, Smithsonian Institution Press, pp.191–204.

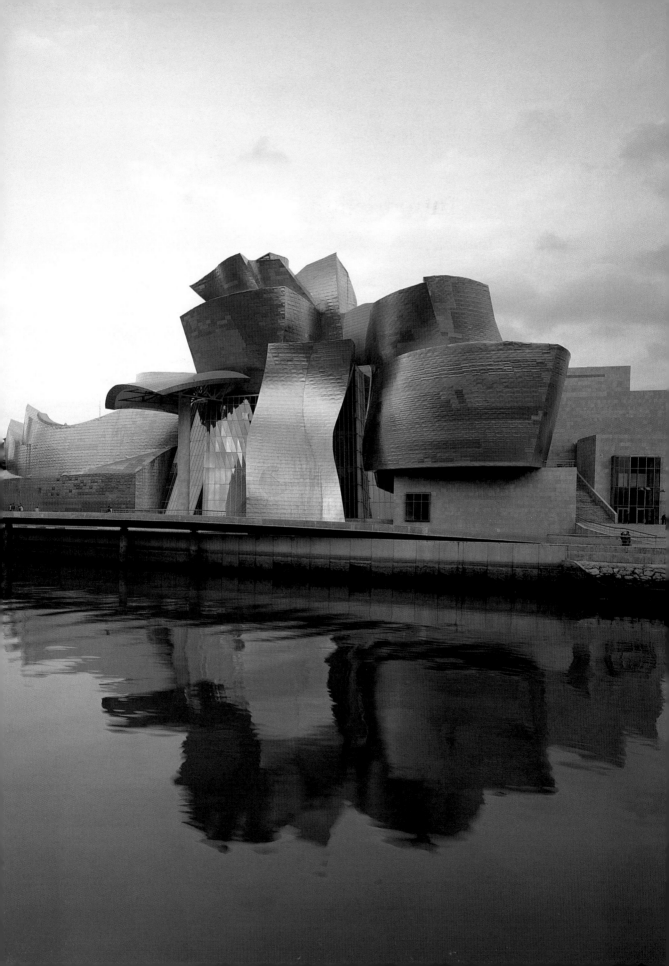

PART 3
ART IN THE
WIDER CULTURE

Introduction

EMMA BARKER

We can focus the themes and issues for this final part by reference to Antony Gormley's *Angel of the North*, which overlooks the A1 motorway at Gateshead in the North-East of England (Plate 111). A monumental work of public art planned and constructed between 1994 and 1998, the *Angel* initially aroused widespread local opposition; it was described as a Nazi-style eyesore and a danger to traffic. Critics also argued that the £800,000 it cost would have been better spent on something useful, like a hospital or school. For Gateshead Council, which commissioned the *Angel* (and obtained funding for it from the National Lottery and other non-local sources), the project functions to 'put the place on the map'. It is expected to attract visitors to the town and give a boost to the local economy; the sculpture itself testifies to the steel-working skills available in the region. As conceived by Gormley, the *Angel* has a symbolic significance for 'the North'; it is meant to raise the spirit and enrich people's lives. While his work can be criticized for its vague idealism and disregard for the particularities of place, the *Angel of the North* looks set to become a familiar and even cherished landmark.

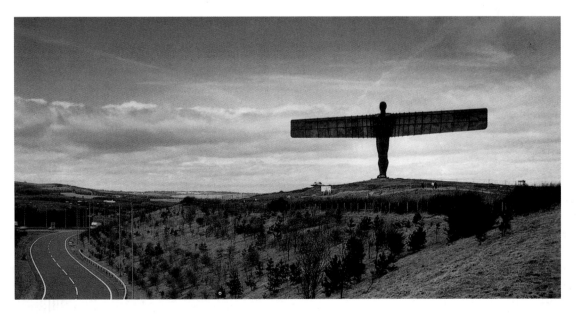

Plate 111 Antony Gormley, *Angel of the North*, unveiled 16 February 1998, steel, height 19.2 metres, wing span 54 metres, Gateshead, Tyne and Wear. Photo: Keith Paisley, courtesy of Gateshead Metropolitan Borough Council.

Plate 110 (Facing page) Guggenheim Museum Bilbao (detail of Plate 113).

In the first place, this example introduces a shift of focus away from the major museums and galleries in the great cities of Europe and the United States. In the following case studies, we will largely be concerned with regional locations, primarily in the British Isles. Case Study 7 discusses the recent expansion of the Tate Gallery from London to new outposts in Liverpool and St Ives in Cornwall. The central issue here is the encounter between a metropolitan culture of modern art and a regional constituency who may (as with Gormley's *Angel*) be deeply sceptical of the new arrival. In Case Study 8, by contrast, we discuss a non-museum context for the display of works of art which, almost by definition, is located outside the city: the country house. The point to be emphasized here is that the vast majority of Britain's population are, though not metropolitan, at any rate urban; the appeal of the country house is to a large extent based on nostalgia for an idealized rural past. In our final pair of case studies, we will be considering the very different cultural and political geography of Ireland, which, as a former colony of Britain yet to become completely independent, raises questions of the relationship of centre and periphery in a particularly acute way.

A second theme raised by the case of Gormley's *Angel* is the role played by public bodies in administering and funding the arts. The following case studies make numerous references to other city councils such as that of Derry in Northern Ireland (see Case Study 9), as well as to regional governments such as that of the Basque country in Spain (see Case Study 7). On a national level, a significant development in British cultural policy was the establishment of a Department of National Heritage by the Conservative government in 1992, which meant that the arts were represented for the first time by a minister at Cabinet level. After the election of a Labour government in 1997, it was renamed the Department of Culture, Media and Sport (for the specifically conservative connotations of the 'heritage' label, see Case Study 8). This development forms part of a general pattern of increasing government responsibility for the arts that can be discerned throughout the developed world to a greater or lesser extent. Much of this responsibility is entrusted in Britain, however, to nominally independent, non-elective official bodies such as the Arts Councils (see Case Study 9) or even, in the case of the National Trust, to a voluntary organization (see Case Study 8).

The *Angel of the North* also draws attention to the problem of justifying public spending on art in view of its minority appeal. It applies particularly to projects funded from the National Lottery (which came into operation in 1994), since the players are disproportionately from the poorest sections of society. This concern provides the context for understanding several of the developments discussed in Case Studies 7 and 9: not only the emphasis on decentralization of visual arts provision but also the accompanying initiatives for taking art out of the gallery and building up close relations with local communities. At the same time, we need to consider an alternative justification for arts spending, exemplified here by the claims made by Gateshead Council; Case Study 7 examines the now widespread practice of founding new museums for purposes of economic development or 'urban regeneration'. This development overlaps with the phenomenon of 'the heritage industry', which is discussed in Case Study 8; regardless of whether their appeal is based on the aura of art or nostalgia for the past, projects can equally well involve the conversion of historic buildings into potentially money-spinning cultural attractions directed primarily at a non-local, tourist audience.

A final issue raised by the example discussed above is the capacity of art to generate shared experiences and to promote a sense of common identity rather than simply providing 'value for money'. Arguably, the problem with works of public art like Gormley's *Angel* is precisely the lack of a common culture of shared values (whether aesthetic or political) in the atomized, individualistic society of today. Hence, there is no distinct regional or indeed national identity for public art to symbolize, however hard the sculpture tries to obscure or compensate for this fact with its colossal scale and angelic wings. It is in the light of this crisis of identity that we need to consider the recent vogue for heritage, which looks to the past as the location of a sure sense of what it means to be British and tries to pin it down to particular symbols such as the country house (see Case Study 8). An alternative response to the current crisis of identity (by no means a solely British phenomenon) is represented by much contemporary art which, rather than seeking to soothe and console, explores the tensions within conventional constructions of cultural and political identity – as in the work of the Irish artists Alice Maher and Willie Doherty (see Case Study 10). For our purposes, their example serves as a reminder that interaction between art and the wider culture can take many different forms.

The museum in the community: the new Tates

EMMA BARKER

Introduction

As we have seen in previous case studies, it has become increasingly important in recent decades for public museums and galleries in Britain and elsewhere to justify their share of government funding by demonstrating that they function for the benefit of a broad public rather than a privileged few and make their collections as accessible as possible. At the same time, museums and art galleries have come to be seen not simply as more or less worthy recipients of subsidy, but as potential generators of income for the communities in which they are located. They are crucial to the cultural policies adopted by many local governments and other official bodies in order to improve the quality of life in their city or region and also to promote economic growth. In Western Europe and North America, this has resulted in the establishment of many new museums, usually of modern art, often in places that hitherto lacked any comparable art institution. As such, these developments can be compared to the great expansion of museum provision to new urban areas that took place in late nineteenth-century Britain and elsewhere; while, as we will see, the political and economic situation is very different, the mixture of civic pride and civilizing mission (or, to put it more critically, social control) underlying that expansion is not simply a thing of the past.[1]

In this case study, we will consider the implications of new museum foundations by looking at the expansion of the Tate Gallery (Plate 112) from its original setting on London's Millbank (just along the Thames from Westminster) to its recently established branches in Liverpool and St Ives. These regional ventures have been followed up by a project for expansion within London: the Tate Gallery of Modern Art at Bankside. In each case, we will need to consider the social, political and economic circumstances in which the new gallery was established and the role played by the Tate itself and other interested parties. So far as is possible, we will try to establish whether or not the benefits of the gallery matched up to expectations. This leads us on to further questions: what kind of benefits and for whom? The priorities of economic growth do not necessarily go hand in hand with a commitment to broadening access, nor the demands of tourists with the concerns of local residents. More specifically, we need to consider the problematics of bringing complex and demanding works of modern art to non-metropolitan locations and to audiences who may not have seen such works before and may indeed be positively hostile to anything other than relatively traditional figurative art.

[1] For a discussion of these developments with specific reference to nineteenth-century Manchester, see Case Study 8 in Perry and Cunningham, *Academies, Museums and Canons of Art* (Book 1 of this series). The civilizing mission of the art museum operates in tension with its function as a demarcator of social status, as discussed by Bourdieu (see Case Study 2).

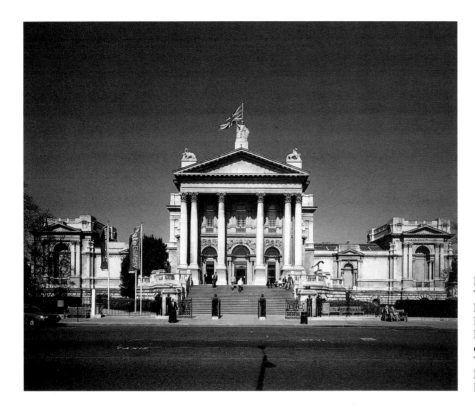

Plate 112 The Tate Gallery at Millbank, London. Photo: Marcus Leith, courtesy of the Tate Gallery, Millbank, London.

Art and urban regeneration

The idea that the establishment of a museum might do something for the surrounding area can be traced back to at least 1897, when the Tate Gallery (named after its founder, the Liverpool-born sugar merchant Henry Tate) opened on a site formerly occupied by Millbank Prison. Contemporary commentators emphasized the transformation that this 'temple of art' had wrought on a hitherto desolate and somewhat inaccessible area of London.[2] However, what are now called 'urban regeneration' schemes led by 'flagship' cultural projects did not become a widespread phenomenon until the 1980s. In *The Condition of Postmodernity* (1989) and other works, David Harvey dates the origins of these developments to the oil crisis of the early 1970s, which was followed by a massive decline in large-scale factory production in Western Europe and North America. The shift of heavy industry to the cheaper labour markets of the developing world and the growing dominance of multinational corporations, both part of a general process of 'globalization', have led to intensified inter-urban competition. Cities now strive to market themselves as attractive places to live in or to visit in order to secure tourist spending and financial investment which, they hope, will generate new jobs.

Urban regeneration plays a crucial role in the attempts that cities make to enhance their image. In the United States many schemes have been launched by public authorities in partnership with property developers in order to

[2] See Taylor, 'From penitentiary to "temple of art"'. After the opening of the Tate Gallery of Modern Art in 2000, the building at Millbank will revert to its original function as a gallery devoted to British art. An official history was published to mark the gallery's centenary; see Spalding, *The Tate*.

bring new life to declining city centres or 'downtowns' and counteract the move of the middle classes out to the suburbs (a phenomenon that has been dubbed 'white flight'). Frequently, they involve the creation of a 'cultural district' combining artists' studios, galleries and so on together with more conventional commercial ventures (restaurants, shops, offices). These foster a process of 'gentrification', as a result of which the neighbourhood's original working-class occupants are typically forced out.[3] In some cities, such as Baltimore, urban regeneration has centred on a waterfront development with a marina, aquarium or equivalent as its 'flagship' attraction. What basically counts for culture here is the way that a decaying dockland area has been re-imagined and re-presented (either by preserving and converting old buildings or by constructing massive, spectacular new ones) as a space for leisure-based consumption.[4] Art museums have unrivalled prestige value, however. In Los Angeles, for example, the Museum of Contemporary Art (opened 1986) forms the centrepiece of the redevelopment of the old downtown as a glossy new urban landscape intended to strengthen its claims to rank as a 'world city' alongside New York, Paris, etc.[5]

Urban regeneration strategies on the American model were widely promoted in Britain during the 1980s as the solution to the problems of the 'inner cities'. The Conservative government established a series of Urban Development Corporations, state-appointed bodies which bypassed local government and gave a large role to private enterprise. However, the most high-profile example of cultural policy being employed in an attempt to counteract the effects of de-industrialization was provided by Labour-controlled Glasgow, which looked towards Europe for its model of a lively city centre with a thriving cultural life. In 1983 the District Council launched its 'Glasgow's Miles Better' campaign in alliance with local business in order to combat the city's reputation as a deprived and violent place. The same year saw the opening of the Burrell Collection, one of the few new public galleries to have been built in Britain since 1945, which rapidly became one of Scotland's top tourist attractions. This and other high-profile arts projects helped Glasgow to secure its designation as 'European City of Culture 1990', which in turn reinforced its new image and brought it yet more visitors.[6] A significant role in such developments was played by a study published in 1988, *The Economic Importance of the Arts*, which, by offering (somewhat dubious) statistics in support of the claim made in its title, 'justified cultural spending as a means of renewing the vitality of … cities' (Hewison, *Culture and Consensus*, p.278).

[3] The most celebrated example of such a 'cultural district' is New York's SoHo, discussed in Case Study 4. The irony here is that artists, while they may see themselves as 'alternative' or even opposed to the dominant culture, can act as 'trojan horses' for property developers and are thus complicit in the process of gentrification; see Zukin, *The Cultures of Cities*, p.23 (with reference to her earlier *Loft Living*) and, more broadly, Deutsche, *Evictions*.

[4] The movement for the preservation of historic buildings is closely bound up with the trend towards promoting cities as cultural attractions; see also Case Study 2.

[5] On the 'Temporary Contemporary' which preceded the opening of the main museum, see Case Study 1 above. The museum itself is a showy 'signature building' (by Arata Isozaki), enabling it to function as a landmark for the city.

[6] In the 1990s, however, Glasgow still faced severe social and economic problems. Attendance figures at the Burrell have declined sharply, though the Museum of Modern Art (opened 1996) received more than double the anticipated number of visitors in its first year. Designated UK City of Architecture and Design for 1999, Glasgow retains at least some faith in urban regeneration through cultural policy.

A new consensus transcending political divisions can be said to have emerged around the use of cultural strategies for purposes of urban regeneration. Not just in Britain but also elsewhere in Europe, public–private partnerships allying local governments with business interests have been formed for this purpose, and a great many new museums and other arts institutions have been established as a result. Ironically, however, studies of these developments tend to suggest that they do not in fact produce the economic benefits that are claimed for them. Far from solving the problem of mass unemployment in a post-industrial society, they generate comparatively few jobs, many of them low-paid and short-term (as waitresses, etc.). Indeed, this type of strategy can exacerbate social divisions by subsidizing the leisure pursuits of the middle classes, especially tourists, at the expense of spending on public services such as housing and education that would benefit the majority of inhabitants. These kinds of objections have been forcefully made by Harvey, who (drawing on Debord's concept of 'the spectacle') defines the cultural orientation of post-1970 urban regeneration schemes as a 'mobilization of the spectacle' which functions for purposes of social control (Harvey, *The Urban Experience*, p.270). Spectacle, he argues, conjures up an illusion of social harmony that denies the harsh realities of injustice and deprivation.[7]

Nevertheless, 'flagship' cultural projects continue to play a key role in strategies for economic regeneration. Autumn 1997 witnessed the opening of one of the most ambitious such projects ever seen, the Guggenheim Museum Bilbao (Plate 113). It is an offshoot of the Guggenheim Museum in New York, which has for some time been seeking to establish branches in America and Europe that would allow it to display more of its collection of modern art. The ambition of Thomas Krens, the Guggenheim's director, is to establish it as a global art institution. The new Guggenheim is located in a declining port and industrial city in northern Spain which is striving to reinvent itself as a centre for financial services and high-tech industry with major cultural attractions. The government of the semi-autonomous Basque country believes that having the museum in Bilbao will create for it a new image as a modern, outward-looking region and banish the spectre of the Basque separatist group, ETA. It has spent approaching £100 million to build and run the museum, for use of the Guggenheim collection and name, and to start its own collection of modern art. The Guggenheim Foundation controls the museum's display programme.

The Guggenheim Bilbao provides an extreme example of the risks and tensions inherent in basing hopes for economic regeneration on a museum of modern art. It starts off with one great advantage: the building itself, designed by the American architect Frank Gehry. A vast, gleaming, ship-like construction, it has transformed a derelict dockland on the river Nervión and provides Bilbao with a truly spectacular symbol of its identity. The acclaim that the museum has received in the world's press has ensured that many visitors come from abroad for a unique architectural experience. Many Basques sceptical about the project have been won over by the building –

[7] Some observers argue against the concentration on 'flagship' projects and accompanying prioritization of economic objectives; instead, they favour an alternative, community-oriented approach to cultural policy that would aim to reintegrate deprived social groups into the life of the city. This type of approach is represented by Bianchini, 'Culture, conflict and cities', and Landry *et al.*, *The Art of Regeneration*.

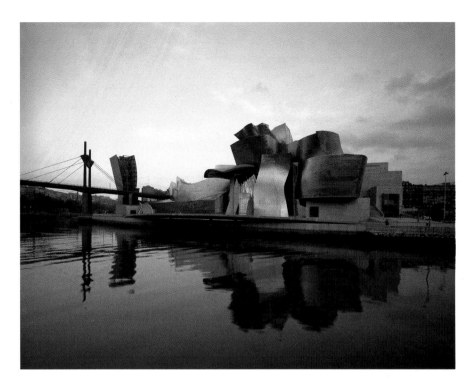

Plate 113
Guggenheim
Museum Bilbao.
Photo: courtesy
of the
Guggenheim
Museum, Bilbao.

though whether the economic spin-offs will be sufficient to justify the financial investment remains to be seen. The basic problem facing the Guggenheim Bilbao lies in the need to build up a regular public for its displays and exhibitions – given that figures for museum attendance in Spain are relatively low and there is as yet little interest in modern art, especially in the Basque country. Critics of the project fear – not unreasonably perhaps – that, as an American institution with an international outlook, the Guggenheim will fail to engage with its local constituency. Ultimately, cultural strategies for coping with the effects of globalization are unlikely to succeed – in either economic or social terms – if they do not also take account of local factors.[8]

The Tate Gallery Liverpool

The Tate Gallery Liverpool, which opened in May 1988, is located in a converted warehouse that forms the north-west corner of a complex built around four sides of a central dock (Plate 114). Albert Dock – named after the Prince Consort who opened it in 1846 – forms the largest group of Grade 1 listed buildings in Britain.[9] Besides the gallery, it also contains Merseyside Maritime Museum and a TV studio as well as shops, cafés, offices and housing. Albert Dock owes its present form to the Merseyside Development Corporation (MDC), which was set up in March 1981 in order to regenerate

[8] A case in point is the MassMoCA (Massachussetts Museum of Contemporary Art) project intended by Krens to be a branch of the Guggenheim. The small factory town of North Adams seized on the idea as the only available solution to its economic ills. The prospects for the museum drawing a metropolitan audience to the area never looked very good, however, and the project collapsed in the early 1990s. It has since been revived on more modest, locally-oriented lines. See Zukin, *The Cultures of Cities*, pp.79–108.

[9] Buildings of historic and architectural importance are 'listed' in a national register in order to protect them from inappropriate alterations or demolition.

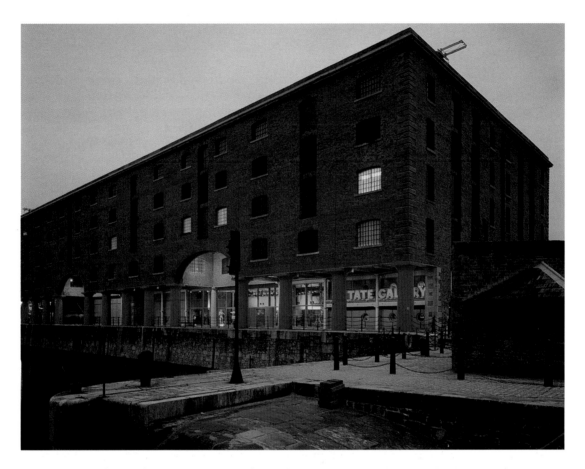

the dockland along the river Mersey. The redevelopment of Albert Dock –
then derelict – by the MDC, in partnership with a property company, was
intended to provide Liverpool with a major tourist attraction that would help
to regenerate the local economy. The extent of the city's deprivation was
underscored by the Toxteth riots in July 1981, as a result of which the
Environment Minister, Michael Heseltine, offered a 'package' of measures to
help the city, including the proposal for the new gallery.

Plate 114 Tate Gallery Liverpool. Photo: courtesy of the Tate Gallery, Albert Dock, Liverpool.

The Tate Liverpool had originated in a convergence between the aims of the
MDC and those of the Tate, which had started in 1980 to look for a site outside
London in which to display works from the national collection of modern art
that there was not room to show at Millbank. The logic for restricting the
works to be shown in the new venue to the modern period derives from the
character of most regional collections, many of which are strong in the art of
earlier periods but tail off after 1900. More particularly, the intention was to
improve access to the collection for people living at a distance from London
(at first, the new gallery was known as 'The Tate of the North'). What decided
the Tate Trustees in favour of Liverpool rather than elsewhere was not merely
the austere grandeur of Albert Dock nor the fine art collections already in the
city, such as the Walker Art Gallery, but most crucially the £5 million of public
money available via the MDC towards conversion costs. The remainder of
the funding had to be raised from business, charitable foundations and other
private sources. Initially, the Tate could not afford to convert the whole of the
space available to it and had great problems covering running costs.

Debate about the Tate Liverpool has centred on a number of different issues. At the time of its opening, the press discussed the conversion carried out by the architects James Stirling and Michael Wilford, who had previously been responsible for the new wing on Millbank housing works by J.M.W. Turner, the Clore Gallery.[10] For some, the results were admirably discreet, respectful of the building's previous function, while others felt that the typically white modernist galleries conveyed little or nothing of the warehouse (Plate 115). A number of specific problems were identified. Cast-iron pillars get in the way of the viewer's line of vision. The bulky lighting and ventilation systems slung from the already low ceilings do not improve matters. It was also commented that the use of bright blue and orange on the exterior struck a garish note, typical of Stirling but quite inappropriate to the weighty, functional architecture. In general terms, the transformation of a one-time workplace into an art gallery can be seen as emblematic of the 'aestheticization of the past' represented by the numerous (mostly private, commercially run) museums and 'heritage centres' that have been set up in former industrial sites in recent years.[11]

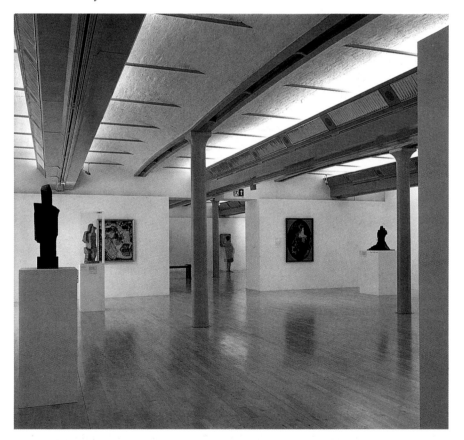

Plate 115 Interior of the Tate Gallery Liverpool. Photo: Richard Bryant, courtesy of the Tate Gallery, Albert Dock, Liverpool.

[10] See Case Study 5 in Perry and Cunningham, *Academies, Museums and Canons of Art* (Book 1 of this series).

[11] Among the best known of these is the Ironbridge Gorge Museum in Shropshire, which opened in 1969. For a discussion of the 'heritage' phenomenon, though with primary reference to country houses rather than 'industrial archaeology', see the next case study.

This leads us on to the question of the gallery's location in Albert Dock amidst gift shops, themed restaurants and commercial displays (such as the 'Beatles Story'). Well before it opened, the critic Waldemar Januszczack disdainfully declared: 'Not to put too fine a point on it, art has been annexed by the Liverpool entertainment industry. The Tate of the North is just one more attraction which will be on offer in the revitalized tourist trap of Albert Dock' (*Guardian*, 23 March 1985). Another commentator has questioned Januszczack's assumption that high culture will necessarily be endangered by contact with mass or popular culture, reporting that several visitors he spoke to thought that 'the Tate rather kept to itself, being neither contaminated by, nor dominating, the rest of the site' (Mellor, 'Enterprise and heritage in the dock', p.103). According to Jonathan Harris, however, Albert Dock provides clues to 'the *global Modernist Art business circuit*'. There is, he argues, no fundamental difference between the Tate Liverpool and the adjacent commercial outlets: the 'poster, print and gift-shops … reinforce the status of the commodities on display in the gallery and echo the goods *actually* available for sale in the Gallery bookshop' (Harris, 'Abstract Expressionism at the Tate Gallery Liverpool', p.105).

More immediately controversial, however, has been the Tate's relationship with the city beyond Albert Dock. At least to start with, many locals viewed the whole development as something foisted on Liverpool by the government in London. Such perceptions are enhanced by the location of Albert Dock, which is cut off from the rest of the city by a six-lane highway. According to one member of the Labour-controlled City Council, 'The resources that have gone into the docks could have been infinitely better used for the benefit of the city as a whole' (quoted in the *Independent*, 18 February 1988). The far left Militant group which dominated the council from 1983 to 1987 had been even more hostile. Much was made of the irony that, in the words of one commentator, 'seven years on from the closure of the Tate and Lyle refinery in the city – and the loss of some 1,500 jobs – Liverpool should be compensated with an offshoot of the old boss's gallery' (Mitchison, 'Style on the Mersey', p.17). Taking a broader critical perspective, Harris has characterized the gallery along with comparable institutions in urban sites as 'attempts to neutralize … problems presented by the underclass in contemporary societies' ('Abstract Expressionism at the Tate Gallery Liverpool', p.108).

More specifically, critique of the Tate Liverpool as an arts venue focused on its identification as an offshoot of a London institution, conceived on a metropolitan model. Philip Dodds, for example, deplored the way that the gallery had 'been airlifted into the city'. Comparing the project unfavourably to the cultural policies being developed in Derry in Northern Ireland,[12] he declared that its 'very existence tells the people of Liverpool that they cannot forge their own models of cultural development' (Dodds, 'Won from the art', p.46). In fact, the Tate Liverpool had never been intended to be a community resource but to attract visitors throughout the 'North' – though the change of name does indicate some sensitivity about the issue. Penelope Curtis, formerly its exhibitions curator, has argued, 'the charge that the gallery is insufficiently part of its locality ignores the disparate, itinerant nature of a leisure audience which could hardly ever be described as local' (Curtis, 'Uses of ownership', p.31). Most importantly, the Tate Liverpool undoubtedly has developed into far more than an additional display space for the parent institution.

[12] For developments in Derry, see Case Study 9.

The Liverpool staff have initiated major exhibitions both of contemporary British art (e.g. Rachel Whiteread, 1996) and of international modern art (e.g. Salvador Dali, 1998). The gallery has established links with art institutions in Europe and America; for example, it hosted the only UK showing of *Africa Explores* (1994).[13] More crucial to its separate identity, however, is the distinctive approach to display and interpretation that it has developed. The overall concern has been to be more helpful and informative. 'Information assistants', rather than traditional warders, stand in the galleries. In addition, labels have become longer since the gallery opened. For some critics, such an approach constitutes 'talking down' to the visitors as opposed to allowing the works 'to speak for themselves'. But it is surely significant that it has evolved in response to the demands of the gallery's visitors, many of whom 'drop in' out of curiosity because it's there in Albert Dock. The virtual lack of a ready-made audience for modern art has forced the Tate Liverpool to take issues of access and communication more seriously than had previously been the case at Millbank. It has been widely praised for its education programme and for its outreach work with local groups: for example, winning a prize from the National Art Collections Fund in 1994 for the project involving people from St Helens in creating Antony Gormley's sculpture *Field for the British Isles* (Plate 116).

Attendance levels at the Tate Liverpool appeared to settle in the 1990s at an annual rate of around 500,000. Some 80 per cent of visitors are from the region. The long delayed second stage of the development finally opened on its tenth anniversary in May 1998. The new space includes additional galleries on the hitherto unused fourth floor which has higher ceilings, enabling the Tate to show larger-scale sculpture, and fewer pillars to block the view. Much of the rest is devoted to new facilities for visitors such as an auditorium, education rooms, and enlarged shop and café. The project was funded with the help of grants from the Heritage Lottery Fund and from the European Regional Development Fund, the latter available because of Merseyside's designation as an area in special need of aid. For, while the Tate has flourished, Liverpool continues to experience much the same problems as before. Official predictions that the gallery would boost its economy by attracting huge numbers of

Plate 116 Antony Gormley, *Field for the British Isles*, 1993, clay, collection of The Arts Council of Great Britain. Photo: courtesy of The Hayward Gallery, SBC. © Antony Gormley.

[13] On this exhibition, see Case Study 6. A significant point here is that Liverpool's wealth was founded on the slave trade.

tourists to Merseyside do not seem to have been borne out. Nevertheless, the local support that the Tate now receives, including from Liverpool City Council, can be said to vindicate the project.

In what ways can Albert Dock and the Tate Liverpool be seen as typical (or otherwise) of the urban regeneration schemes discussed in the previous section?

Discussion

As a leisure-based waterfront development, Albert Dock is reminiscent of similar developments sited in former docklands in the United States. The location of a space for showing modern art from a major metropolitan collection in a declining port parallels Bilbao. The project differs from the more ambitious Basque scheme but recalls any number of urban renewal projects in the conversion of disused warehouses. As a project initiated by one of the Urban Development Corporations set up by the central government, it departs from the model provided by America, Europe and cities elsewhere in Britain such as Glasgow where the local government played a major role. The reliance on a mixture of public and private funding is typical, however. The initial hostility to the gallery fits in with the standard critique of the inegalitarian nature of such projects – as too does the failure to produce the anticipated economic spin-offs. The way that the Tate has adapted to local needs may be contrasted with the global perspective underlying the Guggenheim's expansion.

◆◆

The Tate Gallery St Ives

The Tate Gallery St Ives, which opened in June 1993, is housed in a purpose-built gallery on a site previously occupied by a gasworks, overlooking Porthmeor Beach (Plate 117). The gallery's basic remit is to display art of the St Ives School, a group of artists working in a modernist idiom who lived in and were associated with the town from the 1920s onwards.[14] It was a logical enough move for the Tate to expand to St Ives since it already administered the Barbara Hepworth Museum, which is based in the artist's studio and garden there. But the initiative for the project came from Cornwall County Council, which purchased the site and commissioned the building. To begin with, the Tate agreed simply to lend works by St Ives artists and only later assumed a managerial role. From the first, it was understood that the gallery would have to earn a significant proportion of its own income, and for this reason it (unlike the other Tates) charges an entrance fee.

The origins of the Tate St Ives can be traced back to the exhibition *St Ives 1939–1964*, mounted by the Tate in 1985, which helped to revive interest in St Ives art. The crucial impetus for such a gallery, however, lay in the economic plight of Cornwall, which has become heavily reliant on tourism as the traditional industries of fishing and tin-mining have declined. Its designation as a 'deprived rural area' made it eligible for a grant from the European

[14] The town's history as an 'artists' colony' can, however, be traced back to the late nineteenth century. Its attraction for artists was partly based on its identification as a place of primitive simplicity comparable to Pont-Aven in Brittany, which (like St Ives) now has a tourist industry based on its association with famous artists (notably Paul Gauguin). On Pont-Aven see Case Study 8 in Wood, *The Challenge of the Avant-Garde* (Book 4 of this series).

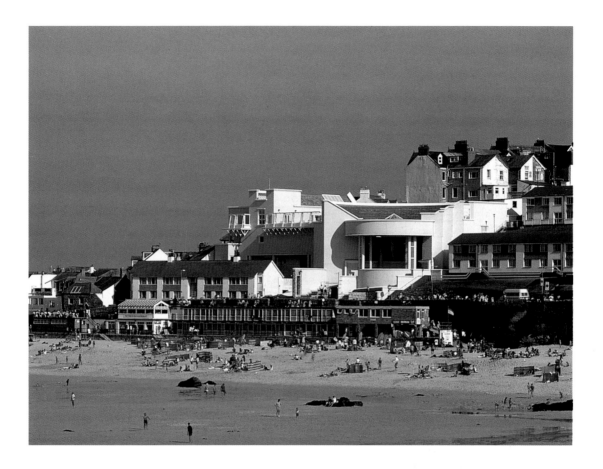

Plate 117 Tate
Gallery St Ives,
seen from
Porthmeor Beach.
Photo: courtesy of
the Tate Gallery,
Porthmeor Beach,
St Ives.

Regional Development Fund, without which the project could not have gone
ahead. Matching funds from the public sector in Britain – a condition of the
grant – were provided by Cornwall County Council and other local councils.
The rest of the cost had to be raised from the private sector. The aim was to
boost the local economy by attracting new visitors and, more especially, to
extend the tourist season beyond the summer months. Sir Richard Carew
Pole, a Cornwall county councillor and prime mover behind the project, was
quoted as saying: 'It will be an educational resource, a flagship for the arts in
Cornwall, and extremely good for employment' (*Sunday Telegraph*, 3 February
1991).

Local attitudes towards the gallery were initially divided. A very small
minority of county councillors (most of them Labour) voted against it. One
described it as a 'luxury project which could not be justified in the present
economic climate' (quoted in the *Cornishman*, 28 February 1991). Many people
in St Ives itself would have preferred the money to be spent on a new
swimming pool. They doubted that the gallery would benefit the community
and feared that it would turn out to be a 'white elephant'. Others
enthusiastically supported the project, forming the St Ives Tate Action Group,
which raised £135,000 towards the eventual £3.5 million cost of the building.
Although scepticism still prevailed when the gallery opened, local opposition
has abated in face of its manifest success. Over 200,000 visitors came in its
first year rather than the 70,000 predicted. A survey published in 1994 by

Cornwall County Council indicated that the Tate had given rise to a 5 per cent increase in local trade and 2 per cent for the whole county. It has also become one of the largest employers in the town (total population: approx. 10,000).

It was crucial for the success of the project that the Tate St Ives should be an exceptional building that would attract visitors in its own right. The architects Eldred Evans and David Shalev designed the gallery to fit in with its surroundings: 'St Ives is a town of white walls, grey slate roofs and small windows; so is the new building' ('A gallery rooted in its context', p.30). The large circular structure dominating the main façade may be seen as reminiscent of the two gas holders formerly on the site. The gleaming whiteness and the overall effect of streamlined elegance also recalls 1930s modernist architecture. The galleries themselves follow the 'white cube' model that you can find in any modern art museum, but the varying sizes and shapes of the internal spaces create an element of the unexpected for visitors (Plate 118). Supposedly, 'negotiating the building encourages the same relaxed pleasure one gets from exploring the curving lanes of St Ives itself' (Shalev and Tooby, *Tate Gallery St Ives*, p.5). The intention is that visiting the gallery should be as unintimidating an experience as possible.

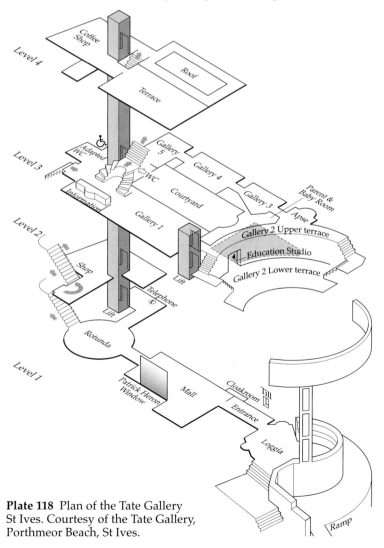

Plate 118 Plan of the Tate Gallery St Ives. Courtesy of the Tate Gallery, Porthmeor Beach, St Ives.

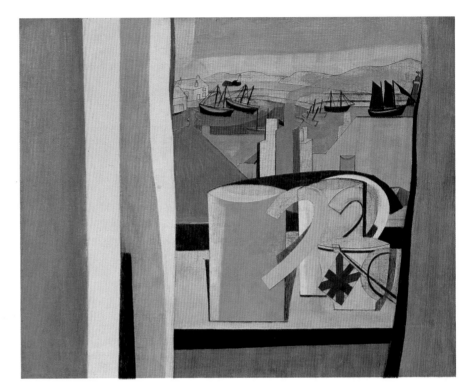

As well as being a piece of spectacular architecture, the Tate St Ives is intended to provide a sympathetic environment for the art it houses. Its combination of local and modernist features consciously parallels the similar mixture of elements that can be discerned in St Ives art. The basic rationale for showing the work of artists such as Hepworth and Ben Nicholson (Plate 119) actually in St Ives is that, though predominantly abstract and in tune with international trends, 'it was nevertheless often deeply influenced by the physical forms and quality of light of their local surroundings' (*Tate Gallery St Ives: Souvenir Guide*, p.10).[15] The Tate's curator stresses that 'the very location of [the] gallery can be a first step towards understanding the exhibits' (Tooby, 'Tate Gallery St Ives', p.50). The design of the building is also intended to provide some insight into the artists' sources of inspiration. In the second gallery, visitors can turn from the works on display to the panorama of sand, sea and sky framed by the huge curving window (Plates 120 and 121). The only problem, as many commentators have noted, is that the architecture and especially the views can overwhelm the art.

Its location right on the beach in a holiday resort means that the gallery is well placed to attract people who would not normally go to a modern art museum. As an indicator of its openness to a new kind of audience, the Tate St Ives provides a space near the entrance for surfers to leave their boards. But it is no easy task to bridge the gap between the metropolitan culture represented by the gallery and its immediate constituency – both local

[15] It has been argued, however, that this emphasis on landscape as the determining condition of 'St Ives art' represents a drastic oversimplification of the actual complexities of artistic production: see Stephens, 'As I was going to St Ives, again'. The painting of the town by Ben Nicholson which is reproduced here is very different from his more characteristic abstract art.

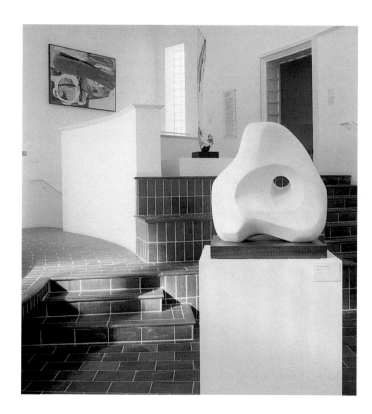

Plate 120 Tate Gallery St Ives, interior of the second gallery (the sculpture in the foreground is Barbara Hepworth, *Image II*, 1960, marble). Photo: courtesy of the Tate Gallery, Porthmeor Beach, St Ives.

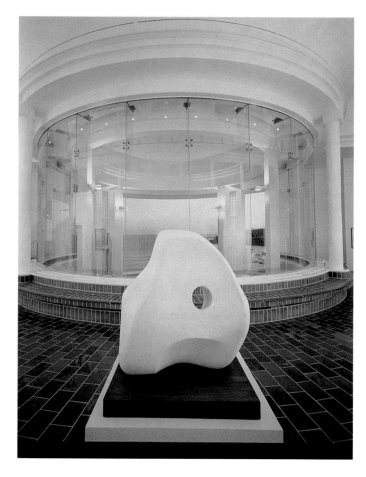

Plate 121 Tate Gallery St Ives, interior of the second gallery with a view of the beach outside. Photo: courtesy of the Tate Gallery, Porthmeor Beach, St Ives.

residents and visitors. An initial source of negative reactions was the discrepancy between the apparent scale of the building and the small number of works displayed within it. The austere modernism of the first display, with large areas of bare white wall between each work, reportedly alienated people. The second display was widely regarded as a significant improvement. According to the St Ives artist Terry Frost: 'There's much more art to see, and you get a feel for its context. The perception of "nice building, shame about the art", has changed' (quoted in Greenberg, 'Surf and sensibility', p.48). The displays are changed each autumn, timed so as to make clear the gallery's all-year-round accessibility and to attract visitors out of season.

The displays are complemented by the gallery's education and outreach programme, which plays a crucial role in making the Tate St Ives a cultural as well as an economic resource for Cornwall. From the start, the gallery ran a whole series of different projects, collaborating with local schools and colleges, institutions and artists. One commentator, however, argued that all these ventures remained subordinate to 'the Tate's determination to be primarily a temple to centrally defined high art' (Davies, 'Every town should have one', p.28). More specifically, the suggestion is that the gallery discriminates against local artists, the majority of whom produce conventionally representational work that does not fit its conception of 'St Ives art'. The Tate itself takes the position that it is most appropriate to renew the canonical modernist tradition of St Ives art by providing mainstream contemporary artists with opportunities to produce new work that relates to the local context. In 1997 it took the lead in staging *A Quality of Light*, an international exhibition involving fourteen artists, only two of them based in Cornwall, who were invited to respond to the theme of light. The results, some with a rather stronger Cornish connection than others, were displayed in a range of sites from galleries to a disused tin mine (Plate 122).[16]

The Tate St Ives is regularly cited by government ministers and arts administrators as proof that an art institution can lead to economic regeneration. Surveys indicate that many visitors do come to the region with the specific intention of visiting the gallery. Eighty-five per cent of the total come from outside Cornwall. In marketing terms, the Tate has succeeded in repositioning St Ives as an 'up-market' holiday destination attracting more affluent, higher-spending tourists. It is seen as redeeming the town from the forces of mass tourism that have left it 'teetering on the brink of Blackpoolisation' (*Observer*, 6 June 1993). From the perspective of cultural critique, the gallery could therefore be identified as a mechanism of social control, functioning to restrain forms of behaviour that transgress the norms of the dominant culture. 'St Ives art', it could be argued, has been used to construct a new image for the town that denies social and economic realities. Equally, however, this 'rebranding' makes sense as a response to the decline of the British seaside holiday with the rise of cheap foreign alternatives. As a further practical point, it should be noted that even such a successful, charging gallery cannot cover its own costs and continues to rely on (always inadequate) government funding and private sector support.

[16] For other recent international exhibitions that similarly involved siting works outside the gallery, see Case Study 4.

Plate 122 David Kemp, *Solar Dancer*, 1997, installation for *A Quality of Light* exhibition, Tate Gallery St Ives. Photo: courtesy of the Tate Gallery, Porthmeor Beach, St Ives.

In what ways does the Tate St Ives resemble other arts-led urban regeneration projects (in Bilbao, for example)? What factors can you discern that might help to account for its success?

Discussion

The gallery's location, in a declining harbour on the site of a gasworks, is comparable to that of other projects. The emphasis on the building as an attraction in its own right parallels (on a smaller scale) the Guggenheim Bilbao. Both could be said to accord with the notion of such projects as a form of 'spectacle' glossing over social divisions. Both also involve a major art institution working in collaboration with local government. The Tate's concern with education and outreach echoes existing policies at Liverpool. In terms of its success, it is important to note that St Ives is such a small town that, for once, a single project can have a discernable effect. It is also significant that, unlike Liverpool or Glasgow, St Ives needed only to develop its existing tourist industry in new directions rather than build one virtually from scratch. Moreover, though it exemplifies some of the tensions involved in showing modern art in a non-metropolitan location, the Tate St Ives benefits from the existing association of the area with art (by contrast to the MassMoCA project, for example). The *Quality of Light* project shows how it makes use of the interpretation of St Ives art as a localized, landscape-oriented version of modernism as the basis for a programme that, at least in theory, combines prestige with accessibility.

◆◆◆

The Tate Gallery of Modern Art at Bankside

At the time of writing this case study, the Tate Gallery of Modern Art is due to open in 2000 (Plate 123). Publicity for the project (announced in December 1992) has stressed that London has until now been the only major capital without a dedicated museum of modern art. As we have seen, any 'world city' now feels that it needs one as an index of its cultural vitality. In this case, it has been suggested that the project will help London to maintain its status as Europe's principal financial centre. Its main rival is Frankfurt, which, since the early 1980s, has succeeded in transforming its once dreary image by building a whole series of prestigious new museums. The new gallery is also expected to attract foreign tourists to London. It has been suggested that its expanded capacity will make it possible to accommodate some of the 'blockbuster' exhibitions that usually bypass London. The immediate justification, however, is that the Tate at present lacks the space it needs to show more than a fraction of its collection or to cope with current visitor levels at Millbank. During the late 1990s, they reached around two million a year.

Plate 123 Tate Gallery of Modern Art, computer-generated image of the exterior by Hayes Davidson. Photo: courtesy of the Tate Gallery, Millbank, London.

Like the Tate Liverpool, the Tate Gallery of Modern Art will be housed in an existing structure, in this case an industrial rather than a commercial one, Bankside Power Station (Plate 124). It thus ensures the conservation of Sir Giles Gilbert Scott's building (built 1947–63), which had been threatened with demolition before the Tate acquired an option on the site in 1994.[17] Its location on the south side of the Thames facing towards St Paul's Cathedral is not quite as accessible as the Tate would have liked, having discovered from the experience of Liverpool and St Ives how much of a difference a 'drop-in' site

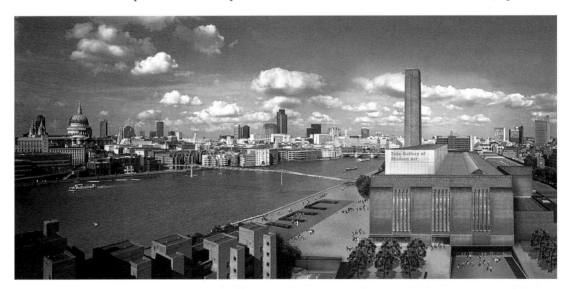

[17] The owners, Nuclear Electric, had gained immunity from listing so they could sell the building for redevelopment. The Tate's attention was drawn to the building by a campaign to reverse this decision and get Bankside listed. Some commentators would, however, have preferred it to be demolished and replaced with a new building; they see its preservation by the Tate as evidence of a failure of vision typical of a backward-looking, heritage-obsessed nation.

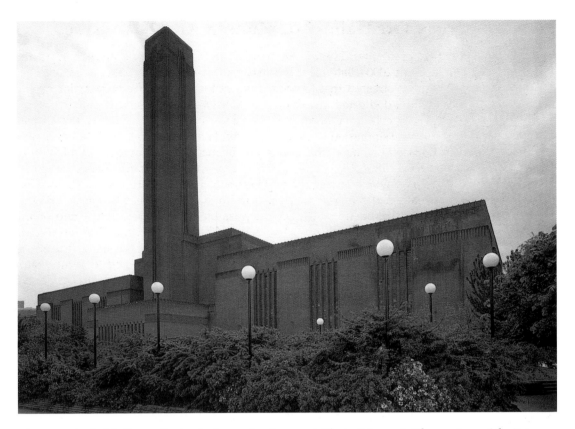

Plate 124 Bankside Power Station before redevelopment. Photo: Marcus Leith, courtesy of the Tate Gallery, Millbank, London.

makes. However, this will improve with the opening of a new underground station in the vicinity and the building of a proposed footbridge across the Thames. It will be one of numerous arts venues on the south bank of the river, including the newly reconstructed Globe Theatre, which (so it is hoped) will help to attract people away from the overcrowded West End of London. The new Tate is clearly envisaged as a tourist attraction as well as an art gallery, offering spectacular views over London from the huge chimney.

The great advantage of Bankside is its sheer scale, which not only answers the Tate's existing needs but also allows plenty of room for expansion. As a redundant industrial building, it also conforms to a widely admired model of gallery space. According to the brief for the competition to select an architect, many artists favour 'daylit conversions of existing buildings where architectural intervention [is] minimal' (quoted in Scott, 'The raw and the converted', p.58).[18] The Swiss team of Herzog and de Meuron, who won the commission, exemplify this approach. Externally, the principal modification to the building will be a glass structure on the roof which will house facilities for visitors and let natural light into the top-floor galleries. Within, the massive turbine hall will be left largely unaltered to provide a 'new public space which will resemble a covered street' (*Tate Gallery of Modern Art*, publicity brochure)

18 See also Case Study 1.

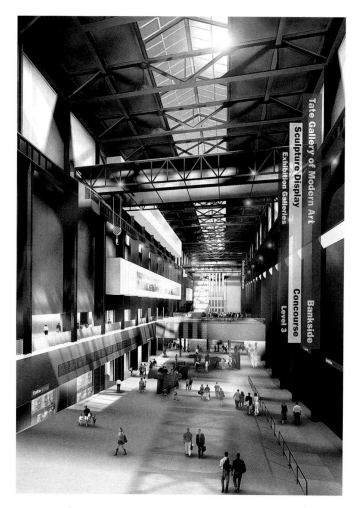

Plate 125
Tate Gallery of
Modern Art,
computer-
generated image of
the former turbine
hall by Hayes
Davidson. Photo:
courtesy of the Tate
Gallery, Millbank,
London.

(Plate 125). The new Tate is intended to function as an attraction in its own
right, a place where people can meet up, wander about, eat and shop, but without
the building overshadowing the art.[19] The need for a balanced approach was
emphasized by one of the architects, who explained, 'We are aware of the
changing social role of museums. Millions of people visit them every year and
they need a spectacular aspect, but they mustn't turn into supermarkets' (Paul
de Meuron, quoted in the *Guardian*, 23 February 1995).

The Tate Gallery of Modern Art will also function as the 'flagship' project for
the regeneration of Bankside, a typically rundown inner city area in the London
Borough of Southwark with many disused warehouses. Southwark Council,
which supported the project from the outset, is promoting the redevelopment
of the area as a 'cultural quarter' that will also include shops, restaurants, offices
and housing. Relatively little modification of the physical fabric of this part of
London is involved – in contrast to the private-property-led urban regeneration
scheme promoted by the London Docklands Development Corporation in the
1980s. This massive rebuilding scheme went ahead without regard for the

[19] Recent museums which have been criticized for overshadowing the works of art they house
include the Museum of Modern Art in Frankfurt (see Case Study 1) and the Guggenheim Bilbao.

existing working-class population of the East End, who gained very few jobs as a result and certainly could not afford the expensive new housing. While Docklands provides a salutary warning against this kind of approach (the main property company involved collapsed in 1992), the Bankside scheme cannot entirely escape comparable problems. The redevelopment of warehouses by companies like the 'Manhattan Loft Corporation' will inevitably change the social make-up of the area, where the majority of residents have hitherto lived in public sector housing. They may also have trouble coping with the influx of tourists.

The Tate is clearly anxious not to be seen as an alien presence in Southwark, as it originally was in Liverpool. Its director, Nicholas Serota, has declared that they 'want to avoid Bankside simply becoming an extension of the City, an enclave of north London across the river' (quoted in Kent, 'Alternating currents', p.13). Some of the emphasis on the new gallery as a 'community' project which will benefit both the immediate locality and London as a whole should clearly be seen as a matter of tactics, using language calculated to persuade the powers-that-be to provide the necessary funding. A report commissioned by the Tate, which estimated that the project would generate 2,400 jobs (1,000 of them in Southwark), served to boost its successful bid for a £50 million grant from the Millennium Fund (the remainder of the cost to be raised from other sources).[20] Nevertheless, the Tate has taken care to forge links with the community, consulting with local groups, appointing a local development officer in 1996, and establishing a visitor centre on the site. It is concerned to ensure that local people do benefit from any job opportunities going, both during construction and once the gallery opens (the latter by collaborating with other arts employers in the area in an Arts Training Trust).

This as yet incomplete project can serve as a significant test case for evaluating the potential of art institutions as vehicles of urban regeneration (both in the narrow economic and broad social sense). In its development, the Tate benefits from its experience at Liverpool and St Ives. The gallery has learned that the problem of covering running costs and developing an education and outreach programme need to be tackled sooner rather than later. What cannot as yet be resolved is just how far the insights drawn from the encounter with a constituency very different from the usual metropolitan art audience will inform the overall conception of the new gallery's programme. To the extent that the Tate aims to compete with New York's MOMA and the Pompidou Centre in terms of worldwide prestige and popularity, it obviously cannot be defined exclusively or even primarily as a 'community' museum. Upgrading the collection with important new acquisitions has to be a priority for Serota and his colleagues. Equally, a museum for the twenty-first century (which is how it has widely been described) can hardly fail to register the increasing interaction between art and new technologies. In essence, the Tate Gallery of Modern Art cannot define itself narrowly as a national insititution but must find some way of reconciling its international aspirations with its local commitments. How else will it be able to satisfy everyone with an interest in the gallery: artists, curators, tourists, 'the general public', funding bodies, the borough council and residents?

[20] The Millennium Commission distributes part of the proceeds from the National Lottery. It provides funding for large-scale projects like the Tate Gallery of Modern Art which would hardly have been possible before the Lottery came into being.

References

'A gallery rooted in its context', *The Architects' Journal*, 23 June 1993, pp.25–35.

Bianchini, Franco (1993) 'Culture, conflict and cities: issues and prospects for the 1990s', in Franco Bianchini and Michael Parkinson (eds) *Cultural Policy and Urban Regeneration: The West European Experience*, Manchester University Press, pp.199–213.

Curtis, Penelope (1993) 'Uses of ownership', *Museums Journal*, September, pp.30–1.

Davies, Maurice (1993) 'Every town should have one', *Museums Journal*, September, pp.27–8.

Deutsche, Rosalyn (1996) *Evictions: Art and Spatial Politics*, Cambridge, Mass., MIT Press.

Dodds, Philip (1988) 'Won from the art', *New Statesman*, 17 June, pp.45–6.

Greenberg, Sarah (1995) 'Surf and sensibility', *Tate*, no.5, Spring, pp.46–9.

Harris, Jonathan (1993) 'Abstract Expressionism at the Tate Gallery Liverpool: region, reference, ratification', in David Thistlewood (ed.) *American Abstract Expressionism*, Liverpool University Press.

Harvey, David (1989) *The Condition of Postmodernity*, Oxford, Blackwell.

Harvey, David (1989) *The Urban Experience*, Oxford, Blackwell.

Hewison, Robert (1997) *Culture and Consensus: England, Art and Politics since 1940*, revised edn, London, Methuen.

Kent, Sarah (1996) 'Alternating currents', *Time Out*, 27 March–3 April, pp.12–13.

Landry, Charles *et al.* (1996) *The Art of Regeneration: Urban Renewal through Cultural Activity*, Stroud, Comedia.

Mellor, Adrian (1991) 'Enterprise and heritage in the dock', in John Corner and Sylvia Harvey (eds) *Enterprise and Heritage: Crosscurrent of National Culture*, London and New York, Routledge, pp.93–115.

Mitchison, Amanda (1988) 'Style on the Mersey', *New Society*, 20 May, pp.14–17.

Perry, Gill and Cunningham, Colin (eds) (1999) *Academies, Museums and Canons of Art*, New Haven and London, Yale University Press.

Scott, Kitty (1995) 'The raw and the converted', *Tate*, no.6, Summer, pp.54–8.

Shalev, David and Tooby, Michael (eds) (1995) *Tate Gallery St Ives: The Building*, London, Tate Publishing.

Spalding, Francis (1998) *The Tate: A History*, London, Tate Publishing.

Stephens, Christopher (1997) 'As I was going to St Ives, again', *Art History*, vol.20, no.4, December, pp.622–6.

St Ives 1939–1964: Twenty Five Years of Painting, Sculpture and Pottery (1985) exhibition catalogue, London, Tate Publishing.

Tate Gallery St Ives: Souvenir Guide (1997) London, Tate Publishing.

Taylor, Brandon (1994) 'From penitentiary to "temple of art": early metaphors of improvement at the Millbank Tate', in Marcia Pointon (ed.) *Art Apart: Art Institutions and Ideology across England and North America*, Manchester University Press.

Tooby, Michael (1993) 'Tate Gallery St Ives', *Art Quarterly*, no.13, Spring, pp.47–50.

Wood, Paul (ed.) (1999) *The Challenge of the Avant-Garde*, New Haven and London, Yale University Press.

Zukin, Sharon (1995) *The Cultures of Cities*, Oxford, Blackwell.

I am grateful to the staff of the Tate Gallery archive and to Catherine Braithwaite, Press and Publicity Officer at the Tate Liverpool, for their assistance. Chris Stephens kindly sent me a copy of a conference paper on the Tate St Ives.

Heritage and the country house
EMMA BARKER

Introduction

This case study considers the various issues relating to the preservation and presentation of 'country houses' (or 'stately homes') and their collections through a focus on the National Trust. The reasons for doing so are, first and foremost, the sheer scale of the Trust, which owns around 250 historic houses scattered over England, Wales and Northern Ireland (there is a separate National Trust for Scotland). With well over two million members enjoying the benefit of free admission, it accounts for a significant proportion of the total visits made to country houses each year. Although it is not an official body but an independent charity, albeit one with a special legal position,[1] the Trust has a high public profile and its every decision is closely scrutinized in the press. It has persistently been accused of two main failings: first, of identifying with the élitist interests and values of the former owners of its properties and, second, of imposing a blandly standardized look on every house in its care, thereby taking all the life out of them. These criticisms form part of a broader debate around the concept of heritage and its place in contemporary Britain.

The fundamental aim of this case study is to provide a historical and critical context for understanding contemporary attitudes and approaches to the country house (whether on the part of architectural historians, politicians, visitors, cultural critics or whomever). On the one hand, it describes the process by which the country house has come to be regarded as the core of Britain's national heritage, before going on to consider the current critique of what is often termed 'the cult of the country house'. On the other hand, it shows how conceptions of restoration and conservation appropriate to country houses have evolved since the mid-twentieth century and examines the different, often opposing principles that make this area controversial. Another central concern for this case study is the country house's role as a setting for the display of works of art. Here too, as we will see, there has been an evolution in practice over the years which has divided expert opinion. For present purposes, the country house is notable because it is not simply a context of display but, arguably at least, a work of art in its own right and, without a doubt, a highly complex cultural phenomenon.

[1] The National Trust Act of 1907 gave the Trust the unique legal privilege of being able to declare its properties inalienable so that they could never be sold. It should be noted that this case study does not attempt to offer a representative account of the full range of its activities and properties.

The nationalization of the country house

Today country house visiting is a popular leisure activity in which as many as a third of the adult population of Britain is said to engage each year. This phenomenon is often said to represent only an expansion of a tradition of country house visiting that goes back at least to the eighteenth century. At that time, however, the practice was restricted to members of 'polite society', often country house owners in their own right, who would be admitted quite informally, usually by the housekeeper whom they would tip (Plate 126). A shift towards the current pattern of mass visiting took place in the mid-nineteenth century as the railways opened up the countryside to city dwellers on day trips. Especially in the Midlands, great houses were open on set days and drew many thousands of visitors a year. However, as Peter Mandler has shown in *The Fall and Rise of the Stately Home*, most such houses shut their doors in the late nineteenth and early twentieth centuries. Faced with an increasingly hostile economic and political climate, owners no longer felt obliged to admit the public.

What is striking is just how long it took for country houses to be regarded as part of the nation's heritage. Attempts to introduce laws to protect historic monuments from alteration or demolition were fiercely resisted by landowners as an invasion of their property rights. Such controls as were enacted (for example, by the Ancient Monuments Act of 1913) applied only to uninhabited buildings. What a noble owner did with his country house remained his own private business. In any case, most people in this period had little interest in great classical mansions built no more than two centuries or so earlier. The expanding urban middle classes much preferred picturesque old manor houses, such as the medieval Baddesley Clinton in Warwickshire, which was featured in the very first issue of *Country Life* magazine in 1897 as 'a truly quaint and beautiful domestic survival of the English country life of the olden time' (quoted in Tinniswood, *A History of Country House Visiting*, p.163) (Plate 127). A few

Plate 126 Thomas Barber, Mrs Garnett, the housekeeper at Kedleston, standing in the Marble Hall holding the catalogue of the collection, *c*.1800, oil on canvas, 90 x 69 cm, Kedleston Hall, Derbyshire. Photo: The National Trust Photo Library, London/ John Hammond.

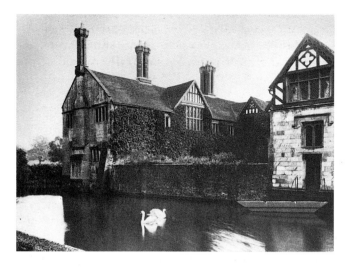

Plate 127
Baddesley Clinton,
Warwickshire,
photographed 1897.
Photo: Country Life
Picture Library,
London.

buildings conforming to this popular taste for vernacular architecture were acquired by the National Trust, but they were incidental to the primary purpose for which it was founded in 1895: preserving beautiful natural sites from the threat of development and making the countryside available for the recreation of city dwellers, especially the poor.

Only around 1930 did a few public-spirited landowners and upper-class aesthetes start to rally to the claim that country houses, together with their art collections and parks, constituted 'national and not merely personal heritages' (*Country Life*, quoted in *Treasures for the Nation*, p.10). While most of the nobility wanted only to be rid of the expense of maintaining vast, inconvenient old houses, the 11th Marquis of Lothian (owner of several country houses, including Blickling Hall, Norfolk) sought to find some means of preserving them from sale and demolition. His attempts gave rise to the National Trust Act of 1937, which enabled owners to transfer their houses to the Trust, along with an endowment to pay for their upkeep, while continuing to reside there. However, most had no interest in doing so at this stage, and it was not until the Second World War (when many houses were requisitioned) that the scheme took off. With the election of a Labour government in 1945, it became even harder to envisage a future for the country house in private ownership. In the years that followed, the number in the Trust's care grew steadily though many more were converted for alternative use or demolished.

However, the post-war period witnessed a fundamental shift towards wider acceptance of the notion of the country house as part of the national heritage. Public money became available for the first time to preserve houses for the benefit of the nation; the National Land Fund, established by Labour in 1947, allowed a number of houses ceded by their owners in lieu of death duties to be transferred to the National Trust before it was cut back ten years later. Of more long-term importance was the Historic Buildings and Ancient Monuments Act of 1953, which made provision for repair and maintenance grants to be given both to organizations with buildings in their care, such as the National Trust, and to private owners. Since grants were conditional on public access, the system boosted the number of houses open to the public. Some of the grandest (most of which remain in private hands today), such as Woburn and Chatsworth, started to admit visitors on a new commercial basis and became major attractions in 'the stately home business'. Rising affluence, in particular the spread of car ownership, helped to swell visitor numbers.

A turning point came in the mid-1970s when the actual term '[national] heritage' first became standard usage. Britain's participation in European Architectural Heritage Year in 1975 is often cited as a contributing factor. A general concern to preserve the built (and the natural) environment undoubtedly did crystallize during this period, but the particular cause of country house preservation also helped to popularize the 'heritage' label.[2] In 1975, for example, the pressure group SAVE Britain's Heritage was founded as an off-shoot of an exhibition on *The Destruction of the Country House* at the Victoria and Albert Museum the previous year. It has also been suggested that public interest in the country house was significantly boosted by the publication of Mark Girouard's best-selling *Life in the English Country House* (1978), which replaced a traditional scholarly focus on the specialized domains of art and architecture with a much more accessible emphasis on social history. Growing concern for country houses helped to bring about the passing of the National Heritage Act by the Conservative government in 1980.

The National Heritage Memorial Fund (NHMF), which was set up by the Act, has no fixed remit. It has made grants for the preservation of everything from endangered species to old movies. Nevertheless, the country house has remained central to this expanded conception of heritage. The NHMF enabled the National Trust to acquire a number of major country houses during the 1980s, notably Kedleston Hall in Derbyshire (Plate 128), which it would otherwise never have been able to take on (the Trust has strict financial requirements for the endowment of the properties it accepts). Large sums of money were involved: it cost £13.5 million to secure the future of Kedleston alone. During the same period, the Trust also saw its membership grow from under a million to its present levels. This combination of public funding and popular support for heritage in general and the country house in particular (further reinforced by the lavish 1981 television dramatization of Evelyn Waugh's elegaic country house novel, *Brideshead Revisited*, first published in 1945) provides the backdrop for the critique of the whole phenomenon that crystallized in the later 1980s.

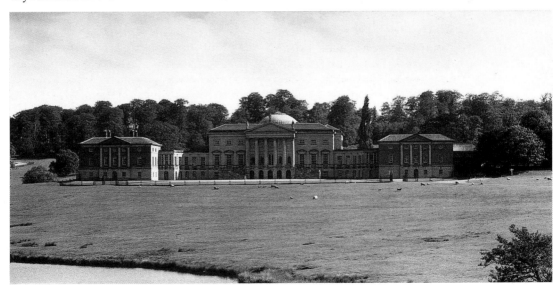

Flate 128 Kedleston Hall, Derbyshire, north front. Photo: © Crown Copyright. RCHME.

2 For the rise of historic building preservation, see Case Study 2. For the British case, see Hunter, *Preserving the Past*.

The heritage debate

Today the case for preserving country houses continues to be made in terms established in the 1930s. The house, 'together with its fine furniture, paintings and other objects, set in an extensively landscaped park', is conventionally said to be 'quintessentially British … one of the more notable British gifts to civilization' (*Treasures for the Nation*, p.118). Critics of heritage have taken their cue from this kind of assertion, presenting the cult of the country house as a symptom of a peculiarly British state of mind. We will consider below to what extent these claims can be sustained, but need first to establish the central elements of the critique of heritage (which is taken in this context to refer to the preservation and presentation of the past in the broadest possible sense). The following quotations are taken from Robert Hewison's *The Heritage Industry: Britain in a Climate of Decline* (1987), which did much to popularize the debate, though similar arguments had already been put forward by other writers, notably Patrick Wright in *On Living in an Old Country* (1985). As should become apparent, the heritage debate has a strong political dimension, pitting left against right.

On what grounds is heritage being criticized below? What purpose does the linkage of heritage and the country house serve in this argument?

> Whatever the true figures for production and employment, this country is gripped by the perception that it is in decline. The heritage industry is an attempt to dispel this climate of decline by exploiting the economic potential of our culture, and it finds a ready market because the perception of decline includes all sorts of insecurities and doubts … that makes its products especially attractive and reassuring.
>
> (pp.9–10)

> The country house is the most familiar symbol of our national heritage … They are not museums – that is the whole basis on which they are promoted – but living organisms. As such they do not merely preserve certain values of the past: hierarchy, a sturdy individualism on the part of their owners, a deference and respect on the part of those who service and support them. They reinforce these values in the present.
>
> (p.53)

> The National Trust's commitment to the continued occupation of houses for whom it accepts responsibility by the families that formerly owned them has preserved a set of social values as well as dining chairs and family portraits … That these houses are therefore not perceived as museums is presented as a great virtue … Part of the magic of the country house is that the privilege of private ownership has become a question of national prestige … Private ownership has been elided into a vague conception of public trusteeship.
>
> (pp.71–2)

> Had we more faith in ourselves, and were more sure of our values, we would have less need to rely on the images and monuments of the past … we project a superficial image of a false past, simultaneously turning our backs on the reality of history, and incapable of moving forward because of the absorbing fantasy before us.
>
> (pp.138–9)

Discussion

For Hewison, heritage functions as a form of backward-looking escapism for a country unable to come to terms with its own economic decline (1). He claims that this obsession with the past is dangerous because it prevents positive steps being made to cope with change. The centrality of country houses to notions of Britain's heritage – especially the emphasis on preserving them 'alive', complete with a family in residence – allows him to present heritage as not just backward-looking but as deeply reactionary (2). He suggests that these claims, which have been fostered by the National Trust, are a con-trick perpetrated on behalf of aristocratic owners (and, of course, those ex-owners who continue to reside in Trust houses). This ties in with Hewison's conception of heritage as essentially false, a nostalgic illusion opposed to the true understanding of the past that is history (3). (Each of these numbered points will be addressed in the following three paragraphs).

◆◆

Against this bold thesis, a number of other commentators have sounded a cautionary note. In particular, they have pointed out that the association of heritage with national decline and a resultant loss of confidence does not provide an adequate explanation, not least because it is a global phenomenon characteristic of the USA (for example) no less than Britain. More recent analyses of heritage have tended to place less weight on decline as an explanation and instead emphasize the broad economic and cultural trends that have allowed nostalgia to thrive in the (post)modern world. The celebration and exploitation of national or regional traditions, for example, can be understood as an affirmation of a local identity in reaction to globalization.[3] These observations still leave open the question as to whether heritage in Britain (if not elsewhere) is a fundamentally malign and reactionary force, as critics such as Hewison argue. Such a claim has been contested by the left-wing social historian Raphael Samuel, who insists on its democratic credentials as a truly popular movement. Indeed, he turns the tables on 'heritage-baiters' by accusing them of an élitist disdain for the ways in which ordinary people seek to make sense of the past. He comments that they tend to describe heritage as 'vulgar' and dismiss heritage sites as 'theme parks' (Samuel, *Theatres of Memory*, pp.260–2). However, Samuel's arguments are not much use to us here since he makes his case by playing down the role of the country house in British heritage.

We need, therefore, to address the specific claim that a view of heritage centred on the country house serves, in the words of one critical commentator, to uphold 'a particular ideology through the promotion of images of ruling-class style' (Walsh, *Representation of the Past*, p.82). The National Trust, in particular, has faced accusations that its properties are celebrations of the aristocracy encouraging deference among their visitors. In recent years, however, such criticism has been partially deflected by the hugely popular opening up of kitchens and other below-stairs areas in increasing numbers of its properties following the success of Erddig, a country house in North

[3] For the trend towards 'globalization' and the exploitation of the industrial and commercial heritage, see Case Study 7. For the debate up to the early 1990s, see Lumley, 'The debate on heritage reviewed'.

Plate 129 The housekeeper's room, Erddig, Clwyd. Photo: The National Trust Photo Library, London/ Andreas von Einsiedel.

Wales (opened to the public in 1978), where the life of the servants was unusually well documented (Plate 129). For the heritage critic, however, this development may not represent genuine democratization but rather completes the sense of a 'community in which everybody had a nicely differentiated and proper place' (Wright, *A Journey through Ruins*, p.82). But need this be a cause for concern? According to Nick Merriman, the ideological interpretation of heritage is wrong in its assumption that visitors passively assimilate a set of reactionary values; his survey of attitudes to heritage suggests that even if they feel nostalgia for the past, they are unlikely to have any real wish to revive it (Merriman, *Beyond the Glass Case*, pp.40–1).

We also need to consider the claim that heritage is superficial and fraudulent, a glossy fake that has hardly anything to do with real history. It can be argued that this criticism applies primarily to the more populist and commercial side of the 'heritage industry', where wax figures, costumed guides and/or audio-visual shows are used to 'bring the past to life': a case in point being Warwick Castle, now owned by Madame Tussaud's (Plate 130). Certainly, it is important to distinguish (as Hewison failed to do) between this type of presentation and the more restrained and scholarly approach associated with the National Trust. Nevertheless, even though it avoids overt signs of marketing, the Trust has often been accused of packaging and prettifying the past: 'Some critics fear that the houses have become too standardized with identical shops, signs, tea-rooms, and with the same paints, wallpapers, chintzes and herbaceous borders like any branches of a multiple business' (Robinson, 'Past, present and future', p.92). Other commentators (such as Walsh) dismiss all country house tourism as hopelessly superficial, arguing that it constitutes merely another form of 'spectacle consumption'. From this perspective, the cult of the country house exemplifies the dangers of the whole

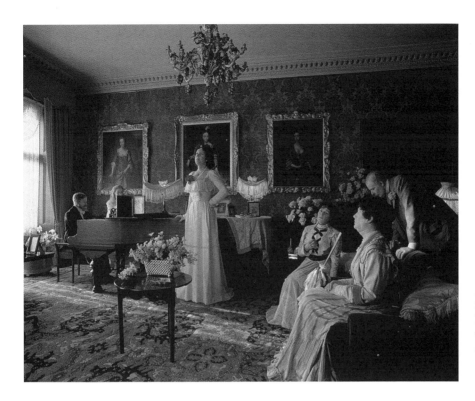

Plate 130 'The Music Room' in 'A Royal Weekend Party, 1898', attraction at Warwick Castle, Warwick.

heritage phenomenon which, in focusing attention on the 'surface' appearances of the past, works against 'depth' of historical understanding.[4] Such a determined suspicion of images and artefacts clearly makes this argument somewhat problematic for art history.

More thoughtful heritage critics accept that preservation is a legitimate concern: 'a genuine cultural responsibility, and a modern impulse that need not always amount to backwardness', in the words of Patrick Wright (*Guardian*, 12 January 1995). Wright also suggests that the National Trust can distance itself from the class bias that characterized it in the decades following the launch of its country house scheme. He has cited the recent restoration of Sutton House in the deprived London borough of Hackney as a sign that it is starting to return to its original concern for the needs of the urban poor. Elsewhere, complaints about the Trust's undemocratic character continue to be repeated, notably in Paula Weideger's *Gilding the Acorn* (1994), published to coincide with its centenary. At the same time, another strand of criticism has emerged in the conservative press. Having benefited from 'socialistic legislation', the National Trust (one journalist argues) 'has replaced family homes with palaces run by bureaucrats' who treat the former owners in a high-handed fashion. Country houses, in this view, should be in private hands, not 'nationalised ownership' (Charles Clover, *Spectator*, 2 November 1991, p.10). What links populist critics such as Weideger with their conservative counterparts is their common complaint that Trust properties have an unlived-in, museum-like quality: both claim that nothing can replace the instinctive

[4] In other words, for proponents of this view, the root of the problem lies in the very idea that the past can be 'brought to life' by means of objects alone, so it doesn't matter whether they are historically authentic or modern replicas.

know-how of aristocratic owners.[5] Conversely, those who consider this emphasis on preserving country houses as 'homes' to be both reactionary and unrealistic may positively endorse the process of 'museumization' (Mandler, *The Fall and Rise of the Stately Home*, p.417).

Art and the country house

As the above discussion has indicated, the conventional claim for the unique importance of the British country house is bound up with the idea that house, park and collection form a harmonious, 'organic' whole which has 'grown' over the centuries. Yet, where the collection remains in private hands, there is no guarantee that this historic ensemble will preserve its integrity. Ever since the late nineteenth century, when landowners first faced a sustained challenge to their economic position, they have found the sale of inherited works of art an invaluable source of funds. It was in response to the flow of masterpieces from country houses to collections abroad that the National Art Collections Fund (NACF) was set up in 1903. It secured its first great success in 1905 when it bought Velázquez's *Rokeby Venus* (so-called after the country house in which it formerly hung) for the National Gallery. As a voluntary organization that seeks to preserve and enrich the national heritage, the NACF is comparable to the National Trust. In 1976 it modified its charter in order to allow grants to be made for purchases for Trust properties (where the contents have remained the property of the original owners, for example).

Underlying this decision lies a significant shift in attitudes towards art and the country house. For most of the twentieth century, the prevailing assumption was that great paintings and sculptures were all that mattered and their proper place was the museum or art gallery. The country house, in which insignificant works compete for attention with masterpieces on densely hung walls, could only seem defective by these standards. Thus, in 1952 Anthony Blunt, Surveyor of the Queen's Pictures, rehung the paintings at Petworth House in Sussex (recently acquired by the National Trust) along the lines of an art gallery – that is, by thinning out the display so as to focus attention on the best works (Plate 131). He also grouped in the same room paintings that seemed, on art-historical grounds, to belong with each other instead of accepting the country house practice of mixing works of different schools and periods. Since then, a new scholarly interest in the history of patronage and collecting has sanctioned a belief that Old Master paintings and other works of art from country houses are usually best appreciated in the setting where they have hung for centuries and for which they may actually have been made. Reflecting these changed priorities, an attempt has recently been made to reconstruct the original hang at Petworth, returning the collection to the way it was displayed in the lifetime of the third Earl of Egremont, the great patron of Turner, partly on the basis of the artist's sketches of the interior (Plate 132).[6] In the process, Blunt's widely admired 'Turner Room' has been dismantled, occasioning some regret in its turn (at least in those who continue to prefer the gallery style of hang).

[5] The Historic Houses Association, an organization representing country house owners, maintains that they are best preserved in private ownership rather than by institutions.

[6] For a discussion of Turner's canonical status, see Case Study 5 in Perry and Cunningham, *Academies, Museums and Canons of Art* (Book 1 of this series).

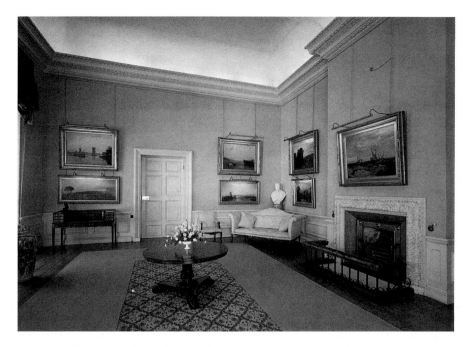

Plate 131 The Turner Room (formerly the Red Room), Petworth House,
West Sussex, photographed 1979. Photo: The National Trust Photo Library,
London/Jonathan Gibson.

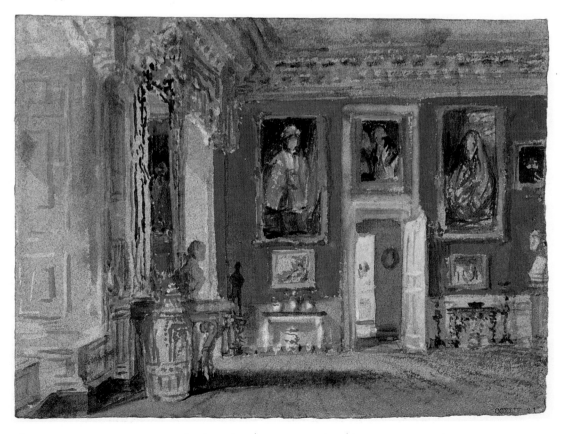

Plate 132 J.M.W. Turner, *Petworth: The Red Room*, *c*.1830, watercolour on blue paper, 14 x 19 cm, Tate
Gallery, London. Photo: © Tate Gallery, London.

Even within the museum world, however, these developments have had repercussions. Public collections have been displayed in the manner of a country house, with rich damask replacing plain colours on the walls and a much denser hang of two or even three tiers. The look of a grand domestic interior is completed by mixing pieces of furniture and sculpture in with the pictures (Plate 133). Timothy Clifford, the prime mover in these developments and director of the National Gallery of Scotland from 1984, justifies his approach by arguing that the public art gallery descends directly from the 'parade [or reception] rooms of a country house' (Gow and Clifford, *The National Gallery of Scotland*, p.55). The changes introduced by Clifford in Scotland are based on a concern for historical authenticity since the declared aim is to return the galleries to their original appearance, reversing the modifications that have been made since the mid-nineteenth century. Critics point out that this aim has not been consistently pursued and find the opulent effect both inauthentic and (in its air of exclusiveness) quite inappropriate to a public gallery. Whereas Clifford insists that picture-hanging is an art form, they dismiss him as an interior decorator. One commentator argues that such accusations ought to be modified in the light of the 'excitement and greatly increased audiences which Clifford's re-creations have generated'. Nevertheless, the same writer also notes that 'there is the danger that "a return to tradition" may become a debased part of the heritage phenomenon or an ossified arrangement too costly to replace' (Summerfield, 'Hanging matters', p.393).

While critics of the new trends in gallery decoration echo the wider heritage debate in viewing them as élitist and bogus, what most specifically concerns art historians is the way that this type of display subordinates the individual work of art to the demands of an overall decorative scheme. The top-most picture

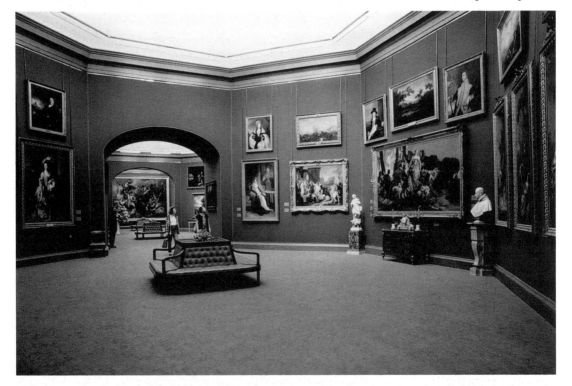

Plate 133 Interior of the National Gallery of Scotland, Edinburgh. Photo: The National Gallery of Scotland.

in a tier of three inevitably suffers from reduced visibility; thus, it is argued, a single-row hang is most appropriate in the case of major public collections. (By contrast, proponents of a denser hang emphasize the advantage of being able to have a greater number of works on display at any one time.) The fact remains, however, that even those galleries that have adopted a 'historic hang' usually allow for much closer scrutiny of most paintings than many a country house, where rope barriers prevent visitors from getting up close. The National Trust's adviser on pictures and sculptures, Alastair Laing, has written: 'we must reluctantly admit – individual pictures in certain houses cannot always be seen properly across rooms' (*In Trust for the Nation*, p.13). Arguments in favour of keeping works of art in their historical context have to be balanced against these sometimes difficult viewing conditions. When it comes to 'saving a painting for the nation', especially in the case of an Old Master which just happens to have been bought by an English collector, it is difficult to disregard the fact that museums and galleries are more easily accessible than most country houses, particularly to people who do not have a car.

The debate around country houses as 'heritage' was thrown into focus by a blockbuster show, *The Treasure Houses of Britain: Five Hundred Years of Private Patronage and Art Collecting*, staged at the National Gallery of Art in Washington, DC in 1985–6, which was curated by the late architectural adviser to the National Trust, Gervase Jackson-Stops. The catalogue made the case for the cultural significance of the country house in even more highly coloured terms than usual, characterizing them as 'temples of the arts' and 'vessels of civilization' (*Treasure Houses*, p.11). It served to encourage American tourism to Britain in general and country houses in particular, thus exemplifying Hewison's arguments about the contribution that 'heritage' is now expected to make to the nation's economy. Like any other blockbuster, *Treasure Houses* had a major business sponsor, cost a fortune to mount, and stimulated reams of media hype. With hundreds of works of art borrowed from mostly private owners and displayed in elaborate installations evocative of country house interiors, it presented a lavish spectacle (Plate 134). At the same time, a few commentators took issue with the nostalgic

Plate 134 Room 14, Waterloo gallery, *The Treasure Houses of Britain* exhibition, 1985–6, National Gallery of Art, Washington, DC. Photo: William Schaeffer.

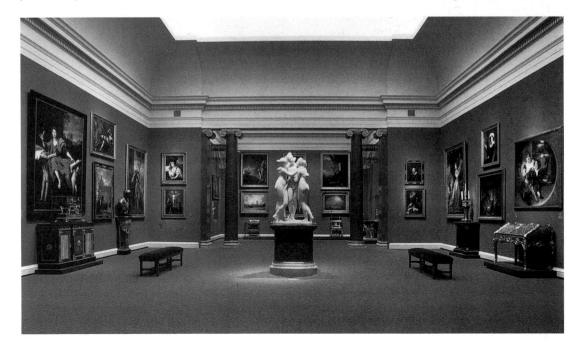

aura and sheer glamour that characterized the exhibition, pointing out its neglect of the harsh realities of political and economic power underlying the aristocratic patronage that it celebrated. 'The other side of the coin is worth remembering, even as one gapes,' declared Robert Hughes ('Brideshead redecorated', p.374).

In retrospect, the *Treasure Houses* exhibition (or rather the huge catalogue that is all that survives of it) stands less as a monument to the eighteenth-century heyday of the country house than to the boom years of the 1980s, during which 'the country house style' became high fashion in the United States while, in Britain, country house owners enjoyed a new lease of confidence. Even at the time, however, it was apparent that the exhibition would actually further undermine the integrity of historic collections by bringing works of art to the attention of potential American buyers. Indeed, Canova's *Three Graces* never returned to its former home at Woburn (Plate 135) but was sold to the Getty Museum in California and, after a long campaign to keep it in Britain, ended up in the shared ownership of the National Gallery of Scotland and the Victoria and Albert Museum. Above all, according to the historian David Cannadine (always sceptical of claims made on behalf of the aristocracy), 'this marvellous museum display is a quite devastating riposte to the claim that works of art are always best kept *in situ*' (Cannadine, 'Nostalgia', p.269). *Treasure Houses* provided 'the museum lobby' with 'the best evidence to date to support the acquisition and museum display of great works of art' (*Burlington Magazine*, editorial, June 1986). While 'the country house lobby' would obviously disagree, they have often had no choice but to accept this option in the face of a new wave of sales in the 1990s.

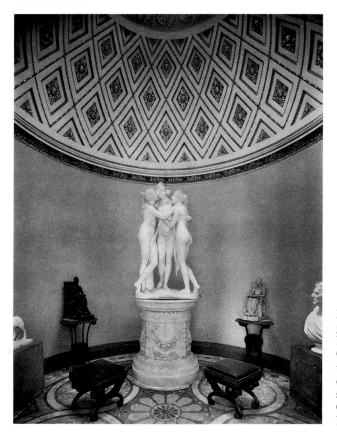

Plate 135 Sculpture gallery, Woburn Abbey, Bedfordshire, showing Canova's *Three Graces* in the space specially created for the sculpture. Photo: Country Life Picture Library, London.

Restoration and presentation

Not simply the picture hang but the whole interior of any country house is now expected to conform to the highest standards of historical authenticity. Here the shift has been away from the relatively casual approach of the post-war decades, when rooms would be redecorated primarily for the sake of appearances, to a much more cautious approach which insists that any change must be justified by historical evidence. In the light of these developments, it has become standard to disparage the restoration work carried out by the National Trust in the 1960s and 1970s on the advice of John Fowler, who had for many years been a fashionable interior decorator specializing in 'the country house style'. A good deal of the criticism about the 'homogenized' and 'prettified' character of its properties relates to his work. Today the Trust undertakes detailed research on its buildings and insists on its concern for historical accuracy. Nevertheless, many commentators argue that anachronistic notions of 'good taste' – aesthetics rather than authenticity – continue to prevail within the Trust.

To trace how approaches to historic interiors have evolved in recent decades, we need to start with Fowler himself. Although he brought a decorator's approach to the houses he restored for the National Trust, Fowler also took care to collect any scrap of evidence that would help him to reconstruct historical decorative schemes. He used 'scrapes' to uncover successive layers of paint and thus to discover the colours in which an interior had once been painted (though the more scientific methods in use today often reveal that what had been thought to be the original paintwork was no such thing). Fowler redecorated a number of houses that presented a particular problem because they had been acquired by the Trust with hardly any contents. At Sudbury Hall in Derbyshire (where no original paintwork survived), he decided to compensate for the bareness of the interior by devising colour schemes to emphasize its architectural features. The staircase hall, for example, was painted a strong yellow to contrast with the staircase, which Fowler thought should be white (Plate 136). When the restoration was completed in 1971, the former owner, Lord Vernon, complained that the Trust had drastically altered the character of the house in order 'to create an interior which they think, regardless of history, is aesthetically satisfying' (quoted in Jenkins and James, *From Acorn to Oak Tree*, p.272). Nevertheless, the effect has been widely admired and, so far at least, Fowler's work has not been undone.

During the same period, however, a more rigorous, academic approach was being pioneered by the Furniture and Woodwork Department of the Victoria and Albert Museum. Moving away from the traditional museum approach focused on individual objects, Peter Thornton (head of the department from 1966 to 1984) aimed to develop a new understanding of how furniture had been arranged in the past and, more generally, the way that historic interiors had been decorated and used. He and his colleagues were able to put their ideas into practice at Ham House in Surrey, a National Trust property then administered by the museum. Ham is exceptional in the richness of its documentation and also retains much of its original furnishings, so that an attempt to reconstruct its seventeenth-century appearance could be made without too much difficulty. In the 1970s the house was rearranged and

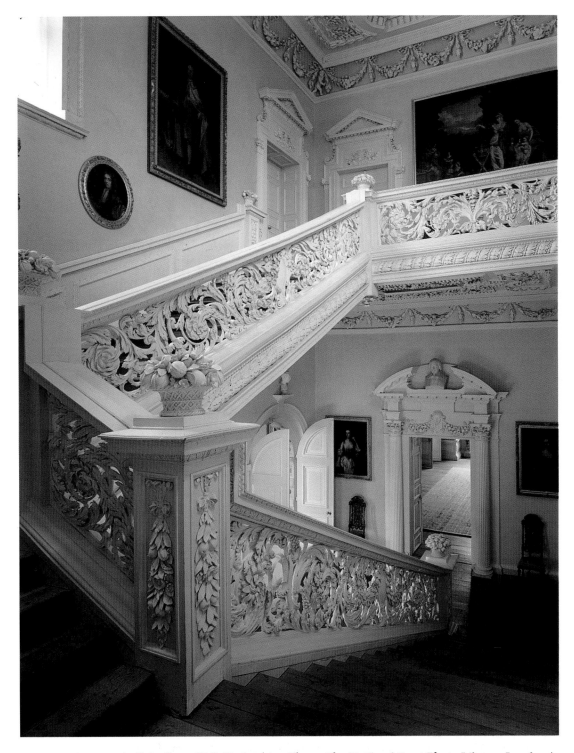

Plate 136 Staircase hall, Sudbury Hall, Derbyshire. Photo: The National Trust Photo Library, London / Andreas von Einsiedel.

Plate 137 Gallery (former dining room), Ham House, Surrey. Photo:
courtesy of Ian C. Bristow, with the permission of The National Trust.

repainted accordingly; an especially striking effect was created in the former
dining room on the first floor, which records showed had been painted a 'fair
blew' (Plate 137). However, this room could not be completely returned to its
seventeenth-century appearance because, at a slightly later date, the floor
had been pierced through in order to turn it into a gallery overlooking the
great hall below. This reveals the problems involved in any attempt to take a
house back wholesale to some earlier period even when, as here, it had
remained largely unchanged throughout the subsequent centuries.

The approach pioneered at Ham has the great advantage of bringing a sense of social history to bear on the visitors' experience of the house in order to make it more meaningful. It was, for example, arranged that the rooms would be seen in the correct sequence so that it would be possible to appreciate how the decoration increases in richness as you penetrate into the higher status rooms into which only the most important guests would have been admitted. The whole ensemble vividly demonstrated the political power of Ham's owners in the 1670s, the Duke and Duchess of Lauderdale. But unlike this couple who spent lavishly in order to turn it into a palatial residence fit for a royal minister, the V & A had to carry out its restoration on a restricted budget. In order to reinstate bedchambers that had lost their original hangings, there was no alternative but to use cheap modern imitations of what would have been the most luxurious textiles (Plate 138). The effect tended to be mean and garish rather than appropriately rich and opulent, regretted John Cornforth, an authority on country house architecture and decoration, who concluded that 'its appeal is to the mind rather than the eye' (*Country Life*, 29 January 1981, p.253). Where the money is available, however, expertise in the reweaving of historic textiles and related skills that have been developed in recent years can now be drawn on to carry out restorations along the lines of Ham but to greater visual effect.

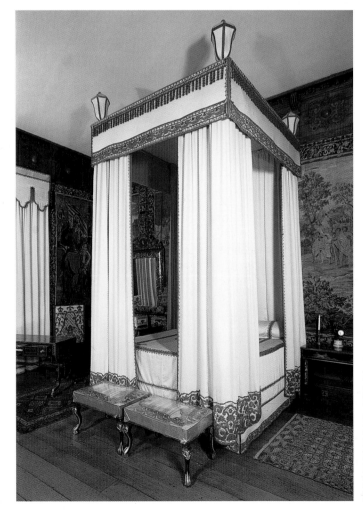

Plate 138 The four-poster bed in Lady Maynard's bedchamber, Ham House, Surrey. Photo: The National Trust Photo Library, London / John Bethell.

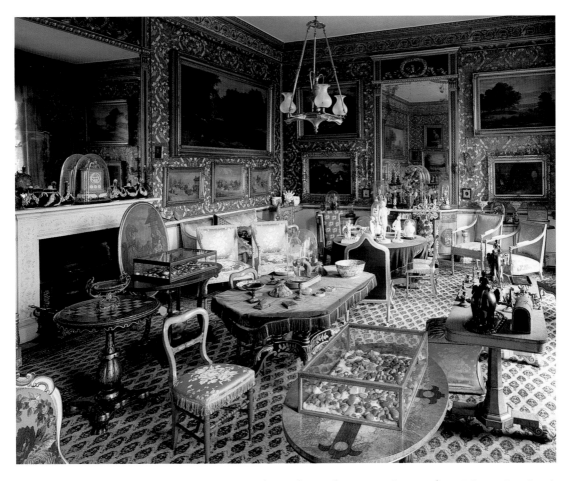

Plate 139 Drawing room, Calke Abbey, Derbyshire. Photo: The National Trust Photo Library, London/ Mike Williams.

Today, however, the prevailing philosophy is to leave things alone as much as possible, thereby respecting the integrity of a building that has evolved over the centuries. Such an approach is considered most appropriate to houses that enter the National Trust's possession straight from the hands of private owners, complete with their contents. (It has less relevance to houses like Ham where the interior has already undergone significant modifications while under institutional control.[7]) Even more than usual, it seemed to apply to Calke Abbey in Derbyshire, ancestral home of the eccentric Harpur-Crewe family, which was transferred to the Trust in 1985 with the help of the NHMF (Plate 139). In the process, this hithertho little known and architecturally undistinguished house achieved sudden fame as a unique survival of the past, 'a time capsule' (as the press invariably called it), on account of the sheer accumulation of possessions that it contained: from stuffed birds and

[7] Having taken over the management of Ham in 1990, the National Trust decided to dismantle much of the 1970s restoration. Since the house's current state lacked the authority of continued use in its original function as a residence, the Trust saw no particular reason to respect it and decided to present the house as it would have appeared at a later date in its history.

children's toys to a great State bed that had never even been put up. Despite the Trust's professed intention of leaving Calke untouched, some observers claim that it has destroyed the 'magical atmosphere' by tidying up the clutter. One architectural historian, for example, asserts that Calke has 'already been deprived of some of its unique tatty charm', complaining that the Trust presented the interiors not as they had been but as 'the public would expect to see [them]' (Parissien, 'The rights and wrongs of restoration', p.394). Nevertheless, this case undoubtedly represents a signficant shift away from 'good taste' towards an 'archaeological' approach (see below) on the Trust's part.

In the case of a building considered to be of exceptional architectural merit, however, the Trust stands against the prevailing tendency to respect the alterations of later periods. After Kedleston was acquired in 1987, it was decided to return the interiors to the time of their designer, Robert Adam, the most renowned of eighteenth-century British architects. Somewhat ironically, this has involved painting out the bright colours that were applied to the dining room ceiling in the 1970s, in accordance with a drawing by Adam (Plate 140). Recent research shows that this colour scheme was never actually executed, and the room has now been redecorated in the original white, green and mauve (Plate 141). Overall, the result has been to reinforce the austere monumentality of Kedleston, especially since pieces of furniture that had

Plate 140 Robert Adam, design for the ceiling of the dining room at Kedleston Hall, 1762, 37 x 50 cm. Photo: The National Trust Photo Library, London/Angelo Hornak.

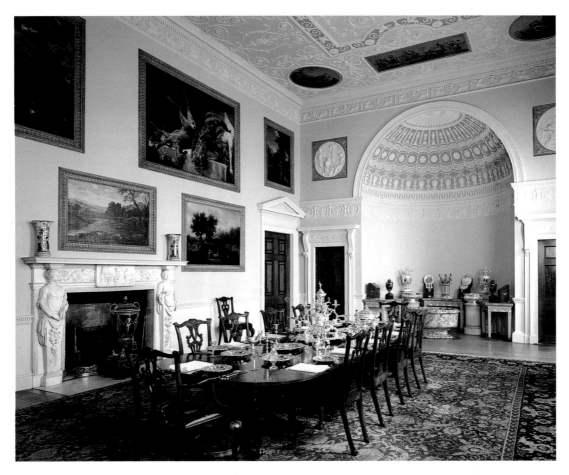

Plate 141 Dining room as it is now, Kedleston Hall, Derbyshire. Photo: The National Trust Photo Library, London / Nadia MacKenzie.

been added to the rooms since the eighteenth century were removed at the same time. The changes enraged the house's former owner, Lord Scarsdale, who accused the Trust of high-handedly obliterating its identity as 'a family home' for the sake of making it 'all 1760 Georgian' (*Independent*, 11 August 1994). In fact, the principal rooms in the central block of Kedleston were always intended primarily for show, with a separate wing for more informal occupation. Its aesthetic and historical interest as a masterpiece of neo-classical interior design is thus incompatible with popular fascination with the country house as a way of life.

On the basis of the above discussion, how might we explain why the National Trust receives so much criticism (it may be helpful to bear in mind the kinds of people who are doing the criticizing), and can you discern any specific factors to account for the standard complaints about homogenization, lifelessness, 'good taste', etc.?

Discussion

In the first place, it seems to me, the Trust is bound to attract criticism because it constantly has to make decisions about what to do with its buildings, while those who criticize (such as architectural writers) do not carry the same practical responsibilities. In addition, the antagonism of some of the former owners might have suggested to you that alterations are almost bound to be

resented by people who are used to the way things were before. Turning to specific complaints about the Trust, it is possible that those who complain that its properties have a bland and lifeless look might be failing to take account of such factors as Sudbury's loss of its contents or the fact that Kedleston has always been rather austere. In terms of the 'homogenization' complaint, it could be argued that the contrasting examples of Calke and Kedleston show that the Trust does not in fact impose exactly the same treatment on every house in its care. On the other hand, the complaints about Calke do seem to show that the Trust cannot help making things blandly over-perfect even when it tries not to. An advocate of an archaeological approach would probably argue that Kedleston should not have been singled out for a 'good taste' approach on the grounds of its supposed special aesthetic merit but, for the sake of consistency, been left as it was.

◆◆

Conservation versus restoration

The key conservation issue is the perennial problem of balancing preservation and access: how to ensure that people do not actually help to destroy the places they flock to see. In order to limit wear and tear, the National Trust maintains a policy of only opening its properties for six months of the year, even though this annoys people who want to visit them out of season. Tensions are exacerbated by an increasingly rigorous approach to conservation that involves covering the windows of Trust houses with blinds to protect textiles and other vulnerable objects from the light. A visitor to Knole in Kent, for example, complained about 'peering through the gloom resulting from a ridiculous attempt to preserve a mass of already faded and rotten fabrics by blocking most of the windows' (letter published in *Country Life*, 24 June 1993, p.98). In response to such complaints, the Trust insists that preservation must take priority as otherwise nothing will be left for future generations to see.

In many respects, conservation overlaps with presentation. The new 'archaeological' approach, which we touched on with reference to Calke, is based on the practical principle of 'conserve as found'. As well as ruling out changing colour schemes to make interiors conform to current taste and/or research, it also entails preserving the existing paint surfaces, only doing what is necessary to prevent further decay. Faded upholstery and worn carpets will also be left *in situ* so far as is possible. Paradoxically, this policy of minimum intervention may require huge amounts of painstaking work by skilled conservators, as at Brodsworth Hall in Yorkshire, which came to English Heritage in an extremely dilapidated condition and opened to the public five years later in 1995 (Plate 142).[8] In theory, this project represents an extreme of scrupulous neutrality, not only in taking as its object a Victorian house which would once have been considered too ugly to merit preservation but also in treating every element of the interior with equal

[8] English Heritage is a public body (established in its present form in 1984) with general responsibility for historic preservation; it also directly administers many ancient monuments and other properties, including a few country houses, and has a membership scheme based on the model of the National Trust.

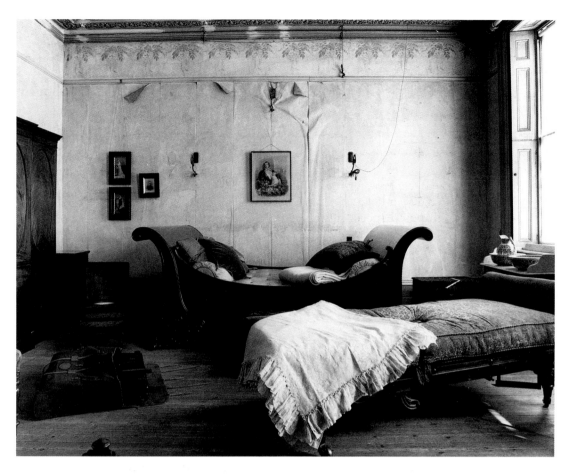

Plate 142 Bedroom no. 8, the 'Lit en Bateau' room, photographed 1996, Brodsworth Hall, nr Doncaster, Yorkshire. Photo: English Heritage Photographic Library.

respect, right down to alterations of the 1960s. In practice, however, it proved necessary to take account of 'visual balance'; as this indicates, even within the most rigorously 'scientific' conservation programme, it is impossible to avoid making subjective aesthetic judgements. 'In time,' one writer observes, 'our obsession with "conservation as found" may seem as much a question of fashion as the restoration schemes of previous generations' (Michael Hall, *Country Life*, 29 June 1995, p.60).

Arguments against comprehensive restoration and in favour of a much more conservative approach are not a recent development. In the later nineteenth century, concern about the remodelling of medieval churches carried out in the name of restoration led William Morris to found the Society for the Protection of Ancient Buildings (SPAB), which has continued since 1877 to oppose unnecessary tampering with historic buildings. Where repairs must be made, the SPAB argues, they should be clearly distinguished from the original fabric so that there can be no confusion between what is old and what is new. While this philosophy has been highly influential, it tends not to be so consistently or rigorously applied to post-medieval structures. Even at Brodsworth the conservative approach applied to the interior did not extend to the stonework of the exterior, which has been restored to a pristine condition

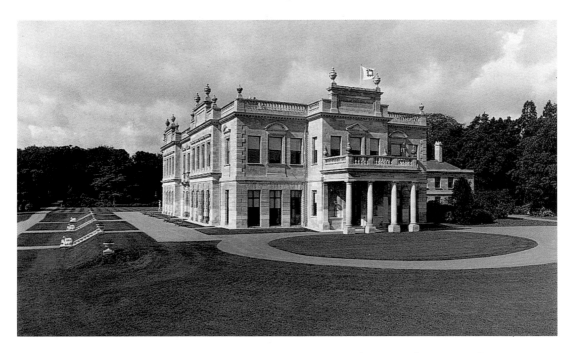

Plate 143 Brodsworth Hall, nr Doncaster, Yorkshire, east and south fronts. Photo: English Heritage Photographic Library.

(Plate 143). Particular difficulties were presented by the case of Uppark, a National Trust house in Sussex which was badly damaged by fire on 30 August 1989. The Trust had to decide whether to restore the house to its condition before the fire or to find an alternative solution. Although the problems presented by Uppark could hardly differ more from those at Brodsworth, what made it possible even to contemplate its restoration was the same kind of thorough archaeological approach which, in this case, led to many fragments of the interior being salvaged from the wreckage.

Below is a selection of quotations from the debate that followed the Uppark fire. Try to account for the different opinions being put forward. You will find it helpful to consider who the author is (for the first example), whether the quotation is from a letter or an article (if the latter, it can be assumed that the author is a professional architectural or design writer), and how long after the fire each of them is writing.

> Sir. The expressed intent to restore the fire-ruined Uppark house in Sussex surprises me. In these days of outrage at development of green-field sites, let alone a prominent one on a Sussex Downs hilltop, here is an ideal opportunity to demolish it altogether and to return the site to nature … In their assaults on vast acres of our countryside, were the yuppies of the 17th century so very different? Why should we allow time to confer legitimacy on *their* depredations?
>
> (David Martin, Conservative MP, *Times*, 6 September 1989)

> Sir. If the National Trust fails to rebuild Uppark, that dreamlike William and Mary house which has been tragically gutted by fire, it will lose much of its credibility as a guardian of the Nation's Heritage.
>
> (Mark Bence-Jones, *Daily Telegraph*, 7 September 1989)

It is virtually a foregone conclusion that Uppark will be rebuilt. But of course, it won't actually be Uppark, no matter how skilful the work of the 20th century craftsmen who seek to recreate it. What the tourists come to see will, in fact, be a replica, one which could be said to diminish those fragments that actually are authentic.

(Deyan Sudjic, *Sunday Correspondent*, 17 September 1989)

A series of simple clean well-designed rooms, not striving in any way for 18th century pastiche, could be created within the shell to display the furniture, pictures, ceramics and textiles collected by generations of the Featherstonhaughs.

(Anna Pavord, *Independent*, 27 September 1989)

… this drastic solution was based on ignorance … it became clear that a lot more had survived than was at first thought possible … the rebuilding of the ground-floor rooms would be a question of skilful repair rather than pastiche reproduction … this opportunity [to re-use salvaged fragments] must be seized, so that the recreated interior possesses the maximum authenticity.

(Dan Cruikshank, *Country Life*, 18 January 1990, pp.56–7)

… where the destruction is total (for example in the area of the stairs) serious consideration should be given to employing the very best architects and designers of our day to add their contribution to the continuing history of the building. In years to come this should make Uppark far more alive and interesting than a sterile copy of a vanished work of art. There is no reason why today's designers should not create something of great beauty that complements what survives of the Georgian interior.

(Philip Venning, *SPAB News*, vol.10, no.4, 1989, p.11)

When the exterior of Uppark is restored and its roof replaced it will still be possible to admire the same satisfying forms and proportions as it had before the fire … the design will retain, or regain, its integrity, which is why the suggestion [made by Sudjic and Pavord] that it should be made obvious by the restorers where the old fabric ends and new begins is patently not on; to draw attention to the contribution of the restorer in this way would be to place dogma above aesthetics … [With regard to suggestions for the interior] The fact is that we live in times of such stylistic confusion and uncertainty that to advocate the use of 'the very best architects and designers of our day' is liable to be a recipe for aesthetic disaster.

(Roger White, *Georgian Group, Report and Journal 1989*, p.16)

Discussion

The first writer represents a right-wing populist stance, appropriating the left-wing critique of heritage for its own very different ends. By contrast, the second (writing, like the first, to a conservative newspaper) represents the traditional view of heritage centred on the cult of the country house. Both Sudjic and Pavord echo the critique of heritage in their suspicion of faking and pastiche. The latter's proposal for creating new interiors in a simple, contemporary style reveals how this position is based on an essentially modernist belief that any building in a historical style is necessarily inauthentic. Both also show the influence of the SPAB's philosophy in suggesting that the joins between old and new work should be left visible. All these commentators were writing shortly after the fire in ignorance of the true extent of the damage. The others offer more informed opinions in the light of the Trust's decision to restore. Cruikshank, writing in the pre-eminent country house journal, basically supports restoration but with qualifications

about the way it should be carried out. The SPAB is naturally opposed but, modifying the position taken by Pavord, refers specifically to the worst damaged areas. The Georgian Group, which (as its name suggests) campaigns on behalf of eighteenth-century buildings, rejects the relevance of the SPAB approach to Uppark and, in its emphasis on the stylistic pluralism prevailing nowadays, challenges the modernist ethos of those opposed to restoration.

◆◆◆

In justifying its decision to restore Uppark, the National Trust could point not only to the survival of most of the contents but also to the existence of a detailed photographic record of the interior – as well as the simple fact that the insurance cover only allowed for facsimile reconstruction. Yet, even if these factors had not all applied, it would have been difficult for the Trust to opt for any other approach. For devotees of the English country house, Uppark represented something of an ideal. Not only was it built during a period that continues to be regarded by many as an aesthetic high point, but as a relatively modestly sized brick structure, it had a kind of doll's-house perfection that made it easy to perceive as a home (Plate 144). Above all, the interior had remained virtually untouched since the late eighteenth century, making Uppark (in a much repeated phrase) a 'sleeping beauty'. For Christopher Hussey, one of the pioneering generation of country house enthusiasts, it was 'the kind of house where you feel you might look through the window into the life of another age' (*Country Life*, 14 June 1941, p.520). Recent owners, including the National Trust on the advice of John Fowler, had restricted themselves to repairing and retouching, thereby anticipating the minimalist approach to conservation that prevails today.

Plate 144 Uppark, West Sussex, south front, post-restoration. Photo: The National Trust Photo Library, London/Matthew Antrobus.

In order to return the house to its condition 'the day before the fire', the Trust employed an army of craftsmen and women not only to remodel plaster ceilings and to replace woodwork (including the staircase which, in defiance of the SPAB, was rebuilt as an exact copy of the old one), but also to create new wallpaper to match the faded tones of the original red flock pattern and to repaint areas of wall in subdued tones to imitate the once white paintwork. The decision to recreate Uppark's shabby elegance was justified on grounds of 'visual unity', the need to harmonize the interior with its reinstated contents (Plate 145).[9] Visiting the house today cannot, however, be the same experience as it would have been before the fire. Instead of being a 'sleeping beauty', Uppark has become (in a new cliché) a phoenix reborn from the ashes. Predictably, the most enthusiastic response came from the pro-heritage camp.

Plate 145
Restored saloon, Uppark, West Sussex. Photo: The National Trust Photo Library, London/ Nadia MacKenzie.

9 A detailed account of the restoration is provided in Rowell and Robinson, *Uppark Restored*.

While Simon Jenkins declared that 'Uppark is more than a house restored. It is an argument won' (*Times*, 3 June 1995), opponents of the restoration remained unconvinced. Catherine Bennett termed it 'a fake, a fraud, a bloody imposture' and 'this elevated Disneyland', taking it as an occasion to condemn the National Trust once again for its 'love affair with the landed gentry' (*Guardian*, 27 April 1995). 'It makes little sense to knock the National Trust for the superb work it has carried out at Uppark,' rejoined Jonathan Glancey, 'for the Trust is simply part of a world of make-believe that most of us want' (*Independent*, 2 June 1995).

Conclusion

The Duchess of Northumberland, an inveterate eighteenth-century sightseer who kept a diary of her travels (which provided useful evidence for the restoration of Kedleston), wrote out a long questionnaire to remind herself of the things she should look out for when visiting any country house. Beginning with 'what is the situation of the House good or bad, sheltered or exposed', she goes on to 'who was the Architect', 'Is there a fine Collection of Pictures' and so on (quoted in *Treasure Houses of Britain*, p.15). Although the aristocratic world of the country house has now largely vanished and, in any case, was never a way of life that would have been available to most of us,[10] we could always take a hint from the duchess and devise our own questionnaire as a guide to country house visiting.

Look back over this case study and consider what kind of questions might be appropriate when visiting a country house today.

Discussion

These are some I came up with. First, is the house privately owned or does it belong to the National Trust or some other organization? If the latter, how long ago did it cease to be private property, and was public money involved in the transfer? Is there still a family in residence, and do they actually occupy any rooms which the public are admitted to? Do they emphasize that this is a 'home' with family photographs, etc.? Does the tour of the house include any below-stairs areas and, if so, how long have these been open to the public? Is there a 'theme park' approach with costumed guides, etc., or do we just rely on a guide book or equivalent in going round the house? Do most of the original contents remain, or has much been removed? In particular, have any important works of art been sold? Does the house date from a single period, or have extensive changes been made since it was built? Is it presented in historical terms with reference to a past way of life, or is there more emphasis on its survival into the present? Has it been subject to a major restoration/conservation project at any stage?

◆◆◆

Of course, what matters in the end is not so much the questions but the answers we come up with. What needs to be emphasized is that the attitudes adopted towards country houses necessarily depend on the person doing

[10] The survival of the country house in the second half of the twentieth century has most recently been discussed in Cornforth, *The Country Houses of England, 1948–98*.

the looking and asking, varying according to their age, class and gender and, more specifically, their taste in art, interest in history (or lack of interest) and, of course, political outlook.[11] The biggest question of all remains the validity of 'national heritage' as a concept and a cause. Here, the important point is that it is not a single, static entity; as David Cannadine has commented of the National Trust, 'Inevitably and rightly, [it] has adjusted its preservationist priorities and redefined the "national heritage" in every generation' (Cannadine, 'The first hundred years', p.22). For the Trust itself, the crucial issue is how far it can succeed in replacing the aristocratic outlook of the past with a truly democratic approach. So far attempts to do so have primarily consisted of re-emphasizing its commitment to the natural environment and of acquiring different types of buildings (most famously Paul McCartney's childhood home in Liverpool). However, it can be argued, there is still much that could be done to make the country house visit not just a pleasurably nostalgic experience but also aesthetically and historically meaningful.

References

Cannadine, David (1989) 'Nostalgia' (reprint of 1985 exhibition review), in *The Pleasures of the Past*, London, Collins, pp.256–71.

Cannadine, David (1995) 'The first hundred years', in Howard Newby (ed.) *The National Trust: The Next Hundred Years*, London, National Trust, pp.11–31.

Cornforth, John (1998) *The Country Houses of England, 1948–98*, London, Constable.

Girouard, Mark (1978) *Life in the English Country House*, New Haven and London, Yale University Press.

Gow, Ian and Clifford, Timothy (1988) *The National Gallery of Scotland: An Architectural and Decorative History*, Edinburgh, National Gallery of Scotland.

Hewison, Robert (1987) *The Heritage Industry: Britain in a Climate of Decline*, London, Methuen.

Hughes, Robert (1990) 'Brideshead redecorated' (reprint of 1985 exhibition review), in *Nothing if Not Critical*, London, Collins-Harvill.

Hunter, Michael (ed.) (1996) *Preserving the Past: The Rise of Heritage in Modern Britain*, London, Alan Sutton.

In Trust for the Nation: Paintings from National Trust Houses (1995) exhibition catalogue, London, National Trust in association with National Gallery Publications.

Jenkins, Jennifer and James, Patrick (1994) *From Acorn to Oak Tree: The Growth of the National Trust 1895–1994*, London, National Trust.

11 On the question of gender, it can be noted that Raphael Samuel accuses heritage critics of misogyny since 'in the attacks on the commodification of the past so much animus is directed against what is almost entirely a female gift culture – pot pourris and toiletries, of the kind on sale at the National Trust gift shops' (Samuel, *Theatres of Memory*, p.267).

Lumley, Robert (1994) 'The debate on heritage reviewed', in Roger Miles and Lauro Zarala (eds) *Towards the Museum of the Future: New European Perspectives*, London and New York, Routledge, pp.57–69.

Mandler, Peter (1997) *The Fall and Rise of the Stately Home*, New Haven and London, Yale University Press.

Merriman, Nick (1991) *Beyond the Glass Case: The Past, the Heritage and the Public in Britain*, Leicester University Press.

Parissien, Steven (1991) 'The rights and wrongs of restoration: interpreting the past', *Apollo*, vol.134, December, pp.394–7.

Robinson, John Martin (1991) 'Past, present and future: country houses and the National Trust', *Apollo*, August, pp.90–3.

Rowell, Christopher and Robinson, John Martin (1996) *Uppark Restored*, London, National Trust.

Samuel, Raphael (1994) *Theatres of Memory: Past and Present in Contemporary Culture*, London, Verso.

Summerfield, Angela (1991) 'Hanging matters: the revolution in the display of national collections', *Apollo*, vol.134, December, pp.387–93.

Tinniswood, Adrian (1989) *A History of Country House Visiting: Five Centuries of Tourism and Taste*, Oxford, Blackwell and the National Trust.

The Treasure Houses of Britain (1985) exhibition catalogue, Washington, DC, National Gallery of Art.

Treasures for the Nation (1988) exhibition catalogue, London, British Museum for the National Heritage Memorial Fund.

Walsh, Kevin (1992) *The Representation of the Past: Museums and Heritage in the Post-Modern World*, London and New York, Routledge.

Weideger, Paula (1994) *Gilding the Acorn: Behind the Facade of the National Trust*, London, Simon and Schuster.

Wright, Patrick (1985) *On Living in an Old Country*, London, Verso.

Wright, Patrick (1991) *A Journey through Ruins: The Last Days of London*, London, Radius.

Contemporary art in Ireland, part one: institutions, viewers and artists

NICK WEBB AND EMMA BARKER

Introduction

> We all learn from the social environment, artists, curators, non-artists, non-curators. One of the things that we have inherited is the idea that there is a separation between art and society. That has been the dominant theory, but I think it is now being successfully challenged, or at least questioned and debated. Under that challenge lies the possibility of raising another, related point: we are not just consumers of some sort of cultural product, we live our lives culturally. The world is legible and people can read the world, we make value judgements all the time. We live by process, if you like.
>
> (McGonagle, 'A new necessity', pp.63–4)

This case study outlines some of the conditions in which art is produced and viewed in contemporary Ireland. It should be read in tandem with the following case study, which examines the work of two contemporary Irish artists, Alice Maher and Willie Doherty. The reason for pairing these case studies together is that (as the above quotation suggests) art does not only exist in some special realm of its own, but can also be understood in broader, cultural terms. As the next case study shows, the preoccupations of Irish artists include questions of personal, political and cultural identity, an awareness of the environment in the widest sense, and a concern with social critique. These preoccupations alone do not constitute a specific reason for considering Irish art: they have played an important part in mainstream international art for several decades. What is particular to Ireland is the relatively late formation of a contemporary art world comparable to that of New York or London. This means that it is still possible to see how the different interests – artists, audiences, critics, public and private galleries, and government institutions – contribute to that formation.

Art in Ireland: general conditions

A significant issue for any consideration of contemporary Irish art is the political division of the island. While Northern Ireland is part of the United Kingdom with a semi-autonomous administration, the rest of Ireland is an independent republic. Each thus has a separate administrative structure for the arts: the Arts Council of Northern Ireland (ACNI), which was constituted out of the earlier Council for the Encouragement of Music and the Arts in 1962, and its 'southern' counterpart, An Chomhairle Ealaion (ACE), which was established in 1951. Both are based on the British model of the Arts Council, which embodies the 'arm's length' principle of arts funding; its purpose is to prevent political interference in and manipulation of the arts.[1] Their basic remit is to support artistic quality and innovation, along with

1 On the Arts Council, see Case Study 4. The acronym ACE is also applied to the Arts Council of England, the main successor body to the original Arts Council of Great Britain.

democratization and decentralization. Rightly or wrongly, this model of arts funding has been persistently subject to charges of lack of democratic accountability which in turn reflect the inherent tensions in their roles between the promotion of the arts and the representation of the public. The visual arts sections of the Arts Councils serve in an advisory capacity, as funding distributors (to galleries and other organizations and also to individual artists) and as the co-ordinators and promoters for particular projects. Both councils also have collections that aim to offer a representative cross-section of current artistic practice and are available for loan to public institutions.

In practice, however, the political division of Ireland has less impact on artistic practice than you might assume from the separate bureaucracies. Artists' activities are not restricted by the border; an artist may be resident in one country and exhibit in the other. Artists' organizations, such as the Sculpture Society of Ireland (SSI) or the Association of Artists in Ireland (AAI), extend across the island. Similarly, art students and tutors from either country may work at the University of Ulster in Belfast, the National College of Art and Design in Dublin, or the Crawford College of Art in Cork in the south-west. Moreover, the two Arts Councils not only pursue similar policies but also have a close working relationship. A number of projects are supervised jointly – for example, 'Artflights', which allows individual artists to travel abroad for free for professional and/or creative purposes. Promotion of Irish artists abroad is a shared objective, though whereas the North comes under the remit of the British Council, there is no equivalent body for the Republic.[2] As part of a one-off promotional exercise, *L'Imaginaire irlandais* (the Irish imaginary), held in 1996, a group of Irish artists (including Doherty and Maher) exhibited in Paris and worked on placements in regional centres around France; it was jointly organized by French institutions and by the Irish Ministries of Arts and Foreign Affairs, with advice from ACE.[3]

The extent to which the whole island constitutes a single art world is also evident from *Circa*, the main Irish art magazine, which receives funding from both Arts Councils. Founded in 1981, it is now published quarterly and has a circulation of about 3,000 copies (including overseas subscribers). This compares with 15,000 copies sold by the bimonthly London art magazine, *Frieze*. Like any other art magazine, *Circa* contains exhibition reviews, more discursive articles, short news items, and advertisements for exhibitions. It plays an important role not simply in evaluating and publicizing contemporary Irish art, but also in investigating the specific conditions (including the ways that they differ between North and South) that affect the production and reception of art in Ireland: 'It is an understanding of these conditions which will enable Irish artists to be judged on their own merits, to take their places on a wider stage as equals, and not as reflections of this or that international fashion' (editorial, *Circa*, Autumn 1992, p.15). No other publication offers comparable coverage (attempts to produce more 'grass-roots' alternatives have been unsuccessful). *Circa* can thus be seen as the 'official' house journal of the contemporary Irish art world. Seeking to balance orthodox opinion with anti-establishment polemic, it is directed at an informed art-world readership. As elsewhere, a wider audience is reached through art criticism in newspapers as well as general arts coverage in the mass media.

[2] For the role of the British Council in supporting exhibitions abroad, see Case Study 4.

[3] Doherty had previously represented Ireland at the Venice Biennale in 1993, Maher at the São Paolo Biennale in 1994.

Public interest in the visual arts has grown significantly in recent years. In 1992, for example, the total number of public and private galleries in Ireland, North and South (population five million), numbered just over 180, double the number of ten years before.[4] The commercial sector remains small by comparison to art markets in other countries so that public institutions have to assume a greater responsibility for showing new work and attracting new audiences. Nevertheless, the demand for contemporary Irish art has grown considerably with the emergence of a new class of private collectors (especially in the Republic as a result of increased prosperity). A number of corporate collections have also been established: for example, by the Bank of Ireland and Ulster Television.[5] As elsewhere, figures for attendance at art exhibitions in Ireland indicate that it is a middle-class, minority pastime. They also show that attendance at contemporary art exhibitions among all social groups was approximately half the number of visitors to museum and galleries of earlier art. The contemporary art world relies on the professional involvement, financial commitment and / or strong aesthetic convictions of a comparatively small number of people. However, institutions that receive public subsidy need to attract as wide an audience as possible, including those who are uninterested in or even hostile to contemporary art. We can focus this issue by reference to the work of Maher and Doherty, both of whom have received Arts Council funding; from the point of view of an Irish taxpayer, you might agree with their selection, object to it, or decide that it is none of your business.

Art in the North: the Orchard Gallery, Derry

A model for bridging the gap between high art and the public at large has been provided by the Orchard Gallery in Derry. In the summer of 1991, for example, it helped to organize a series of events, installations, videos, workshops and residencies under the umbrella title of *Available Resources*. The site-specific work included a video made with the help of a primary school, a performance in a funeral parlour, and a series of drawings made of women workers in a shirt factory. The programme concluded with a public debate about the work. *Available Resources* was symptomatic of the achievements of Declan McGonagle, who had been appointed director of the newly founded Orchard Gallery in 1978. McGonagle not only managed to attract a range of international artists (including Richard Hamilton from England and Leon Golub from the United States) to exhibit at the Orchard, but also established a role for the gallery in the local community. Fundamental here has been an emphasis on taking art out of the gallery (as in *Available Resources*), which McGonagle has said that he prefers to call 'social' (rather than public) art on the grounds that it implies 'use rather than ownership'.[6]

4 This figure comes from Finlay, *A Guide to Exhibition Venues in Ireland*, pp.7–8.

5 Corporate art collections are intended to enhance a company's public image through the gloss of patronage and also to provide a more agreeable working environment for their employees. Many banks and other businesses in Western Europe and North America have such collections.

6 In other words, 'social art' is to be distinguished from conventional public sculptures which have tended to be erected by councils or other authorities, sometimes with little or no consultation, and have often aroused violent reactions in the local community; for a discussion of Antony Gormley's controversial *Angel of the North*, see the Introduction to Part 3. Gormley also attracted considerable hostility with his earlier *Sculpture for Derry Walls* (1987), which was placed in a location in the city imbued with strong historical and political associations.

He has sought to challenge the conventional barriers of the art world: 'this idea that you can't be local and international at the same time, or that you can't be professional and also engage with the voluntary or the non-professional at the same time without compromising either' (McGonagle, 'A new necessity', pp.63–4). This notion of a local/global dialectic departs from previous models of 'community art', which viewed the professionalism of the international art world as irrelevant to its goals of access and participation.[7]

While the policies adopted at the Orchard can be most readily understood in terms of McGonagle's personal achievement in promoting public access to contemporary art, it is also important to locate the gallery in the specific context of Derry. The population of the city is divided between Catholics and Protestants (its official name of Londonderry is avoided by many because of its Unionist connotations). These divisions have found visual expression in the sectarian wall murals that have been painted round the city (an example of non-professional artistic practice). Under Nationalist control since 1973, the City Council spends more of its budget per head on the visual arts than any other urban centre in Northern Ireland.[8] From 1986 to 1990 McGonagle was its visual arts officer with continuing responsibility for the Orchard, which is funded by the council; the gallery's outreach activities expanded as part of the council's commitment to community art projects.[9] A sense of the politics of place has informed the Orchard's programmes: this concern reflects the contested nature of Derry's 'community'. McGonagle organized residencies that provided artists, both Irish and foreign, with an opportunity to engage with the city and its conflicts. More recently, the current director of the Orchard, Liam Kelly, curated *Language, Mapping, Power*, an exhibition dealing with surveillance, control and the semantic links between words and images, held in Paris as part of *L'Imaginaire irlandais*. As the following case study shows, these concerns are central to the work of the Derry-based Doherty. Both he and Maher have had exhibitions at the Orchard.

The Orchard also needs to be considered as part of the contemporary art scene of Northern Ireland as a whole. It is one of a number of galleries subsidized by ACNI, which is the smallest Arts Council in the UK but has a larger provision per head than the English one.[10] While most of its budget comes directly from the British government, ACNI also receives funds from local sources; this makes it more answerable to the taxpayers of the region. ACNI was restructured in 1995, and the remit of the visual arts section now covers a wide range of art forms, including craft and film. In the same year, as the result of an ACNI initative, the Ormeau Baths Gallery opened in Belfast;

[7] For comparable local/global projects taking art out of the gallery, see Case Study 4.

[8] For an explanation of the 'Nationalist' and 'Unionist' labels, see the following case study. 'Derry' is used here only for consistency with the next case study and carries no political connotations.

[9] Between 1984 and 1986 McGonagle was director of exhibitions at the Institute of Contemporary Arts (ICA) in London; in 1987 he became one of only two curators ever to be nominated for the Turner Prize on the basis of his work in Derry.

[10] In 1994–5 per capita expenditure in England was £3.83, Scotland £4.65, and Northern Ireland £4.11. See *Towards the Millennium*, p.95. The ACE per capita expenditure for 1994 was Ir £3.80. Both the UK and the Irish Republic devote considerably less of their total public expenditure to the arts than do other European countries.

housed in a former public baths, it is much larger than the Orchard, which occupies a modestly-sized basement space. As such, it not only receives a larger share of ACNI funding but also rivals the Orchard in terms of media attention and the range of prominent artists it can attract from abroad. Belfast (as the principal city of Northern Ireland) boasts a greater number of exhibition venues, including Catalyst Arts (an artist-run space) and the Fenderesky Gallery (a commercial gallery partly funded by ACNI), both founded in 1984. However, Belfast City Council lagged behind Derry in its visual arts provision, only appointing an arts officer in 1993. (Some councils have been understandably more diffident about financial commitments to the visual arts through taxation rather than lottery funding.) Belfast's new support for the arts is associated with an economic development/urban renewal programme.[11]

Art in the South: the Douglas Hyde Gallery, Dublin

Dublin, as you might expect, offers the greatest concentration of art galleries in the Republic of Ireland. Exhibition venues for contemporary art include the Douglas Hyde Gallery, which opened in 1978. The gallery occupies a 1960s wing of Trinity College Dublin, and originally supervised the college's collection of modern art. During the 1980s, benefiting from increased funding from ACE, it developed a high reputation as an international showcase for a new generation of Irish artists. 'By placing exhibitions of high quality work by Irish artists alongside carefully selected exhibitions by international artists, the Hyde attempted to challenge the notion of the periphery as something defined by the centre' (Walsh, 'The Douglas Hyde', p.24). In 1990 the Hyde staged a series of exhibitions under the umbrella title *A New Tradition: Irish Art in the 1980s*, with a substantial catalogue. The project had a mixed reception, however; Fionna Barber, for example, argued that the representation of women artists could be regarded as tokenism given the gallery's poor record of holding one-person shows by women over the last decade (Barber, 'The Hyde and women's art').[12] Furthermore, the Hyde's claim to be the foremost gallery of contemporary art south of the border was challenged by the opening of the Irish Museum of Modern Art (IMMA) in 1991.

The Hyde now needs to define its aims and identity in relation to IMMA and other Dublin galleries. Although it receives a fifth of IMMA's funding, it benefits from a prime location in the city centre, whereas the museum is located two miles away on the western edge of Dublin. The Hyde's daily average of around 200 visitors exceeds that of IMMA. Its modestly-scaled, purpose-built, modernist gallery space also offers a strong contrast to the building occupied by IMMA, the former Royal Hospital Kilmainham, which is not obviously appropriate to the display of modern art.[13] Under the

[11] For a discussion of this type of project, see Case Study 7.

[12] There had, however, been a group exhibition of *Irish Women Artists* in 1987.

[13] Ireland's first major classical building, the hospital was built for British Army veterans in the seventeenth century. The architectural and cultural legacy of the colonial past is inseparable from contemporary art in Ireland; 'heritage' issues have been extensively discussed in *Circa* over the years.

directorship of Declan McGonagle, IMMA has not sought to build up a major collection of historical modern art in the same way as MOMA or the Tate (though this area is represented thanks to gifts and long-term loans), but acquires more affordable work from living (mostly Irish) artists, stages exhibitions and has an outreach programme.[14] In response, the Hyde has developed a distinctive approach to contemporary art under its director, John Hutchinson, who on his appointment in 1991 wrote that he hoped 'to curate and host shows which deal with [historical] identity and [spiritual] transformation' (Hutchinson, 'On the record', p.21). The latter concern is exemplified by the *Kalachara Sand Mandala* (1994), which was created in the gallery by Tibetan Buddhist monks. Speaking in February 1996, Hutchinson said that it had been his most popular exhibition to date in terms of visitor numbers (interview with N. Webb). The Hyde frequently functions as a venue for one-person exhibitions, balancing Irish and foreign artists.[15] Maher and Doherty have both exhibited there; Maher's 1995 exhibition at the Hyde, *familiar*, formed part of her commendation for the Glen Dimplex Award, the Irish equivalent to the Turner Prize.[16]

The Hyde occupies a particular niche within Dublin's contemporary art scene. Primarily catering for an informed audience, it too has sought to widen access through an educational and community programme. (An example of this commitment was the *Crios* exhibition of March–April 1998, in which two German artists worked in the gallery alongside local disabled children.) It thereby contributes to the richness and diversity of the city's visual arts provision, complementing IMMA: as we have seen from earlier case studies, the existence of a museum of modern art is now crucial to civic and national pride.[17] Dublin also boasts a 'cultural quarter', Temple Bar, which, like similar quarters elsewhere, has increasingly become a tourist and leisure district rather than one in which artists live and work. Contemporary art venues here include Temple Bar Studios (an artist-led space), the Project Arts Centre, and Arthouse (a multi-media centre).

At the same time, however, the dominant role of Dublin as a magnet for contemporary artists has been counterbalanced by new regional developments. In Cork a number of artists' initiatives have been set up, such as the Cork Artists' Collective, established in 1985. Cork has now been designated as a 'centre of excellence' for the visual arts, ensuring its priority for additional funding, such as the European financial support for the enlargement of the Crawford Municipal Gallery. By such means, ACE is endeavouring to fulfil its commitment to decentralization, which for the visual arts may have only limited success. Tensions between rural and urban cultures

[14] In any case, the Hugh Lane Gallery in Dublin already houses a collection of modern art.

[15] The latter have included José Badia (1996), whose monochrome acrylic paintings, sometimes combined with photographs, explore aspects of his Kongo-Cuban cultural identity using a transcultural range of symbols. Badia was one of the artists included in *Magiciens de la Terre* (see Case Studies 4 and 6).

[16] Maher, however, is reported to have said that 'she sees irony in the fact that while she survives on a FAS scheme, most of her international peers who have exhibited at the Douglas Hyde can make a good living from art' (interview with Kay Sheehy, *Irish Times*, 10 January 1995). (Foras Áiseanna Saophair (FAS) is an Irish government training scheme.)

[17] IMMA was set up at great speed in order to be ready for Dublin's year as European City of Culture. It is not funded by ACE but is directly responsible to the arts ministry.

remain in the Irish Republic. Historically defined as a rural, Catholic nation, it has recently seen a sharp growth in the urban population and challenges to the patriarchal authority of church, state and family, especially from the women's movement (symbolic of these shifts was the election of Mary Robinson as the Republic's first woman president in 1990). These issues inform the work of Maher, herself from Cork but since 1992 resident in Dublin.

Conclusion

What similarities and differences can you discern between the Orchard and the Hyde?

Discussion

Both provide a venue for displaying contemporary Irish art alongside international work. Neither of them is a national institution (the one being a municipal gallery, the other a college gallery), and each has perhaps been somewhat overshadowed by the arrival on the scene of a major art institution with a similar remit in the same 'catchment' area. However, whereas the Orchard's connection with Derry Council means that it needs to maintain an extensive outreach programme, the Hyde is not answerable to a particular local community to the same extent and puts less emphasis on outreach. While its more specialized approach might be viewed as less accessible, it could also be justified by the Hyde's prominent position culturally and geographically within the Republic's capital city. In their different ways, however, the work of both these galleries indicates how a curator-director (respectively, McGonagle and Hutchinson) can develop an exhibition programme that expresses a particular aesthetic vision.

◆◆

A common concern that emerges from this case study is with the perception of contemporary Irish art as 'peripheral' or 'marginal' in relation to 'international' art as it is produced and consumed in the metropolitan centres of the West. As we have seen, such perceptions are being challenged by the development of an increasingly sophisticated art infrastructure with exhibiting practices and promotional strategies comparable to those elsewhere. At the same time, as the statements of McGonagle and *Circa* magazine reveal, it is acknowledged that it is important both for artistic practice and for art criticism not to neglect the particular circumstances of Ireland. As mentioned at the start of this case study, one way of understanding these is in terms of identity, a theme in the work of both Maher and Doherty. In the Republic this can be understood in terms of a 'post-colonial' condition; this means that Irish artists are able to explore issues which have resonances for other countries with the same cultural status. Similarly, while Northern Irish artists may have been preoccupied with the effects of social conflict, a 'critical regionalism' has developed in which local concerns are expressed through techniques and ideas with a wider significance. To quote McGonagle again: 'I have found in Derry that the more opportunities I have created for artists … to engage with Derry, its location and its meanings, the more international the programme has been understood to be' ('A new necessity', p.65).

References

Barber, Fionna (1991) 'The Hyde and women's art', *Circa*, 58, July / August, pp.34–6.

Finlay, S. (ed.) (1992) *The Guide to Exhibition Venues in Ireland*, Dublin, Arts Council.

Hutchinson, John (1991) 'On the record', *Circa*, 56, March / April, p.21.

McGonagle, Declan (1990) 'A new necessity' (interview), *Artscribe*, Summer, pp.63–8.

Towards the Millennium: A Strategy for the Arts in Northern Ireland (1995) Belfast, Arts Council of Northern Ireland.

Walsh, Kieran (1991) 'The Douglas Hyde: a short history', *Circa*, 58, July / August, pp.20–5.

Contemporary art in Ireland, part two: Alice Maher and Willie Doherty – location, identity and practice

FIONNA BARBER

Introduction

In this case study I want to look at some works by two contemporary Irish artists, Alice Maher (b.1956) and Willie Doherty (b.1959). My aim is to examine the ways in which certain aspects of location can have an effect on an artist's practice: that is, through a focus on the significance of the cultural and historical aspects of where a work is made. These two artists are also particularly interesting for our purposes in that their work has been widely exhibited both within and outside Ireland. In 1994 Maher represented Ireland at the São Paolo Biennale, while Doherty's work has been shown extensively in Britain, Ireland and the United States. Both artists also participated in the major touring exhibition *Distant Relations* (1994–7), a highly ambitious project which brought together Irish, Mexican and Chicano (Mexican-American) artists in an investigation of the effects of post-colonialism on issues of cultural identity. In this study, however, I want to concentrate on two areas: first, some work exhibited by Maher at the São Paolo Biennale in 1994 which was subsequently part of the exhibition *familiar*, held in the Douglas Hyde Gallery in Dublin and various venues in England in 1995–6. Second, Doherty's video installation entitled *The Only Good One is a Dead One*, which was one of the submissions for the Turner Prize in 1994.

Alice Maher: gender and cultural identity

Look at the reproduction of Alice Maher's work entitled *familiar I* (Plate 146). How would you describe this work in terms of both its means of construction and its subject-matter? Can the two components be said to have any effect on each other? (You should pay close attention to the physical dimensions of the work here.) Is there any significance of the materials used in this piece?

Discussion

familiar I is a composite piece made up of a painting with an accompanying object. On first appearance, these probably look very different from each other in terms of the meanings that can be ascribed to them by us as viewers; one is a figurative painting, while the other is difficult even to define as sculpture in that it is made out of long strands of flax hanging from a wooden stake attached to the wall of the gallery. However, when we look more closely, links between the two components become more apparent. In the centre of the large red canvas there is a very small image of a girl with her arms folded and her hair streaming upwards; once we have identified this, the concern

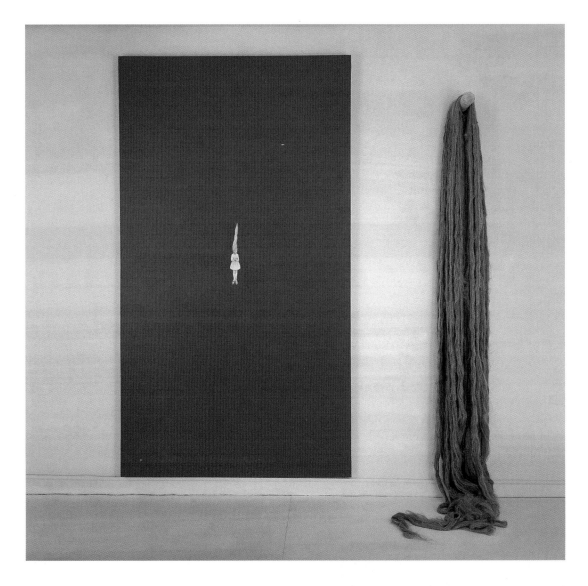

Plate 146 Alice Maher, *familiar 1*, 1994, acrylic on canvas, flax and wood, 250 x 250 cm, Irish Museum of Modern Art, Dublin. Photo: courtesy of Alice Maher.

with qualities of hair now seems to be echoed by the suspended flax. Each element of the work clearly determines the meaning of the other, and indeed the height both of the hanging flax and of the canvas itself in relation to the size of the figure within it raise questions of scale and proportion. This has a further significance in terms of how we read the work. Which is the norm: are the tresses of flax gigantic, or is the image of the girl minuscule?

◆◆◆

In this exercise I've singled out just one example of the body of work by Alice Maher known collectively as *familiar*. This concern with the combination of disparate elements is one that characterizes the work as a whole. *familiar III* (Plate 147), for example, is also comprised of a large canvas with a small central motif accompanied by a constructed flax object. (Even in *familiar I* we can describe the object as 'constructed'. Despite its appearance of being unpremeditated, decisions have been made about the height at which the stake is driven into the wall, the length and arrangement of the flax, and its distance from the canvas.) And again in *familiar III* the central image is a

small female figure, this time basking in front of a fire on top of what could be either an isolated mountain top or an iceberg. Many other works by Maher also contain images of the female figure. The earlier series of drawings entitled *The Thicket* (1990) depicts young girls either singly or in pairs; rather than just playing, they appear to be engaged in a series of investigations into the properties of inanimate objects (Plates 148 and 149). Some of the more obvious concerns in Maher's work would thus seem to be with the construction of femininity or with issues of narrative and fantasy; the bringing together of two seemingly unconnected elements to create a composite meaning would also seem to refer to such historical precedents as that of Surrealism. The question is, however, what do both the range of issues and the type of materials either used or referred to mean in terms of cultural identity and the significance of location?

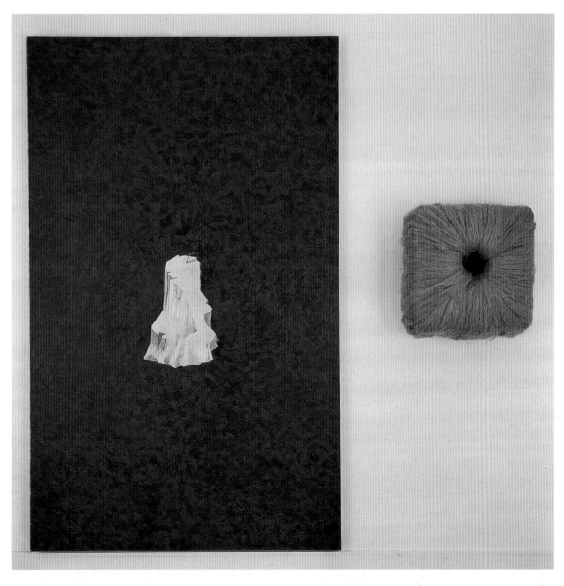

Plate 147 Alice Maher, *familiar III*, 1994, oil and acrylic on canvas, flax and light steel, 250 x 250 cm, The Crawford Gallery, Cork. Photo: courtesy of Alice Maher.

Plate 148 Alice Maher, *The Thicket*, 1990, charcoal and collage on paper, 140 x 112 cm, Huizinge Collection, Ireland. Photo: courtesy of Alice Maher.

Plate 149 Alice Maher, *The Thicket*, 1990, charcoal and collage on paper, 140 x 112 cm, private collection, Ireland. Photo: courtesy of Alice Maher.

The investigation of the construction of different aspects of feminine identity through an exploration of both narcissism and fantasy has been a consistent focus within Maher's practice since the mid-1980s. An early example of this work is the mixed media collage *Icon* (1987) (Plate 150). This depicts an image of the Virgin Mary, arms outstretched in a gesture of benediction and protection derived from the fifteenth-century Italian painter Piero della Francesca's *Madonna of the Misericordia* (Plate 151). But despite the collaged jewelled cross that covers her torso, this is not a typical image of the Virgin: her facial features are distorted, almost monstrous, and the foetus she carries is clearly visible. Both comical and threatening, *Icon* thereby draws attention to the Virgin's pregnancy as a physical process – something generally not acknowledged within Catholicism's construction of a perfect and unattainable femininity. Religion has been a major force shaping the lives of Irish women, especially in the South, where the position of Catholicism as the state religion has led to its control of education and the banning of contraception, abortion and, until very recently, divorce. In common with many women artists in Britain and elsewhere, Maher's concern here was with the unravelling of ideologies of femininity that structure the lived experience of women within a given culture. But what is distinctive is that for Maher – as for other women artists working in Ireland – these wider feminist concerns are given a more specific cultural identity through being shaped within a specifically Irish context. This is the case also in subsequent works such as *The Thicket*, where the investigation of childhood femininity is carried out in a rural setting where vegetation and ambivalent objects play their part, and it is significant here that Maher's childhood was spent on a farm in County Tipperary. But within this series the treatment of materials also begins to acquire a thematic significance; the gradual emergence of identity through play and experimentation is consciously reinforced through Maher's treatment of the surface of these drawings. Although in places collaged and layered with different marks, the surface is also rubbed and scraped. And in making these works, Maher has stated that the process of penetration to another layer suggests revealing 'the vastness of the space that lies within a woman's head' (Alice Maher quoted in Barber, 'Unfamiliar distillations', p.15).

This thematic significance of both subject-matter and materials is carried through to the later piece *familiar I*, where both flax and hair become significant in relation to issues of cultural identity. For Maher, these are ambivalent materials capable of being worked physically in many ways, just as they carry different levels of meaning. The flax in *familiar* is no longer in its natural state, but it has not yet become thread. Despite being the raw material of 'Irish' linen, it is imported into Ireland from Belgium. In *familiar*, teased into various sculptural forms, it acquires a further significance in that these are evocative of the reductive forms of Minimalism, itself a form of art practice associated primarily with the work of American practitioners such as Carl Andre or Eva Hesse in the mid-1960s.[1] There are similarities for Maher in the significance of hair within a given culture. Hairstyles are one of the means whereby women define their identity, yet they are often produced within other cultural contexts and given specific meaning through their adaptations

[1] For a discussion of the work of Eva Hesse, see Case Study 10 in Perry, *Gender and Art* (Book 3 of this series).

Plate 150 Alice
Maher, *Icon*, 1987,
mixed media
collage on paper,
30 x 21 cm,
private collection,
Ireland. Photo:
courtesy of Alice
Maher.

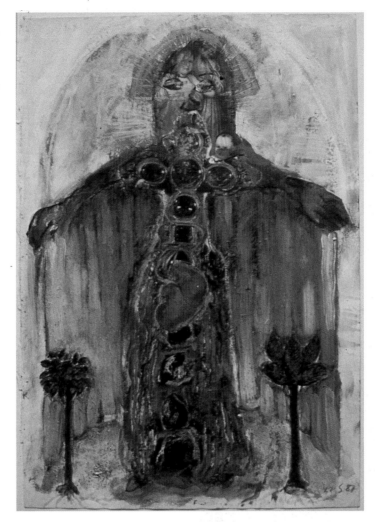

Plate 151 Piero della
Francesca, *The Madonna
of the Misericordia*,
1460?, panel, 134 x 91
cm, Palazzo Comunale,
Borgo San Sepolcro.
Photo: Alinari.

by individuals, dependent on preference and history.[2] Flax is also a pliant, natural material that acquires its cultural significance through being worked into linen – a recognizable signifier of Irishness. But for Maher the significance of hair goes further than this analogy. She makes this clear in some notes to accompany an earlier 'hair piece' entitled *Folt* (Plate 152), which she defines as meaning in Irish 'abundance, weeds, tresses, forests of hair':

> The image and arrangement of hair plays a role in the formation of gender and cultural identity. The many different meanings ascribed to hair – particularly women's hair – as a culturally significant material are a central part of numerous themes in Western folklore, mythology, and consciousness … [Irish] is our own language, yet we do not speak it … English strains to denote the nuances that are everywhere in this familiar language that we recognize but cannot speak … The language of Irish and the language of hair are both embroiled in a dense thicket of history which involves the construction and loss of identity, as well as vast entanglements of shifting meanings.
>
> (Alice Maher quoted in Ziff, *Distant Relations*, p.123)

To a certain extent, the relationship between the English and Irish languages, or the complex process of merging visual forms from 'outside' with aspects of Irish identity (such as ruralism or the role of Catholicism in determining gender identity), can be seen as part of a process known as *hybridization.* This is a term that has recently gained popularity within cultural theory as a means of explaining certain features of post-colonial societies such as the Republic

Plate 152 Alice Maher, detail of *Folt*, 1993, oil on paper, sewing pins, 125 x 103 cm, collection of the artist.

[2] See, for example, the mention of Mangbetu women's hairstyles in Case Study 6, p.149.

of Ireland.[3] Hybridization tends to take place some time after independence from colonial rule has been gained; in cultural terms it involves artists and writers in attempts to negotiate types of identity not possible previously, mixing elements from indigenous cultural history with those from 'outside' – usually from within the colonizing culture. The result is neither one nor the other – a hybrid. We should be careful here. It's not as simple as merely trying to say something about 'the role of flax in the Irish economy in the style of Minimalism'. More accurate would be to see works such as *familiar I* as multivalent: rich in the associations raised by different types of representation and materials, and the evocation of a many-layered gendered identity produced within the broad context of post-colonial Irish culture. What is more, it would be facile to equate the forms of art referred to by Maher with the former presence of Britain. Nevertheless, Surrealism or Minimalism can be identified broadly under the label of 'international modernism', in relation to which art produced in Ireland has historically been regarded as peripheral and derivative.

Willie Doherty and the politics of everyday life

The cultural characteristics of Ireland as a certain type of location have a clear significance in relation to the work of Alice Maher, but in Willie Doherty's photo and video works these become much more specific. Even within such a small island as Ireland, the cultural and political contexts that inform the work of these two artists are in some ways radically different. Maher works within the Republic of Ireland, a post-colonial society that has had to come to terms with its historical legacy in many different ways; Doherty works in Northern Ireland, which is still part of the United Kingdom. In Northern Ireland the continuing conflicts are often incomprehensible to outsiders, and this is not the place to attempt an explanation. It's important for this study, nevertheless, to be aware that what appear to be simple religious differences between Catholic and Protestant also involve deep-rooted political allegiances; those who want a united Ireland (Nationalists and Republicans) tend to be mainly Catholic, while those who want to remain part of the United Kingdom (Unionists and Loyalists) are mainly Protestant. Within these allegiances a crucial role in shaping people's knowledge of everyday reality is played as much by interpretations of the historical past as it is by the experience of more recent conflict. In this context, location acquires a particular significance, whether as the site of a violent 'incident' or more prosaically as an area known to be either Protestant or Catholic; the majority of working-class people in Northern Ireland tend to live in areas segregated by religion.

It is upon this terrain – the intersection of highly specific notions of location and the political – that the work of Willie Doherty situates itself. Although it has become more difficult to identify individual locations in his more recent work, Doherty's photoworks of the 1980s drew upon the specific characteristics of the city of Derry, where he lives and works. Territorial distinctions are very clearly defined in Derry by the River Foyle that divides

[3] A useful discussion of hybridization within Irish culture, and which also discusses the work of Alice Maher, can be found in Gibbons, 'Unapproved roads: post-colonialism and Irish identity', pp.56–67. For a brief general discussion of the concept of 'hybridity' in post-colonial theory, see the Introduction to King, *Views of Difference* (Book 5 of this series).

the city. Immediately to the west lies the border with the Irish Republic – also known colloquially throughout Ireland as 'the South'. The Catholic majority of the city's population tend to live west of the river, many of them crammed into the public housing schemes of the Bogside and the Creggan, while the main Protestant community is confined to the east bank, the Waterside. Territorial differences even apply to the name of the city: 'Derry' to Nationalists and 'Londonderry' to Unionists, stressing the link with Britain. In addition to its long historical significance, Derry has also been the site of some of the key moments in Northern Ireland's more recent political conflict; most notoriously in 1972 thirteen unarmed civilians were shot dead by the British Army on what became known as Bloody Sunday.

A photowork by Doherty from 1988, *The Other Side*, depicts a panoramic view of the city of Derry (Plate 153). The superimposed text shows up the ambivalent nature of political identities that help to determine lived reality in such a situation. The Catholic west bank of the River Foyle can be largely identified with the Nationalist political allegiances to a United Ireland alluded to in the statement 'West is South', yet this also refers to the proximity of the border. The communities of the Protestant east bank, meanwhile, tend to perceive their identity as part of Northern Ireland, staunchly independent of any Nationalist intervention. Each term, and its range of associations, clearly defines the other's parameters. This work draws upon the highly specific nature of political identities that define the nature of public space within the city, but other works relate to more covert forms of political activity that are equally relevant. The diptych *Protecting* and *Invading* (1987) deals with the issue of surveillance. In *Protecting* (Plate 154), it's unclear who is watching: a paramilitary or a member of a British Army patrol.

Doherty's work has evolved in relation to the contested nature of political identity within Derry, but it has also developed in relation to the visual *representations* of political conflict that have saturated media coverage of the struggles in Northern Ireland since 1968. These construct an account of 'the Troubles' that is far from objective, usually relying on a few conventional stereotypes (such as 'victim' or terrorist') which they in turn perpetuate while

Plate 153 Willie Doherty, *The Other Side*, 1988, black and white photograph with text, 61 x 152 cm. Photo: Matt's Gallery, London.

Plate 154 Willie Doherty, *Protecting*, 1987, black and white photograph with text, 122 x 183 cm. Photo: Matt's Gallery, London.

claiming to provide a 'true' picture for readers and viewers. Willie Doherty's work, by comparison, takes up a position very different from attempts to sensationalize the everyday experience of political conflict, although frequently, as in *Protecting*, it engages with the same subject-matter. His practice also has what the writer Jean Fisher has described as 'a critical and dialectical relation with the codes of newspaper reportage' rather than ignoring the ways in which these images are produced.[4] One piece where this is apparent is a slide installation entitled *Same Difference*, shown at Matt's Gallery in London in 1992 (Plate 155).[5] The same image of a young woman rephotographed from a television news broadcast is projected on to two walls of the gallery, with a sequence of words superimposed on top of it. On one wall these repeat the familiar stereotypes of Irishness – 'barbaric' or 'murderer' – while on the other she is identified in the eulogistic terms of Irish republicanism – 'heroic' or 'volunteer'. Each sequence contains some identical words – 'wild' or 'mythical' – with the possibility that these may be projected simultaneously. In each case the image itself is unaltered, but its meaning shifts in accordance with the way it is 'framed' by the accompanying text; a key aspect of this type of work is to make us conscious of how we are manipulated as viewers.[6]

[4] *Willie Doherty: The Only Good One is a Dead One*, p.4. In this essay Fisher also discusses Doherty's work in terms of hybridization.

[5] Matt's Gallery is an exhibition space in the East End of London which provides opportunities for artists to make experimental, often site-specific works. Founded and run by Robin Klassnik, it is an independent venture bridging the public and private sectors.

[6] The photograph was actually of Donna Maguire, who had been arrested in Holland in 1992 under suspicion of IRA activities.

Plate 155 Willie Doherty, *Same Difference*, 1992, installation view, Matt's Gallery, London, Arts Council Collection. Photo: Willie Doherty, courtesy of Matt's Gallery.

A further feature of this work is to emphasize the banalities of daily existence – a strategy which shows that everyday life in many parts of Northern Ireland is very different from elsewhere. The video installation *The Only Good One is a Dead One* (1993) is a work that engages with the specificity of daily routine to great effect (Plates 156 and 157). Video itself is a practice that has been increasingly used by many artists from the early 1980s onwards both for its technological potential and its ability to explore issues difficult to address within more traditional media. As an installation, this piece was designed initially for a specific location, Matt's Gallery in London, and subsequently restaged in the Tate Gallery for the 1994 Turner Prize. In the stills included here, the oblique angle of the image framed by the surrounding space indicates that we are looking at a photograph of a video projected on to the gallery wall. In this case two video tracks are projected simultaneously on to different walls of the gallery, accompanied by a voice-over lasting for slightly less time than the videos. One effect is to reduce any sense of sound and vision working together to produce a coherent narrative. Here the disjuncture between the two is reinforced by the spectator's need to shift position continually to view the two projections. One effect of this disorientation is a sense of unease, emphasized by the content of the video and audio tracks. One projection is a hand-held 'point of view' shot from the inside of a car driving repetitively down a country road at night, with the lights of a city glimpsed in the distance, accompanied by the sound of a car engine. The other is a similar shot from inside a car but this time static, watching the occasional comings and goings on a city street at night lit only by street lights. The voice-over, spoken by a young man with a Northern Irish accent, also offers two perspectives: one of a man targeted for assassination and the other of his killer.

Plate 156 Willie Doherty, *The Only Good One is a Dead One*, 1993, double screen video projection with sound, installation view, Matt's Gallery, London. Photo: Edward Woodman, courtesy of Matt's Gallery.

Plate 157 Willie Doherty, *The Only Good One is a Dead One*, 1993, double screen video projection with sound, installation view, Matt's Gallery, London, Collection of Weltkunst Foundation. Photo: courtesy of Alexander and Bonin, New York and Matt's Gallery, London.

In what ways can *The Only Good One is a Dead One* be seen to carry issues of both subject-matter and the means of representation from the earlier *The Other Side* and *Protecting*? For this exercise you should both look at the stills from the video and read the accompanying text in the Appendix (pp.250–1), which is a transcript of the voice-over.

Discussion

All of these works use what could be termed as non-traditional media – either photography or video – and within which a spoken or written aspect plays an important part in determining the meaning of the piece. *The Only Good One* also shares with *The Other Side* a sense of everyday normality in the view of the city or the speaker's regular journey to work. Beyond these initial appearances the situation is very different, either in the sense of political loyalties not visible from the outside or in the paranoia of the victim realizing that he is being stalked. *The Only Good One* has more in common with *Protecting* here in the impossibility of working out either the speaker's identity or his politics – whether as victim or gunman. There is also a similar concern with covert surveillance in the continuous observation of the urban street. The lack of definition in the image of the country road is similar to the problems in pinning down a specific location for *Protecting*: here, however, the insecurity indicated in the voice-over adds to a sense of menace in the face of the victim's imminent assassination. Finally, all of these works display a concern for the means of their representation. The combination of image and text in the earlier photoworks helps to make viewers more conscious of how they are reading these images. Something similar takes place in the latter part of the voice-over as the victim imagines the filming of his own death. This, I think, further reduces the potential sensationalism of this scene; it becomes difficult to read it as part of the cinematic narrative of a thriller, for example.

◆◆◆

Although rooted in a specific political context, one of the characteristics of Doherty's work is that it is far from parochial. The use of video actually reinforces this, in opening up a range of emotional responses arguably absent from the earlier work. Both the unconscious familiarity of a daily routine and the sense of displacement and paranoia in *The Only Good One is a Dead One* are accessible to viewers whose lives take a very different course to that depicted here. Yet this is not something that dissipates the meaning of these works; it draws us back, rather, into a consideration of the everyday realities of political situations within which works such as these are produced.

Conclusion

The work of Alice Maher and Willie Doherty engages with issues of location in very different ways and with very different results. In the case of Maher this involves a diversity of practices including painting and drawing in addition to collage and installation. In Maher's usage, however, this range of practices has a common concern with issues of cultural identity as gendered: in this case, what it means to be female in Ireland. Willie Doherty's practice, by comparison, is more closely confined to photography and video

installation. This restriction in the means of representation provides a valuable way of addressing the problematic issues of cultural identity in Northern Ireland through an examination of the clichés of 'the Troubles' as seen in the mass media. Finally, though it is difficult to make generalizations from looking at the work of only two artists, it should be clear by now that contemporary Irish art practice engages with a range of different cultural identities rather than being confined to one position alone.

Appendix

I worry about driving the same route every day … Maybe I should try out different roads … alternate my journey. That way I could keep them guessing.

I don't remember now when I started feeling conspicuous … A legitimate target.

I've been watching him for weeks now. He does the same things every day … Sadly predictable, I suppose. The fucker deserves it.

We've known about him for a long time but we've been waiting for the right moment. Waiting for him to make a move.

I keep thinking about this guy who was shot … I remember his brother said, 'We were sitting having a cup of tea watching the TV when I heard this loud bang at the front door … We both jumped up to see what it was, he was nearer the door than me and got into the hall first … But by that time the gunman was also in the hall and fired three or four shots directly at him … point-blank range … I'm a lucky man because then he panicked and ran out to the street where a car was waiting for him.'

Sometimes I feel like I'm wearing a big sign … 'SHOOT ME'.

As far as I'm concerned he's a legitimate target.

The only good one is a dead one.

If I'd had the shooter earlier I could have had him a dozen times. Dead easy! … I've walked right up behind him, looked straight at the back of his head … He was wearing a checked shirt and faded jeans … He didn't even notice me and I walked straight past him.

I'm certain that my phone's bugged and that someone is listening to my conversations … Every time I lift the receiver to answer a call I hear a loud click … as if someone else is lifting the phone at the same time … I'm not imagining it because some of my friends also hear this strange noise when they call me … I think my killer is ringing to check if I'm at home.

He reminds me of someone …

Maybe someone I went to school with.

I feel like I know this fucker. I know where he lives, his neighbours, his car … I'm sick of looking at him.

I saw a funeral on TV last night. Some man who was shot in Belfast. A young woman and three children standing crying at the side of a grave … Heartbreaking.

One morning, just before I left home at half six, I heard a news report about a particularly savage and random murder … That's how I imagine I will be shot … as I drive alone in the dark I visualise myself falling into an ambush or being stopped by a group of masked gunmen … I see these horrific events unfold like a scene from a movie … I was very relieved when dawn broke and the sky brightened to reveal a beautiful clear winter morning.

He drives the same road every day, buys petrol at the same garage … It'll be easy. No sweat!

I can't stop thinking about the awful fear and terror he must have felt … Maybe it was so quick he didn't know a thing.

I can almost see myself waiting for him along the road … It's fairly quiet so it should be safe to hide the car and wait for him as he slows down at the corner. A couple of good clean shots should do the job.

This particular part of the road is very shaded. Tall oak trees form a luxuriant canopy of cool green foliage … The road twists gently and disappears at every leafy bend.

As my assassin jumps out in front of me everything starts to happen in slow motion. I can see him raise his gun and I can't do a thing. I see the same scene shot from different angles. I see a sequence of fast edits as the car swerves to avoid him and he starts shooting. The windscreen explodes around me. I see a clump of dark green bushes in front of me, illuminated by car headlights. The car crashes out of control and I feel a deep burning sensation in my chest.

In the early morning the roads are really quiet … You can drive for ages without passing another car … the landscape is completely undisturbed and passes by like some strange detached film.

It might be just as easy on the street … I could wait until he's coming out of the house or I could just walk up to the door, ring the bell and when he answers … BANG BANG! … Let the fucker have it.

It should be an easy job with a car waiting at the end of the street … I've seen it so many times I could write the script.

In the past year I've had so many irrational panic attacks … There is no reason for this but I think that I'm a victim.

I worry about driving the same route every day … Maybe I should try out different roads … alternate my journey. That way I could keep them guessing.

I don't remember now when I started feeling conspicuous … A legitimate target.

(*Willie Doherty: No Smoke Without Fire*, pp.8–10)

References

Barber, Fionna (1995) 'Unfamiliar distillations', in *Alice Maher: familiar*, exhibition catalogue, Douglas Hyde Gallery Dublin and Orchard Gallery Derry.

Gibbons, Luke (1995) 'Unapproved roads: post-colonialism and Irish identity', in Trisha Ziff (ed.) *Distant Relations: Chicano, Irish, Mexican Critical Art and Writing*, New York, Smart Art Press, pp.56–67.

King, Catherine (ed.) (1999) *Views of Difference: Different Views of Art*, New Haven and London, Yale University Press.

Perry, Gill (ed.) (1999) *Gender and Art*, New Haven and London, Yale University Press.

Willie Doherty: No Smoke Without Fire (1996) exhibition catalogue, London, Matt's Gallery.

Willie Doherty: The Only Good One is a Dead One (1996) exhibition catalogue, catalogue essay by Jean Fisher, Saskatoon, Edmonton and Mendel Art Gallery.

Ziff, Trisha (ed.) (1995) *Distant Relations: Chicano, Irish, Mexican Critical Art and Writing*, New York, Smart Art Press.

Conclusion

EMMA BARKER

In this book we have primarily been concerned with the display of works of art in museums and galleries. We have examined not only the proliferation and expansion of these institutions, but also the diversification of the displays that they present and of the functions that they are expected to fulfil. We have considered these developments as part of a general trend towards popularization and commercialization that has been both welcomed as democratization and condemned as 'spectacle'. A recent article entitled 'Glory days for the art museum', for example, qualified its up-beat tenor by acknowledging concerns that the vogue for blockbusters and the rise of marketing reduce art to the level of entertainment and compromise the future of institutions (Judith H. Dobryzinski, *New York Times*, 5 October 1997). While the case studies here tend to suggest that art retains a unique prestige that continues to set it apart from other forms of display (like the theme park), its prestige could ultimately be undermined by these developments.

One of the recurrent themes of this book has been the extent to which the established canons of art, both traditional and modernist, have been challenged by new display practices. Several of the case studies have shown that there has been a significant expansion of the boundaries of official taste as even mainstream institutions have begun to collect and exhibit contemporary and 'non-western' art. Equally, it has been shown that such displays can (sometimes) attract substantial audiences. However, the weight of the evidence hardly seems to demonstrate that the special status and popular appeal of the most renowned artists have been undermined to any significant extent. Indeed, a survey of British taste in art commissioned for the New York-based Russian artists Vitaly Komar and Alexander Melamid found that 41 per cent of those questioned chose (from a list of nine names) Constable as a favourite artist, 34 per cent Monet, 31 per cent Van Gogh, 25 per cent Turner and 16 per cent Picasso, with living artists the least popular (reported in the *Independent*, 14 September 1998). Although apparently conceived as a bit of a joke, the survey confirms the difficulty that museums face in trying to bring new and unfamiliar art to a wide audience.

Above all, this book has shown how the notion of the museum as a sacred space dedicated to the timeless and universal values of art has persisted in the face of the many mutations that art institutions have undergone in recent years. As such, they have remained largely resistant to the critical concerns that have emerged within academic art history over the past few decades. Some of the case studies here have noted that certain museums and exhibitions have not done as much as they could have done to question conventional notions of 'genius' and 'the masterpiece' or to do justice to the historical and political complexity of the works of art on display. While, as we have seen, others have sought to ask such questions and raise these issues, they are the exception rather than the rule. The reason for this lies not simply in the institutional conservatism of museums but also perhaps in the pressures of contemporary culture which, as the introduction to this book suggested, mean that people are more likely than ever to cling to the consoling myths of the artist-genius and national heritage. As this book has tried to show, it is important not simply to criticize art institutions – whether for their failure to change or for the changes that they have made – but also to seek to understand the reasons for this state of affairs.

Recommended reading

Museums and exhibitions

Many of the books in this section are essay collections covering a wide range of subjects. They should therefore be read selectively.

Bourdieu, Pierre and Darbel, Alain (1991) *The Love of Art: European Art Museums and their Public*, Cambridge, Polity Press.

'Contemporary museums' (1997) special issue of *Architectural Design*, vol.67, no.11–12, Nov.–Dec.

'Curating: the contemporary art museum and beyond' (1997) *Art and Design* (special issue: ed. Anna Harding), vol.12, no.1–2, Jan.–Feb.

Duncan, Carol (1995) *Civilizing Rituals: Inside Public Art Museums*, London and New York, Routledge.

Greenberg, Reesa, Ferguson, Bruce W. and Nairne, Sandy (eds) (1996) *Thinking about Exhibitions*, London and New York, Routledge.

Karp, Ivan and Lavine, Steven D. (eds) (1991) *Exhibiting Cultures: The Poetics and Politics of Museum Display*, Washington, DC, Smithsonian Institution Press.

Lumley, Robert (ed.) (1988) *The Museum Time Machine: Putting Cultures on Display*, London, Routledge / Comedia.

Newhouse, Victoria (1998) *Towards a New Museum*, New York, Monacelli Press.

Pointon, Marcia (ed.) (1994) *Art Apart: Art Institutions and Ideology across England and North America*, Manchester University Press.

Preziosi, Donald (ed.) (1998) *The Art of Art History: A Critical Anthology*, Oxford University Press (Part 9: 'The Other: art history and / as museology').

Serota, Nicholas (1996) *Experience or Interpretation: The Dilemma of Museums of Modern Art*, London, Thames and Hudson.

Sherman, Daniel J. and Rogoff, Irit (eds) (1994) *Museum/Culture: Histories, Discourses, Spectacles*, London, Routledge and Minneapolis, University of Minnesota Press.

Vergo, Peter (ed.) (1989) *The New Museology*, London, Reaktion Books.

Art and culture

Baudrillard, Jean (1988) *Selected Writings*, ed. Mark Poster, Cambridge, Polity Press.

Connor, Steven (1996) *Postmodernist Culture: An Introduction to Theories of the Contemporary*, 2nd edn, Oxford, Blackwell.

Crow, Thomas (1996) *Modern Art in the Common Culture*, New Haven and London, Yale University Press.

Harvey, David (1989) *The Condition of Postmodernity: An Enquiry into the Origins of Cultural Change*, Oxford, Blackwell.

Hewison, Robert (1997) *Culture and Consensus: England, Art and Politics*, 2nd edn, London, Methuen.

McGuigan, Jim (1996) *Culture and the Public Sphere*, London and New York, Routledge.

Miles, Malcolm (1997) *Art, Space and the City*, London and New York, Routledge.

Mitchell, W.J.T. (ed.) (1992) *Art and the Public Sphere*, University of Chicago Press.

Nelson, Robert S. and Shiff, Richard (1996) *Critical Terms for Art History*, University of Chicago Press (section on 'Societies').

Taylor, Brandon (1995) *The Art of Today*, London, Everyman Art Library.

Urry, John (1990) *The Tourist Gaze: Leisure and Travel in Contemporary Societies*, London, Newbury Park and New Delhi, Sage (especially chapter 6).

Walker, John A. (1994) *Art in the Age of Mass Media*, 2nd edn, London, Pluto Press.

Wright, Patrick (1985) *On Living in an Old Country*, London, Verso.

Index

Page numbers in *italics* refer to illustrations. Works of art are listed under the artist where known; if the artist is not known, they are listed under their title.